Photography
The guide to technique

Andrew Hawkins and Dennis Avon

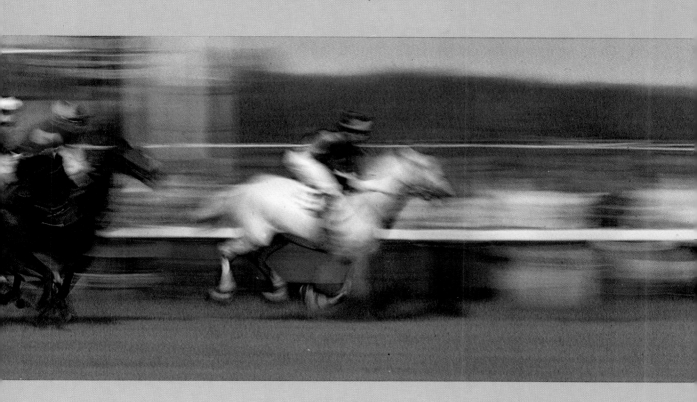

Blandford Press Poole Dorset

First published in the UK 1979
Reprinted 1980
Revised Edition 1984
Copyright © 1979 Blandford Press Ltd
This Edition © 1984 Blandford Press Ltd
Link House, West Street
Poole, Dorset BH15 1LL

British Library Cataloguing in Publication Data

Hawkins, Andrew
 Photography. — Rev. ed.
 1. Photography
 I. Title II. Avon, Dennis
 770' .28 TR146

ISBN 0 7137 1456 5 Hardback
ISBN 0 7137 1411 5 Paperback

Printed in Singapore by Toppan Printing Co. (S) Pte. Ltd.

Contents

Introduction *page* 7

Acknowledgements 8

Light and colour 9
Nature and properties of light – formation of the
photographic image

The basic camera 17
Components – design

The lens and aperture 20
Image-forming role – focusing – aperture – aberrations

The shutter 26
Main types – leaf and focal plane – characteristics

Types of cameras 34
Viewfinder – twin-lens reflex – single-lens reflex – view
camera – advantages and disadvantages

The film 44
Basic features – main types – monochrome – colour reversal –
colour negative – lith – X-ray – infra-red – film sizes

Exposure meters 54
Types – hand-held – built-in – through-the-lens metering –
automatic exposure – reflected light – incident light –
grey card – precautions

Shutter and aperture 64
Control of exposure – depth of field – freezing the action

Depth of field 68
Limits of sharpness – circles of confusion – hyperfocal
distance

Interchangeable lenses 75
Angle of view – perspective – construction of lenses

Camera and subject movement 84
Camera shake – tripods – capturing the feeling of movement

Limitations of film 92
Resolving power and graininess – contrast – colour balance –
reciprocity failure

Composition 104
 Basic rules – when to break them

Photographing architecture 122
 Special problems – converging verticals – interiors by
 available light

People and portraits 126
 Subject co-operation – lighting – glamour

Natural history photography 136
 Equipment necessary – in the wild – zoos and wildlife
 parks – plants

Underwater photography 150
 Special equipment – importance of lighting – colour filters

Photography after dark 156
 Illuminations – floodlit buildings – fairgrounds – fireworks

Flash photography 162
 Bulbs – flashcubes – flashbars – electronic flash –
 automatic types – fill-in flash – multiple flash –
 particular applications

Close-up photography 188
 Supplementary lenses – extension tubes and bellows –
 exposure adjustments – depth of field

Photomicrography 204
 Use of microscope – lighting and techniques

Special techniques 224
 Fish in aquaria – insects under controlled conditions –
 small pond organisms – coins and medals – fluorescence –
 glassware – water-colour technique – oil-painting
 technique – crystals by polarized light

Filters 242
 How filters work – filters with black-and-white – filters with
 colour – using filters creatively

Audio-visual work 258
 Preparation of slide show – presentation – rehearsals

Glossary 266

Index 270

Introduction

Why another book about photography? The answer to this understandable question is that we are convinced that no book has yet been produced which provides the up-and-coming photographer with the necessary information on technique. We have attempted to put this to rights by including such information in order to provide the reader with maximum assistance in efforts towards advancement. In many instances more than one picture of the same subject have been included to provide a comparison of results which occur with different techniques – or to show the right and wrong ways to take a picture.

We have also described techniques requiring a minimum of special equipment but which yield unusual and interesting results. These include photography of fish in aquaria, insects, glassware and crystals. Two very special techniques enable the photographer to produce effects which simulate water colours or oil paintings. These two techniques have never before been described and illustrated in a book.

Despite their technological sophistication, modern films have certain limitations, so we have shown how the photographer must often make allowances to ensure that his pictures are reasonably faithful to the original subject – although sometimes these same limitations can actually be exploited for creative effect.

Flash equipment is discussed in considerable detail. In addition to explanations of fill-in and multiple flash techniques, details are provided of any necessary calculations. A special feature is construction details for a flash delay unit which enables certain high-speed events to be photographed at various stages of the action. Its use is illustrated by a sequence showing an ink drop falling into water.

We have described the various methods and equipment for close-up photography with details of relevant calculations. The chapter on photomicrography discusses the practical aspects of photography through the microscope and of the special illumination required. The microscope described is a relatively simple and inexpensive type found in most schools.

Despite this attention to technique, we have not neglected the basics. The opening chapters discuss the nature of light and all the principal features and main types of cameras and films. We have looked at the various types of exposure meters and discussed their use, and have dealt with depth of field and related focusing calculations. Also we have explained the all-important requirements for the control of camera movement and subject movement.

Photography is all things to all photographers, whether it is used for holiday pictures of the family or as a fully creative art form in its own right. Whatever your aspirations as a photographer, we feel that an understanding of techniques is needed before you can truly apply yourself to taking the pictures you want. We have attempted to explain and illustrate these techniques in as interesting and stimulating a way as possible.

<div align="right">A. H. and D. A.</div>

Acknowledgements

Unless otherwise indicated below, the text and captions for this book were written and researched by Andrew Hawkins, and the diagrams and artwork were drawn by Dennis Avon.

Natural History: section dealing with the photography of wild birds and animals, pages 136 to 143, text and diagrams by **Tony Tilford**.
Underwater Photography: pages 150 to 155, text and diagrams by **Peter Scoones**.

Photographs by Andrew Hawkins and Dennis Avon with the exception of the following:
page 240 centre and bottom, **Michael Allman**; 127 bottom, 132 top right, **Jennifer Carter**; 115 centre and bottom, **Keith Chant**; 145 (3 pictures), 146 (2 pictures), by courtesy of **The Chipperfield Organisation**; 186 top left, **A. E. Coe and Sons Limited**; 97 bottom, 128 bottom, **Coe Colour Centre**; 95, 117 (3 pictures), **Mike Cox**; 105 top, 113 (3 pictures), 131 bottom, **Roger Gamble**; 91, **Bill Goodchild**; 105 bottom, 115 top, **Susan Hind**; 16 top, 93 top, 104 right, 109 (2 pictures), 122, 125, 137 centre, 148 centre, 149, 189 bottom, 191, **Jarrold, Norwich**; 105 centre (2 pictures), 111 top, 118 (2 pictures), **Neil Jinkerson**; 44 bottom, 102 (2 pictures), 246 (4 pictures), 247 (4 pictures), 248 (2 pictures), by courtesy of **Kodak Limited**; 120 (3 pictures), 127 top (2 pictures), **Jack Oakley**; 114 centre (2 pictures), **Andrew T. Paton**; 119 bottom, **Ted Rule**; 151, 152 (2 pictures), 154 (2 pictures), 155, **Peter Scoones/Seaphot**; 130 top, 131 top right, 132 bottom, **Ian Shaw**; 159 bottom, **Robin Smith Photography Limited**; 119 top left, **Richard Tilbrook**; 190, 255 top left, **Tony Tilford**; 133 left (3 pictures), **Geoffrey Unwin**; 89 bottom, 131 top left, **Patrick Walmsley**; 106, 130 bottom, 132 top left, **John Ward**.

Grateful thanks are also due to:
Canon Incorporated, for the illustration of the Canon A-1 appearing on page 38;
Jean Churchyard, for her artistic arrangement of the flowers for the photographs on page 237;
George Elliott and Sons Limited, the United Kingdom importers of Compur and Prontor shutters, for the photographs of the Prontor Electronic shutter on page 33;
Norwich Camera Centre, for allowing us on numerous occasions to photograph cameras and other equipment from their stock;
Ron Stillwell, the designer of the Cromatek filter system, for his advice and photographs illustrating the creative use of filters.
Trevor Weinle of **Exposure Camera Service, Norwich**, for his frequent advice and help on the technicalities of camera mechanisms.
Dougal Dixon, for editing the text.
And last, but not least, thanks to our wives **Margaret** and **May**, for their forbearance and understanding over the two-year period during which we were preparing the contents of this book.

Light and colour

What is light?

The natural daylight by which we see is a form of electromagnetic radiation and is emitted by the sun as a series of waves which travel away from it in a similar manner to the ripples produced on the surface of a pond after a pebble is thrown in.

The sun emits an enormous range, or spectrum, of electromagnetic radiation, from gamma rays with wavelengths of from less than 0·000000001 mm to low-frequency radio waves with wavelengths in excess of 10,000 m. (The wavelength is the distance between two successive crests of the waveform. The number of crests which pass a point in a given time – the figure is usually quoted for a 1-second period – is the frequency of the radiation.) Somewhere in between is the very narrow band of wavelengths to which the human eye is sensitive, and which we call light. Within this narrow band – the visible spectrum – the wavelength at any point determines the colour of the light at that point. The wavelengths extend from around 0·0004 mm, at which the colour is deep violet, through blue, green, yellow, orange and red to around 0·0007 mm, where the colour is deep red.

Immediately beyond the blue end of the visible spectrum and continuing to around 0·000005 mm is the band known as ultra-violet radiation, parts of which, in large quantities, are harmful to living cells, and which is responsible for the formation of the brown pigment melanin in the skin producing a sun tan. The sun emits large amounts of ultra-violet radiation, but fortunately the vast majority is absorbed by the ozone layer encircling the earth. This layer is produced by the action of the ultra-violet radiation itself, which breaks down oxygen molecules (O_2) in the upper atmosphere to produce oxygen atoms, many of which recombine to produce molecules of ozone (O_3).

Extending from immediately outside the red end of the visible spectrum is the band of infra-red radiation, responsible for the transmission of radiant heat.

Most photographic films, in addition to being sensitive to the visible spectrum, have some sensitivity to parts of both the ultra-violet and infra-red bands, a characteristic which may be used to advantage to photograph things not normally visible to the human eye, with applications in the medical and forensic fields. This can, however, also produce unwanted false effects, particularly with colour films, if steps are not taken to prevent such radiation from reaching the film.

Light travels in straight lines, a fact evident from the formation of shadows, and nicely demonstrated by the pinhole camera.

The speed of light depends on the medium in which it is travelling, and is approximately 186,200 miles per second in a vacuum. It is interesting to ponder on the fact that Alpha Centauri,

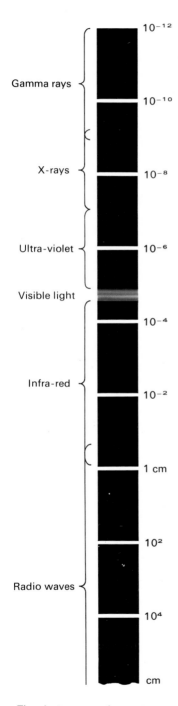

The electromagnetic spectrum

the *nearest* true star to Earth, is so far away that the light from it takes just over four years to reach us.

Artificial light

Light radiation may be produced artificially by several means, the oldest and most common being the heating of an object until it emits light. The atoms of which any object consists are constantly vibrating, causing the object to emit electromagnetic radiation. At normal room temperatures this radiation is extremely weak and of wavelengths much longer than those of the visible spectrum. If the temperature of the object is raised, however, the rate of emission increases and the wavelength decreases until, when the object is very hot, it emits radiation at wavelengths just short enough to fall within the visible spectrum. At this point the colour of the emitted light is red – the object is red hot. If the temperature is increased still further until the object is radiating at all the wavelengths of the visible spectrum, the emitted light appears white and the object is said to be white hot.

Carbon particles within the flame of a candle or oil lamp are heated by the chemical reaction of combustion to a temperature at which they emit a yellowish-white light. A domestic light bulb consists of a glass envelope containing a fine tungsten wire, or filament, which is heated to incandescence by passing an electric current through it.

Light rays travel in straight lines – a fact which is demonstrated by the pinhole camera. Rays from the subject pass through a small hole to form an inverted image on a suitably positioned sheet of paper or film. The picture, right, was taken with a home-made pinhole camera, using a pinhole of 0·5 mm diameter positioned 125 mm from the film. Because of the pinhole's small diameter the intensity of the light was so low that an exposure of 3 seconds was required, even though the picture was taken in bright sunshine.

Other means of producing light artificially include the gas-discharge lamp, in which an electric current is passed between two electrodes within a gas-filled glass or quartz tube, causing the gas to glow, each gas producing its own characteristic colour. In addition to visible light, most gases produce radiation at wavelengths outside the visible spectrum, and operating efficiency is often low. The electronic flashgun is a photographic application of the gas-discharge lamp, the flash being produced by the sudden discharge of an electric current through a xenon-filled tube, efficiency in this instance being fairly high.

Fluorescent tubes are a form of gas-discharge lamp in which the inside of the tube is coated with a fluorescent phosphor, a substance with the ability to absorb much of the non-visible radiation and to re-emit it at wavelengths within the visible spectrum, giving considerable increase in efficiency.

The subject of artificial lighting and its suitability or otherwise for photographic purposes is discussed later in this book, in the section dealing with colour temperature (see p. 96).

Reflection

Few of the objects we see around us emit light themselves. Most reflect light falling on them from the sun or some other source, and this reflected light stimulates our eyes to give us the sensation of sight.

Whether an object appears light or dark in tone depends on how much of the light falling on it – the incident light – is absorbed and how much is reflected. White paper, for instance, reflects over 80%, while the black ink with which this text is printed reflects only 2–3%.

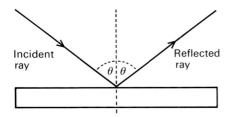

Reflection at a shiny surface

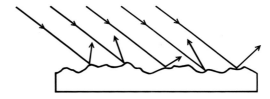

Scattering at a matt surface

Shiny and matt surfaces reflect light differently. In the case of a very highly polished material, the reflected light leaves the surface at the same angle as the incident light falling on it, obeying the fundamental law of reflection which states that **the angle of incidence is equal to the angle of reflection**. With a matt surface, scattering occurs and the light is reflected in a haphazard manner. This is due to the very irregular nature of the surface, each minute bit of which is inclined differently. For each light ray hitting the surface, however, the law of reflection is still obeyed.

Colour

We have seen that white light is made up of all the colours of the visible spectrum. This can be demonstrated by passing a narrow beam of white light through a glass prism. When light passes the boundary between two mediums, in this case air and glass, it is bent, or refracted, due to the change in velocity of the waves as they pass the boundary (see **Refraction**, p. 14). The amount of refraction is dependent on the wavelength of the light, the shorter wavelengths being refracted slightly more than the longer ones. The result of this selective refraction is that the prism splits the beam of light into its constituent wavelengths, each emerging from the prism at a different angle, enabling the visible spectrum to be observed by allowing the emerging beam to fall on a white surface.

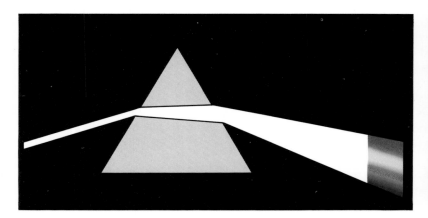

White light can be synthesized by optically combining all the colours of the visible spectrum. This can be demonstrated by allowing the spectrum emerging from one prism to fall on a second prism, inverted in respect to the first. The colours produced by the first prism are recombined by the second to give white light.

Objects appear coloured if they reflect light of one part of the visible spectrum more than another. A red book, for instance, appears red because it reflects only the wavelengths at the red end of the spectrum. The same red book illuminated by green or blue light appears black because the red surface absorbs all the green or blue light and no light is reflected.

We have seen that white light can be synthesized by combining all

The colour of light is dependent on its wavelength. Of the wavelengths to which the eye is sensitive, blue is the shortest and red the longest, with all the other colours of the spectrum in between. White light is a mixture of light of all the wavelengths of the visible spectrum, and can be separated into its constituents by passing it through a prism, left.

A red book appears red because it reflects red light and absorbs all other colours. Similarly, blue glass appears blue because it transmits only the blue wavelengths and absorbs all others.

the colours of the spectrum. This can also be achieved by adding together only red, green and blue light. This is known as **additive colour mixing**, and may be demonstrated by the use of three projectors, each with a coloured filter over the lens, to project overlapping circles of red, green and blue light on to a white surface. Red, green and blue are **primary colours**. Where all three colours overlap, white light is produced. Where only two colours overlap, one of the three **secondary colours** is produced. Red and green overlap to give yellow, red and blue to give magenta, and green and blue to give cyan.

The mixing of coloured paints, inks or dyes, as opposed to coloured lights, is known as **subtractive colour mixing**. This is easily demonstrated by holding together coloured filters in front of a light source. Combining filters of any two of the primary colours will result in no light passing, the combination appearing black. Combinations of any two of the secondary colours pass only the primary colour which is a common constituent of the two secondaries. Holding together all three secondary colours produces black, there being no colour which is common to all three.

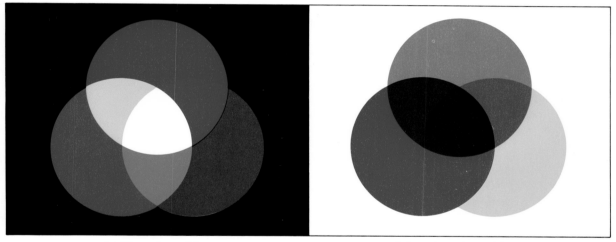

Additive colour mixing Subtractive colour mixing

This discussion on colour mixing assumes the filters to be of fully saturated colours. The term saturation refers to the strength of the colour as opposed to the hue. A fully saturated colour transmits or reflects no more than two of the primary colours. A fully saturated red paint, for example, reflects only red light, absorbing blue and green. Pink, which is a desaturated, or pastel, red reflects all three primary colours, but red more than blue and green.

Most photographic colour processes rely on subtractive colour mixing to reproduce the colours of the original subject, using only dyes of the three secondary colours, yellow, magenta and cyan, in varying quantities.

A good magnifying glass, 10× or greater, will reveal that the colour photographs in this book have been reproduced by printing

various size dots of yellow, magenta and cyan ink. (In fact a black ink is also used, because the colour purity of pigments suitable for use in printing inks is such that all three colours together produce a brownish black rather than a neutral black.) The hue of the original subject is recorded by the relative dot sizes of the three colours, while the saturation is represented by the size of the dots in relation to the area of white paper between them.

Refraction

In the previous paragraphs we have seen that light passing the boundary between one medium and another is refracted, because of the change in velocity of the waves as they pass the boundary.

A simple example of refraction is the apparent bending of a stick in water, due to the rays of light reflected from the parts of the stick under water being refracted as they pass from the water to the air above.

The amount a light ray is bent as it passes from one medium to another is dependent not only on the wavelength of the light but also on the difference in the velocity of light in the two mediums – the greater the difference, the more the ray is refracted.

For any transparent material, the velocity of light in a vacuum divided by the velocity in the material is known as the **refractive index** of the material. Since light travels slower in a denser medium than in a vacuum, the refractive index is always greater than 1. Water, for instance, has a refractive index of about 1·3, glass about 1·5, and diamond 2·4. Light rays passing from a medium with a low refractive index to one with a higher index are refracted towards the normal (perpendicular), while rays travelling into a medium with a lower index are refracted away from the normal.

If a ray of light is passed obliquely through a glass block which has parallel sides, the emerging ray is displaced in relation to the incident ray, but is parallel to it. If a block with converging surfaces – a prism – is used, the emerging ray is at an angle to the incident ray.

If two identical prisms are positioned symmetrically in relation to a point light source, rays of light entering the two prisms at the same point on each are refracted equally, and on emerging are brought to a focus at a common point.

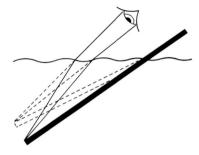

Light reflected by those parts of the stick, above, which are under water is refracted as it passes from the water into the air above, with the result that the stick appears to be bent at the point at which it leaves the water.

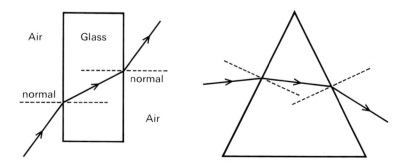

A ray of light passing through a block of glass is refracted towards the normal as it enters the glass and away from the normal as it leaves it. If the block has parallel sides, far left, the emerging ray is parallel to the incident ray. If the sides are not parallel, left, the emerging ray is at an angle to the incident ray.

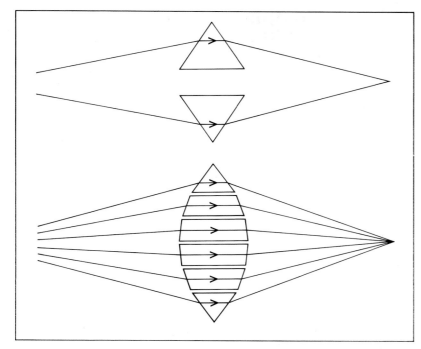

The basics of the simple lens: two identical prisms positioned symmetrically will bring light rays to a common point, or focus. A simple coverging lens may be regarded as an infinite number of prisms, each with a slightly different angle from its neighbour.

A converging, or convex, lens may be considered as an infinite number of prisms, each with a slightly different angle from its neighbour. For a perfect lens, light from a common point at one side of the lens is brought to a focus at a common point on the other side, no matter where the light strikes the surface of the lens. This holds true even when the source of light is not on the axis of the lens, in which case the light rays are brought to a focus at a point which is itself not on the axis, the displacement of this point from the axis being proportional to the displacement of the light source from the axis. It is this characteristic which gives the converging lens its unique ability to form images.

When the rays of light striking the surface of a lens are parallel to each other, and to the optical axis of the lens, they are brought to a focus at a point known as the **focal point** of the lens. The distance between the focal point and the optical centre of the lens is known as the **focal length** of the lens.

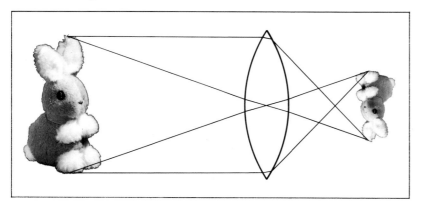

In photography, the formation of an image on the film in the camera relies on the property of the converging lens to bring light from a common point on one side of the lens to a common focus on the other.

Modern camera lenses, although largely corrected for chromatic aberration, can still exhibit the fault to a degree sufficient for it to be noticeable when a picture is viewed many times enlarged. The picture, left, was taken with an expensive wide-angle lens but, as the colour fringes around the lettering in the enlarged section above demonstrates, chromatic aberration is evident at the edges of the picture.

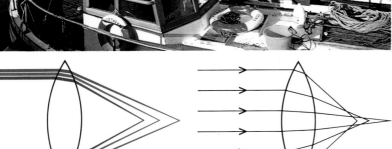

We have seen that the amount a light ray is refracted is partly dependent on the wavelength, i.e. the colour, of the light, a fact that gives rise to problems with simple lenses, as each wavelength is brought to a focus at a slightly different point. This is known as **chromatic aberration** and in black-and-white photography is evident as a slight loss of sharpness towards the edges of the picture. In colour the effect is much more pronounced, showing on the picture as coloured fringes around any sharply defined object.

A simple convex lens, made with spherical surfaces, is far from perfect and will not bring rays of light from a common point on one side of the lens to a common point on the other side. Instead, each ray comes to one of a series of points, the exact one being dependent on the diameter of the lens at the point at which that particular ray passed through. This defect is known as **spherical aberration**. Used photographically, such a lens is unable to produce a really sharp image of the subject. Some improvement is possible by restricting the effective diameter of the lens by means of a plate with a circular hole, known as a stop or aperture, positioned concentrically with the lens. Most of the very cheapest cameras use a single lens of small effective diameter to achieve results which are acceptably sharp, considering the low cost of the camera. More expensive cameras have lenses consisting of several lens units, or elements, usually made of glasses with different refractive indices, which together form a converging lens in which chromatic, spherical and other aberrations have been almost entirely eliminated.

Spherical aberration is an inability of a lens to bring rays of light which pass through the lens near its perimeter to the same point of focus as rays which pass through the lens near its centre. Modern camera lenses are well corrected for this fault. The picture, below, was taken using a cheap magnifying glass instead of a proper camera lens. The lack of sharpness is almost entirely due to spherical aberration.

The basic camera

All cameras, from the cheapest to the most expensive and complex, have a similar basic construction. Remove the trimmings and they all consist of a box from which all unwanted light is excluded, at one end of which is a means of holding the light-sensitive film, and at the other a lens to form on the film an image of the subject to be photographed.

Somewhere in the light path is a shutter which can be opened for a predetermined time to allow the film to be given a controlled exposure to the light passing through the lens. Most cameras have some form of viewfinder to indicate the area of the subject which will be included in the picture.

In all but the very cheapest cameras the lens consists of two or more elements designed to minimize the aberrations produced by a single-element lens.

Most cameras have a means of adjusting the effective diameter of the lens – and hence the amount of light passing through it – in accordance with the sensitivity of the film, the time for which the shutter is open, and the lighting conditions, in order to ensure that the film receives the right amount of light to produce a correctly

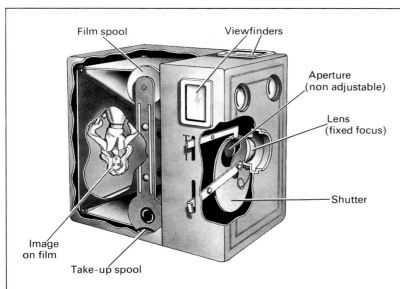

Film spool

Viewfinders

Aperture
(non adjustable)

Lens
(fixed focus)

Shutter

Image
on film

Take-up spool

The box camera. Now only part of photographic history, but a good example of the camera at its most basic.

The once familiar box camera was introduced by George Eastman in 1888, along with the famous slogan 'You press the button, we do the rest', to bring photography within the reach of ordinary people. Available in various models for about the next fifty years, it was little more than a wooden box, blackened on the inside, with the film at one end and a single-element, fixed-focus lens at the other. The very simple shutter usually had two settings – 'instantaneous', which gave a fixed exposure of about 1/25 second, and 'time', at which the shutter remained open for as long as the operating lever was depressed.

Later models had two viewfinders, one for upright and one for horizontal pictures, which gave a fairly accurate but laterally reversed indication of the area of the subject included in the picture.

exposed image of the subject. In the cheapest cameras this is often achieved by a movable metal plate, punched with holes of various sizes, which is positioned between or behind the lens elements. In most cameras, however, the amount of light is controlled by an iris

diaphragm. This is an assembly of overlapping metal blades positioned between the lens elements to form a central, roughly circular aperture, the diameter of which is continuously variable, within its limits, by the rotation of the blades on their pivots. The operating lever or ring is calibrated with a series of numbers – e.g. 2, 2·8, 4, 5·6, 8, 11, 16, etc. – which at first glance may appear rather baffling. The significance of these figures and how they are derived is discussed in the sections dealing more fully with the aperture and its role in the control of exposure.

The viewfinders of most cheaper cameras are of a simple design which gives a slightly smaller-than-life-size view of the subject. Many of these are of the 'bright-line' type, in which a brightly illuminated frame is optically superimposed on the view of the subject to indicate the area to be included in the picture.

Many of the more expensive cameras are of the reflex type, of which there are two basic designs. One, the twin-lens reflex (TLR), has an additional viewing lens, similar in focal length to that which takes the picture, focusing an image of the subject via a fixed mirror on to a ground-glass screen where it can be viewed. The single-lens reflex (SLR) uses the same lens to take the picture and to view the subject. For viewing, a mirror intercepts the light passing through the lens and deflects it on to a ground-glass screen. At the moment of taking the picture the mirror momentarily flips out of the light path, allowing the image to fall on the film for the duration of the exposure.

All cameras, except the very cheapest and some pocket models, have a focusing system which allows the separation between lens and film to be adjusted so that the image on the film is as sharp as possible, whatever the distance between camera and subject. The nearer the subject, the greater is the separation required between the lens and film. Often the focusing system incorporates a visual indication of when the subject is in focus, eliminating the need to guess or measure the camera to subject distance. In many cameras this indication is given by a rangefinder, usually an integral part of the viewfinder, through which can be seen a double image of the subject which merges into one when the focusing is correctly set. With reflex cameras the sharpness of the image on the ground-glass screen can be visually checked as the focusing is adjusted.

In most low- to medium-priced cameras, and in some of the more expensive, the shutter is positioned between the lens elements and consists of metal blades, similar to those in the iris diaphragm, which open to allow light to pass through the lens for the duration of the exposure. Such shutters are usually referred to as 'between-lens' or 'leaf' shutters.

The majority of the most expensive cameras are fitted with 'focal plane' shutters, consisting of two metal or fabric blinds positioned a few millimetres in front of the film plane. At the moment of taking the picture one blind moves away, exposing the film to the image of the subject. To terminate the exposure the second blind moves into the position originally occupied by the first. This type of shutter is particularly suitable for the SLR camera, as it does not interrupt the

passage of light through the lens to the viewing screen, as would a
between-lens shutter.

In both types of shutter the duration of the period during which
the shutter is open – the shutter speed – is controlled by either a
mechanical assembly of gears and escapements or an electronic
timing system. The shutter speed is usually selected by an external
control, calibrated in seconds and fractions of a second, although in
some cameras it is automatically set by a photo-electric exposure
meter which measures the strength of the light reflected from the
subject.

Most shutters have the facility to synchronize the firing of a
flashgun with the opening of the shutter. This is achieved by a pair
of electrical contacts which close to fire the flashgun at a precise
moment during the shutter's operating sequence, such that the peak
light output of the flashgun is reached when the shutter is in a fully
opened position.

In the early days of photography the light-sensitive emulsion was
coated on glass plates which were loaded, in a darkened room, into
special light-tight plate holders which attached to the back of the
camera. Before taking a picture the photographer had to pull out a
slide of wood or metal to uncover the plate within the camera. The
exposure, which was often of several minutes duration, could then
be made, after which the slide had to be pushed back in, the plate
holder removed from the camera, and another fitted before the next
picture could be taken.

The enjoyment of photography by ordinary people, most of whom
aspired only to take holiday and family snapshots, really gained
momentum around the turn of the century, with the introduction of
simple-to-use cameras which took film in rolls, long enough for
several pictures to be taken on each. The light-sensitive emulsion
was coated on a length of flexible transparent plastic which was
wound, together with a longer piece of opaque backing paper, on to
a simple spool. The backing paper protected the film from light
outside the camera and served as a leader to enable the camera to be
loaded and unloaded in fairly bright light. Such film is still available
today, and the term 'roll film' is still used to indicate this specific
type of film. Nowadays most cameras use film which is contained in
metal or plastic cassettes or cartridges, making camera loading and
unloading a very simple operation.

The early roll-film cameras had a small window in the back
through which numbers printed on the backing paper could be seen,
to allow the film to be wound on the required amount after each
picture and to indicate the number of pictures taken. Most modern
cameras, whichever film type they use, have winding mechanisms
which automatically stop when sufficient film has been advanced for
the next picture. An automatic frame counter indicates either the
number of pictures taken, or the number of exposures left, and after
each picture a mechanical interlock prevents the shutter from being
operated again until the film has been advanced.

The lens and aperture

The most important single component of any camera is the lens. It is this item which projects on to the film an image of the subject, and its quality will determine the sharpness and clarity of the resulting photographs. In an earlier section of this book (p. 16), we saw that the simple single-element lens suffers from defects such as chromatic and spherical aberrations, which can be almost entirely eliminated by the use of a compound lens, consisting of several elements made from glasses of different refractive indices. Modern cameras have lenses consisting of anything from between one and three elements in some cheaper cameras, to ten or more in some zoom and extremely wide-angle lenses. The design of such lenses requires the optimum shape and refractive index of each element to be calculated mathematically. The possible permutations of these factors are almost limitless but, ideally, the lens designer should explore each in turn to evaluate that which best suits the requirements for the lens. Until the advent of the modern computer the length of time required for each calculation considerably restricted the designer in his choice. Today the speed at which computers operate allows many more of the permutations to be evaluated, making possible the design and manufacture of lenses of hitherto unequalled quality, with very few residual aberrations.

In order that the image at the camera's film plane shall be as sharp as possible, it is necessary for the distance between the lens and the film to be adjustable, the actual setting being dependent on the distance between the lens and the subject – the nearer the subject the greater the lens to film distance required. The operation of adjusting the lens position to obtain the sharpest possible image is known as focusing. Very cheap cameras have fixed-focus lenses, the position of which is fixed during manufacture to give a reasonably sharp image of subjects which are more than about 5 feet away from the camera. Most cameras, however, have some means of focusing the lens. In many this takes the form of a coarse screw thread holding the lens assembly in its mount. Rotating a ring on the mount moves the lens assembly nearer to or further from the film plane. In many cameras the whole lens assembly moves, but in some only the front elements move – this is known as front-cell focusing. The focusing ring is calibrated in distance and often incorporates a depth of field scale to indicate how far an object can be either side of the set distance and still remain acceptably sharp.

Many cameras have a means of visually checking the focusing, either by an optical rangefinder, mechanically coupled to the focusing mechanism, or by inspecting visually the image on a ground-glass screen which forms part of the viewfinder system. Such aids to focusing are referred to more fully in the pages dealing with different types of cameras (p. 34).

Most cameras have an adjustable iris diaphragm, positioned

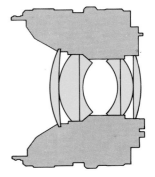

A cross-section of a typical camera lens. The shape and inter-relation of the various elements is carefully calculated to reduce aberrations to an absolute minimum.

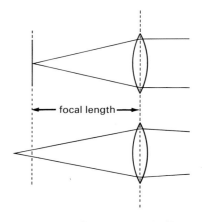

focal length

Top: light rays from an infinitely distant object are parallel and on passing through a lens are brought to a focus at a point which is spaced from the optical centre of the lens by a distance equal to the focal length of the lens.
Bottom: light rays from a closer object are brought to a focus further behind the lens, and the lens to film distance must be increased accordingly if a sharp picture is to be obtained.

between the lens elements, the primary purpose of which is to control the amount of light passing through the lens and hence, in conjunction with the shutter, the exposure of the film. Usually the iris diaphragm consists of pivoted metal blades, placed concentrically around the lens. The blades overlap one another,

Some cameras incorporate the focusing mechanism into the body of the camera rather than as a part of the lens mount. In the twin-lens reflex camera, above, this is necessary because taking and viewing lenses must move together to retain the relationship between the

images on viewing screen and film (see p. 36). In this example the entire lens panel assembly is moved by a rack-and-pinion mechanism coupled to the focusing knob on the camera body. An expandable light-tight bellows connects the lens panel to the camera body.

leaving a central, roughly circular aperture, the diameter of which is adjustable by the rotation of the blades on their pivots. The operating ring or lever is calibrated in settings referred to as 'stops', 'f-numbers' or 'apertures'. As the iris diaphragm is closed, each setting passes exactly half the light of the previous one. On many lenses the ring has a 'click-stop' mechanism which allows precise location of each whole-stop setting and often of intermediate half-stops. The numerical value of each setting represents the relationship between the focal length of the lens and the effective diameter of the lens at that aperture. The values form an internationally accepted series, based on a starting point of f1. At this setting the effective diameter of the aperture is equal to the focal length of the lens. For the next setting to pass only half the light, the effective *area* of the aperture must be halved. Because the area of a circle is proportional to the square of the radius, the *diameter* must be reduced to a value equal to focal length$/\sqrt{2}=$focal length$/1\cdot414$. The denominator is rounded to $1\cdot4$ and the setting is known simply as f1·4. The next setting must again pass only half the light, and hence only a quarter of that passed at f1. Therefore, the effective diameter of the aperture must be reduced to focal length$/\sqrt{4}=$focal length$/2$, and the setting is known as f2. The complete series runs f1, $1\cdot4$, 2, 2·8, 4, 5·6, 8, 11, 16, 22, 32, 45, 64, etc., each of these whole-stop settings passing half the light of its predecessor. In practice,

In many cameras the focusing mechanism consists of a coarse screw thread incorporated in the lens mount. The focusing scale is usually calibrated in both feet and metres and includes a depth of field scale. In the diagram, above, the focusing is set to 5 m and the aperture to f16. The depth of field scale indicates that at these settings depth of field extends from about 2·5 m to infinity.

lenses are rarely made with apertures as large as f1. The maximum aperture usually depends on the price of the camera and the type of lens. The reduction of lens aberrations is more difficult to achieve for lenses with particularly large maximum apertures, and consequently such lenses are very costly. On many medium-priced cameras the maximum aperture is about f2·8, while on some more expensive SLR cameras, lenses with maximum apertures of f1·4 and even f1·2 are available. Sometimes the maximum aperture is a value which is not part of the accepted series, e.g. f1·2 or f1·8. In such cases the settings revert to the normal series after the initial odd value. On most 35 mm cameras the smallest aperture is usually f16 or f22, while on larger format cameras it may be as small as f32 and occasionally f45.

Because f-numbers are derived from the direct relationship between the focal length and the effective diameter of the aperture,

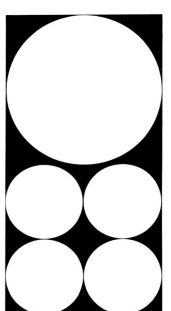

The diagram, above and right, gives an indication of the relative size of the aperture at various settings of the aperture ring.

The diagram, left, shows that the area of a circle is proportional to the square of its diameter. The large circle has four times the area of each of the small circles, yet its diameter is only twice as great.

Left: The role of the aperture in the control of exposure is to regulate the intensity of the image at the film plane.

lenses of any focal length, when set to the same f-number and under identical lighting conditions, give the same intensity of light at the film plane, give or take very slight manufacturing variations. This basic principle allows exposure information, derived from an exposure meter or table, to be easily set on any type of camera, regardless of the focal length of its lens.

In the above discussion we have repeatedly referred to the effective diameter of the aperture. Because of the complex light path through a compound lens, this may not be the same as the actual diameter (see explanatory diagram).

Although the primary purpose of the aperture is to control the exposure of the film in conjunction with the shutter, it is also used in conjunction with the focusing to control depth of field – the smaller the aperture the greater the depth (see p. 69).

The choice of aperture setting also has an effect on the ability of a

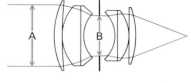

The *effective* diameter, A, of the aperture of a compound lens may not be the same as the *actual* diameter, B, due to the complexity of the light path through the lens. It is the effective diameter which is used in the calibration of the aperture ring.

In addition to its role in the control of exposure, the aperture also affects the depth of field obtained in a picture. Depth of field is smallest at large apertures and greatest at small apertures. The picture, far left, was taken at f1·4 and the picture, left, was taken at f22.

lens to resolve very fine detail. Even in the finest computer-aided optical works it is impossible to design and manufacture a lens which is completely free from aberrations. Those that remain have most effect on light passing through the lens nearest to its perimeter, the centre being almost aberration-free. The use of a small aperture restricts the light path to the centre of the lens, and thus keeps to a minimum any degradation of the image quality by lens aberrations.

When light is obstructed, diffraction occurs at the edge of the obstruction, effectively causing bending of the light rays around the edge. In a lens, diffraction always occurs at the edge of the aperture, producing around the edge a narrow band through which the light rays are bent away from their intended path. For a photograph to be perfectly sharp, light rays emanating from the same point of the subject should all fall on a common point on the film, regardless of which part of the lens they pass through. Light rays which have been bent by diffraction as they pass close to the edge of the aperture do not fall on this common point, however, and therefore spoil the sharpness of the image. At large apertures, the area of the narrow band in which diffraction occurs is small in relation to the total area of the aperture, so diffracted rays form only a very small part of the total light reaching the film, and their effect on the image is not discernible. At small apertures, however, the band forms a much larger percentage of the total area, and diffracted rays form a much larger part of the light reaching the film, noticeably degrading the sharpness of the image.

The two factors of diffraction and residual lens aberrations, therefore, have their most effect at opposite ends of the aperture scale. At maximum aperture, light passes through all the area of the lens and the effects of diffraction are not noticeable, but image quality is slightly degraded by residual aberrations. As the aperture is gradually stopped down, the light path is confined more and more to the relatively aberration-free centre of the lens, and image quality improves. A point is soon reached, however, at which the effects of diffraction become noticeable, and image quality gradually deteriorates as the aperture is further stopped down. Most camera lenses give their optimum resolution at about three to four stops down from maximum aperture, a point worth remembering when resolution is of prime importance, such as when big enlargements are required.

Many cameras have interchangeable lenses, i.e. the lens can be removed from the camera body and replaced by another, usually of a different focal length. Changing the focal length changes the angle of view, enabling the photographer to include more or less of his subject than he would with a 'standard' lens from the same viewpoint. Increasing the focal length reduces the angle of view and allows distant objects to fill more of the frame, while reducing the focal length gives a wider angle, allowing more of the subject and its surroundings to be included. Changing both the focal length and the viewpoint enables the perspective to be altered, affecting the apparent size of nearer and more distant objects relative to the subject (see p. 83). Most interchangeable lenses are of fixed focal length. Zoom lenses, however, are adjustable in focal length, and one of these can do the job of several of fixed focal length (see p. 79).

Each interchangeable lens has its own aperture and, in most cases, its own focusing mechanism, although in some cameras, notably certain larger format reflex and view cameras, the focusing mechanism is a part of the camera body. The method of attaching the lens to the camera body varies from make to make, some using a screw thread and some a bayonet mount, the type of thread or bayonet mount also varying from make to make. Generally speaking, the lenses from one camera manufacturer will only fit that particular make of camera, although there are a few exceptions.

One of the problems facing the designer of compound lenses is that of reflections from the surfaces of the glass. Ideally, all the light falling on a glass surface would pass into the glass. In practice about 5% is lost by reflection. In a lens of several elements, reflection at each air to glass surface would result in a considerable total light

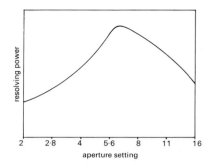

A typical lens gives its optimum resolution at about three stops down from its maximum aperture, as the graph, above, shows. At aperture settings larger than the optimum the resolution is limited by residual lens aberrations, at smaller settings it is limited by diffraction.

A camera's angle of view is determined by the focal length of its lens. Cameras with interchangeable lenses have the advantage that the lens can be changed to alter the angle of view.
Far left: wide-angle. Centre: normal.
Below: telephoto.

The 'blooming' of each air to glass surface of a lens increases light transmission and reduces flare. The control of flare is particularly important when photographing against the light. The picture, far left, was taken using an uncoated lens, while the picture, left, was taken with a modern multi-coated lens.

loss. Even worse, some of the reflected light may bounce around from element to element, finally reaching the film in a haphazard manner, producing flare which may be evident on the photograph as bright patches near or surrounding a bright light source, or as a general haze which reduces the overall contrast of the picture.

During lens manufacture, these reflections are reduced by 'blooming' each glass surface with a thin coating of a transparent material, usually a fluoride of sodium or magnesium, which has a refractive index different from that of the glass. The coating is applied by enclosing the lens elements in a vacuum chamber, along with an electrically heated crucible containing the fluoride. The heat evaporates the fluoride, which condenses evenly on the exposed lens surfaces. The thickness of the coating is allowed to build up, usually until it equals one-quarter of the wavelength of green light. Green is usually chosen because it falls roughly in the middle of the visible spectrum. The coating reduces reflections by ensuring that rays reflected from the surface of the coating are out of phase with those reflected from the surface of the glass, and cancel each other out. By these means reflections are reduced to about 2% for each air to glass surface. Because the coating is optimized for green light, some red and blue is reflected, giving rise to the purplish appearance of the coatings of many lenses.

Many manufacturers now produce 'multi-coated' lenses in which the light reflectance is reduced even further, sometimes to as low as 0·2%. This is achieved by coating two or more materials simultaneously to produce a coating with a refractive index which gradually changes throughout its depth. The flare from these lenses is so little that the sun may be included in the picture with no adverse effects. To do this with a normally coated lens would result in flare degrading the image to an unacceptable degree.

The shutter

In the early days of photography, the light-sensitive emulsions available were so slow that exposures of several minutes were often required, and shutters as we know them today were unnecessary. Exposures were commenced by the simple expedient of removing the lens cap, and were terminated by replacing it. Progress was soon made, however, and the time came when photographic emulsions had become too fast for the exposure to be controlled by this method, and simple forms of mechanical shutter were developed. These early designs were bulky affairs, capable only of speeds which were slow by modern standards. Over the years, the design of shutters has progressed with the demand for faster speeds and smaller cameras, resulting in the sophisticated and very compact shutters found in cameras today.

Modern shutters fall into two distinct categories – 'between-lens', also known as the 'leaf' shutter, and 'focal plane'.

The between-lens shutter
The between-lens shutter, as its name implies, is usually placed between the lens elements, next to the iris diaphragm. It has a number of pivoted metal blades, similar to those in the iris diaphragm, which are operated by a complex spring-loaded mechanism. In the closed position the blades overlap, blocking the passage of light through the lens. When the shutter release button is pressed, the tension on the spring is released and the mechanism causes the blades to fly open, allowing the light to pass through to expose the film. After a preset time delay the blades close to terminate the exposure. This delay can be provided either by purely mechanical means or by an electronic timing circuit. Once fired, the shutter will not operate again until the spring has been re-tensioned, or 'cocked'. On older cameras this was done by a cocking lever, but

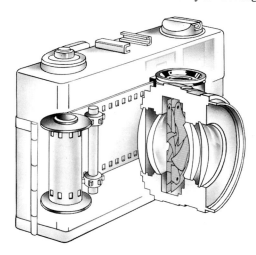

As its name implies, the between-lens shutter, shown here in red, left, is positioned between the lens elements, next to the iris diaphragm, shown in blue. In some cameras the shutter is in front of the diaphragm as shown here, in others the two are reversed.

on most modern cameras it is performed by the film advance mechanism when the film is wound on for the next exposure.

The fastest speed which can be achieved by a between-lens shutter is usually 1/500 second. This limitation is imposed by the inertia of the shutter mechanism. In an ideal shutter, the blades

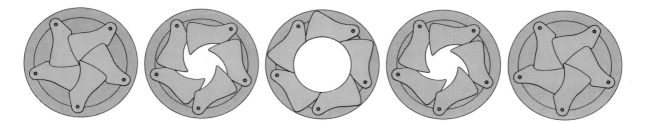

would fly open instantaneously, remain open for the duration of the shutter speed, and then close instantaneously. In practice this is not possible. Due to the mass of both the blades and their operating mechanism, the blades take a finite time to accelerate from the closed to the fully open position. Similarly they take a finite time to close. These times are such that at a shutter speed of 1/500 second the blades only just reach the fully open position before they must reverse direction to close again.

Purely mechanical shutters usually have a maximum range of speeds from 1/500 second to 1 second. Each speed is approximately twice as long as the one before it, i.e. 1/500, 1/250, 1/125, 1/60, 1/30, 1/15, 1/8, 1/4, 1/2, and 1 second. Intermediate settings are not usually possible. This system works well in conjunction with the standard settings of the aperture, each of which passes half the light of the previous setting. In the section dealing with the use of shutter and aperture together we shall see how these two controls are used in practice to control not only the exposure level, but also the depth of field and the way in which movement of the subject is conveyed in the photograph.

Electronically timed shutters are often continuously variable throughout their speed range, which makes them ideal for use in the type of 'automatic' camera in which the shutter speed is automatically selected according to the lighting conditions. The slow speed end of the range is often extended, in some shutters to as long as 30 seconds.

In addition to the controlled shutter speeds, most cameras have a 'B' setting which allows the shutter to remain open for as long as the release is pressed. The 'B' stands for 'Bulb', and is a legacy from the days when shutters were opened pneumatically by squeezing a rubber bulb which was connected to the shutter mechanism by a length of tubing. Some cameras also have a 'T' (for 'Time') setting which requires the release to be pressed once to open the shutter and a second time to close it. These settings are used when the lighting conditions demand a shutter speed longer than those obtainable with the controlled settings, e.g. for night photography.

Many shutters have a delayed-action facility, which delays the

Above: In the closed position the blades of a between-lens shutter overlap, preventing light from passing through. When the release button is pressed a spring-loaded mechanism causes the blades to rotate on their pivots, allowing light to pass. After a preset delay the blades return to their original position, terminating the exposure.

Below: Due to the inertia of the shutter's mechanism the blades take a finite time to open and close. This limits the fastest speed possible with this type of shutter to about 1/500 second. Here the shutter is shown opening at a setting of 1/250 second.

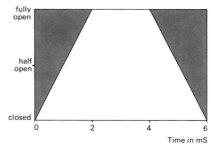

opening of the shutter until about 10 seconds after the shutter release has been pressed. This can be used to allow the photographer to include himself in the picture, or, with the camera mounted on a tripod or other support, to permit really smooth and jerk-free operation of the shutter at the slower speeds (see p. 87).

Most between-lens shutters have a pair of electrical contacts which are connected to a socket on the body of the camera, into which the synchronizing cable of a flashgun may be connected. The contacts close at a precise moment during the operating sequence of the shutter, firing the flashgun. Due to the inherent differences between the firing characteristics of electronic flashguns and flashbulbs, the exact moment at which the contacts must close is different for the two types. Consequently, many shutters have two settings for the synchronizing contacts – 'X' for electronic flash and 'M' for flashbulbs.

Electronic flashguns produce their full light output almost simultaneously with the closing of the synchronizing contacts, so on the 'X' setting the contacts are set to close at the moment the blades

Note. The graphs on these pages show the light emission characteristics of electronic flash and flashbulbs, and how the settings of the between-lens shutter must be selected accordingly to ensure synchronization of the opening of the shutter with the output of the flash. In each graph the horizontal scale indicates time in mS, and the light area cut away from the red tone represents the output of the flash. In the graphs which show the effect of particular combinations of shutter speed, sync. contact setting and flash type the red flash graph has been superimposed on a grey tone from which a light area has been cut away to represent the opening of the shutter. Exposure of the film can only occur where the cut-away areas of both tones coincide to reveal white paper.

reach a fully opened position. Electronic flash usually has a duration of about 1/800 second or faster, and can therefore be used on any speed setting on a between-lens shutter, the choice of speed having no effect on the amount of the exposure of the film to the flash.

Flashbulbs, however, take some time to ignite and produce their full light output. They begin to emit light about 2 milliseconds (1 mS = 1/1000 second) after electrical power is first applied, i.e. 2 mS after the synchronizing contacts close. By about 16 mS the light output is at its peak, after which it gradually dies away, until at about 40 mS it is zero. On the 'M' setting, therefore, the opening of the shutter is delayed such that the blades reach the fully opened position about 12 mS after the synchronizing contacts close, just in time to catch the peak light output of the flashbulb. At a fast shutter speed, say 1/250 or 1/500 second, only a small part of the total light output is used to expose the picture, although that part should coincide with the bulb's peak light output. At slower speeds the film is exposed during the peak and, in addition, during some or all of the die-away period. Thus when using flashbulbs, the shutter speed selected has an effect on the exposure of the film.

With between-lens shutters, flashbulbs can also be used on the 'X' setting, provided the shutter speed used is slow enough to include a substantial amount of the light output. Electronic flash cannot be used on the 'M' setting, however, as the flash would fire immediately

The graph, far left, shows the output of a typical electronic flash. The vertical scale represents light intensity. The majority of the output of the flash occurs within about 1–2 mS. The graph, centre, shows the same flash graph superimposed on a graph of the opening characteristics of a between-lens shutter set to 1/500 second on the 'X' setting. The synchronizing contacts close to fire the flash as soon as the shutter is fully open, and the shutter is open for virtually all of the flash's output. The graph, above, shows the effect of setting the shutter to 1/30 second, again on the 'X' setting. As before, the flash fires as soon as the shutter is fully open, and all of the flash's output is used. The flash exposure is completed within the first small fraction of the period in which the shutter is open and, unless the picture is being taken by mixed lighting, the film receives no further exposure during the remainder of the period. Thus when using electronic flash with the between-lens shutter the actual speed selected has no effect on the amount of the exposure of the film to the flash.

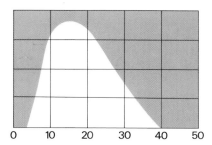

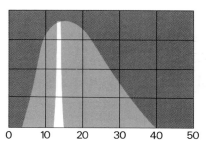

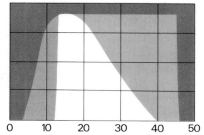

the contacts close, before the blades begin to open, and the film would receive no exposure.

On many shutters the type of synchronization in use is selected by a small lever, marked 'V', 'X' and 'M'. The 'V' setting brings the delayed-action mechanism into operation (the 'V' stands for 'Verzögerung', german for 'delay'). When the shutter is used on delayed action, 'X' synchronization only is available.

Most cartridge-loading cameras, i.e. those which take 110 or 126 film, have a socket into which a flashcube or flashbar may be plugged. Flashcubes contain four flashbulbs, each with its own built-in reflector. There are two types. The original variety contains conventional, electrically fired bulbs, and requires the camera to be equipped with a battery and conventional synchronizing contacts. These have been largely superseded by the 'Magicube' variety which are fired by percussion, each bulb having its own spring-loaded firing hammer. To fire a bulb, the hammer is released by a pin which projects from the camera, and which is mechanically coupled to the shutter mechanism. Flashbars each contain eight or ten bulbs which are fired electrically, but the camera does not

The graph, far left, shows the output of a typical flashbulb. If it is assumed that electrical power is first applied at 0 mS, the graph shows that there is a delay while the bulb ignites before light is emitted, and that the peak output occurs at about 16 mS. The graph, centre, shows the effect of using a flashbulb with the shutter set to 1/500 second on the 'M' setting. The shutter's sync. contacts close as soon as the shutter release is pressed but the opening of the shutter is delayed until the bulb is approaching peak output. At this shutter speed only part of the bulb's output is used, however, and a slower speed is normally used. The graph, above, shows that with a shutter speed of 1/30 second much more of the bulb's output contributes to the exposure. Thus when using flashbulbs the choice of shutter speed does affect the amount of exposure received by the film.

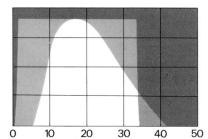

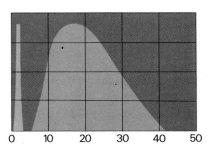

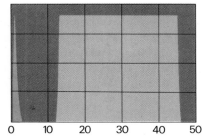

contain a battery. Instead, a piezo-electric device similar to that used in some makes of cigarette lighters generates a pulse of electrical energy when it is stressed by a mechanism coupled to the shutter.

The focal plane shutter

For certain types of camera the use of a between-lens shutter is impractical. To use such a shutter in a camera with interchangeable lenses, for instance, would require each lens to have its own shutter, which would make the cost of the lenses very high. The use of a focal plane shutter, which is an inherent part of the camera rather than of the lens, eliminates this necessity and also considerably simplifies the design of cameras with a viewing system of which the lens itself is a part, i.e. the single-lens reflex.

Flashbulbs can be used with the shutter set to the 'X' setting provided a sufficiently slow speed is selected to allow for the considerable delay in the bulb reaching full output. The graph, far left, shows that at 1/30 second the shutter is open for long enough to include most of the bulb's useful output. The graph, centre, shows that if a very fast speed is used, in this case 1/500 second, the shutter has opened and closed again before the bulb has begun to emit light. The graph, above, shows that electronic flash cannot be used satisfactorily with the shutter on the 'M' setting at any speed, as the flash will fire before the shutter opens.

The focal plane shutter, were it to live up to its name, would be positioned exactly at the focal plane of the camera. This is not possible, of course, as the film itself must occupy this position, and in practice the shutter is located 1 or 2 mm in front of the film.

A basic focal plane shutter consists of two blinds, also known as curtains, of an opaque flexible material – usually either black fabric or thin metal. Prior to depressing the shutter release, one blind, known as the first or leading blind, is positioned across the film gate, protecting the film from light, in a manner similar to the old-fashioned domestic roller blind pulled down over a window. When the release is pressed, this blind retracts across the film gate and winds on to a roller to one side of the gate. A predetermined time after the first blind begins to move, the second blind, which at this stage is wound on another roller at the opposite side of the gate, starts to follow the first blind across the gate, continuing its travel until it occupies the position originally held by the first blind, completely covering the gate and protecting the film from light.

The delay between the traverse of the two blinds has the effect of producing a slit, formed by the trailing edge of the first blind and the leading edge of the second, which moves across the film gate, progressively exposing each part of the film to the light passing through the lens. The shutter speed of a focal plane shutter is the time interval between the two edges passing the same point on the film, each point receiving its exposure only as the slit passes over it. The blinds always travel at the same speed across the film, regardless of the shutter speed selected, and on a typical 35 mm SLR they take about 10 mS to traverse the film gate completely. The shutter speed is set by adjusting the delay between the two blinds, and the effect of this is to alter the width of the slit. At the shutter's fastest speed, the slit is at its narrowest and becomes wider as the slower speeds are selected. At speeds of about 1/60 second or longer, the delay between the blinds is such that the first blind has completely uncovered the film gate before the second blind commences its travel. At this moment the whole of the film gate is simultaneously exposed to the light passing through the lens.

The diagrams, below, illustrate the operating principle of the focal plane shutter. The first, or leading blind, shown here in grey, moves across the film gate, progressively uncovering the film and exposing it to the image produced by the lens. A predetermined time after the first blind starts moving, the second blind, shown here in red begins to follow, covering the film again and thus terminating the exposure. The effect of the combined movement of the two blinds is that of a slit moving across the film gate.

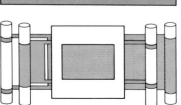

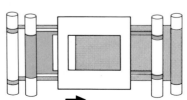

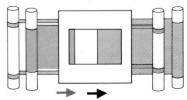

As we shall see later, this is an important factor so far as flash synchronization is concerned.

The timing mechanism which delays the traverse of the second blind may be either a purely mechanical assembly, or an electronic timing circuit electromagnetically coupled to the blind mechanism.

Unlike the between-lens shutter, focal plane shutters have no parts which suddenly change direction half way through the exposure, and higher speeds, up to 1/4000 second on some cameras, are possible.

We have seen that at the faster shutter speeds the exposure is made by a narrow slit, which traverses the film gate, progressively exposing each part of the film. Thus, one edge of the picture is exposed somewhat before the other. This can give rise to a characteristic distortion of very fast-moving subjects, the nature of the distortion being dependent on the direction of the movement of the subject relative to the direction of the travel of the shutter blinds.

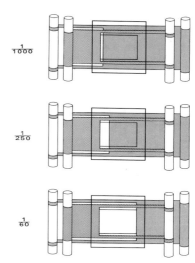

Above: The blinds of the focal plane shutter traverse the film gate at the same speed regardless of the shutter speed selected. The settings of the shutter speed dial determine the delay between the traverse of the two blinds, and hence the width of the slit which the blinds form. At the fastest speed the slit is at its narrowest, increasing in width as slower speeds are selected. At settings equal to or slower than a certain value the first blind uncovers the entire film area before the second blind begins to move. This value varies according to the make of camera, but is normally between 1/60 and 1/125 second, or even 1/200 second on some more recent models, and is an important consideration when flash is used.

Left: The focal plane shutter is positioned immediately in front of the film and as close to it as possible.

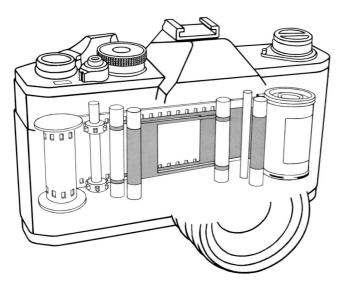

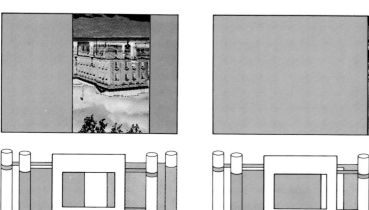

After the shutter has operated, it is reset by the film advance mechanism, which winds the blinds back to their original positions in readiness for the next exposure. During this operation the blinds slightly overlap to prevent unwanted exposure of the film.

In common with their between-lens counterparts, most focal plane shutters have an additional timing mechanism to provide a delayed-action facility.

On some cameras the shutter blinds travel horizontally and on others vertically. There is an advantage relating to flash synchronization in having a vertical blind movement (see below), but the vertical travel is achieved only by reducing the physical dimensions, and hence the robustness, of the operating mechanism so that it may fit into the smaller space available above and below the film gate. Consequently, most leading manufacturers put a horizontally running shutter in their most expensive models, i.e. the ones most likely to be used by professionals requiring a rigorous and lengthy service from their cameras.

Most modern cameras with focal plane shutters have 'X' synchronization only, the synchronizing contacts closing at the moment the trailing edge of the first blind is just clear of the film gate. A shutter speed must be selected at which the second blind has not started to move when the contacts close, in order that the whole of the picture area is uncovered when the flash fires. In most cases this means using a shutter speed no faster than 1/60 second with horizontally running shutters, or 1/125 second if the shutter runs vertically, although some recently introduced cameras allow flash synchronization at 1/200 second. Usually the fastest speed possible for correct synchronization is marked on the speed setting dial. Use of a speed faster than that stated will result in only part of the picture being exposed.

Some older focal plane cameras have additional contacts for FP (focal plane) flashbulbs, which have an extended and fairly flat peak output. Provided the time taken for the slit to cross the film is no longer than this peak, the exposure is even. For FP synchronization, the contacts are set to close about 16 mS before the first blind starts its travel, to allow the bulb's output to build up to its peak level. This is all rather academic, however, as in many countries FP bulbs are no longer obtainable.

Ordinary, easily obtainable flashbulbs can be used with focal plane shutters with 'X' synchronization, providing the selected shutter speed is longer than the time taken for the bulb to ignite and pass its peak output, i.e. about 1/25 second or longer.

The shutter release
On many older cameras the shutter operating lever or button left much to be desired, often being awkwardly placed and jerky in operation. Fortunately, manufacturers in all fields are nowadays much more aware of the ergonomic requirements of their products, and in the design of most modern cameras much thought has gone into the placing of the release button, the actual position being chosen so that the user's finger falls naturally and comfortably upon

The effect of using too fast a shutter speed with electronic flash. The camera used for these pictures has a vertically travelling shutter and can be used at a maximum speed of 1/125 second with electronic flash. For the top picture the shutter was set to 1/250 second. The second blind has begun its travel before the first blind has completely uncovered the film gate, resulting in an area of the frame which has received no exposure. The lower picture was taken at the correct speed of 1/125 second.

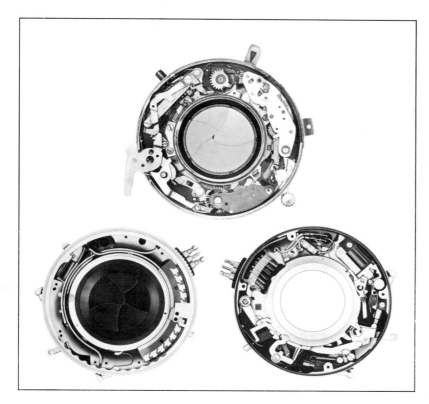

These pictures show a comparison between the mechanisms of mechanically and electronically timed between-lens shutters.

The upper picture shows a front view of a Synchro-Compur shutter, in which the timing is performed purely mechanically by means of the gear train which can be seen in the upper right of the shutter.

The lower pictures show front and rear views of a Prontor-Press electronic shutter, in which the timing is performed by the charging of a capacitor through one of a series of resistors, the values of which determine the shutter speeds. The front view, left-hand picture, clearly shows the electrical speed selection contacts, each of which is connected to one of the timing resistors. A sliding contact attached to the speed setting ring makes connection with the speed selection contacts and completes the circuit to the capacitor through the resistor appropriate to the selected shutter speed.

Compur and Prontor shutters are made by Alfred Gauthier GMBH, of Wildbad, in the Black Forest region of West Germany.

it. In order to avoid unsharp pictures due to camera shake at the moment of exposure, it is important that the linkage between the release button and the shutter itself is as smooth and jerk-free in operation as possible. On some cameras with electronic shutters there is no mechanical linkage, the button operating only an electrical switch to energize an electro-mechanical release within the shutter mechanism.

Most cameras incorporate a threaded socket to take a cable release, essential to avoid jarring the camera when long exposures are being made with the camera mounted on a tripod. On many cameras the cable release socket is concentric with the shutter release button itself, the plunger of the cable depressing the same mechanism as does the button when the shutter is released in the normal manner.

Cable releases are used to avoid accidental movement of the camera when making exposures longer than those for which the camera can be satisfactorily hand-held.

The upper model shown here has the tapered-thread fitting common to the majority of cameras, while the lower model has the special fitting for Nikon cameras. Both have locking mechanisms to allow the shutter speed to be held open on 'B' without the need to keep the button depressed manually.

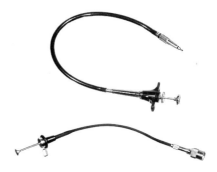

Types of cameras

The viewfinder camera

The term 'viewfinder camera' is generally applied to any camera in which the viewfinding system is a simple optical device through which the subject is viewed directly. Usually the viewfinder of such cameras consists of two lenses which together act as a telescope in reverse, to give a slightly smaller-than-life-size view of the subject, which allows the user to see the whole scene with ease. The area of the subject actually included in the picture is indicated either by suitably masking down the area seen by the viewfinder or, in those cameras with 'bright-line' viewfinders, by using a semi-silvered mirror to superimpose a brightly illuminated frame on to the view.

Although a few viewfinder cameras are equipped with focal plane shutters and interchangeable lenses, the vast majority have between-lens shutters and fixed, non-interchangeable lenses. The cheapest have a non-adjustable aperture and a shutter with only one or two speeds. More expensive models have a range of speeds and a fully adjustable aperture. Many have built-in exposure meters, usually coupled to the shutter and aperture controls, often in such a way that the required exposure is selected automatically by the metering system. Such cameras are ideal for the person who aspires only to take pictures of holidays and family, with no interest in the technicalities of photography, and will produce an acceptable result under the majority of lighting conditions. Many such cameras also cater for the more discerning user by providing a manual override which allows the exposure to be adjusted manually, a useful feature for those subjects or lighting conditions which might otherwise fool

A viewfinder camera of fairly advanced design, taking 35 mm film and equipped with coupled rangefinder and built-in, partially automatic exposure metering system.

A pocket camera of basic design, taking 110 size film. The handle folds over the camera to act as a protective case when not in use.

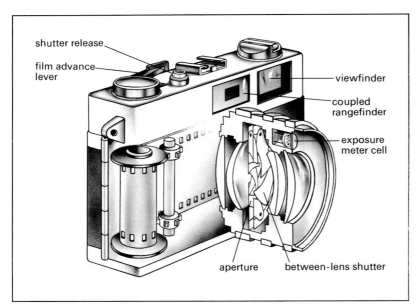

shutter release
film advance lever
viewfinder
coupled rangefinder
exposure meter cell
aperture
between-lens shutter

A 'disc' camera, so named because the film is in the form of a flat disc. Most disc cameras have a fixed-focus lens, automatic exposure, automatic film advance, and a built-in electronic flash.

Left: A typical 35 mm format viewfinder camera.

an automatic metering system into giving the wrong exposure, e.g. backlit, or lighter- or darker-than-average subjects.

Viewfinder cameras have one particular shortcoming which can give rise to problems if not compensated for. Because of the physical displacement between the viewfinder and the lens, each sees the subject from a slightly different viewpoint. If the viewfinder is adjusted at manufacture to include exactly the same area of a distant subject as that seen by the camera lens, then for close-up work the area of the subject seen by lens and viewfinder will not agree, but will differ by an amount roughly equal to the displacement. This difference is known as the **parallax error**, and in more expensive cameras is compensated for by making the alignment of the viewfinder adjustable and coupling the adjusting mechanism to the focusing mechanism of the lens, such that the optical axes of lens and viewfinder always converge to meet at the distance to which the focusing is set, at which the subject is located.

Many viewfinder cameras incorporate a rangefinder within the viewfinder system. This is also coupled to the focusing mechanism and provides a means of accurately focusing the camera lens on the subject without the need to physically measure or even guess the camera to subject distance. In the centre of the picture as seen through the viewfinder there appears a second image of the subject, superimposed on the first by a beamsplitter located in the direct optical path of the viewfinder. The beamsplitter receives this second image from a movable mirror which looks at the subject through an additional window which is displaced from the viewfinder itself, and therefore sees the subject from a slightly different viewpoint (see diagram). The mirror is mechanically coupled to the focusing mechanism of the lens such that it rotates very slightly as the focusing is altered. This coupling is adjusted at manufacture so that the optical axis of the viewfinder and that of the additional optical

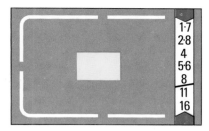

Above: The viewfinder of a fairly expensive viewfinder-type camera. The 'bright-line' frame is optically superimposed on the scene, and is coupled to the lens focusing mechanism to compensate for parallax error, and moves as the focusing is adjusted, accurately indicating the area of the subject included in the picture at any subject distance within the camera's normal focusing range.

In the rectangle in the centre of the frame appears the coupled rangefinder image, optically superimposed on the main viewfinder image and tinted yellow for good visual contrast.

This particular camera has a semi-automatic exposure metering system. The user selects a shutter speed suited to the nature of the subject and the camera automatically selects the appropriate aperture, indicating its choice on the scale to the right of the frame. Provided the needle falls between the red marks correct exposure of the picture should result. Should the needle fall on either of the red marks the user must select an appropriately different shutter speed.

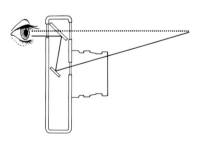
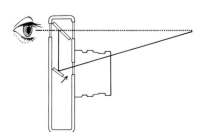

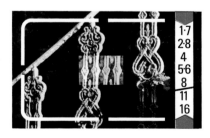
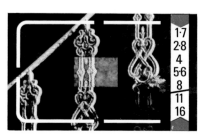

In the coupled rangefinder a small, movable mirror is mechanically coupled to the lens focusing and rotates slightly as the lens is adjusted. When the focusing is incorrectly set for the distance between camera and subject the angle of the mirror is such that the user sees a double image of the subject in the central area of the viewfinder. The user then adjusts the focusing until the two images merge and appear as one, when the lens will be accurately focused on the subject.

path through the rangefinder always cross at the distance on which the lens is focused. When the focusing is not correctly set for the subject distance, the two images in the central area of the viewfinder can be seen to be separate. As the focus setting is corrected they gradually come together until, when the lens is exactly focused on the subject, they are superimposed and appear as one. The light path to the rangefinder window often passes through a yellow filter which makes the second image more easily visible.

The twin-lens reflex

The twin-lens reflex, or 'TLR', has two lenses mounted one above the other on a common lens panel, behind which the camera is divided into two separate compartments, such that each lens admits light to one compartment only. The lower compartment contains the film and, other than at the actual moment of exposure, is completely light-tight. The lower lens, known as the 'taking' lens, is equipped with an iris diaphragm and a between-lens shutter and it is this lens which forms an image on the film during the exposure. The upper lens, known as the 'viewing' lens, forms a similar image on a

The image on the viewing screen of the TLR is the same size as the image formed on the film, but is laterally reversed.

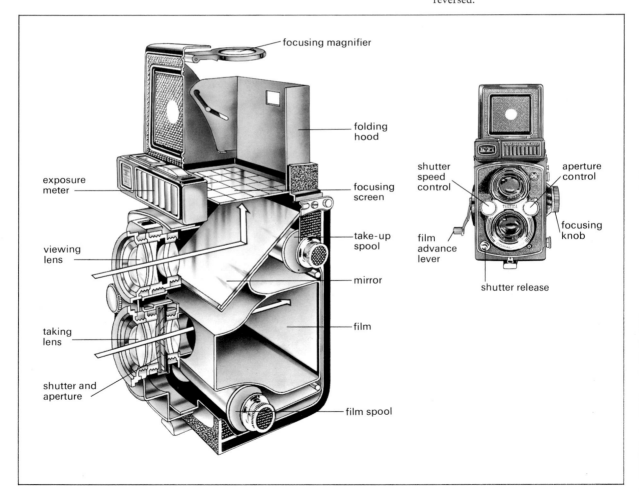

- focusing magnifier
- folding hood
- exposure meter
- focusing screen
- viewing lens
- take-up spool
- mirror
- taking lens
- film
- shutter and aperture
- film spool
- shutter speed control
- aperture control
- film advance lever
- focusing knob
- shutter release

ground-glass focusing screen which is positioned horizontally across the top of the upper, viewfinder compartment. The light path from this lens is deflected at right angles on to the ground glass by a surface silvered mirror within the viewfinder compartment, with the result that the image seen on the focusing screen is laterally reversed. Because the viewing lens plays no part in exposing the film, its optical qualities need not be so high as those of the taking lens, and it can therefore be of simpler construction, provided the focal lengths of both lenses are identical.

The focusing mechanism of the TLR is usually operated by a knob on the side of the camera, and moves the whole lens panel backwards or forwards. Sharpness can be visually checked by inspecting the image formed by the viewing lens on the focusing screen, which is shielded from ambient light by a hood which folds away when the camera is not in use. A flip-up magnifier built into the hood can be used to give an enlarged view of the central area of the screen for really critical focusing.

Because the viewing lens is displaced from the taking lens, the viewfinder system of the TLR suffers from parallax error to some extent, and this is compensated for on many models by a movable mask connected to the focusing mechanism, such that the focusing screen shows exactly the area of the subject which will appear on the final picture.

A drawback of the basic TLR is that the user is required to look downwards into the viewfinder screen, instead of directly towards the subject as with cameras with eye-level viewfinders. This restricts the use of the TLR to fairly static subjects, such as studio shots and weddings (for which it is a favourite among many photographers). The basic TLR is not really an ideal camera for any type of action photography, as it is difficult to keep a moving subject in frame, especially as the image in the viewfinder is laterally reversed, which can fool an inexperienced user into moving the camera in the opposite direction to that required. Many TLRs cater to some extent for this type of photography by incorporating a simple non-optical 'sports finder', formed by a hole in the back panel of the viewing hood and a window revealed by flipping down a hinged panel in the front of the hood. Some manufacturers also offer as an accessory a pentaprism which fits over the focusing screen, in place of the hood, to provide an eye-level and correct-way-round view of the subject.

Some TLR cameras have interchangeable lenses, and in these models the complete lens panel is removable, as the taking and viewing lenses must be changed as a pair to retain correct operation of the viewfinder system. This, combined with the necessity for each taking lens to have its own between-lens shutter, makes the interchangeable lens assemblies somewhat expensive.

Most TLRs take 120 size film (some also take 220) with a nominal picture format of 6 × 6 cm, giving 12 pictures per 120 roll. The square format permits both vertical and horizontal compositions to be made with the camera in the upright position, picture cropping being performed at the printing stage.

The viewing lens of the TLR sees the subject from a slightly different viewpoint from the taking lens. In many models this parallax error is automatically compensated for over the camera's normal focusing range by a movable mask in the viewfinder, coupled to the focusing mechanism.

Some TLRs are fitted with interchangeable lenses. Taking and viewing lenses are mounted on a common panel, as they must both be changed together to retain the relationship between the viewfinder image and the image on film. Each taking lens has its own between-lens shutter.

The single-lens reflex

Probably the most important advance in photographic equipment over the last thirty years has been the development and acceptance into widespread use of the single-lens reflex camera, the features of which have considerably revolutionized many fields of photography.

The single-lens reflex, or 'SLR', offers something which is provided by no other camera – a clear view of the subject through the actual lens which takes the picture. There is no parallax error, and the photographer sees through the viewfinder almost exactly the result he will obtain on film. Most SLRs accept interchangeable lenses, to which their viewing system is particularly suited. Because the lens itself becomes part of the viewing system the viewfinder image is automatically correct for any lens, whatever its focal length.

The absence of any parallax error makes the SLR camera the ideal choice for extreme close-up photography when using supplementary close-up lenses or extension tubes. The automatic parallax correction incorporated in some models of other camera types usually operates correctly only down to the minimum focusing distance of the lens without close-up attachments, and considerable parallax error can result when these cameras are used for close-up work.

The viewfinder of the SLR camera incorporates a ground-glass

A useful single lens reflex outfit, comprising 50 mm normal, 28 mm wide-angle, and 70–210 mm zoom lenses.

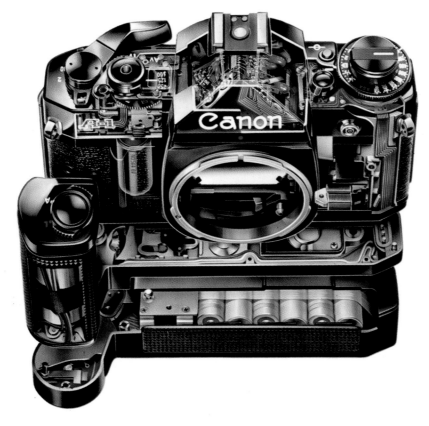

The Canon A-1, shown here in section with its lens removed, is an example of the latest breed of SLR cameras incorporating highly sophisticated digital electronic circuitry to control camera functions which would previously have been controlled by purely mechanical means. The A–1 offers no less than six modes of exposure control, including a fully automatic mode in which the camera selects both aperture and shutter speed, modes in which the user selects either the aperture or shutter speed and the camera automatically selects the other, and a completely manual mode in which the user selects both. A digital display, visible in the viewfinder, keeps the user informed of the camera's decisions.

The accessory motor drive unit and battery pack shown below the camera itself will automatically advance the film after each frame has been exposed and allows pictures to be taken in rapid succession, up to a maximum rate of five per second.

screen on to which the camera lens projects the image of the subject. Focusing can thus be checked and adjusted visually, and by stopping down the lens aperture to the actual setting to be used for the exposure, the photographer can obtain a visual indication of the depth of field.

Because the SLR uses just one lens for both viewfinding and picture taking, provision must be made for the image to be switched from the viewfinder screen to the film immediately before the start of the exposure and back again as soon as the exposure has finished. This requires the mechanism of the camera to be more complex than that of other camera types – the SLR is truly a precision instrument.

The majority of SLRs have a focal plane shutter positioned a millimetre or so in front of the film. Thus, even when the shutter is closed light from the subject can still pass through the lens and into the camera body. For viewfinding purposes this light is deflected by a surface silvered mirror positioned at 45° to the film plane, and is allowed to fall on to the ground-glass screen, the position of which is such that the length of the light path from the lens to the screen is exactly the same as that from lens to film. Thus, an image which is sharp on the focusing screen will be equally sharp when it is allowed to fall on to the film.

The mirror which deflects the light on to the screen for viewing is hinged, usually along its upper edge, and when the shutter release is pressed it flips up out of the light path, blacking out the viewfinder but allowing the image to fall on to the film when the shutter opens. As soon as the shutter closes at the end of the exposure the mirror returns to its original position, restoring normal viewfinder operation.

Because the light path to the focusing screen is via a mirror the image formed on the screen is laterally reversed, as with the TLR, and because of this nearly all 35 mm SLRs, and also some larger format models, have a pentaprism fitted above the screen. This reverses the image again so that it is laterally correct, having effectively bent the light path through another 90° so that the camera can be used at eye level. The pentaprism is a specially shaped solid block of glass which actually reflects the image several times before it is seen by the photographer. This is necessary to give an image which is the right way up as well as being laterally correct. If a simple mirror were to be fitted above the focusing screen instead of a pentaprism the image seen by the photographer would be upside-down. In larger format models with no pentaprism the laterally reversed image on the focusing screen is viewed in a way similar to that for the TLR.

Many SLRs incorporate through-the-lens (TTL) metering, in which the measurement of the required exposure is made by one or more photo-cells which read the brightness of the image falling on the focusing screen. Usually the exposure meter readout is visible within the viewfinder and the meter mechanism is coupled in some way to the shutter and aperture controls. In its simplest form this coupling is such that the correct exposure is set when the photographer has adjusted the controls so that the meter needle

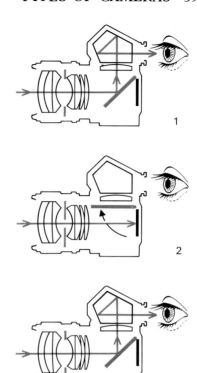

The diagrams, above, show the operating sequence of an SLR with a lens with automatic diaphragm.
1. For viewing the subject the mirror is in its 'down' position, and reflects light coming through the lens upwards to form an image on the ground-glass screen. The pentaprism presents this image to the eye, which sees an upright, correct-way-round view of the subject. The iris diaphragm is fully open, ensuring that the image on the viewing screen is as bright as possible for ease of viewing.
2. Immediately after the shutter release button is pressed the iris diaphragm stops down to the preselected value and the mirror flips up out of the light path, temporarily blacking-out the viewfinder, but allowing light to reach the back of the camera, ready to form an image on the film as soon as the focal plane shutter opens, which it does as soon as the mirror reaches its fully raised position.
3. As soon as the shutter has closed to terminate the exposure the iris diaphragm re-opens fully and the mirror returns to the 'down' position, restoring viewfinder operation in readiness for the next picture to be taken.

appears against an index mark in the viewfinder. In cameras with more complicated systems this coupling is completely automated, requiring the user to take little or no active part in exposure assessment. TTL metering systems are discussed more fully in the section on *Exposure Meters* (p. 60).

Most SLRs accept interchangeable lenses, and there are three main methods of attaching them to the camera body. These are screw thread, bayonet, and breech-lock mounts. Mechanically, the simplest is the screw thread mount, the lenses being changed by rotating the entire lens, so that it unscrews from the camera body, and screwing in another. In practice this is rather a fiddly operation, as it is difficult to know exactly when the lens has been unscrewed sufficiently for it to come free from the camera body until it and the body suddenly part company, at which moment the photographer must have a firm grip on the lens to prevent it from dropping at his feet. In addition, the screw thread mount is susceptible to wear, which after prolonged use may affect the lens to film distance, which is very critical. The bayonet mount is easier to use, being much more positive in its action, but is also susceptible to wear, due to the rotation of the rear surface of the lens mount against the lens flange on the camera body as the lens is changed. The breech-lock mount is also easy to use and has the advantage of not being affected by wear, as the mating surfaces of lens mount and camera body do not rotate on one another. Instead, a locking ring on the lens mount is rotated until its movement becomes tight, when it will have pulled the mating surfaces into intimate contact. Any wear in the locking ring mechanism is of no consequence, simply requiring the locking ring to be rotated a little further before it becomes tight, and can have no effect on the lens to film distance.

In order that the image on the focusing screen shall be as bright as possible for ease of viewing, most SLRs have a system whereby the setting of the lens aperture ring to the required setting does not at that time change the size of the aperture, which remains fully open to give the brightest possible viewfinder image. When the shutter release is pressed to take the picture the iris diaphragm closes to the selected aperture setting at the same time as the mirror flips up, just before the shutter opens. In most lenses the aperture returns to the fully open position as soon as the shutter has closed at the end of the exposure. Such lenses are said to have a fully automatic diaphragm.

The vast majority of SLR cameras currently available are designed to use 35 mm film, with a negative format of 24 × 36 mm. In addition, SLRs are available to give one of three formats – 6 × 4·5 cm, 6 × 6 cm and 6 × 9 cm – on 120 roll-film. At least one manufacturer also produces an SLR which takes the diminutive 110 film used by many 'viewfinder'-type pocket cameras. In recent years the trend for 35 mm models has been to develop smaller, more compact cameras, some of these being little larger than many 35 mm 'viewfinder' cameras. The leading manufacturers produce a phenomenal range of lenses and accessories for their cameras, some of these being for general-purpose use and some for more specialized applications such as medical and scientific photography.

The Hasselblad is a large format SLR camera, producing 6 × 6 cm negatives on 120 or 220 film. In addition to the facility for changing lenses, the camera back containing the film is also interchangeable, allowing easy change of film type, even when half-way through a roll. A large range of accessories is available.

The Polaroid SX-70 instant picture camera is in fact a folding SLR of very ingenious design. The film pack itself contains the battery to power the camera's electrical system. Immediately after a picture is taken a blank print is automatically ejected from the camera. All the neccessary processing chemicals are contained within the print material itself, and the picture develops outside the camera, reaching its full density and colour saturation within a few minutes.

The view camera

The view camera is extensively used by professional photographers for advertising, industrial and architectural photography. It produces large format negatives and transparencies of a very high quality, which in the majority of applications need enlarging only a relatively small amount to produce the final print.

Basically the view camera consists of two panels, one holding the lens and the other the film, connected together by a light-tight bellows. Both panels are usually mounted on a single rail (monorail), and their positions along the rail are independently adjustable to allow for focusing of the image. The lens panel accepts a range of interchangeable lenses, each with its own between-lens shutter. The back panel incorporates a ground-glass focusing screen on which an inverted image of the subject appears. When all the adjustments necessary for a picture have been made the focusing screen is replaced by a film holder fitted with a light-tight slide which protects the film before and after the exposure. The film holders are usually double-sided, each side holding just one sheet of film, although magazine-type holders which hold several sheets at a time, and holders which accept roll-film, are also available.

The view camera has certain features which are almost entirely unique to this type of camera. These are the camera 'movements' achieved by moving the lens and back panels relative to each other and to the lens axis. The photographer uses these movements to distort the geometry of the image, either to correct for apparent distortions such as 'converging verticals' or to introduce intentional distortions to achieve special effects, or as a means of increasing the apparent depth of field.

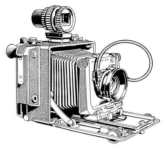

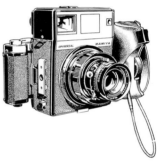

The 'technical' camera, top, and the 'press' camera, above, are both types of view camera, although both are limited in the versatility of their movements, when compared with the 'monorail' camera, left.

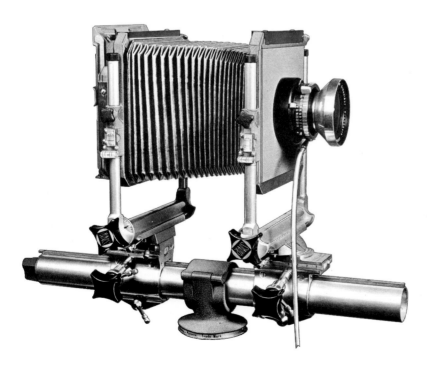

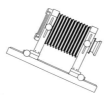

A few applications of the view camera's movements are shown below in a simple form. In practice the movements are used in quite complicated combinations to achieve precisely the desired result.

Rise and fall movement. Often a photographer requires his subject to be recorded from a slight angle in order to reveal it as a three-dimensional object. If the camera is positioned to give the required viewpoint and the picture is taken with no compensating camera movements the subject will appear out of square due to perspective, left. This is the problem of 'converging verticals', so common in architectural photography.

The problem of 'converging verticals' can be solved by ensuring that the film plane of the camera is kept absolutely parallel to the face of the subject which is to be maintained square. By using the rise and fall movements of the lens and back panels this can be achieved, with the result that the subject can be kept square and yet still be shown to be three-dimensional, left. This movement must be used in moderation, however, as when used excessively it results in the lens no longer being able to cover the entire area of the film, with a consequent loss is usable picture area.

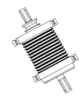

Cross movement. The pictures, left, illustrate the use of the cross movement to achieve a similar result to that obtained by using the rise and fall movement, but to show a vertical face of the cube instead of the top. For this and some other applications the cross movement could be achieved equally well by using the rise and fall movement with the camera mounted on its side, and may be used for the same reason, i.e. to correct 'converging verticals'. Often the application requires the rise and fall and the cross movements to be used in combination, however, as illustrated at the top of the opposite page. When using the cross movement the same restrictions regarding the covering power of the lens apply.

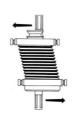

These pictures illustrate the use of the rise and fall and the cross movements in combination. The picture, far left, was taken with no movements at all, with the result that the face of the cube is out of square. The picture, left, was taken using a combination of the rise and fall and cross movements shown on the previous page. The face of the cube has been maintained as a square and yet two other sides of the cube are visible.

subject plane

Tilt movement. One of the problems most frequently encountered by the photographer is that of insufficient depth of field, which prevents him from obtaining a sharp image of all parts of his subject simultaneously. When the subject is confined mainly to a single plane the view camera offers a method of effectively increasing the depth of field so that all parts of the subject are recorded sharply. This can be achieved by tilting lens and back panels so that they are no longer parallel to one another. The Scheimpflug principle states that if the amount of tilt is such that imaginary lines drawn through lens panel, film plane and subject plane all converge to a common point, as illustrated left, all parts of the subject plane will be recorded equally sharply.

The pictures, left, illustrate the use of the tilt movement to give increased depth of field when photographing a subject which is confined to a single plane (in this instance the subject is a flat, printed sheet of calendar illustrations before they are cut up and collated to produce the final calendars). The picture, far left, was taken with no tilt movement in operation, i.e. with lens and back panels parallel to each other. The picture, left, was taken at the same aperture but with the tilt movement adjusted so that imaginary lines through lens panel, film plane and subject plane all converge at the same point.

The film

Many chemical substances react to light, changing their chemical structure in some way. Over the years, many of these substances have been studied to evaluate their suitability for photographic purposes. The majority have been found to be unsatisfactory for some reason or other. Of the few which are suitable most have been adopted for specialized applications, and for technical and commercial reasons only one small group is in common use for general-purpose photography. These are certain silver halides which, when exposed to light, undergo a chemical change permitting the action of the photographic developer to reduce them to metallic silver. Silver appears black in finely divided form, and in black-and-white photography it is this silver that forms the final image seen on the negative or print. In colour photography the image is initially formed in silver, but at some stage during processing the silver is replaced by coloured dyes to give a full-colour image.

Film speed

By careful control of the size of the silver halide crystals – or grains – in an emulsion, and by the addition of certain sensitizing agents, the sensitivity of a film to light – the film speed – can be adjusted at manufacture to make the film suitable for a particular application. Films for general-purpose photography are given a number to indicate their speed. Over the years there have been several different film speed scales, of which only two are in common use today. These are the American ASA index and the European DIN rating. ASA bears a straightforward numerical relationship to the film speed, twice the number indicating twice the speed. The DIN system has a logarithmic scale, each doubling of the film speed adding 3 to the DIN rating; 50 ASA is the same as 18 DIN, and a film of this speed is twice as fast as one of 25 ASA/15 DIN, and half as fast as one of 100 ASA/21 DIN. The majority of general-purpose films fall somewhere within a range of 25 ASA/15 DIN to 400 ASA/27 DIN.

Types of film

There are many different film types available. In the following paragraphs we will look at the more common types and at some of the more specialized ones, and where appropriate give a very brief description of how they work.

Black-and white (monochrome) film. A basic black-and-white film consists of a thin (between 0·005 and 0·007 inch) film of transparent plastic on which is coated the light-sensitive emulsion – silver halide crystals suspended in gelatin. The speed of the emulsion is controlled partly by the size of the crystals – the larger the crystals the faster the film – and partly by the inclusion of certain sensitizing

ASA	DIN
25	15
32	16
40	17
50	18
64	19
80	20
100	21
125	22
160	23
200	24
240	25
320	26
400	27
500	28
640	29
800	30
1000	31

A table comparing ASA and DIN film speed values. The values for a film are often printed together on the carton as an ISO value, e.g. ISO 64/19°.

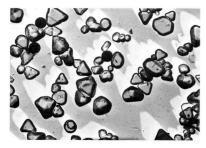

A photomicrograph showing silver halide crystals in a typical high-speed black-and-white emulsion (actually Kodak Tri-X). The opaque black discs are latex spheres of known diameter specially included for assessment of the magnification, which for this picture is approximately × 4000.

agents. These agents also control the regions of the spectrum, and hence the colours, to which the emulsion is sensitive. General-purpose black-and-white films are panchromatic, i.e. they are sensitive to all the colours of the visible spectrum. In addition, they exhibit some sensitivity to part of the ultra-violet band. At one time films were only orthochromatic. They were sensitive to all colours except red. Red objects would, therefore, appear dark on the final print. This was a particular problem in portrait photography, as flesh tones, especially the redder areas such as the lips, recorded unnaturally dark. Orthochromatic film did have one advantage, however. The unprotected film could be safely handled in red light enabling the photographer to develop the film by inspection, stopping the process when he considered the image density to be just right.

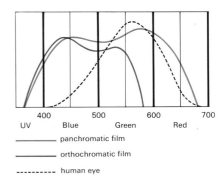

Relative spectral sensitivity graph for panchromatic and orthochromatic films and the human eye

Most black-and-white films are negative films. After processing, the image is a negative, i.e. all the tonal values of the subject are reversed. Light areas of the subject appear dark, and dark areas appear light. In order to view the image correctly a positive must be made. This is normally in the form of a print which is usually made by projecting an enlarged image of the negative on to a special paper, also coated with a photographic emulsion, to produce a print of convenient size for viewing. The exposed paper is processed in a manner similar to that for film. The tonal values are the reverse of those on the negative and the image appears correct.

Black-and-white films can be divided into three film speed categories – slow, medium and fast. A medium-speed film – about 125 ASA – is a good general-purpose film, suitable for a large variety of work. Action photography, where short exposures are needed to 'freeze' movement, and photography in dim light both require a fast film – between 200 and 400 ASA or even higher. Because the extra film speed has been achieved by increasing the size of the silver halide crystals, fast films are more 'grainy' and resolution and image quality are not so good. Slow films – about 25 to 50 ASA – are used when the subject is well illuminated and fairly static, and resolution and image quality are of great importance. The silver halide crystals are very small, producing an image of very fine grain from which enlargements of exceptional quality can be made.

Reversal colour films. Reversal colour films are so named because the negative image produced by the action of light is reversed during processing to give a positive image. Unlike negative films, which require a print to be made, the reversal film itself becomes the final photograph, and is viewed in the form of a colour transparency, either directly or by projecting the image, many times enlarged, on to a screen.

Reversal colour films are very complex in both chemical and physical structure. Basically they consist of three black-and-white emulsions coated one on another, each sensitive to one of the three primary colours, red, green and blue, (see page 13) and to that colour only. During the initial stage of the processing of the exposed film, the images on these emulsions are developed to give three

superimposed black-and-white silver negatives, each representing either the red, green or blue content of the subject. Following the first processing stage the silver halide which was not exposed when the photograph was taken is now fogged, either by chemical means or by exposing the entire film to light. The fogged silver halide is then developed in a special colour developer which produces in each emulsion not only a positive silver image but also a transparent dye image of the complementary colour to that to which the emulsion was originally sensitive, i.e. the red-sensitive layer produces a cyan dye image, the green-sensitive a magenta image, and the blue-sensitive a yellow image. After this stage the film carries in each emulsion a negative silver image, a positive silver image, and a positive coloured dye image, and appears totally black. The next stage dissolves away the silver images, leaving only the three dye images which, by subtractive colour mixing, re-create the colours of the original subject.

In most colour films the constituents of the dyes which produce the final coloured image are incorporated in the film during manufacture. During the processing of the exposed film, the colour developer causes an appropriate amount of dye to be generated in the area immediately surrounding each silver grain. This results in a slight spreading of the image, and the definition of the dye image is therefore not quite so good as that of the original silver image. With 'Kodachrome' films, however, the dyes are not incorporated in the film during manufacture, but are introduced during processing. Each silver grain of the negative image is replaced by the

The colours of an original subject, above, are represented by a colour negative, below, in a totally negative form, both in tonal values and colours. The tones of the subject are reversed, black becoming white and vice versa, and the colours are represented by their complementaries, blue as yellow, green as magenta, red as cyan, and vice versa. The overall orange hue is due to an integral masking layer which is compensated for when the print is made, and which is necessary to achieve the best possible colour rendition in the final print.

The modern colour reversal film is a very complicated structure, both physically and chemically. This diagram shows its *basic* physical construction and, in conjunction with the main text, offers a simplified explanation of how it works. Note that in the final stage of the diagram the fully processed transparency has been drawn as a three-dimensional object to show not only the individual dyes in each of the three coloured-dye layers but also how the overlapping of these dyes re-creates the colours of the subject by subtractive colour mixing when the transparency is viewed in the normal manner.

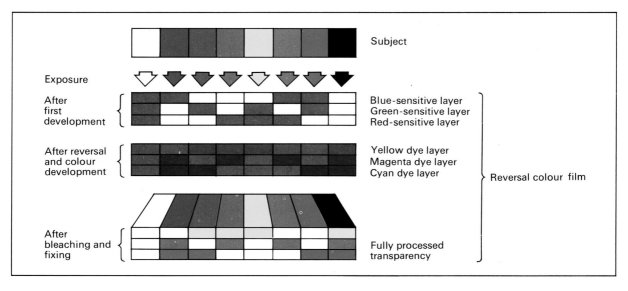

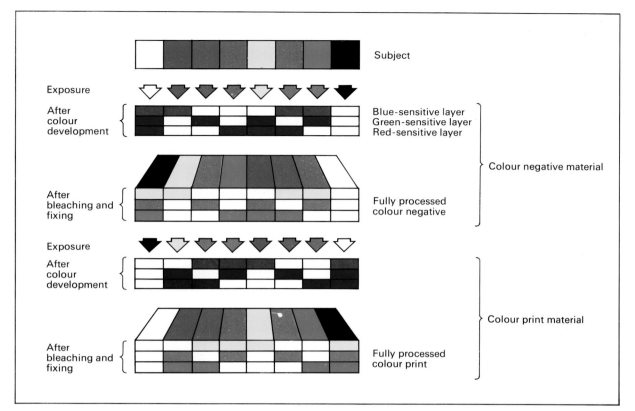

	Subject
Exposure	
After colour development	Blue-sensitive layer Green-sensitive layer Red-sensitive layer
	Colour negative material
After bleaching and fixing	Fully processed colour negative
Exposure	
After colour development	
	Colour print material
After bleaching and fixing	Fully processed colour print

appropriate amount of dye, such that the dye occupies precisely the area previously held by the silver grain, with no spreading of the image. It is this difference in the dye coupling technique which gives 'Kodachrome' films their exceptional resolving power.

Reversal colour films are made in two distinct types, balanced for use either in daylight or in tungsten lighting (see p. 96).

Negative colour films. These are designed to produce a negative image from which colour prints can be made. In common with reversal colour films, they have three emulsions, each sensitive to one of the three primary colours. Unlike reversal films, however, the coloured dye image is produced with the negative silver image in the first stage of processing. After the silver image has been bleached away a negative dye image remains. This image is negative not only in tonal values but also in colour, each colour of the original subject being represented by its complementary colour on the negative. Prints are made on a special colour print paper which has three emulsions similar to those of the film, the printing process reversing the tonal values and colours of the negative to produce a positive paper print.

Infra-red films. The spectral sensitivity of a general-purpose film extends from the ultra-violet to the end of the visible red. The sensitivity of infra-red films extends beyond the visible red to include part of the infra-red band. Both black-and-white and colour

This diagram shows the basic principles of colour negative film and how it works in conjunction with the colour print material to re-create the tones and colours of the original subject. The fully processed negative film and the fully processed colour print have both been drawn as three-dimensional objects to show the individual dyes and the visual effect of their overlapping when negative or print are viewed in the normal way.

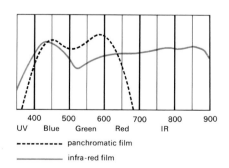

400	500	600	700	800	900
UV	Blue	Green	Red	IR	

- - - - - - - - panchromatic film

———— infra-red film

Relative spectral sensitivity graph for panchromatic and infra-red films

versions are available, and their main applications are in medical, forensic, and other scientific fields. The black-and-white film is often used with a special filter over the camera lens. This filter passes only infra-red, absorbing visible light, and the exposure is thus made by infra-red light only. The resulting photograph can make visible certain phenomena which cannot normally be seen by the human eye. A particular application is the detection of forgeries, as certain inks or pigments which appear the same by visible light may exhibit quite different properties in infra-red.

Infra-red colour film is a reversal film which differs from a conventional colour film mainly in that the blue-sensitive layer is replaced by an infra-red-sensitive layer. In addition, the dye coupling order within the emulsions is transposed (see diagram). The colour rendering is thus grossly distorted, and on the final result infra-red records as red, visible red records as green, and green records as blue. A yellow filter is used over the camera lens to absorb blue light. A frequent use of the film is for the detection of diseased trees. Chlorophyl is a strong reflector of infra-red, and

The pictures, left, show an application of infra-red sensitive film in the forensic laboratory. The upper picture, taken on a normal panchromatic film, shows a cheque as it appears to the eye. The lower picture, of the same cheque but taken on a high-speed infra-red film using infra-red radiation only, shows that the cheque has been altered, the 'ty' of 'Ninety' and the figure 'o' having been added in an ink which is transparent to infra-red, the ink with which the cheque was originally written being opaque to infra-red.

The pictures above show the same scene photographed on normal and infra-red colour film.

Visual appearance of object	Reproduction on film	
	Infra-red absorbed	Infra-red reflected
blue	grey to black	red
green	blue	magenta
red	green	yellow
yellow	cyan	grey to white
magenta	green	yellow
cyan	blue	magenta
grey	cyan	grey

The table, above, shows how coloured objects are recorded on an infra-red colour film, depending on whether they absorb or reflect infra-red.

The diagram, left, compares the dye layers and sensitivities of normal and infra-red colour films. Note that the exposure for the infra-red film is made through a yellow filter to prevent blue light, to which the emulsion layers are also sensitive, from reaching the film.

I.R.

Yellow filter

Blue-sensitive
Green-sensitive
Red-sensitive

After exposure

Infra-red-sensitive
Green-sensitive
Red-sensitive

Reversal process

Yellow dye layer
Magenta dye layer
Cyan dye layer

After bleaching and fixing

Cyan dye layer
Yellow dye layer
Magenta dye layer

Transparency

Normal reversal colour film

Infra-red colour film

healthy foliage appears red or magenta on infra-red colour film. Early in the attack on a tree by disease there is a structural change in the leaf below the chlorophyl layer, causing a reduction in the amount of infra-red light reflected, and diseased foliage records as a bluish grey. This change occurs before any evidence of the disease is visible to the naked eye or to a conventional colour film. By taking regular aerial photographs of forest areas on infra-red colour film an early indication of the onset of disease can be obtained.

X-ray films. Most photographic emulsions exhibit some sensitivity to X-rays. Films designed specially for X-ray use have extra-thick emulsion layers and are often coated on both sides of the film base. This enables the X-ray radiation level to be kept to an absolute minimum, an important consideration in medical applications due to the harmful effect on living tissue of excessive exposure to this radiation.

The fact that most general-purpose films are sensitive to X-rays is well worth remembering when passing through airport security checks, many of which use X-rays to inspect the contents of baggage. To prevent possible fogging, it is advisable to carry films in your hand baggage only, so that they may be easily removed before the baggage is checked. The security staff at most airports are aware of the effect their equipment can have on photographic materials, and will be found to be quite co-operative in this matter.

Lith films. Films for general-purpose photography are of fairly low contrast. This characteristic is necessary for the film to record the considerable brightness range of an average subject. An outside scene photographed in bright sunshine, for instance, can have a brightness range between the brightest highlight and the darkest shadow of 1000 to 1. An ordinary black-and-white negative film is designed so that changes in brightness within this range result in corresponding changes in the density of the image on the developed film, the density *gradually* increasing with an increase in exposure. Lith film is a very high-contrast black-and-white material in which a gradual increase in exposure results in a *sudden* increase in image density. The film has an exposure threshold level below which no image develops, resulting in clear film, and above which a very dense black image is produced. An ideal lith film produces an image consisting of black and white only, with no intermediate tones of grey.

One of the main applications of lith film is in the graphic arts industry, which is concerned with the preparation of originals for printing (by ink on paper, as opposed to photographic printing). The nature of certain printing processes is such that there are only two printing conditions – ink printed or not printed. There can be no intermediate settings. Before the blocks or plates from which a book is printed can be made, all the contents, whether text or illustrations, must be in this 'yes/no' form. Photographs and other illustrations requiring a range of intermediate tones are subjected to a process known as 'screening', which breaks up the image into a

Above: This illustration shows the same scene photographed on conventional black-and-white film, lower right, and infra-red film, upper left. The latter was taken using a red 29A filter to allow only red and infra-red light to reach the film. Note the darkening of the sky and the very light rendering of the foliage caused by the high infra-red reflectance of the chlorophyll in the leaves.

X-ray pictures, which are normally viewed as a negative image, record the shadows of areas of the subject which are totally or partially impervious to the X-ray radiation. The dental X-ray, above, clearly shows the teeth set into the bone of the upper jaw. The teeth have been crowned, the material of the artificial crowns and the cement with which they have been attached transmitting X-rays differently from the teeth themselves. The narrow white line extending along the middle tooth shows that this tooth has been root-filled.

pattern of small dots, usually positioned in a regular grid formation.
The tonal value of any point of the original photograph is
represented by the size of the dots at the corresponding point on the
printed copy. Lith film plays an important part in the screening
process. At some time during the preparation of this book the entire
contents, whether text, diagrams or photographs, have been in the
form of an image on lith film.

Instant picture films. Instant picture films virtually eliminate the
delay between taking a picture and viewing the result. They are
available in both black and white and colour and can normally be
used only in cameras designed specially for them, although special
camera backs are available for some makes of 'view' and large reflex
cameras. The film is usually supplied in film packs, each sufficient
for eight or ten exposures. All the chemicals required to process the
film and produce a finished print are contained within the film pack
itself.

There are two different types of instant picture systems. For each
exposure, film packs of the original type contain a sheet of negative
material, a sheet of positive material, and a pod containing the
processing chemical. After an exposure has been made, a paper tab is
pulled to withdraw from the pack the material for that exposure. As
they are withdrawn the negative and positive sheets come together
with the pod of chemical sandwiched between them. As the
sandwich leaves the camera it passes between rollers which rupture
the pod and squeeze out the chemical, spreading it evenly within the
sandwich. After the required processing time, usually 60 seconds,
the two parts of the sandwich can be separated, the negative material
and the used developer pod being discarded, leaving the finished
positive print. One type of black-and-white material provides, in
addition to a paper print, a film negative which can be retained for
future use, provided that immediately after processing it is treated in
sodium sulphite solution and thoroughly washed before it is allowed
to dry.

The latest type of instant picture film eliminates the need to
dispose of the somewhat messy waste products of the original type of
film. After the exposure has been made the print is ejected from the
camera, either automatically by an electric motor, or manually by a
hand-operated crank. Any waste material remains inside the film
pack. Immediately after ejection the print is blank. The image
gradually appears, diffusing through a white opaque layer from
behind. Development is automatic and requires no timing, the image
reaching full density and colour saturation within a few minutes.

Instant pictures have certain limitations compared with
conventional photographic systems. The image quality of the print
is generally lower than that of prints or transparencies produced by
conventional materials. In addition, apart from the black-and-white
negative/positive material, further prints can be obtained only by
copying the original print, resulting in further loss of image quality.
For these reasons instant picture cameras are not used to any great
extent by professional photographers, except as a means of checking

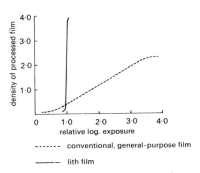

The characteristic curves, above, of a
general-purpose film and a lith film
illustrate the much higher contrast of the
lith film, for which a relatively small
change in exposure level produces a large
change in image density.

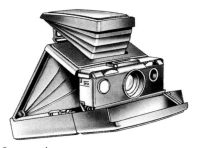

Instant picture cameras.

lighting, subject position, or other variables of a complicated picture set-up. When the photographer is satisfied with these variables as shown on the instant picture print, he can take the picture on a conventional film and leave the location or dismantle his studio set with a reasonable certainty that when he receives his processed film he will have a satisfactory result.

Film sizes

Films for general-purpose photography are available in a number of different sizes and packings. For some film sizes the picture format, i.e. the shape and area of each negative, and the number of exposures per film are common to every camera using that film. With other sizes, however, there are differences in the way in which the film is used by the various types of camera using a particular film size, with the result that these film sizes have more than one possible

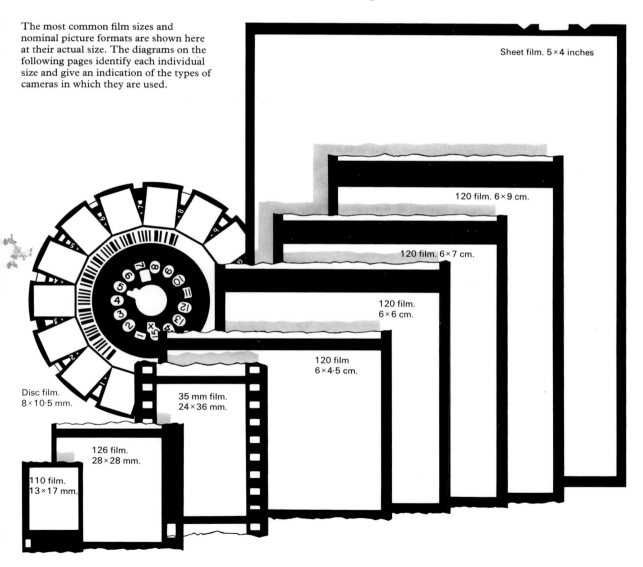

The most common film sizes and nominal picture formats are shown here at their actual size. The diagrams on the following pages identify each individual size and give an indication of the types of cameras in which they are used.

Sheet film. 5 × 4 inches

120 film. 6 × 9 cm.

120 film. 6 × 7 cm.

120 film. 6 × 6 cm.

120 film 6 × 4·5 cm.

Disc film. 8 × 10·5 mm.

35 mm film. 24 × 36 mm.

126 film. 28 × 28 mm.

110 film. 13 × 17 mm.

combination of picture format and number of exposures per film.

The following description of the various film sizes available includes an indication of the type of equipment which uses them. For further details of camera types see p. 34.

Disc film. This relative newcomer to the photographic scene produces negatives with a picture area of only 8 × 10·5 mm. Fifteen pictures are exposed onto a circular disc of film. Despite the very small picture area, quality is acceptable up to about postcard size, due to the development of a high resolution colour negative film. Most cameras using disc film are entirely automatic, including motorized film advance and built-in electronic flash which automatically comes into operation when the normal lighting conditions are inadequate.

Disc format

110 film. This film is used by small, pocket cameras producing negatives with a picture area of only 13 × 17 mm, allowing enlargements of acceptable quality to be made to a maximum of about postcard size only. The film is supplied in plastic cartridges which drop into the back of the camera, giving the advantage of extremely simple film loading and unloading. The film is available in 12 and 20 exposure lengths.

110 format

126 film. The original cartridge loading film, also in 12 or 20 exposure lengths, with a picture format of 28 × 28 mm. Aimed primarily at the lower priced end of the amateur market, most cameras using 126 or 110 film are fairly basic types and are very limited in their capabilities, although some of the more expensive ones have fully automated exposure control and a few have two built-in lenses, allowing the selection of a wide or narrow angle of view. Films for 110 and 126 cameras are available in only a limited number of film types. Most owners of these cameras use them with colour negative film for colour prints.

126 format

35 mm film. The most popular film size of all. The film itself is the same size as that used in many professional motion picture cameras, with perforations along both edges, and is supplied in a plastic or metal cassette, each of which contains a length of film sufficient for 20 or 36 exposures, although a few makes are available in 12 exposure lengths and some manufacturers are producing 24 exposure films. The standard picture format is 24 × 36 mm, and this is used by the vast majority of 35 mm cameras, although a few cameras were produced with a picture format of 18 × 24 mm, known as 'half-frame', giving twice the number of exposures per film.

The choice of cameras which take 35 mm film is enormous, ranging from very basic types to extremely complicated, expensive cameras of professional quality. During recent years, film quality has improved considerably, particularly that of colour negative and colour transparency films, and despite its small picture format, 35 mm film is capable of producing transparencies and prints of very high quality.

35 mm full-frame: 24 × 36 mm format

120 and 220 film. 120 film, often referred to as 'roll-film', is supplied on a plastic or metal spool, and has an opaque backing paper which is longer than the film itself and extends beyond it at both ends. Film and backing paper are wound together on to the spool by the manufacturer, and the extra length of paper at the beginning of the film protects the emulsion from light until the film is safely inside the camera. After the camera back is closed, the film/paper sandwich is wound by the camera's film transport mechanism on to a take-up spool until the start of the film itself is positioned across the film plane, ready for the first exposure. After each exposure has been made, the film is advanced sufficiently for the next, and when it has all been used the entire film and backing paper is wound on to the take-up spool, so that the film is again protected from light when the camera back is opened. After the film is removed, the empty spool left in the camera is transferred to the take-up position, and becomes the take-up spool for the next film.

Roll-film: 6 × 4·5 cm format

Cameras which use 120 film usually have one of four possible picture formats. These are 6 × 4·5 cm, giving 15 pictures per film; 6 × 6 cm, 12 pictures per film; 6 × 7 cm, 10 per film; and 6 × 9 cm, 8 per film. Of these, 6 × 6 cm is probably the most common of all, and is the format provided by most twin-lens reflex cameras, and also by certain SLRs. 6 × 4·5 cm and 6 × 7 cm are formats currently available in some SLRs, and 6 × 9 cm is mainly confined to the roll-film backs of certain view cameras, some of which also have backs available in the 6 × 7 cm format.

Roll-film: 6 × 6 cm format

220 roll-film is the same width as 120, but is twice as long, and consequently allows twice as many exposures per film. Many cameras designed for 120 film will not accept 220. Those which do usually have a switch or lever which adjusts the automatic film counter and transport mechanism according to which is being used.

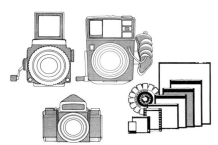
Roll-film: 6 × 7 cm format

Sheet film. This is available in a number of formats, ranging from 12·7 × 10·2 cm to 50·8 × 40·8 cm (more often referred to in their imperial equivalents 5 × 4 inches to 20 × 16 inches). Each sheet is sufficient for just one exposure, and before use must be loaded in the dark into a special light-tight holder, known as a 'dark-slide', which may be subsequently loaded into the camera in normal lighting conditions. Once the dark-slide is in the camera, a sheath, which until now has protected the film from light, is withdrawn in readiness for the exposure. Most dark-slides are double-sided, allowing each to hold two sheets of film.

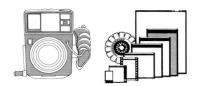
Roll-film or sheet film: 6 × 9 cm format

Sheet film offers the professional photographer the ultimate in image quality. Because the negative itself is large, quite big prints can be made by enlarging the negative by only two or three times, with the advantage that grain and any dirt or blemishes on the negative are far less conspicuous on the print than they would be on similar size prints made from smaller negatives. As we shall see in the section dealing with camera types, the 'movements' of the view camera provide a versatility not fully afforded by any other type of camera.

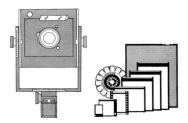
Sheet film: 5 × 4 inches and larger

Exposure meters

In order that the film in the camera may receive the correct exposure it is important that the aperture and shutter speed controls are correctly adjusted, according to the strength of the light arriving at the camera lens. In black-and-white photography there is some tolerance in the accuracy required of these settings, and errors of a stop either side of the optimum will have little effect on the resulting picture, as corrections for small degrees of over- or under-exposure of the negative can be made at the printing stage. Similar corrections are possible when printing from colour negative films, although over- or under-exposure of the negative will also affect colour saturation, for which no correction is possible during printing. Colour reversal films, however, require much more accurate control of the exposure. Errors of only a half-stop either side of the optimum produce noticeably inferior results. The degree by which the exposure of a film may be varied and still give acceptable results is known as the latitude of the film.

The light levels encountered in photography vary enormously, from bright tropical sunshine to weak artificial light, or even moonlight. If the exposure is to be sufficiently accurate to fall within the latitude of the film some means of accurately measuring this light level is required. The human eye can detect quite small changes in level at the moment they occur, but is unable to make an accurate quantitative assessment. Photo-electric cells do measure light levels very accurately, and these form the basis of virtually all modern exposure meters. There are three types of photo-cell commonly used for this application. These are the selenium cell, the cadmium sulphide (CdS) cell, and the silicon photo-diode (SPD).

Meters with selenium cells

Selenium photo-cells are usually in the form of thin circular or rectangular plates, to each side of which an electrical connection is made. Selenium has the property of releasing electrons when light falls upon it. If a circuit is made between the cell's two connections, a small electrical current will flow. The strength of this current is proportional to the intensity of the light falling on the active surface of the cell, and may be measured by allowing the current to flow through a sensitive galvanometer. At low light levels, however, the current is too small to be measured accurately, which rather limits the versatility of exposure meters using this type of cell.

Meters with CdS cells

Cadmium sulphide has the property of changing its effective electrical resistance according to the strength of the light falling upon it – the stronger the light the lower the resistance – and CdS photo-cells are often referred to as photo-resistors. If a CdS cell is connected in series with a battery and a galvanometer, the current

Photo-cells of the three types commonly used in exposure meters. Top: selenium cell. Bottom right: CdS photo-resistor. Bottom left: silicon photo-diode.

flow is dependent on the resistance of the cell, and hence on the strength of the light falling upon it.

Meters with CdS cells have very good sensitivity at low light levels – at least one make gives an accurate reading when the light is too dim to read the scale by – but at such levels their response

Below: The basic circuit diagrams of exposure meters using the three photo-cell types.

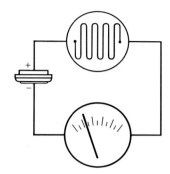

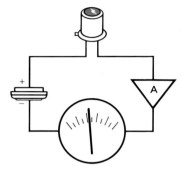

A selenium cell generates a small amount of electrical energy, the strength of which is proportional to the intensity of the light falling on it. This energy is sufficient to operate a sensitive galvanometer directly, and exposure meters using this type of cell do not require a battery.

Exposure meters with CdS cells require a small battery, as the cell does not itself generate energy, but alters its electrical resistance according to the intensity of light. In the exposure meter the cell thus controls, according to the light level, the flow of current between battery and galvanometer.

Exposure meters with silicon photo-diodes also require a battery, but as the current which flows through the cell when it is illuminated is too small to be measured directly, an amplifier (A) is necessary to boost the current to a usable level.

becomes very slow, requiring the user to allow several seconds for the reading to become stable. This problem is particularly acute when the cell has been exposed to very bright light immediately before its use in dim light. In such cases the photo-cell suffers from a 'memory effect'. When the dim-light reading is taken, the meter needle becomes apparently stable within a few seconds, but, because of the effect on the cell of its recent exposure to bright light, the reading is artificially high, and if it is assumed to be correct, under-exposure of the film will result. It may take many minutes for the reading to drop to its correct level. For maximum accuracy when taking dim-light readings, the cell of a CdS meter should be kept covered for as long as possible before the readings are taken.

Meters with silicon photo-diodes
When an electrical potential is applied across a photo-diode, a current flows which is directly proportional to the intensity of the light falling upon it. The current is extremely small and is usually too weak to operate a galvanometer directly, and so it is boosted to a usable level by an amplifier.

Silicon photo-diodes exhibit a good low-light sensitivity but with a much faster response time than that of the CdS cell and with no memory effect. Due to the need for an amplifier, exposure meters using SPDs are somewhat complex and expensive. Because of this the use of SPDs is mainly confined to the built-in exposure meters of some of the most expensive SLR cameras, an application which is also suited by their very small physical size. Because of the electrical

requirements of the amplifier the current drain from the battery is rather high. Some meters incorporate a timer which switches the meter off after a predetermined time, preventing it from being left on accidentally, and thus conserving the battery.

The basic exposure meter

Although many cameras for professional use have built-in exposure meters, many photographers prefer to use separate hand-held meters because of their extreme versatility and simplicity of use.

The range of light levels that an exposure meter is required to measure is so large that if it were to be compressed on to one scale the divisions would be so close together as to be almost unreadable. Because of this most meters have two scales, one for high and one for low light levels. The high-level scale is selected by moving a baffle or filter over the photo-cell to reduce the amount of light reaching the cell. Many meters have a mechanism to lock the needle, thus holding the reading. This facility is useful when taking incident light readings (see p. 58) or at any other time when a reading must be taken with the meter held in a position which makes it difficult to see the scale.

Once a measurement has been taken, the scale reading is transferred to a disc calculator which indicates the combinations of shutter speed and aperture which will give correct exposure of the film at that light level.

Most hand-held meters can measure the exposure in two distinct ways – by the reflected light method or by the incident light method.

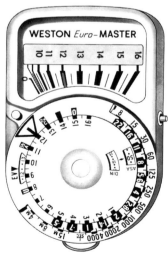

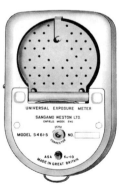

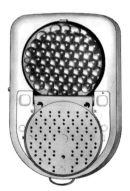

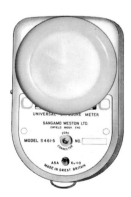

A very popular meter of the selenium cell variety.

After setting the meter to the required film speed the reading of the light level is taken, and the reading on the meter scale is transferred to the 'calculator' disc, which then indicates the various combinations of shutter speed and aperture settings which will give the correct exposure.

The meter has two sensitivity ranges. When set to the low sensitivity range, for use in bright lighting conditions, the selenium cell is covered by a perforated baffle which reduces the amount of light reaching the cell. To engage the high sensitivity range, used in dull light, the baffle is hinged back to allow light to

reach the cell unhindered. This also changes the numbers which appear alongside the meter needle.

For taking readings by the incident light method a white translucent diffuser is clipped into position over the cell.

The position of the needle at any time can be locked by using the small button protruding from the side of the meter.

No battery is required, and consequently there is no on/off switch.

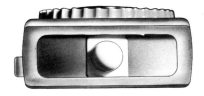

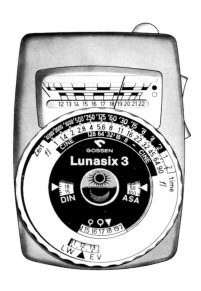

A very sensitive meter of the CdS type.

The meter is powered by two small mercury batteries, and is switched on by a control on the side of the meter. This control also selects which of the two sensitivity ranges is in operation.

For readings by the incident light method a domed translucent diffuser is slid into position over the cell window.

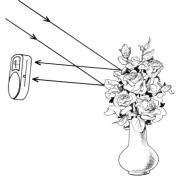

When taking readings by the reflected light method, the meter is pointed directly towards the subject, so that the cell reads the intensity of the light reflected by the subject.

The reflected light method

This is the most common method of exposure evaluation. The cell of the meter is pointed towards the subject from roughly the same direction as the camera, and a reading is taken of the light reflected from the subject. This method requires some care in use, as the meter always assumes the subject to be of average reflectance, containing a balance of light and dark tones. An average subject is considered to be one which reflects about 18% of the light falling upon it, and most meters are calibrated to give the correct exposure for such a subject. If in reality the subject reflects more or less light than average, the meter cannot know this and will give a reading which assumes that the subject is an average one. If the photographer accepts this reading, and uses it without modification, darker-than-average subjects will receive too much exposure and lighter-than-average ones will receive too little. Beach and snow scenes are typical examples of lighter-than-average subjects. If an unmodified reading is used the beach or snow will be given only sufficient exposure to record it as an average subject, and it will appear too dark on the result. In practice beach scenes require about one stop more exposure than that indicated, and snow scenes between one and two stops more.

Whenever possible, reflected light readings should be taken from an area of the subject which does have a reflectance of about 18%. This may prove difficult, as it is not easy to assess visually which area of the subject complies with this requirement. In some cases there may not even be such an area. One solution to this problem is to take the reading from an artificial average subject, such as a photographic 'grey card', which is positioned in such a way that it receives identical lighting to the subject proper. A grey card is a specially prepared product, grey on one side and white on the other. The grey side reflects 18% of the light falling upon it – the same as an average subject – and for normal use the reading is taken from this surface. The white side reflects 90% of the light, and may be

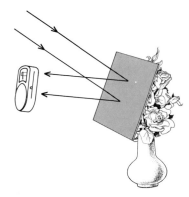

If the subject is lighter or darker than average, and its correct tonal values are to be retained, a reading taken of the light reflected from the subject itself will give an incorrect assessment of the exposure required. By holding an object of average reflectance, such as a photographic grey card, so that the light falling on it is identical to that falling on the subject, and reading the light reflected from the card rather than that reflected from the subject, a more accurate assessment of the exposure will be obtained.

used to extend the effective sensitivity of the meter at low light levels, at which many meters are relatively inaccurate. Taking the reading from the white surface will result in the cell receiving more light than it would from the grey side, and this may be sufficient to bring the reading into the more accurate part of the scale. Whatever reading is obtained, five times more exposure must be given to compensate for the five times higher reflectance of the white surface.

Readings taken from a grey card can be used without modification for many subjects, and will result in lighter- or darker-than-average subjects recording at approximately their correct tonal value. Sometimes, however, it is necessary to darken a lighter-than-average subject or to lighten a darker-than-average one. A dark wood-carving, for example, may benefit from being reproduced lighter in tone than it really is, in order that all the detail of the carving may be clearly seen. A grey-card reading would result in the carving reproducing darker than required, while a reflected light reading from the wood itself may result in too light a tone. Something in between the two will probably be correct.

The incident light method

Most hand-held light meters have provision for taking incident light readings. A white plastic diffuser is placed over the photo-cell and the meter is positioned so that it receives the same illumination as the subject, with the diffuser pointing *towards* the light source. The meter thus reads the incident light falling on the subject. As with the grey-card method, the reading obtained is independent of the tonal values of the subject and will give an accurate indication of the exposure required for the majority of subjects.

Whichever method of exposure evaluation is used, it is always good practice to 'bracket' the exposures given, by taking one frame at the estimated exposure and additional ones with more and less exposure. This should ensure that one frame will be precisely correct. With black-and-white and colour negative films, the exposures should be made at one-stop increments, and in addition to

The incident light method also gives more accurate readings with non-average subjects. With its diffuser in position over the cell, the exposure meter is held at the subject position and pointed *towards the light source*, so that the intensity of the incident light, i.e. that falling *onto* the subject, is measured.

Snow scenes are typical lighter-than-average subjects. Because an exposure meter can only assume that the subject is of average reflectance, a picture, far left, taken using exposure information derived by the straightforward reflected light method will be considerably under-exposed. By taking the reading from an object of average reflectance, such as a grey card, or by using the incident light method, a more accurate assessment of the exposure is obtained, left.

Depending on the precise conditions at the time, the error produced when using the reflected light method for snow scenes may be anything up to about two stops.

Beach scenes are another example of lighter-than-average subjects, requiring special care to avoid the under-exposure which will result from using an unmodified reflected light reading.

the exposure at the estimated setting, one either side should be made. When using colour reversal films, which have less latitude than negative films, exposures at half-stop increments should be given. With most subjects one exposure at the estimated setting and one either side will be sufficient, but with subjects where there is particular doubt about the accuracy of the estimated setting it may be wise to make five exposures, i.e. one at the estimated setting, one at a $\frac{1}{2}$ stop more, one at 1 stop more, one at a $\frac{1}{2}$ stop less, and one at 1 stop less. Don't feel that by bracketing your exposures you are any less of a photographer – professionals do it all the time.

Built-in exposure meters

Many viewfinder-type cameras have built-in exposure meters, which in their simplest form consist of a selenium or CdS photo-cell mounted on the front of the camera body. The reading is indicated by a small galvanometer, and must be transferred to the aperture and shutter controls in the same way as a reading taken from a separate hand-held meter. On most viewfinder cameras, however, the meter is 'coupled' to the aperture and shutter controls. There are several methods by which this is achieved, one of which is the 'match-needle' system in which a second needle, physically linked to the controls, must be visually lined up with the exposure meter needle to set the correct exposure. Usually the two needles are positioned so that they can be seen through the viewfinder. In another system, operation of the aperture and shutter controls adjusts the sensitivity of the meter movement, and hence the deflection of the needle, which in this case must be lined up with a fixed mark.

Readings with built-in exposure meters can only be taken by the reflected light method and one must exercise the same care in evaluating the nature of the subject, and from which part of it the reading should be taken, as is necessary with a separate hand-held meter.

The viewfinder of a 'viewfinder-type' camera with a built-in exposure meter. The user sets the film speed and shutter speed and the scale indicates the aperture to be used.

In fact, this particular camera is an 'automatic' model, and automatically sets the aperture to the value indicated on the scale. Provided the needle remains between the red marks (if it does not the user must select a suitably different shutter speed), and any necessary allowance is made for non-average subjects, correct exposure should result.

Most SLR cameras have through-the-lens (TTL) metering, in which the exposure reading is taken from light which has entered the camera through the lens. The light is usually measured from the focusing screen by photo-cells positioned adjacent to the pentaprism. The cells are usually of the CdS or SPD types, because of their small physical size and their high sensitivity, which is particularly necessary when measuring the comparatively low light levels within the camera.

The main advantage of TTL metering is that the reading is taken from only those parts of the subject which are to be included in the picture. If the camera lens is changed for one of a different focal length, the angle of view of the meter is automatically modified accordingly.

There are three different TTL metering systems which are incorporated in modern cameras – average reading, centre-weighted, and spot reading.

The average reading system
In this system a single photo-cell or sometimes two, one each side of the pentaprism, measure the light from the focusing screen, the positioning of the cells being such that the sensitivity of the meter is substantially even over the whole area of the screen. A disadvantage of this system is that areas of exceptionally dark or light tone, such as a bright sky, can produce a misleading reading, even when they are well to the side of the frame. The user can overcome this problem by pointing the camera slightly away from the offending area while taking the reading.

The centre-weighted system
Probably the most common of the three systems, the centre-weighted meter also uses two photo-cells, but with their positions adjusted so that their fields of view overlap in the centre of the focusing screen. Within the area of overlap the reading is taken by both cells, and outside it by only one. The overall sensitivity is therefore biased towards the central area. This design is based on the assumption that the main interest of a picture is usually positioned in the centre of the frame and, while still requiring careful use, performs well in practice and is the system most likely to give the correct exposure in the hands of an inexperienced user.

The spot reading system
This system usually employs a single cell positioned so that it takes a reading from only a small sharply defined area in the centre of the focusing screen. The screen is usually marked in some way to indicate to the user the precise measuring area. This system must be used intelligently, as the photographer must select a suitable area of the subject from which the reading is to be taken. The freedom which this choice allows, however, makes spot metering the system most favoured by many professional photographers.

Most TTL metering systems indicate the light reading to the user by means of a conventional but miniaturized galvanometer, the needle of which is visible to one side of the viewing frame. The

The average reading system. In this method of TTL metering the reading is taken equally from the entire area of the frame. This can cause incorrect readings to be obtained when the main subject occupies only a small part of the picture area and the remainder is filled by tones which are much lighter or darker than the subject. In the picture, above, metering with the subject framed as it is

to be taken would cause the meter to be over-influenced by the large area of bright sky, and would result in under-exposure of the subject itself. A much more accurate assessment of the exposure is obtained if the metering operation is performed with the camera tilted to exclude most of the sky, as shown above.

The centre-weighted system. The reading is taken from the entire area of the frame but, on the assumption that the centre of interest of a picture lies in the centre of the frame, the sensitivity of the system is biased so that it is much greater in the centre of the frame than it is at the edges. Although care is still necessary to obtain perfect exposures every time, the centre-weighted system is more likely to produce good results with difficult subjects than is the average reading system.

correct settings of aperture and shutter speed are selected by 'match-needle' or similar methods. In some cameras, however, there is no galvanometer and the correct settings are indicated by a series of light-emitting diodes, the manufacturers claiming that this system is more rugged and resistant to mechanical damage than is the delicate mechanism of a conventional galvanometer-based meter.

In the majority of SLRs the choice of metering system – average, centre-weighted, or spot – is decided by the camera designer, and the photographer can exert his preference only by purchasing a model equipped with his favourite system. Some cameras, however, have two systems, usually average and spot, and the user can operate a switch to select the one he prefers.

For a TTL metering system to function correctly it must be coupled in some way to the aperture mechanism, so that as the aperture setting is progressively altered a position is found at which the 'match-needle' requirement of the meter is met. There are two ways by which this coupling may be achieved – stopped-down metering and full aperture metering.

The spot reading system. The reading is taken from a sharply defined area in the centre of the frame. The precise extent of this area is shown in the viewfinder. This system offers the photographer complete freedom in the choice of the part of the subject from which the exposure is assessed, and is capable of very accurate results when used intelligently.

Stopped-down metering

Most SLRs have 'automatic' lenses which remain at full aperture, i.e. with the aperture fully open, while the subject is viewed and framed, regardless of the setting selected on the aperture ring. When the shutter release is pressed, the aperture closes down to the selected setting just before the shutter opens. As soon as the shutter closes, the aperture returns to its fully open position. The advantages are twofold. Firstly, the image in the viewfinder is as bright as possible. Secondly, depth of field is at its smallest at full aperture, allowing very precise visual adjustment of focus.

As the name implies, in a stopped-down metering system the exposure reading is taken with the aperture stopped down. The closure of the aperture for metering purposes is usually effected by a lever or button, which often incorporates the meter's electrical

on/off switch. When the meter is in use, the aperture value complies with that selected by the aperture ring, and as the ring is rotated the light falling on the photo-cells changes accordingly. The coupling between aperture and meter is thus effected by purely optical means, giving this system the advantage of requiring no mechanical linkage between the camera body and the lens, apart from the relatively simple mechanism which stops down the aperture just before the shutter fires. The disadvantage is that during the metering operation the image in the viewfinder is darker and more difficult to see, particularly at very small aperture settings.

Full aperture metering

Full aperture metering systems use mechanical or electrical couplings between the lens and the camera body to indicate to the meter the aperture to which the lens is set. Within the lens the coupling is connected to the aperture setting ring only, and not to the aperture mechanism itself. As the aperture ring is rotated the linkage simulates the stopping-down of the aperture, the blades themselves remaining fully open, with the advantage that the image in the viewfinder remains bright, even during the metering operation. This advantage is achieved at a price, however, as the additional and fairly complex coupling required between lens and camera body usually makes the lenses more expensive than their counterparts for cameras with stopped-down metering. Most full aperture metering systems can also be used in the stopped-down mode. This is often necessary when using certain accessories, such as extension tubes or bellows, and also allows the use of lenses from independent lens manufacturers who, in order to offer their products at comparatively low prices, have not incorporated the full aperture coupling.

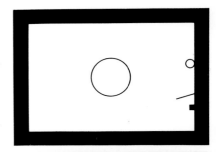

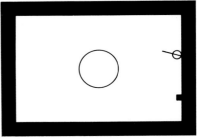

Above: The viewfinder of a camera with a full-aperture metering system of the 'match needle' type.

Setting the shutter speed adjusts the sensitivity of the meter, and hence the amount the needle is deflected for a given light level. Adjusting the lens aperture ring moves the position of the circular tab. Adjusting aperture and/or shutter speed so that the needle exactly bisects the circle sets the correct exposure.

When the camera is used in the stopped-down mode, as is necessary with certain accessories, aperture and shutter speed are adjusted to align the needle with the square, fixed tab.

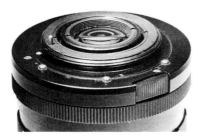

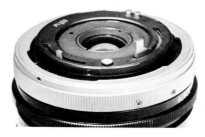

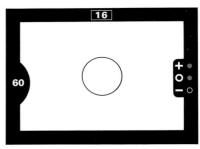

The viewfinder of a camera with an electronic metering system. The three light emitting diodes at the right of the viewfinder perform the task of the needle in a camera with a mechanical meter.

To set the correct exposure the lens aperture ring is rotated until only the central l.e.d. is illuminated, the outer l.e.d.s indicating to the user whether the aperture is too large or too small. When two l.e.d.s are lit simultaneously, as above, the exposure is within a half stop of the correct value.

When pressed by a lever within the camera body the small pin protruding from the rear of the lens mount, left, closes the lens aperture to the value to which the aperture ring is set. In addition to its operation at the moment of exposure, this coupling is also operated by the camera's 'stop-down' or 'preview' lever, and on a camera equipped only with stopped-down metering this is the only coupling

required between lens and body. In fact, this lens is from a camera with full aperture metering and the three electrical contacts towards the edge of the mount convey electrical signals to the camera body, informing it of the setting of the aperture ring.

On the lens, right, from a different make of camera with full-aperture metering, the same functions are performed by purely mechanical means.

Automatic exposure systems

Many SLRs have fully automatic exposure systems in which no manual matching of needles is necessary. There are two types – shutter priority and aperture priority. In a shutter priority system the photographer selects a shutter speed suited to the degree of subject movement and the automatic exposure system selects the correct aperture setting. In an aperture priority system the photographer selects the aperture and the automatic exposure system selects the shutter speed. The aperture priority system has been made possible by the advent of electronically timed shutters in which the shutter speeds are continuously variable. (In most mechanically timed shutters settings intermediate between those marked are not possible.)

There are devotees of both systems, who will argue the advantages of their particular choice. Most cameras are of only one system or the other, although some have both systems, with a switch to change from one to the other.

In both systems the actual value of the variable which is selected automatically is usually displayed in the viewfinder. This allows the user some degree of control. For example, if the photographer feels that the aperture automatically selected by a shutter priority system will give too little or too much depth of field, he can manually change the shutter speed, thus causing the camera to select a different aperture. Similarly, in an aperture priority system, if the user is not happy that the automatically selected shutter speed will be fast enough to arrest the movement of the subject, he can manually select a larger aperture, thus making the camera select a faster shutter speed.

A particular problem with automatic exposure systems occurs when they are confronted with non-average subjects. If the meter reading is taken at the moment the shutter release is pressed, the framing of the subject in the viewfinder may be such that the photo-cells are adversely affected by large areas of light or dark tone, with the result that the wrong exposure is given. There are two ways in which the designer of an automatic camera can allow for such occasions. The first is to provide a manual override, allowing the photographer full access to the exposure controls in order to make any necessary modifications to the settings selected by the camera. In some cameras the extent to which the automatic exposure may be overriden is limited to about two stops, often in $\frac{1}{3}$-stop increments. The other way is to provide a facility whereby the exposure settings determined by the camera may be locked, often by the first pressure on the shutter release. This allows the photographer to point the camera at an area of the subject which he considers will give a correct exposure setting for the whole scene, lock the setting thus obtained, and having repositioned the camera to frame the subject as he requires it, to use this setting to make his exposure.

Many viewfinder cameras and some SLRs offer a fully automatic exposure system where the camera decides both the aperture and shutter speed. The degree to which the user can override the selected settings varies from make to make.

Above: The viewfinder of the Canon A1 displays both aperture and shutter speed in an illuminated and digital form.

Below: The Canon A1 is an example of a camera offering both shutter priority and aperture priority automatic exposure systems.

In this particular camera a lever concentric with the shutter release button selects the exposure mode. In the shutter priority mode, top, the lever is set to Tv, which reveals the shutter speed dial and allows the user to select the speed required. The camera automatically selects the appropriate aperture. With the lever set to Av the speed dial is concealed and an aperture scale appears. The user selects the required aperture on this scale and the camera selects the appropriate shutter speed.

In addition to aperture priority and shutter priority modes, this camera offers a 'programmed' mode where the camera selects both the aperture and shutter speed, a manual mode which allows the user full control over both aperture and shutter speed, and an automatic exposure mode for use with flash.

Shutter and aperture

In the previous sections of this book we have seen that on most cameras both the aperture and shutter are adjustable to allow control of the exposure of the film. The aperture is adjustable to govern the strength of the light passing through the lens, and the shutter is adjustable to control the time during which this light is allowed to fall on the film.

In these pages we shall discuss the ways in which these fundamental parts of the camera are used in conjunction with one another, not only to obtain the correct exposure, but also to affect two other criteria important to the making of a successful photograph—the depth of field and the control of movement.

The control of exposure

We have already seen that the lens aperture ring is calibrated in f-numbers, or stops, and that as we close, or stop down the aperture each setting passes half the light of the previous one. The shutter is calibrated in such a way that the shutter speeds bear a similar two-to-one relationship.

By referring to the exposure table printed on the instruction leaflet provided with the film, we may well find that under certain lighting conditions the film requires an exposure of, say, 1/60 second at f5·6. We could adjust the camera to this setting and take a correctly exposed transparency, but we could equally well set the camera to 1/125 second at f4, or to 1/30 second at f8, or to several other equivalent settings, and still obtain a correctly exposed picture. To understand the reason for this let us examine these

The relationship between shutter speed and aperture in the control of exposure may be likened to the relationship between length and area of cross-section in the determination of the volume of a cylinder. In both instances there are many combinations of the two variables which will achieve the same end result.

The diagram, below, shows that for each stop by which the aperture is closed (or each halving of the area of cross-section of the cylinder) the duration of the exposure (or length of the cylinder) must be doubled in order to maintain the same exposure of the film (or volume of the cylinder).

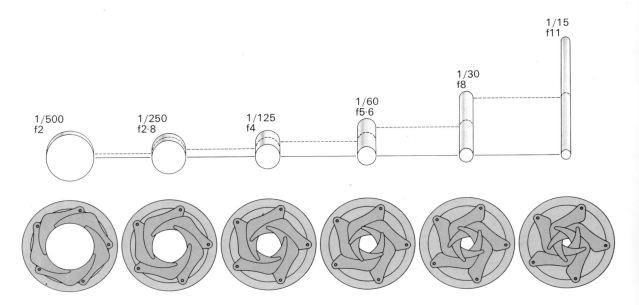

1/500
f2

1/250
f2·8

1/125
f4

1/60
f5·6

1/30
f8

1/15
f11

figures more closely. The leaflet says f5·6, but let us assume that we will use f4. We know that at f4 the aperture will be one whole stop more open than at f5·6, therefore the *intensity* of the light reaching the film will be twice what it was at f5·6. If we have twice the intensity we must allow the light to fall on the film for only half the *time*, so we must use a shutter speed of 1/125 second. Conversely, if we use f8 the intensity of the light will be only half what it was at f5·6, so it must be allowed to fall on the film for twice as long. If 1/60 second was right at f5·6, then 1/30 second will be correct at f8. We can continue opening the aperture and reducing the exposure time, or closing the aperture and increasing the time, until we run out of settings, i.e. with the aperture fully opened or fully closed, or with the shutter set to its shortest or longest time. (If the shutter has a 'B' setting there is actually no limit to how long an exposure can be given, as the shutter can be operated manually if the slowest setting on the speed dial is insufficient. In practice, due to reciprocity failure of the film (see p. 102), if the duration of the exposure is extended beyond a certain point more exposure than that calculated must be given.)

If the lens of our camera has an aperture which is f2 when fully opened and f16 when fully closed, then for our example of 1/60 second at f5·6 we could take a series of pictures at settings ranging from 1/500 second at f2 to 1/8 second at f16, with all the appropriate combinations in between, and get a correct exposure every time.

How then do we choose which of these settings to use? The answer lies in examining the nature of the subject and deciding which of the several combinations of shutter speed and aperture, all correct so far as exposure is concerned, will best convey our intended interpretation of the subject. We must consider how our choice of shutter speed will affect the way in which any movement of the subject is recorded, and how our choice of aperture will control how much, or how little, depth of field we will obtain in our picture. Sometimes the choice is easy, one factor particularly outweighing the other, but, as we shall see, the final decision is often a compromise resulting from careful balancing of the criteria, one against the other.

The control of movement and depth of field

By the careful selection of shutter speed, we can control the way in which moving subjects are recorded in our pictures. Let us assume, for instance, that we are photographing a car which is travelling across our field of view at 60 miles per hour, and that we are using a shutter speed of 1/30 second. During the time that the shutter is open the car will travel almost 3 feet, and consequently will record on the film as a blurred image. If we increase the shutter speed to 1/500 second, the car's movement will be only about 2 inches and the resulting image will be much sharper.

In sports photography it is often necessary to use a fast shutter speed to 'freeze' the movement in order to record as much detail in the subject as possible (see p. 88). Sometimes it is necessary to use a fast shutter speed not because of subject movement, but because the

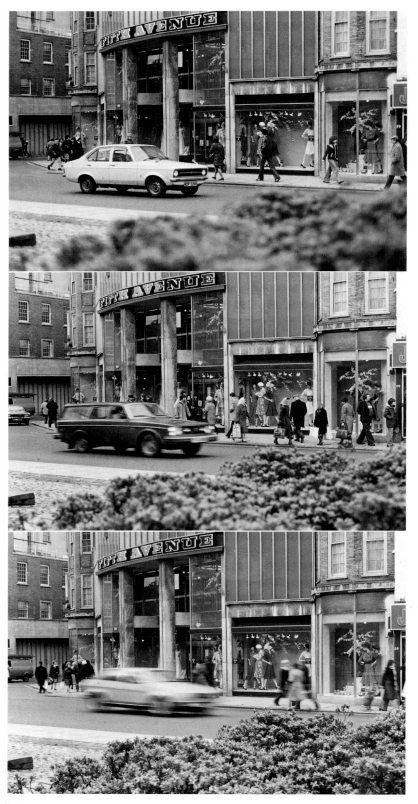

f2

These pictures show the effects of different combinations of shutter speed and aperture. Each combination has been chosen to give correct exposure of the film, but the effect of each on depth of field and subject movement is different.

The top picture was taken at 1/500 second and f2. The fast shutter speed has 'frozen' the movement of the car, but the large aperture has given insufficient depth of field for the foreground foliage to be recorded sharply.

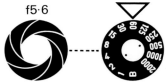

f5·6

This picture was taken at 1/60 second at f5·6. The slower shutter speed has resulted in the moving car being recorded slightly blurred, but the smaller aperture has given increased depth of field, somewhat improving the sharpness of the foreground foliage.

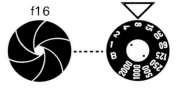

f16

The final picture was taken at 1/8 second at f16. The very small aperture has given much greater depth of field, sufficient for the foreground foliage to be recorded very sharply, but the very slow shutter speed has resulted in the car recording only as a blur.

camera is moving, e.g. when taking pictures from a moving car or train. When the camera is being hand-held, even from a fixed vantage point, it is always necessary to select a shutter speed which is fast enough to overcome the inevitable slight camera movements – camera shake – caused partly by the lack of rigidity of the human body allowing the momentary pressure on the shutter release at the instant of taking the picture to jerk the camera slightly, and partly by slight but ever-present involuntary body movements, which prevent the camera from being held perfectly still, however hard one tries. The problems of reducing unwanted camera movement to a minimum are dealt with in detail later (p. 84).

The aperture setting at which a photograph is taken greatly influences the depth of field, which is the distance between the points nearest to and furthest from the camera between which all parts of the subject appear equally sharp on the result. The smaller the aperture, the greater the depth of field (see p. 69).

It is often important for a photograph to have a large depth of field, so that both near and distant objects are recorded sharply. In landscape photography, for example, the photographer may wish to help the composition of his picture by including a bed of flowers or some other interest in the near foreground. The use of a small aperture will ensure that both the distant scenery and the flowers are as sharp as possible. Sometimes, however, a small depth of field may be required, so that only the main subject itself is recorded sharply. This provides the photographer with a means of isolating the subject from what may be a distracting background, or of drawing the attention to one particular part of the picture. A small depth of field will be obtained by the use of a large aperture setting.

From the above it should be obvious that arresting any subject movement and obtaining a large depth of field are mutually exclusive goals. One requires a fast shutter speed, which in turn demands a large aperture to maintain correct exposure of the film, and the other requires a small aperture, and hence a slower shutter speed. When a picture requires only one of these criteria to be satisfied, the choice of settings is easy. The problems arise when we need to stop movement *and* obtain a large depth of field in the same picture. In such instances we can either make a compromise by using a medium shutter speed and a medium aperture setting, in which case neither criterion will be fully satisfied, or, when possible, we can use a film of higher sensitivity, which will allow the use of both a fast shutter speed and a small aperture. High-speed films, however are inherently more grainy than those of medium speed, and may give a result of slightly lower overall quality, due to the increased breaking up of the image by the larger grain size, but this may be considered a small price to pay if their use makes possible the taking of a picture which might otherwise have been impossible.

Depth of field

What is depth of field?

When a camera lens is accurately focused on a distant point of light – for example a star – the light from the object passes through the lens and converges within the camera as a cone of light, the point of which falls precisely on the film plane, with the result that a sharp image of the object is formed on the emulsion of the film.

If the lens is focused inaccurately, so that it is either too far back or too far forward, the film will not lie at the exact point of the cone, but in a position where the rays of light either have not yet come to a point or have already passed through the point of sharpest focus and are diverging again. In either case the star will be recorded on the film not as a minute point, but as a small blurred disc, known as a circle of confusion.

Any object which we wish to photograph either emits light itself or reflects light from another source. The object can therefore be considered, as far as photography is concerned, as an assembly of many minute points of light. When the camera is focused on a plane of the object, all the points on that particular plane are recorded sharply on the film. All points nearer or further away are recorded as circles of confusion, the diameter of which increases the further the particular points of the subject are away from the plane of sharpest focus. The effect on film is that only those parts of the subject on which the lens is accurately focused are recorded perfectly sharply, all other parts recording as various size circles of confusion. The circles overlap each other, rendering these areas of the subject

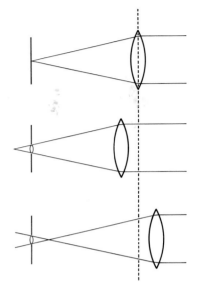

When a camera lens is accurately focused on a very distant object such as a star, the light rays from the object pass through the lens and are brought to a focus precisely on the film plane, and the object is recorded on the film as a minute point.

If the focusing is set incorrectly the image is formed either in front of or behind the film plane, and the object is recorded not as a minute point but as a blurred disc, known as a circle of confusion.

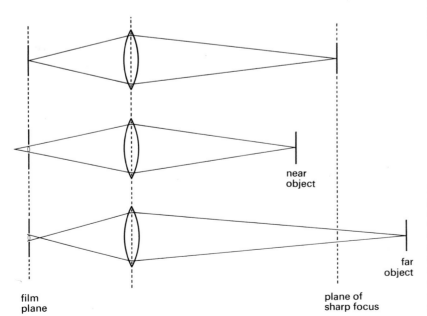

film plane

near object

plane of sharp focus

far object

From a photographic point of view, an object can be regarded as an assembly of many minute points of light, and a camera which is accurately focused on the object will record each of these points as a corresponding minute point on the film. Objects in front of or behind this object will be recorded unsharply, each point of their surface recording as a corresponding circle of confusion on the film.

unsharp, the degree of unsharpness at any point being dependent on the diameter of the circles of confusion at that point.

If we examine a photograph we find that although only parts of the subject are actually on the plane of exact focus other parts

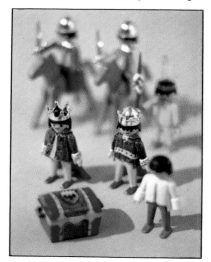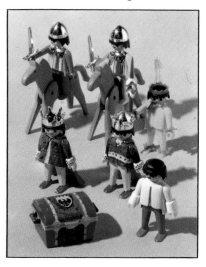

The picture, far left, was taken at f1·4 and shows very little depth of field, objects either side of the plane of sharp focus appearing very unsharp. The picture, left, was taken at f22 and shows the very much greater depth of field which results when a small aperture is used.

slightly in front or behind the plane also appear acceptably sharp. Areas of the subject further away from the plane of sharp focus are noticeably unsharp and become progressively more so with distance from the plane.

At the point where we can first detect that the image is no longer quite sharp, the diameter of the circles of confusion is such that if we could look at one circle only it would be just large enough for our eyes to recognize it as a circle rather than a single minute point.

The width of the zone in which everything appears equally sharp is known as the *depth of field.*

Depth of field is smallest when the lens is used at large apertures and increases as it is stopped down. The depth is also dependent on the focal length of the lens, the distance on which the lens is focused, and the diameter which the circles of confusion must have for us to detect that the image is just unsharp.

Depth of field scales and tables
Many modern camera lenses have a depth of field scale engraved on the lens barrel to provide the photographer with a quick indication of the depth of field at various aperture and distance settings – see diagram.

Such scales can be extremely useful, but they should be used with discretion, as they are intended only as a general-purpose guide. The more discerning photographer may find, for reasons which we will discuss later, that the sharpness at the near and far distance limits using the aperture indicated may not be quite to the standard he desires, and he may consider that he needs to use an aperture of, perhaps, one stop smaller than that indicated. Alternatively he may prefer to prepare his own depth of field tables.

Most lenses incorporate a depth of field scale as a part of their focusing mount. In the example above the scale shows that with the focusing set to 5 m and the aperture to f16, the depth of field extends from about 2·5 m to infinity.

Calculating the depth of field

The near and far limits of the depth of field for any aperture/distance/focal length combination may be calculated using the following formulae:

$$\text{Near limit of sharp focus} = \frac{Fu(F+cf)}{(F^2+ucf)}$$

$$\text{Far limit of sharp focus} = \frac{Fu(F-cf)}{(F^2-ucf)}$$

where u = focused distance
c = diameter of circle of confusion on the negative
f = f-number of selected aperture setting
F = focal length of lens.

Care should be taken to ensure that all dimensions are in the same units, i.e. all in inches or feet, or all in mm or cm.

The value which we assign to the diameter of the circle of confusion is itself dependent on the conditions under which we view the final photograph.

It is generally accepted that a person with normal eyesight, in good lighting conditions, can distinguish two separate points only if they subtend to the eye an angle in excess of about 2·25 minutes of a degree. This corresponds to two separate dots $\frac{1}{150}$ inch (0·166 mm) apart, viewed at the normal minimum reading distance – approximately 10 inches (25 cm). At this viewing distance dots any closer together cannot be recognized as such, but appear as one single dot.

If we adopt the above figure of $\frac{1}{150}$ inch (0·166 mm) as the maximum diameter of the circles of confusion in sharp areas of the final print, and if we assume that an 8 × 10 inch (20 × 25 cm) print is the largest we will view at normal reading distance, we can calculate the diameter of the circles of confusion on the negative itself. For instance, an 8 × 10 inch print is approximately a 3 × enlargement from a $2\frac{1}{2} \times 3\frac{1}{2}$ inch (6 × 9 cm) negative. On this size negative the diameter in sharp areas must therefore be no more than $\frac{1}{150 \times 3} = \frac{1}{450}$ inch (0·055 mm). On a 35 mm negative, from which the above size print would be an 8 × enlargement, the diameter must be no more than $\frac{1}{150 \times 8} = \frac{1}{1200}$ inch (0·021 mm), assuming, of course, that the print is made from the whole of the negative.

The values above are, as we have seen, based on the assumption that we will be viewing an 8 × 10 inch print at normal reading distance. What if we wish to produce 16 × 20 inch (40 × 45 cm) prints, or if we are taking colour slides for projection? The circles of confusion on a 16 × 20 inch print would have twice the diameter of those on an 8 × 10 from the same negative. The viewing distance, however, would normally be greater for the larger print, and if this is the case it will automatically compensate for the larger circles of confusion. The different degrees of enlargement encountered when projecting transparencies are also fairly self-compensating, as the projected image size is usually adjusted to suit the viewing distance.

People often do tend to view big enlargements at less than normal distances, however, and they do sometimes sit much too close to the projection screen. The choice of value to adopt for the circles of

confusion is therefore somewhat subjective, and the photographer who frequently produces large exhibition quality prints, perhaps from only a section of his negative, and which may be viewed at closer than normal distances, will need to calculate his depth of field using a circle of confusion value smaller than would a person producing only postcard-size prints for the family album.

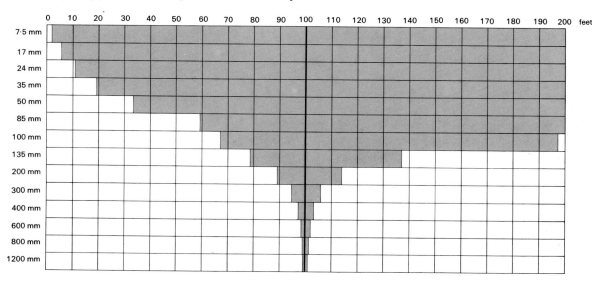

This table shows the effect of lens focal length on depth of field for a common subject distance (100 feet) and a common aperture (f8).

Hyperfocal distance

When a camera lens is focused on infinity, the distance between the camera and the nearest object which is acceptably sharp is known as the hyperfocal distance. It is dependent on the focal length of the lens, the aperture used, and the diameters of the circles of confusion at a point considered to be just acceptably sharp, and may be calculated from the formula:

$$\text{hyperfocal distance (H)} = \frac{F^2}{fc}$$

where F = focal length
f = f-number of selected aperture
c = diameter of circle of confusion on the negative.

The relationship between hyperfocal distance and depth of field is such that it provides the photographer who has calculated the hyperfocal distances of his lenses at various apertures with a means of rapidly assessing the depth of field he will obtain in his pictures. The relationship is known as the rule of consecutive depths, and states that if a lens is focused on any of the series of distances equal to infinity, the hyperfocal distance H, H/2, H/3, H/4, H/5, H/6, and so on, then no matter to which of these distances the focusing is set, the depth of field extends to the next on either side. For a lens which at a certain stop has a hyperfocal distance of, for example, 90 feet, the series will be infinity, 90, 45, 30, 22½, 18, 15, etc. feet. If the lens is focused on 90 feet, the depth of field will extend from 45 feet to infinity, if focused on 18 feet, from 15 to 22½ feet. The series may be extended as far as one wishes, but for small subject to camera

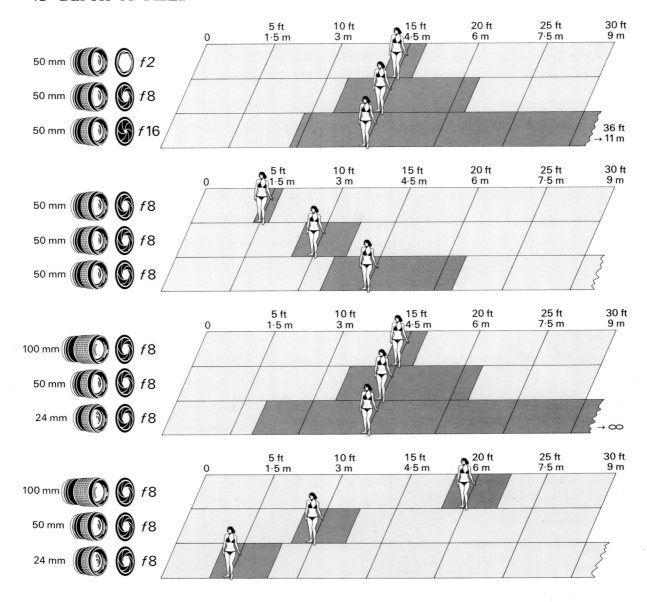

distances, such as those encountered in close-up work, the numbers become too cumbersome for mental calculations.

Making use of depth of field information

We have seen that when a lens is focused on its hyperfocal distance, the depth of field extends from half the hyperfocal distance to infinity. This condition offers the maximum depth of field at the selected aperture and can be used to advantage when photographing landscapes, when the sharpness of foreground interest and distant scenery are often of equal importance.

When a very great depth of field is required but cannot be achieved using a lens of the correct focal length to fill the frame with the subject, more depth can be obtained by changing to a shorter

The top three diagrams show the effect on the depth of field of changing one of the three variables – aperture, subject distance and focal length – while the other two variables remain the same.

The fourth diagram shows that if the focal length is changed but the subject distance is also changed in order to maintain the same image size on film, the depth of field remains substantially the same.

This picture, right, was taken in a zoo with the camera approximately 3 ft/1 m from the wire mesh of the lion's enclosure. With the focus set to be correct for the lion, the exposure was made at f16. The wire mesh has recorded sharp enough to be very obtrusive. *Nikkormat, 135 mm lens, 1/30 sec, f16, Kodachrome 64.* ▶

◀ The pictures of the daffodils show how, by careful selection of the lens aperture setting, it is possible to control the depth of field in a picture, and hence the extent to which the subject is isolated from the background. The first picture was exposed at an aperture of f2.8. The depth of field is insufficient to give a sharp image of even the entire depth of the flowers. *Canon FTb, 50 mm lens with + 1 close-up lens, 1/500 sec, f2.8, Kodachrome 25.*

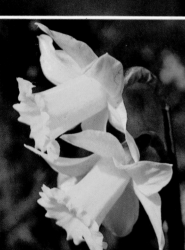

With the camera the same distance ▶ from the wire as above, this picture was taken at an aperture of f11. The wires are less sharp but are still obvious enough to spoil an otherwise pleasant picture. *Nikkormat, 135 mm lens, 1/60 sec, f11, Kodachrome 64.*

◀ The exposure for the second picture was made at f8. The daffodils are sharp and they stand out well from the background, which is still well out of focus. *Canon FTb, 50 mm lens with + 1 close-up lens, 1/60 sec, f8, Kodachrome 25.*

For this picture, again taken at the same ▶ distance from the wire, an aperture of f5.6 was used. Now the wires have become so out of focus that they are not apparent, allowing a clear view of the subject. *Nikkormat, 135 mm lens, 1/250 sec, f5.6, Kodachrome 64.*

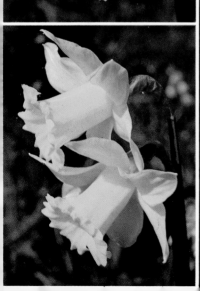

◀ For the third picture the aperture was set at f16. The background is sharper and has a tendency to distract the eye from the subject. *Canon FTb, 50 mm lens with + 1 close-up lens, 1/15 sec, f16, Kodachrome 25.*

focal length lens and enlarging the negative more at the printing stage to compensate for the smaller image size.

A 50 mm lens at f16, for example, for a circle of confusion of 0·0008 inch diameter, has a hyperfocal distance of 25 feet. With the lens focused on this distance depth of field extends from $12\frac{1}{2}$ feet to infinity. A 25 mm lens, also at f16, for a circle of confusion diameter of 0·0004 inch, has a hyperfocal distance of $12\frac{1}{2}$ feet, giving a depth of field from $6\frac{1}{4}$ feet to infinity, the same as would be obtained with the 50 mm lens if it were possible to use it with the aperture closed down by a further two stops, i.e. f32. The smaller circle of confusion for the shorter focal length lens is necessary because the negative must be enlarged twice as much to obtain the same image size on the final print.

In the previous paragraphs we have discussed ways of achieving a large depth of field. Sometimes, however, exactly the opposite is required. Making only the subject itself sharp and allowing everything in front of or behind it to be out of focus is a very effective way of isolating the subject from its surroundings and bringing it to the attention of the viewer. This can be achieved by using large apertures, at which the depth of field is at a minimum, and works best with the longer focal length lenses, due to their inherently smaller depth of field.

Interchangeable lenses

Cameras fitted with a fixed, non-interchangeable lens impose considerable limitations on the photographer in his choice of viewpoint. If for some reason the photographer equipped with such a camera is unable to find a vantage point from which he can include exactly the area of the subject he requires, there is little he can do to rectify the situation. Cameras with interchangeable lenses, however, offer a means of altering the angle of view of the camera, and thus allow the photographer to change the amount of the subject included in the picture from a given viewpoint.

Changing both the angle of view and the viewpoint provides the photographer with a means of altering the perspective obtained in a picture, and allows him to control the apparent relationship between the sizes of foreground and background objects. This facility is an important tool with which the photographer can express his own personal interpretation of the subject.

In addition to their range of interchangeable lenses designed for general-purpose photography, many manufacturers produce special lenses for certain specialized fields of photography which require the use of optics which are specifically designed for the particular application and method of use. An example of this is extreme close-up photography, for which special 'macro' lenses designed to give their optimum results at very small camera to subject distances are necessary if the results are to be of the highest quality possible.

The facility by which the lens can be completely removed from the camera body also permits the coupling to the body of accessories other than lenses, e.g. microscope adaptors which permit the camera to be attached to a standard microscope, and extension tubes and bellows units which fit between camera body and lens, used in close-up photography to allow the lens to focus closer than otherwise possible.

A useful SLR outfit comprising 50 mm normal, 28 mm wide-angle and 70–210 mm zoom lenses. Such an outfit is sufficiently versatile to cope with most photographic situations.

The normal or standard lens

Unless otherwise specified, the lens supplied with a camera at the time of purchase is of a focal length which is designated as 'standard' or 'normal' for the film format of the camera. Often the relationship between the focal length of the lens and the negative size of the camera is such that the focal length is approximately equal to the diagonal of the negative. Thus for a camera which takes 6 × 6 cm negatives the standard lens usually has a focal length of about 85 mm (lens focal lengths are almost always quoted in millimetres). For a full-frame 35 mm camera, however, the standard lens is usually 50 mm, which is slightly longer than the diagonal of the negative, although recently there has been a trend towards standard lenses of shorter focal lengths, some manufacturers supplying their cameras with lenses of 45 mm, 40 mm, or even shorter.

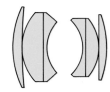

A cross-section through the optical components of a typical lens of 'standard' focal length.

Long focus lenses

Lenses with a focal length longer than that of the standard lens have
a narrower angle of view and consequently allow the subject to fill
the frame from a greater distance. There are two main reasons why
this may be necessary. The first, and the more obvious, is that for
some reason the subject cannot be approached sufficiently closely for
it to occupy the required area of the frame using the standard lens,
for example when photographing wild animals. The second reason is
that it is often better to photograph certain subjects from a distance
which is greater than that which would be used with a standard lens,
in order to obtain a more natural perspective. A particular example
of this is found in portrait photography. If the model is
photographed with a standard lens so that the head and shoulders fill
the frame, those parts of the face which are nearest to the camera,
such as the nose and perhaps the chin, will appear larger in relation
to the rest of the face than the model would like to think they are. By
using a lens of longer focal length the same head and shoulders pose
will fill the frame from a greater distance, and consequently will be
photographed with a smaller angle of perspective, and a much more
flattering result will be obtained. For this reason portrait
photography is often undertaken with a lens of focal length about
twice that of the standard lens, e.g. with a 100 mm lens on a full-
frame 35 mm camera.

Lenses of longer focal length than the standard fall into two
distinct types, categorized by differences in their design and
construction. These are *conventional long focus* and *true telephoto*,
although both types are commonly referred to as telephotos, or
'teles'. The main difference between the two types concerns the
position of the principal plane of refraction. As we have seen in the
first chapter of this book (p. 14), light rays entering a lens are
refracted so that on leaving the lens they converge to form an image
of the object from which they emanated. In a compound lens,
i.e. one comprising several elements, this bending of the light rays
takes place in several distinct stages. If a diagram is drawn in which
an incoming ray and its corresponding outgoing ray are both
extended, a point will be found at which the two extensions cross. A
line drawn perpendicular to the optical axis and passing through this
point is known as the principal plane of refraction of the lens. When
the distance between object and lens is very great the incoming rays
may be considered to be parallel, and the image will be formed at a
distance from the principal plane of refraction equal to the focal
length of the lens. In a lens of conventional design the principal
plane falls within the confines of the mechanical structure of the
lens. Consequently a lens of focal length considerably longer than
that of the standard lens is physically long, and a camera fitted with
such a lens is cumbersome and does not balance nicely in the hand.
Lenses of true telephoto design overcome these problems by the use
of two distinct groups of elements. The front group, that nearest the
subject, is predominantly convex and causes rays of light from the
subject to converge. This convergence is partially cancelled by the
rear group, which is predominantly concave. The result is that the

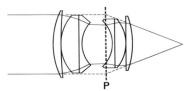

In a lens of conventional design, above,
the principal plane of refraction, **P**, falls
within the confines of the mechanical
structure of the lens. A lens of long focal
length and of conventional design is
therefore physically long.

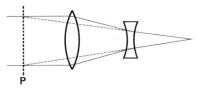

A lens of true telephoto design consists
of two distinct groups of elements
(shown here as single elements for
simplicity). The group nearest the
subject is predominantly convex and the
group nearest the film predominantly
concave. The principal plane of
refraction falls in front of the mechanical
structure of the lens, producing a lens
which is physically shorter than a lens of
the same focal length but of conventional
design.

principal plane of refraction, from which the rays appear to converge, is actually in front of the lens. Consequently the lens is physically shorter than its focal length. The lens is, therefore, less bulky than a conventional lens of the same focal length. The true telephoto is used in the same way as a lens 'of conventional design, and the two designs produce results which for all practical purposes are identical.

The mirror lens is a special design of long focal length lens in which some or all of the lens elements have been replaced by mirrors, usually two in number. The optical path is folded back on itself with the result that the physical length of the lens is much shorter than the focal length (see diagram), and the weight of the lens is usually less than that of a more conventional lens of similar focal length.

A mirror lens with no lens elements at all would be completely free from chromatic aberration, as the image would be formed entirely by reflection rather than by refraction. (Chromatic aberration is a lens defect caused by the refractive index of glass being different for light of different colours. It is never caused solely by reflection.) Such a lens would exhibit considerable spherical aberration, however, due to the spherical curvature of the surfaces of the mirrors. In modern mirror lenses spherical aberration of the mirrors is compensated for by the inclusion of several conventional lens elements. A mirror lens of this nature forms an image by a combination of reflection and refraction and, strictly speaking, should be described as a 'catadioptric' lens. (A lens which forms an image solely by reflection is known as 'catoptric', while one which forms an image solely by refraction is known as 'dioptric'.)

Mirror lenses are normally of fixed aperture, usually about f8, and this considerably limits the photographer in his selection of film speed and exposure times. In addition, because of the long focal length and consequent small depth of field, focusing must be performed with great accuracy, even though it is made difficult by the small aperture, which gives a correspondingly dim image on the camera's focusing screen.

Wide-angle lenses

Lenses of focal length shorter than the standard have a wider angle of view, and consequently allow the photographer to include a greater area of the subject than is possible with a standard lens from the same viewpoint. Alternatively, by moving closer to the subject so that the area originally included with the standard lens again fills the frame the perspective can be altered, making background objects appear smaller in relation to the subject.

Wide-angle lenses of conventional design, in which the principal plane of refraction falls within the mechanical structure of the lens, are usually unsuitable for single-lens reflex cameras, as their short focal length would require them to be positioned so close to the film that there would be insufficient clearance to allow correct operation of the camera's mirror mechanism. For this reason wide-angle lenses for SLR cameras are usually of the *retrofocus*, or *inverted telephoto*

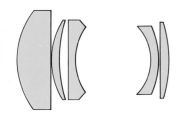

A cross-section through a lens of true telephoto design. This particular lens is of 200 mm focal length, for use with a 35 mm SLR camera.

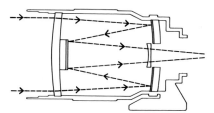

A cross-section through a 500 mm mirror lens.

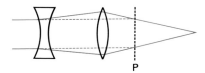

A lens of retrofocus design consists of two groups of elements, that nearest the subject being predominantly concave and that nearest the film predominantly convex. This results in the principal plane of refraction falling behind the physical structure of the lens. The distance between the lens and the film is thus greater than it is with a lens of conventional design of the same focal length. The retrofocus design is necessary with wide-angle lenses for SLR cameras to allow sufficient clearance for the operation of the camera's mirror mechanism.

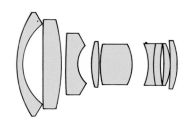

A cross-section through a 24 mm wide-angle lens of retrofocus design.

design. As the name implies, such lenses may be likened to a true telephoto lens in reverse, i.e. they also consist of two distinct groups of elements, but with the predominantly concave, diverging group nearer the subject. The principal plane of refraction falls behind the lens, allowing a greater clearance between the rear surface of the lens and the film than is possible with a lens of conventional design.

Pictures taken with wide-angle lenses often show a characteristic distortion of the subject, particularly evident on circular objects imaged near the edge of the frame, these being recorded as ovals rather than as circles. This particular distortion is not really a fault of the lens itself, which if it is of a focal length longer than a certain value – about 17 mm for a lens for use with a full-frame 35 mm camera – faithfully records all it sees, but is due to the lens having recorded the scene with an angle of view and perspective which is normally denied us when we view the subject directly with our eyes, and with which we are, therefore, unfamiliar. Extremely wide-angle lenses, e.g. those of less than 17 mm focal length intended for use with a full-frame 35 mm camera, do optically distort the image, however. This is most apparent towards the edges of the frame, straight lines in the subject appearing curved on the resulting picture. Such lenses are known as 'fish-eye' lenses, and in those of the shortest focal length the distortion is so great that they produce a circular field which does not fill the entire area of the frame. Fish-eye lenses are sometimes used for scientific photography, for example in meteorology to photograph the entire sky in one picture, but in the main their use is limited to the occasional advertising or promotional shots which intentionally exploit their gross distortion.

In recent years special wide-angle lenses, known as 'perspective control' lenses, have become available. Their main application is in architectural photography, where they are used to correct 'converging verticals'. This is a problem encountered in the photography of tall buildings, and occurs whenever the film plane of the camera is tilted from the vertical, usually to allow the top of the building to be included in the picture. The result is a picture in which the verticals of the building converge, instead of being parallel, causing the building to appear to lean. Actually, the same thing happens when we look up at a building with our eyes, but because we expect the building to be upright our brain modifies its interpretation of the images formed within our eyes, and we see the building as we expect it to be. With the camera, however, the only way to record the verticals of a building as parallel lines on the resulting photograph is to ensure that the camera back, and hence the film plane, is absolutely vertical and, therefore, parallel to the walls of the building. With conventional wide-angle lenses this often results in the top of the building being excluded from the picture. The perspective control lens incorporates a sliding stage which allows the lens elements to be displaced from their normal axis, in a similar way to the rising front movement of the view camera, and in many instances will permit the top of the building to be included in the picture *and* the camera back to be kept vertical, thus solving the problem of converging verticals. In addition to its application in

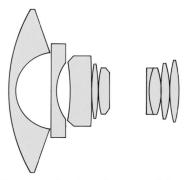

A cross-section through a 15 mm fish-eye lens.

To prevent 'converging verticals' when photographing buildings the film plane of the camera must be kept vertical. This may prevent the top of the building from being included in the picture.

By using the perspective control lens the film plane can be kept vertical *and* the top of the building included in the picture.

Above left: Taken with a conventional lens.
Above right: Taken with a perspective control lens.

architectural photography, the perspective control lens is useful for any subject which has parallel sides which must be kept parallel even when the subject is viewed from an angle which would normally cause them to converge. To cater for such applications the direction of shift is adjustable through a full 360°.

The 'tilt and shift' lens is a variation of the basic perspective control lens which, in addition to the shift movement for correcting verticals, has a facility for tilting the lens axis in relation to the film plane, in a manner similar to the tilt movement of the view camera. The tilt facility can be used, on suitable subjects, as a means of obtaining an apparently greater depth of field than is normally possible. Only subjects which are confined to a single plane receding away from the camera are really suitable, the apparent increase in depth of field being obtained by using the lens movement to tilt the zone of sharp focus until it coincides with the subject plane.

The mechanism for adjusting the lens movement of both perspective control and tilt and shift lenses is calibrated in order that the degree of movement in use can be easily seen. With the controls set at zero, i.e. with no tilt or shift, the lens can be used in exactly the same way as an ordinary wide-angle of the same focal length.

Zoom lenses

Variable focal length, or 'zoom' lenses have been available for motion picture use since the 1930s, but it is only in comparatively recent years that they have become widely available for use with still cameras.

The zoom lens is an assembly of positive (converging) and negative (diverging) groups of elements arranged such that the movement of some of the elements along the optical axis provides a facility whereby the focal length, and hence the angle of view, is continuously variable within certain limits. The ratio of maximum to minimum focal length imposed by these limits is known as the 'zooming range'. On zoom lenses for still cameras the range is less than that of lenses for cine use, and is usually limited to a maximum of about 3:1. This is because of design restrictions imposed by the need for very high optical qualities at an affordable price.

A particular requirement of the zoom lens is that neither the distance on which the lens is focused nor its effective aperture should be affected by adjustment of the focal length control. To comply fully with this requirement a typical zoom lens is constructed with four distinct groups of elements, the total number of elements being about ten to fifteen. Effective blooming of all air-to-glass surfaces is, therefore, essential to ensure low flare and high light transmission. In a typical lens the position of the group of elements nearest the subject is not altered by adjustment of the focal length control, but is adjustable for focusing purposes and is, therefore, coupled to the lens focusing ring. The second group of elements is the 'variator', which slides coaxially to change the focal length of the lens and is coupled to the focal length control. The third group, the 'compensator', also moves axially as the focal length is adjusted, but by a different amount to the variator, and

To give an idea of its thickness, this book had to be photographed so that its edges could be seen, yet the front of the book had to be kept square. This was impossible with a conventional lens, left, but no problem for the perspective control lens, right.

The tilt movement of the tilt and shift lens allows an apparent increase in depth of field, in a manner similar to the tilt movement of the view camera (p. 43).

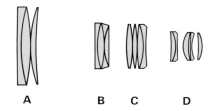

A cross-section through a zoom lens of four-group design.
A. Front group, adjustable for focusing.
B. Variator, coupled to zooming control, moves to change focal length of the entire lens.
C. Compensator, also coupled to the zooming control, moves to compensate for any shift in focus caused by movement of variator.
D. Fixed rear group.

compensates for the focus shift which would otherwise result from the movement of the variator. The final group is fixed, and brings the light rays to a focus to form the image.

Zoom lenses which are adjustable to a relatively short focal length – less than about 40 mm for a lens to fit a full-frame 35 mm camera – often consist of only two groups of elements. The front group performs both zooming and focusing, and the rear group acts both as compensator and the main image forming component. The two-group design has certain advantages relating to the correction of aberrations which make it particularly suitable for use in wide-angle zoom lenses. Disadvantages are that the zooming range is limited to a maximum of about 2:1, and there may be some variation of effective aperture with focal length.

A 35–70 mm zoom lens. This particular model is small enough to fit within the camera's normal ever-ready case, and offers a versatile alternative to the standard 50 mm lens.

Early zoom lenses for still photography were rather disappointing, as their resolving power and aberration correction was noticeably inferior to that of lenses of fixed focal length, and this has led many photographers to have considerable doubts about adding a zoom to their collection of lenses. This is unfortunate, however, as optical design and technology have improved immensely in recent years, and most modern zoom lenses from the major manufacturers are of a quality which is quite adequate for the majority of photographic purposes, and it is often impossible to distinguish between a picture taken with a zoom lens and one of the same subject taken with a lens of fixed focal length. However, for those applications where the image is to be reproduced many times enlarged, and the greatest possible resolution is required, a high quality lens of fixed focal length will usually provide a marginally better result. Whether or not a zoom lens is suited to a photographer's requirements therefore depends entirely on the type of work in which he is involved.

Many zoom lenses incorporate a 'macro' facility whereby the lens can be adjusted to focus on very close objects, giving a minimum reproduction ratio of about 1:2, i.e. half life size. This facility is really a by-product of the zoom design, and is also achieved by moving one or more groups of elements within the lens. Often the quality achieved by a zoom lens when used in its macro mode is not so high as that given by a lens of fixed focal length used with supplementary close-up lenses or extension tubes.

Macro lenses

Lenses for general-purpose photography are designed so that the optical correction for lens aberrations is at its greatest, and lens performance therefore at its highest, when the lens to subject distance is many times greater than the lens to film distance, i.e. when the lens is used in the normal manner to photograph large subjects. When such a lens is used to photograph small subjects, requiring the addition of attachments such as supplementary close-up lenses or extension tubes in order to allow the lens to focus on objects which are closer to the lens than its normal minimum focusing distance, the carefully calculated optical corrections incorporated by the lens designer become less effective, and the

A macro lens, showing the long focusing movement which allows the focusing to be set over a range of distances from infinity down to a distance which provides a half-life-size image of the subject on the film.

image quality is less than ideal. For this reason many manufacturers include in their range of lenses a special 'macro' lens, the optical corrections of which have been optimized for the small lens to subject distances encountered in close-up photography. Usually the focusing range of such lenses is much greater than that of lenses intended solely for general-purpose photography, and focusing is usually continuously variable from infinity right down to a distance from which the subject is reproduced on film at about half its true life size.

Aspheric and fluorite lenses

In most lenses designed for photographic use the surfaces of each element have a spherical curvature. Spherical surfaces are relatively easy to manufacture, and are well suited to mass production techniques. However, they do have one particular drawback – they suffer from spherical aberration, i.e. light rays passing through the lens near its perimeter are brought to a focus at a different point from rays which pass through the lens near its axis. The lens designer can correct for this spherical aberration to some extent, but his task becomes increasingly difficult the larger the effective diameter of the lens. If the maximum aperture of a spherical-surfaced lens is to be greater than about f1·4 the spherical aberration remaining after he has done all he can to reduce it is still too great to be acceptable. It can be reduced to an acceptable level, however, by designing the lens so that one of its elements has a surface with a curvature which deviates from the spherical. Such a surface is known as aspherical (not spherical). Lenses incorporating an aspherical surface are usually known as 'aspheric' lenses. The precise shape of the aspherical surface is worked out by computer to correct exactly for the spherical aberration produced by the spherical elements within the lens. The manufacturing technique for grinding lens elements with a non-spherical surface does not lend itself very well to mass production, and aspheric lenses are, therefore, comparatively expensive. Their main users are photographers who have to take technically excellent pictures in poor lighting conditions, and who, therefore, require a lens with a large maximum aperture and which will perform very well even when used at that aperture. Typical applications are news and sports photography.

The other inherent defect of lenses which gives the lens designer acute problems is chromatic aberration which, as we have seen, is an inability of the lens to bring light of different colours to a common focus. This is caused by the refractive index of glass being different for light of different wavelengths and, therefore, of different colours. This variation of the refractive index with wavelength of light is known as dispersion, and is responsible for the ability of a prism to split white light into its constituent colours to produce a spectrum. However good the design of a lens made only with elements of optical glass may be, some residual amount of chromatic aberration is unavoidable. This residual aberration is known as the secondary spectrum, and its magnitude is proportional to the focal length of the lens. Consequently secondary spectrum chromatic aberration is

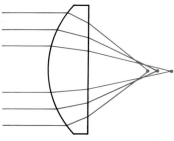

Light rays passing through a spherical-surfaced lens near its axis are brought to a different focus from those passing through near its perimeter. This is the lens defect known as spherical aberration.

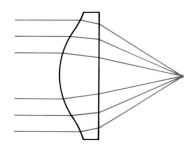

Spherical aberration can be eliminated by making the surface of the lens aspherical, i.e. not spherical. Expensive lenses of particularly large maximum aperture (f1.4 or larger) often contain one element with an aspherical surface which cancels out the spherical aberration caused by the other elements of the lens.

an especially disturbing problem in the design of lenses of particularly long focal length. It can be considerably reduced, however, by incorporating in the lens one or more elements made from a material other than optical glass. Of the several materials which are potentially suited to this purpose, calcium fluoride is the most suitable. It has a very low dispersion and is mechanically strong enough to withstand the machining processes to which the artificially grown crystals are subjected in the course of grinding and polishing them to produce lens elements. Lenses incorporating some elements made of calcium fluoride are known as 'fluorite' lenses, and exhibit an almost total freedom from chromatic aberration. Because calcium fluoride is not so hard as glass, and can be scratched comparatively easily, it is not suitable for use as the exposed front and rear elements, but only for those which are internal and normally inaccessible to the user.

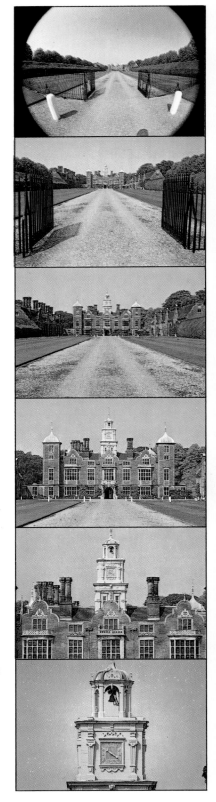

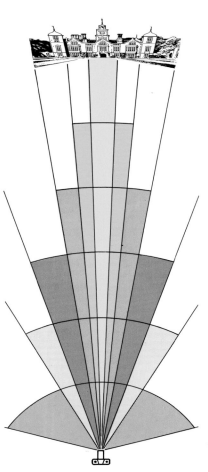

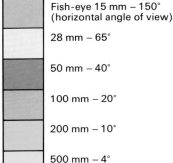

Fish-eye 15 mm – 150°
(horizontal angle of view)

28 mm – 65°

50 mm – 40°

100 mm – 20°

200 mm – 10°

500 mm – 4°

The relationship between the focal length of the camera lens and the size of the camera film plane determines the angle of view of the camera and hence the amount of the subject included in the photograph.

The pictures, right, were all taken on a full-frame 35 mm camera from exactly the same viewpoint, using lenses ranging from a very wide-angle 'fish-eye' to a long focal length telephoto.

The result has been to change only the amount of the subject included within the frame. Perspective and the relative positions of near and distant objects have remained unchanged. With the exception of the picture taken with the fish-eye, which shows the characteristic distortion produced by these lenses, each picture could well be an enlargement of the one preceding it.

These pictures of Blickling Hall, North Norfolk, were photographed by kind permission of the National Trust, a charity, Britain's largest conservation society.

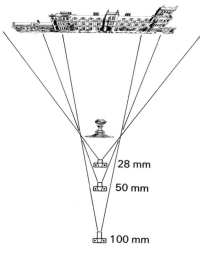

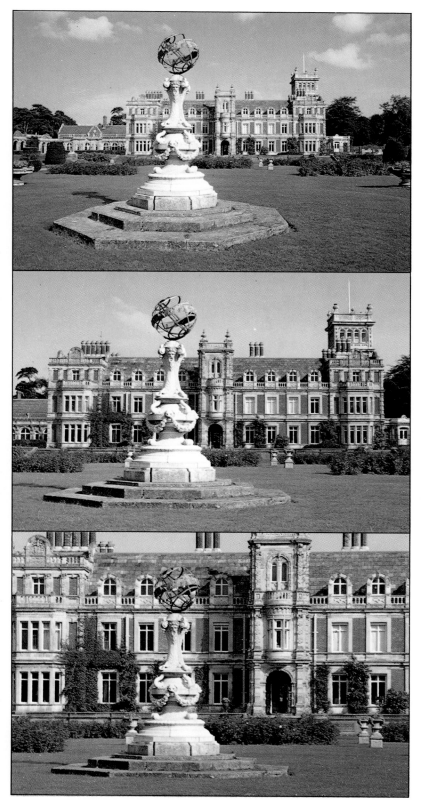

The pictures, left, and diagram, above, show how by changing both the focal length of the camera lens and the camera position the photographer can influence the relative image sizes of his foreground and background subject matter.

The top picture was taken with a 28 mm wide-angle lens on a full-frame 35 mm single-lens reflex camera. A mental note was made of the area which the statue in the foreground occupied in the viewfinder frame.

The middle picture was taken with a 50 mm lens, the camera having been moved back to a position from which the statue occupied the same area in the frame as it did in the picture taken with the 28 mm lens. Although the statue has remained approximately the same size, the house now appears larger in relation to it.

The bottom picture was taken with a 100 mm lens, the camera position again having been moved back to obtain the same image size of the statue.

Notice how the 28 mm lens/camera position has given the impression of a large distance between the statue and the house, while in the picture taken with the 100 mm lens the distance has been compressed, the statue appearing to be only a few steps from the entrance. *These pictures of Somerleyton Hall, Suffolk, were photographed by kind permission of The Lord Somerleyton.*

Camera and subject movement

In addition to incorrect focusing of the lens, which has already been discussed in the section on depth of field, the most likely cause of unsharp photographs is movement of the image in relation to the film during the exposure. Theoretically, there must be no movement of the image at all if the maximum resolving power of the lens/film combination is to be realized. In practice, however, such an ideal is usually unattainable, and some loss of resolution due to image movement is almost inevitable. If the movement is only very slight the resultant degrading of the image may not in fact be great enough to be noticeable, in more extreme cases it may show as a blurring of the image in the direction of the movement. To what degree this blurring is acceptable in a picture depends on the amount the negative or transparency is to be enlarged, the distance from which the enlarged result is to be viewed, the nature of the subject, and the purpose of the photograph. A picture taken as an informative record of the subject, every detail of which must be clearly visible, will obviously be less tolerant of camera shake than a picture taken purely for artistic reasons, for which some degree of unsharpness may be acceptable or, as we shall see later, even desirable.

There are two possible causes of image movement during the exposure. One is movement of the camera relative to the subject and the other is the opposite, movement of the subject relative to the camera. While the ultimate effect of both is the same – unsharpness of the image – they must be considered separately, as the measures required to control them are very different.

Movement of the camera

Unwanted movement of the camera relative to the subject is known as camera shake, and usually, although not always, is the result of the photographer's inability to hold the camera absolutely steady while the exposure is made. The effect of camera shake can be kept to a minimum by the use of as fast a shutter speed as possible. (If the camera is assumed to be moving at the time of the exposure, then obviously the longer the exposure the further the image will move across the surface of the film, and the more unsharp the resulting picture will be.) It is impossible to devise any hard and fast rules as to what is the slowest shutter speed possible before the effects of camera shake become noticeable, as the ability to hold a camera steady varies from person to person, and even may not be consistently the same for a particular individual, varying according to his physical condition. One is much less likely to hold the camera absolutely steady after vigorous exercise, for example (this should be borne in mind when the taking of a picture entails a brisk walk to reach the desired viewpoint). As a guide, however, pictures taken with a standard lens, with the camera hand-held, should be exposed at a shutter speed of 1/125 second or faster. If the lens is of longer

Movement of the camera during the exposure results in a general blurring of the picture.

focal length than the standard the shutter speed must be increased
accordingly. The reason for this is obvious if one considers an
example of pictures taken with two cameras, one equipped with a
lens of standard focal length, say 50 mm, and the other with a
medium telephoto, say 100 mm. If both cameras are subjected to the
same amount of camera shake, i.e. the angular velocity of their
movement at the moment of exposure is the same, they will both
move through the same angle in a given time. The angle of view of
the 100 mm lens is only half that of the 50 mm lens, however, and
consequently for the 100 mm lens the proportion of the angle of
view which the angle of movement represents will be double that for
the 50 mm lens, and the effect of the camera movement on the
sharpness of the result will be twice as great.

A very light camera is usually more prone to camera shake than a
heavier one, and therefore may require the use of a higher shutter
speed. The reason for this is that the lighter an object is the lower is
its inertia, and the less is the force required to move it.

The way in which a camera is held and the shutter release pressed
has a considerable bearing on the amount of camera movement likely
at the moment of exposure. The position of the photographer's
hands on the camera body is to some extent dictated by the physical
shape of the camera and the positioning of its controls, but the
photographer should experiment to find the position which gives the
most comfortable hold, with the camera well balanced in the hands,
and yet allows easy access to the controls. The camera should be
held firmly, but not gripped so tightly that the muscles which
control the hands and fingers are unduly tense, as this in itself can
cause slight involuntary movements which may jerk the camera.
Ideally, the photographer should adopt a stance in which all parts of
his body are as comfortable and relaxed as possible, as any tenseness
will increase the likelihood of camera shake. In practice the choice of
camera viewpoint often requires the photographer to adopt an
uncomfortable position. However, there often may be alternative
configurations of the body which allow the same viewpoint to be
achieved in more comfort than others. When photographing from a
low viewpoint, for example, it is usually best either to find a suitable
object to sit on – some photographers prefer a rigid equipment case
because it can be used for this very purpose – or to adopt a kneeling
position. Both these positions are preferable to sitting on the heels
and balancing on the balls of the feet, a position in which it is
usually difficult to maintain balance. When taking pictures from a
low sitting position the knees can often be used to provide support
for the elbows, further increasing the rigidity of the body.

When the moment to take the picture arrives the shutter release
should be pressed gently and with a smooth action. Jerking the
release button will also jerk the camera.

Often the optimum moment for taking a picture lasts only a brief
moment, e.g. when photographing children or animals. If the
shutter release is partially depressed as soon as the ideal moment
seems imminent it will only need to be pressed a small distance
further to fire the shutter when the moment arrives (a few

experiments with the unloaded camera will soon show just how far the release button can be pressed without actually firing the shutter). By adopting this technique the photographer can fire his shutter sooner, and with less likelihood of camera shake, than he could if the release had to be depressed through the full extent of its travel.

When the shutter speed required for a picture is longer than that at which the camera can be hand-held without risk of camera shake, some other means of support, such as a tripod, must be employed. When purchasing a tripod the one selected should be as solid and rigid as possible, within the restrictions of cost and portability. For most applications rigidity is of greater importance than maximum height, and if some trimming of one's ideal specification is necessary to keep the price below the chosen limit, then height should be sacrificed before rigidity. Most very lightweight tripods are too flimsy to be of much benefit and, as we shall see later, in certain circumstances may even be detrimental to picture sharpness.

To gain the maximum possible benefit from the use of a tripod, particularly when the shutter is set to 'B' or to one of the slower speeds, the shutter should not be fired in the usual manner, as the pressure of the finger on the release button will almost certainly jar the camera and result in an unsharp picture. Instead, a cable release should be used, the flexibility of which will prevent any unwanted movement from being transmitted to the camera itself. Cable releases are available in various lengths, but to ensure sufficient

The pictures, below, show various ways of holding the camera. Of the four positions shown in the upper pictures only the three to the left are likely to lead to sharp results. The position shown in the extreme right-hand picture is very unstable and is likely to give rise to camera shake. The lower pictures show how additional support for the camera can be provided by a convenient fence or wall, either by holding the camera directly on or against the chosen surface or by resting the camera on a small bean-bag or cushion.

flexibility one with a length greater than about 20 cm should be chosen.

When the subject is so static that the precise moment at which the picture is taken is not critical, the camera's delayed action mechanism can be used instead of a cable release. Any movement induced by actuating the delay mechanism will have died away by the time the shutter actually operates.

Unsharpness due to camera movement is not always the result of the photographer's inability to hold the camera still during the exposure. Sometimes it is caused by the normal operation of the camera's internal mechanism itself jarring the entire camera. On cameras with between-lens shutters this problem is usually not sufficiently acute for its effects to be noticeable, as the moving parts of the shutter are so light that the vibration they cause is only very slight. The moving parts of the focal plane shutter of an SLR camera are much heavier, however, and travel some considerable distance during their operation. Consequently the likelihood of vibration being transmitted to the camera body is much greater. In addition, the action of the mirror as it flips out of the light path just prior to the exposure may also jar the camera. Most SLRs incorporate damping mechanisms which absorb most of the mechanical shock produced by mirror and shutter. Any residual vibration is usually not sufficient to be apparent on most pictures, but may be noticeable when telephoto lenses of particularly long

The double image in this picture, taken with a telephoto lens, is due to vibration caused by the mirror flipping out of the light path immediately prior to exposure.

The illustrations below show a variety of camera supports. The two left-hand pictures show a tripod with a facility for reversing the centre column to allow the camera to be mounted underneath for taking pictures of objects close to the ground such as flowers. The legs have two stages of extension and provide a maximum camera height of about 7 feet/2·25 m.

The picture, upper centre, shows a 'table-top' tripod for close-up work.

The three remaining pictures show a multi-purpose device which can be used as a table-top tripod, or can be screwed into a suitable wooden surface, such as a tree trunk or fence post, or can be clamped to a convenient object.

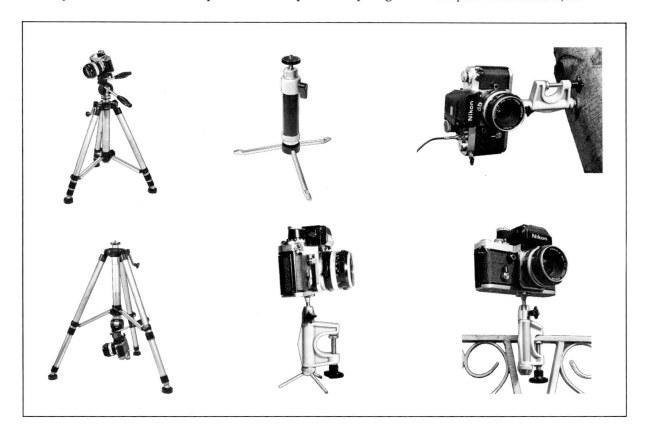

focal length are used, or when photographs are taken at relatively large magnification factors, such as are encountered in extreme close-up photography and photomicrography, when the effect of any vibration will also be considerably magnified. Many SLRs have a 'mirror lock' facility, whereby the mirror can be raised to the 'up' position prior to operating the shutter release, thus eliminating the mirror as a potential cause of camera movement. Obviously this facility can be used only on static subjects, and with the camera rigidly supported by a tripod or other means, as the viewfinder is blacked out by the raising of the mirror.

When an SLR is used on a very lightweight tripod it is possible that any vibration of mirror or shutter may have a *more* detrimental effect on picture sharpness than if the camera had been used hand-held. This is because the tripod may resonate with the vibration, amplifying the camera movement, whereas holding the camera by hand may dampen the vibration and reduce the movement. This does not imply that the camera should be used hand-held, however, as camera shake due to the photographer's movements may then result, but rather that a sturdier tripod should be used.

The efficiency of the damping mechanism in suppressing mirror or shutter vibrations varies according to the make and model of the camera and, as might be expected, is usually better the more expensive the camera is. Two differently priced models from the same manufacturer may show markedly different vibration characteristics, a point not usually mentioned in the advertising literature for the cheaper model. This should be borne in mind when deciding which model to purchase, particularly if the camera is expected to be used with very long telephoto lenses or for photomicrography or any other applications involving high magnifications.

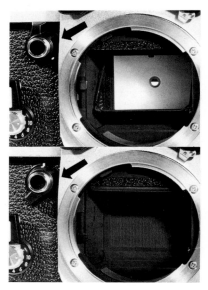

A camera with a mirror-lock control (arrowed).

Movement of the subject

The effects of movement of the subject relative to the camera are identical to those of movement of the camera in so far as both produce a movement of the image across the surface of the film which is a potential cause of loss of picture sharpness. The degree of unsharpness is dependent on the shutter speed in use and the rate at which the image traverses the film. However, while unsharpness due to camera shake is nearly always undesirable, this is not always the case with unsharpness due to subject movement – indeed in many instances a controlled amount of blur is necessary if the picture is to convey an impression of the subject's movement.

Pictures which do require the subject to be as sharp as possible must be taken with as fast a shutter speed as possible, bearing in mind that a faster shutter speed will require a larger aperture, with a consequent reduction in depth of field. For many subjects a small depth of field may not be acceptable, however. A close-up picture of flowers which are being blown in the wind, for example, requires the use of a fast shutter speed to 'freeze' the movement of the flowers and yet needs a fairly small aperture to obtain sufficient depth of field. With many subjects the only way to meet the conflicting

For this picture, taken on a 35 mm SLR camera with a 135 mm lens, a shutter speed of 1/1000 second was used to completely arrest the movement of the subject.

requirements of depth of field and the freezing of movement is to use a film of higher sensitivity, even though the image quality will then suffer to some extent due to the larger grain size of the faster film.

Many sports involve movement which is not continuous, but has brief moments when the subject is almost stationary. In the pole vault, for example, the competitor's speed of movement at the top of his trajectory is small compared with the speed of his ascent and descent. Although this is an extreme example, many other sporting activities have similar moments. By taking his pictures precisely at these moments the photographer can obtain sharper results than would be possible when the action is at its fastest.

The actual shutter speed necessary to arrest the subject's movement depends not only on the rate at which the subject is moving, but also on the direction of its travel relative to the camera. If the subject is moving towards or away from the camera the image movement on the film will be less than it would if the subject was moving directly across the field of view, and a slower shutter speed can be used.

Although sports pictures of the type published in newspapers and magazines to illustrate major sporting events are excellent in so far as the photographer has caught the action at just the right moment, and the pictures are so sharp that all the details of the subject are clearly visible, the very crispness of the image often prevents the picture from conveying any great impression of speed.

For pictures in which overall sharpness is of less importance than giving the picture an impression of movement, a slower shutter speed can be used to introduce a controlled amount of blur. There are two methods of operation, both of which record the movement in a different manner. One is to keep the camera quite still and to allow the subject to pass before it, and the other is to swing the camera, following the moving subject in the viewfinder as it passes. The first method – keeping the camera still – will record the background sharply, with the moving subject appearing blurred. This technique has very limited applications, an example being the illustration of the moving subject's intrusion into an otherwise peaceful scene, e.g. a picture taken to illustrate the disruption of normally peaceful village life by the thundering of lorries through the main street. The second technique – swinging, or 'panning', the camera with the subject – is the more common. The subject is recorded fairly sharply against a blurred background. Most of the detail of the subject itself is clearly visible, and the blurred background provides a good impression of speed and also serves to concentrate the viewer's attention on the subject. Panning is best suited to the photography of subjects which travel along a fairly straight and predictable course, such as motor racing, cycling, running, etc. The subject should be observed through the viewfinder as it approaches, and the camera should be panned in a smooth swing, keeping the subject always in the same area of the frame. It may be helpful to make a mental note beforehand of the point in the subject's path at which the picture is to be taken, and to focus the camera accurately on this

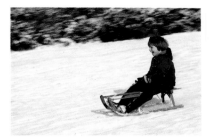

This picture was taken at a shutter speed of 1/125 second. By panning the camera with the boy as he passed, he and his sledge have been recorded sharply, while the snow and background have recorded as a blur, giving a good impression of speed.

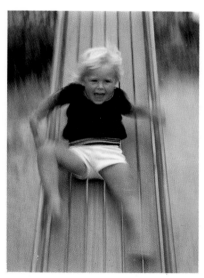

For this picture the camera was panned with the little boy as he sped down the slide. A very slow shutter speed (1/8 second) was used, and the resulting blur has given a very good feeling of the boy's speed and exhilaration.

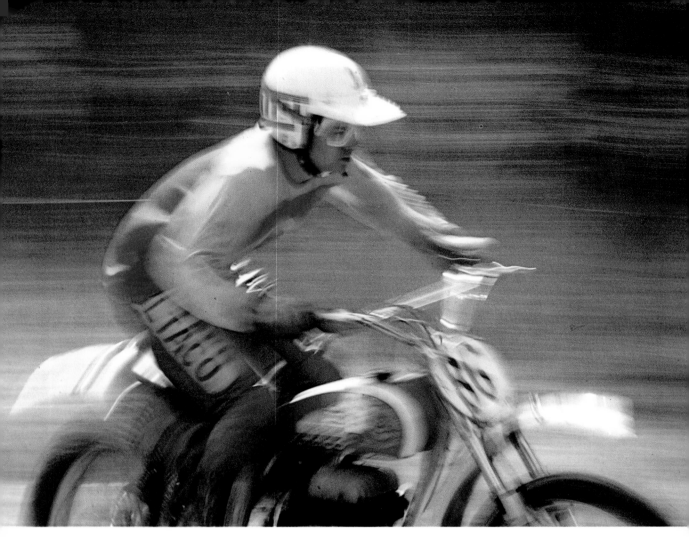

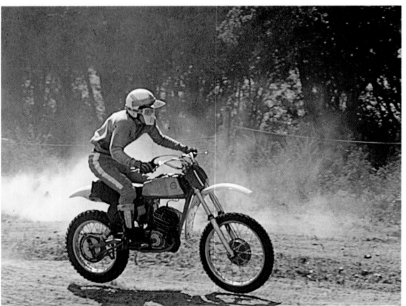

When photographing moving subjects, the choice of shutter speed and whether to keep the camera still or pan it with the subject will determine the way in which the feeling of movement is conveyed in the picture.

For the picture above, the camera was panned with the motor-cycle and the exposure made at a shutter speed of 1/30 second. The resulting blur on the handlebars, mudguards and the rider's arms as they absorb the ups and downs of the rough track have given the picture a sense of speed and urgency. *Canon FTb, 100 mm lens, 1/30 sec, f16, Kodachrome 64.*

The picture left was taken at a shutter speed of 1/500 second. Virtually all the movement has been frozen—even the spokes of the wheels are sharp. Although both wheels are off the ground, the picture conveys little impression of speed. *Canon FTb, 100 mm lens, 1/500 sec, f4, Ektachrome 64.*

point. When the camera is subsequently panned with the subject the release can be pressed as the subject is seen to reach the chosen point. This technique is particularly useful when the subject is approaching the camera at an angle and the lighting conditions demand the use of a large aperture with a consequent lack of great depth of field, as it is virtually impossible to adjust the focusing of the lens to continuously maintain the subject in sharp focus while the camera is being panned.

For certain types of subject a relatively slow shutter speed can often be used to emphasize the movement of certain parts of the subject more than others. If the camera is panned with a runner, for example, the image of his head and body will move less in relation to the film than will his arms and legs, which will consequently appear more blurred on the resulting picture. The motorcycle and rider, opposite top, was photographed at a shutter speed of 1/30 second, panning the camera with the subject. Those parts of the subject which are following a fairly steady course, such as the rider's head, are recorded fairly sharply, while those parts which are bouncing up and down to absorb the roughness of the track, such as arms and handlebars, are recorded as a blur. The picture of the racehorses used as the frontispiece of this book is an extreme example of this technique, and was exposed for 1/8 second while the camera was panned with the subject.

Action such as this lasts only a split-second. A moment's hesitation in pressing the shutter release and the picture is lost.

To obtain this dramatic picture the photographer positioned himself at a spot where such action was likely, and waited with his camera's focusing and exposure set in readiness.
Practika LTL, 135 mm lens, 1/250 sec, f8, Agfa CT18.

Limitations of film

Modern photographic films, particularly those for colour photography, are extremely sophisticated, both in their chemistry and their physical structure, and have arrived at their present state of excellence as a result of several decades of patient research and development. Excellent as they are, however, they do have certain characteristics which limit particular aspects of their performance to something less than ideal. It is desirable that the photographer is aware of these limitations in order that he may make allowances for them, where possible, and thus obtain the best possible result from the film he is using.

The limitations of film most likely to result in a less than perfect picture can be classified into three distinct groups – limitations of sharpness, limitations of contrast, and limitations of colour.

Limitations of sharpness

Any conventional film for normal camera use, whether black-and-white or colour, relies for the production of its image on the photo-sensitive characteristics of certain silver salts which are present in the emulsion as a suspension of crystals. The physical size of these crystals, or 'grains', limits the film's resolving power and hence its ability to record fine detail. The sensitivity of the film to light – its 'speed' – is also partly dependent on the grain size, fast films having larger grains than slow films. Because of this fast films have lower resolving powers than slow films. For most photographic work it is desirable that the grain structure of the image should not be visible on the result (although intentionally grainy pictures are sometimes taken for artistic effect). The extent to which grain is evident on the result is, of course, dependent on the degree of enlargement of the negative or transparency necessary to produce the final print or projected image, and on the distance from which the print or projected image is viewed. Pictures taken on a slow film can usually be enlarged more than can those on a fast film before the grain of the image becomes objectionable. Consequently, unless grain is specifically required for artistic effect, photographs should be taken on the slowest film possible, commensurate with there being sufficient light to obtain the correct exposure, bearing in mind the requirements of depth of field and the 'freezing' of movement.

Limitations of contrast

A modern colour reversal film designed to provide transparencies for projection usually produces, after processing, an image of which the maximum possible contrast range is about 1000:1. This means that the light transmitted by the darkest shadow area of the transparency can be typically no less than 1/1000 of that transmitted by the lightest highlight area. The exact values for a particular film are

The picture left was taken on a fast colour film using only the available lighting of the stage production. The shutter was fired at a moment when everybody was fairly still. Such moments often occur at the end of a scene or act, but one must be ready to press the camera release as soon as they happen, as they are soon gone.

The picture left, reminiscent of a French Impressionist painting, was taken to illustrate the coarseness of grain of fast colour films, and is a 24× enlargement of the area indicated by the rectangle in the picture above. The camera, a single-lens reflex on a tripod, was positioned in front of a slide projector containing the original transparency of the picture above. The camera lens was removed and the image of the original slide was projected into the camera. While looking into the viewfinder, the projector lens was focused and the camera position was adjusted to include only the required area. The exposure was determined using the camera's through-the-lens metering in the stopped-down mode (see chapter on Exposure), although with some cameras it may not be possible to use the meter accurately without the lens on, in which case a series of trial exposures would be necessary. Daylight film was used with a Wratten 80A (3200 Kelvins to daylight) filter, although film balanced for tungsten light would have given equally satisfactory results. *Canon FTb, Carousel projector with 85 mm lens, 1/500 sec, 80A filter, Agfa CT18.*

determined at the highlight end by the film's lowest possible optical density, typically 0·2, which is the combined densities of the clear film base and the fully exposed, and therefore clear, emulsion layers, and at the shadow end by the film's highest possible optical density, typically between 3·0 and 3·4, which is the density of an area in which none of the three colour layers have received any exposure at all.

$$\textbf{Note: } \text{optical density} = \log_{10} \frac{1}{\text{transmission}}$$

For a typical colour reversal film the *exposure* range which will cause maximum contrast in the processed image is only about 300:1. Consequently, if all the detail of the subject, from the brightest highlight to the darkest shadow, is to be satisfactorily recorded, the *brightness* range of the subject must fall within this value. In many instances the photographer has sufficient control over the subject and its lighting to ensure that this requirement is met. In studio photography, for example, he can adjust the position of his various lights to obtain the brightness range he requires. For subjects taken outside in bright sunshine, however, the brightness range between sunlit highlight areas and areas of dark shadow can often be excessive. When the subject is fairly small, and close to the camera, a white reflector or fill-in flash can often be used to put sufficient light into the shadow areas to reduce the brightness range to an acceptable level. If the subject is of larger proportions, such as a landscape or a building, the photographer will have little or no control over the brightness range. Because the exposure for a transparency is normally chosen so that essential detail in the highlight areas is just retained, detail in the shadow areas will fall outside the brightness range which the film can handle, and will consequently be lost. If the shadow detail is of great importance the photographer must return either at a different time of day when the

An example of a picture in which the film has been unable to handle the contrast of the subject. To the eye all the detail of those parts of the house in the shadow between roof and balcony could be clearly seen. On the film, which was exposed to just retain the essential highlight detail, this shadow detail has been lost.

important areas are not in shadow, or on an overcast day, when there are no shadows at all (although the second alternative may result in a generally less attractive picture, due to the absence of sunshine).

Unfortunately, it is difficult to assess visually whether or not the brightness range of the subject is too great for a satisfactory result to be obtained, as the human eye can handle a much greater brightness range than can the film. Detail in dark shadow areas which will be totally lost on the transparency is clearly visible to the eye at the time of taking the picture. Consequently the inexperienced photographer may not even realize that his subject has an excessive contrast range until he sees his processed film. The only way he can be fairly confident of his results at the time of exposure is to check the brightness range with a lightmeter, although with larger subjects this may be difficult unless the photographer has a meter with a fairly small measuring angle, as the areas to be measured may often be inaccessible.

The contrast problem of colour reversal films is even more acute when colour prints are to be made from the transparencies by the direct reversal method, i.e. direct from the transparency rather than via an internegative, as the direct reversal print material is often unable to handle the full contrast range of the transparency. Consequently some of the shadow or highlight detail which has been satisfactorily recorded on the transparency will be lost and will not be visible on the print. Prints from transparencies made via an internegative do not suffer from this problem to such an extent, as the internegative material has been specially designed to compress the tonal values of a transparency to a range which can be handled by the colour print material.

Colour prints made directly from colour negative film also present less of a contrast problem than do direct reversal prints from transparencies, as the colour negative film is designed to compress the tonal range of the average subject to a value which the colour

Excessive contrast may not always be detrimental to a picture. Here the exposure is correct for the distant sunlit mountains. The very dark areas of shaded forest have recorded on the film only as an area of solid black, which has given the picture a good impression of the vastness of the landscape.

print material can handle. For black-and-white photography a considerable degree of control is possible, as the print material is available in about five different contrast 'grades', which are chosen according to the contrast range of the negatives.

Modern camera lenses with multi-layer coatings are very effective in the reduction of flare. This quality is particularly valuable when photographing against the light, a notable flare-invoking situation which with older, single-coated lenses would almost inevitably produce an image of inferior quality. For the average front-lit subject, however, the small amount of flare produced by a single-coated lens is usually insufficient to be noticeably detrimental to image quality. In fact it may even be beneficial, as the effect of the flare is to reduce slightly the contrast of the image projected by the lens on to the film, thus allowing the film a better chance of satisfactorily recording the entire brightness range of the subject. It is interesting that modern multi-coated lenses, while their overall image quality is excellent may, therefore, actually aggravate the contrast problem by their almost total freedom from flare.

Limitations of colour

The colour of the light by which we view and photograph objects before us is a variable factor which must be taken into account if the colour rendering of the photographic result is to be acceptable. The colour of natural daylight varies according to the time of day and the prevailing atmospheric conditions. The colour of artificial light depends on the nature of the light source. The human eye is remarkably efficient at adapting itself to the colour of the light by which we see; so much so that unless the coloration of the light is particularly pronounced it will appear to us to be what we call 'white light', and objects illuminated by it will appear normal in colour. Colour film does not possess this remarkable ability, however, and the colour rendering of a photograph will be correct only when the colour of the light by which the picture is taken is exactly that for which the film was designed. This is particularly so with colour reversal film, where the material exposed in the camera itself becomes, after processing, the final transparency. Colour negative film is a little more tolerant, however, as a *slight* overall colour error can be corrected when the colour print is made.

Colour film is made in two distinct types – 'daylight' film for use in light of 5500 K, and 'tungsten' film for use in light of 3200 K. These figures are the **colour temperature** of the light, and indicate the temperature to which a black body must be heated in order to radiate light of the same colour. The units **K** are Kelvins, formerly known as degrees Kelvin (°K), and have the same temperature interval as degrees on the Centigrade scale, but start from absolute zero (−273 °C), e.g. 3000 °C = 3273 K.

When the colour temperature of the illumination is not exactly matched to the film it is often possible to use a colour filter, either over the light source or, more usually, over the camera lens, to convert the light reaching the film to the correct value. If the colour temperature of the light is too low, i.e. the light is too yellow, a

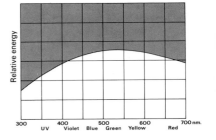

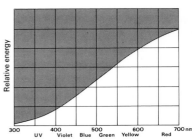

The spectral emission graphs of daylight, top, and of a tungsten filament lamp, bottom, show that daylight is much richer in blue light than is the light from a tungsten lamp, while the latter is much richer in red light than is daylight.

The statue of Hermes carrying the young Dionysus, in the museum at Olympia, Greece, was photographed on a daylight colour film under two different conditions of lighting. In the picture far left, the exposure was made using only the normal tungsten lighting of the museum gallery. The resulting picture is far too warm in colour – a more accurate result would have been obtained if a film balanced for tungsten lighting had been used. The picture left, was taken using a small electronic flash. The result is slightly blue, but the colour is much more accurate. *Far left: tungsten lighting, 1 sec, f5·6, Kodachrome 25. Left: electronic flash, f5·6, Kodachrome 25.*

This picture was taken solely by the light of the candles on the table, and no attempt was made to correct for their very yellow light. The resulting colour cast has given the picture a feeling of the warmth and intimacy of the moment. *1/4 sec, f3·5, Vericolor S film.*

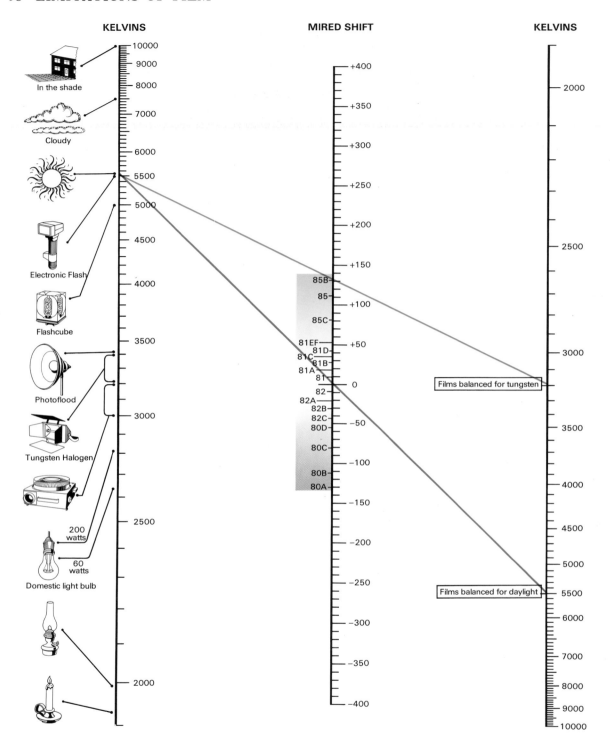

A nomograph for finding the colour conversion filter required for a particular light source/film combination.

A straight-edge placed between light source (left-hand scale) and film type (right-hand scale) indicates the colour and type number or mired shift value of the required filter at the point at which it intersects the centre scale. Two examples are given. The red line shows that when a film balanced for daylight is used in bright sunlight no filter is required, and the blue line shows that when a film balanced for tungsten lighting is used in sunlight an 85B filter is needed.

bluish-coloured filter must be used, if it is too high, i.e. too blue, a yellowish filter is required.

Filters specifically designed for colour temperature conversion are available in several strengths, and are given a code number by the manufacturer. This number usually does not by itself directly indicate either the strength or colour of the filter, this information being specified by the manufacturer as a **mired shift value**. The mired (**mi**cro **re**ciprocal **d**egrees) scale is another way of indicating colour temperature, and bears the following relationship to the Kelvin scale:

$$\text{mired value} = \frac{1,000,000}{\text{colour temperature in Kelvins}}$$

Note that the higher the colour temperature is on the Kelvin scale the lower is its mired value.

The mired shift value of a filter indicates by how much the filter will shift the colour temperature, in mireds, of the light passing through it. The shift value will be either positive or negative, depending on the colour of the filter. Yellowish filters have a positive mired shift value, as they increase the mired value of the light passing through them and, therefore, reduce the colour temperature in Kelvins, while bluish filters have a negative value, reducing the mired value and, therefore, increasing the colour temperature in Kelvins.

The concept of indicating the colour of a light source as the temperature of a black body radiating light of the same colour is only valid when it is applied to a light source which emits a continuous spectrum, i.e. it radiates energy at *all* the wavelengths of the visible spectrum. The only light sources which fully comply with this requirement are those in which the light is produced by the incandescence of some heated material. Examples of such light sources are the sun, the candle, the oil lamp, and electric lamps which use a heated filament as the source of light. Electric lamps which produce light by the discharge of electrical energy through a gas have spectral emission curves varying from a series of intense but disconnected peaks, of which the position in the spectrum is dependent on the actual gas within the lamp, to a continuous spectrum on to which similar peaks are superimposed (see diagrams). Discharge lamps cannot be given a true colour temperature value, as a heated black body could never emit a light of exactly the same spectral distribution. The colour of some discharge lamps can be indicated by quoting an *equivalent* colour temperature, which is the temperature of a black body emitting a light which, to the eye, *appears* to be of identical colour to the light emitted by the lamp in question.

Discharge lamps with pronouncedly discontinuous spectra, such as mercury vapour and sodium lamps, in which many wavelengths are completely absent, are totally unsuitable for colour photography. Some of those for which the spectral emission curve consists of disconnected peaks superimposed on a continuous spectrum are suitable, however, although fairly heavy colour filtration is often

The spectral emission graph for a mercury vapour lamp shows that its output consists mainly of intense but disconnected peaks and that it is therefore unsuitable for colour photography.

required. Electronic flash tubes are xenon-filled discharge lamps, and are particularly suitable for photography, as their colour balance is almost exactly right for use with colour film balanced for exposure to daylight. A small amount of filtration, usually yellow, may be required when colour accuracy is of great importance (often the required filter is incorporated in the flash equipment by the manufacturer, either as a yellow tint in the transparent plastic protective shield or as a yellow coating on the flash tube itself).

Fluorescent lamps are basically mercury vapour lamps with a phosphor coating on the inside of the tube. Ultra-violet light emitted by the electrical discharge through the tube causes the phosphor coating to fluoresce, converting the energy into visible light of wavelengths which partially compensate for the colour deficiencies of the basic mercury vapour lamp.

To the eye the light emitted by most fluorescent lamps is entirely acceptable. The effect on colour film is rather unpredictable, however, and unexpected colour casts may result. This is because the spectral *sensitivity* curve of a colour film is considerably different from that of the eye. The eye has a sensitivity which is substantially even throughout the visible spectrum, whereas the sensitivity curve of the colour film consists of three distinct but overlapping curves, each of which represents the spectral sensitivity of one of the three individual colour-sensitive layers. The relationship between the positions within the visible spectrum of these curves and of the peak emissions of the fluorescent lamp determines how the colour film will respond to the light. The sensitivity curves of different makes of film may fall in slightly different places, even though they are balanced for light of the same colour temperature; consequently they may respond differently to light from the same fluorescent lamp. Even different types of film from the same manufacturer may give differing results. Unless preliminary tests have been made, the only way of ensuring a reasonably accurate colour balance with a particular fluorescent lamp/film combination is to take some test pictures, have them processed and assess the results, and then return to re-take the pictures, this time equipped with the colour filter indicated by the test results as necessary to achieve a satisfactory colour balance. Often this is the only possible method of working when photographing in an unfamiliar setting, as it is frequently difficult to discover the type of lamp being used. Although the tubes are marked with their type, they are often in an inaccessible position or concealed within a decorative fitting which prevents their markings from being seen.

Colour temperature meters are available for assessing the colour quality of light sources to be used for photography. The prospective purchaser of such an instrument should be aware of certain limitations of their performance, however, as under certain circumstances some types are far more accurate than others.

The simplest colour temperature meters and, therefore, usually the least expensive, measure the relative amounts of red and blue light in the illumination. They do this either by taking simultaneous readings with two photo-cells, one covered by a red filter and the

The spectral emission graph of a 'Northlight' fluorescent tube.

The spectral emission graph of a 'White' fluorescent tube.

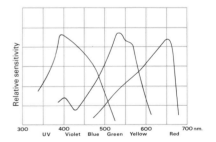

The spectral sensitivity graph of a typical colour reversal film. Note the distinct, but overlapping curves of the blue-sensitive, green-sensitive, and red-sensitive layers.

other by a blue filter, or by using a single photo-cell to take readings through red and blue filters in succession. The relative amounts of red and blue light are indicated by a galvanometer, the scale of which is calibrated in colour temperature.

The accuracy of colour temperature meters of the above type relies on the validity of the simple assumption, on which their mode of operation is based, that colour temperature can be assessed by measuring the relative intensities of the illumination at the two ends of the visible spectrum only. The meter makes no allowance for the intensity in the middle of the spectrum, i.e. for the green content of the light, but assumes it to be midway between the intensities of the red and blue. While this assumption is satisfactory for light sources which emit a continuous spectrum, with which a meter operating on this principle will give reasonably accurate readings, it is not valid for lighting with a discontinuous spectrum, for which the meter may not give a correct reading. To predict accurately the effect of such lighting on a colour film an ideal colour temperature meter would have three photo-cells, filtered so that their spectral sensitivities exactly match the sensitivities of the three colour-sensitive layers of the *actual* make of film on which the photograph is to be taken.

In practice, while the better quality, more expensive colour temperature meters do take readings through red, blue and green filters, their spectral sensitivity is only an approximation to that of a *typical* colour film. Consequently their accuracy when used with fluorescent lamps or other lighting with discontinuous spectra, although much superior to that of a meter which reads only red and blue, may be a little less than perfect, and will vary slightly according to the characteristics of the specific film in use. Nevertheless, their accuracy is such that a picture taken using a filter selected according to the indicated reading, while probably not absolutely correct for colour, is usually quite acceptable for most purposes.

Colour problems caused by differences in spectral sensitivity between eye and film are by no means restricted solely to instances where their presence is due to peculiarities of the light source. Often the subject itself has certain colour qualities which cause it to be reproduced on film differently from its appearance to the eye. A particular example of this occurs when photographing certain blue flowers, such as those of the Gentian and Morning Glory. Although

The same scene photographed with different combinations of fluorescent tube and film types.
From left to right:
1. 'Warm White', Kodachrome 64.
2. 'Colour Matching', Kodachrome 64.
3. Philips 'Colour 32', Kodachrome 64.
4. Philips 'Colour 34' Kodachrome 64.
5. Philips 'Colour 34' Agfa CT18.
Note that for pictures 4 and 5 the fluorescent tube is the same but the film is different. Although both films are designed for daylight they have recorded the colours of the subject quite differently.

A high quality colour temperature meter of the three-cell type.

they appear blue to the eye, these flowers record on some colour films with a pinkish hue. This is because they strongly reflect light at the very extreme of the red end of the spectrum, which is almost invisible to the eye, but to which some films are still relatively sensitive.

In addition to the problems arising from the spectral *sensitivity* characteristics of the film, colour errors can also be caused by the *transmission* characteristics of the dyes which make up the final image on the processed transparency or colour print. As we have already seen (p. 47) the colours of the subject are re-created in the photographic image by the subtractive colour mixing of only three basic colours – yellow, magenta and cyan. Certain limitations of this process and of the colour purity of the individual dyes make it impossible for the dye image to achieve an exact facsimile of the original subject colours, with some colours being reproduced less faithfully than others. Although the resulting colour error is quite acceptable for many purposes, there are some fields of photography where colour accuracy is of the greatest importance. Colour errors in a transparency taken for an advertisement for a new fabric or wallpaper, for example, may cause considerable difficulty to the printer who is called upon to reproduce the picture in a magazine or catalogue and is also expected to achieve an excellent colour match of the actual product.

Reciprocity failure

We have already seen (p. 64) that under normal circumstances the response of a photographic emulsion to light is such that the two controlling factors of an exposure, i.e. duration and intensity, are inversely proportional to one another, so that if, for instance, one factor is doubled the other must be halved if correct exposure of the emulsion is to be maintained. This relationship, known as the **reciprocity law**, may be stated as the equation $E = I \times T$, where E = exposure amount, I = light intensity at the film, and T = exposure duration. However, when the exposure is very long, such as is required in dim light, or when it is very short, such as when using high-speed electronic flash, the film is no longer able to comply with the reciprocity law and, unless more exposure than that calculated is given, under-exposure of the film will result. This shortcoming of the film is known as the film's **reciprocity law failure** (usually abbreviated simply to 'reciprocity failure'). It presents no great problem with black-and-white film, and can usually be adequately compensated for by suitably increasing the exposure duration. With colour film the problem is somewhat more complex, however, as the reciprocity failure may be different for each of the three colour-sensitive layers of the emulsion. If it is not compensated for, reciprocity failure will result not only in a general under-exposure of the film but also in the appearance of an unwanted colour cast. The actual colour of the cast caused by extra long exposures is different from and usually opposite to that of the cast caused by very short exposures. For many applications such colour casts can be prevented by the use of a suitable filter, placed

Top: How the 'Morning Glory' appears to the eye.
Bottom: How it records on some colour films.

The stained-glass window was photographed on two different types of daylight colour film under identical lighting conditions. In the right-hand picture, the yellow area surrounding the figure has photographed fairly accurately for colour but the blue robe has become dark and degraded. In the left-hand picture the robe has photographed much nearer to its true colour but the yellow areas have become too warm. Neither film has recorded all areas of the subject correctly.

Often it is only necessary for the colours in a picture to be pleasing. If they are not an exact match of the colours in the original subject it is of little consequence. However, in advertising photography colour fidelity is often of prime importance. Consider, for instance, a textile manufacturer who has produced a new range of coloured fabrics. He will require the colours of his product to be accurately reproduced in his advertising literature. Due to the limitations of available colour films the photographer will often have to be satisfied with transparencies in which only some of the colours are correct, and during the reproduction process it will usually be necessary for the printer to have samples of the actual fabric in order to correct certain colours to achieve a more faithful result.

over the camera lens and selected, according to the duration of the exposure, from information supplied by the film manufacturer. Difficulties can arise, however, when the film is exposed by mixed lighting, as might occur when an interior scene is illuminated mainly by the daylight coming through the windows, but with any particularly dark areas assisted by electronic flash. The exposure duration required for the daylight may be several seconds, while the fill-in exposure provided by the flash may be in the order of only 1/1000 second, or even less if a 'computer' flashgun is used. Depending on the precise exposure durations, reciprocity failure may occur with both illuminants. Even when both illuminants are of the same nominal colour temperature they may each be recorded with a different colour cast. There is no easy solution to this problem, as the use of a filter over the lens to correct the cast caused by one illuminant will equally affect the other, and any colour difference between them will be maintained. Ideally, the required filter should be determined for each illuminant and placed over the actual light source, although this is usually impossible to achieve in practice, due to the physical size of the filter required. Fortunately the latest colour films are much more tolerant of long and short exposure durations than were their predecessors, and reciprocity failure is usually minimal provided the manufacturer's recommendations for their use are not exceeded.

Composition

Photography may be regarded as a highly efficient means for the communication of information. Often this communication is directly between the photographer and the person who views his pictures, although in many instances it is between some other person and the viewer, with the photographer acting only as an intermediary. The nature of the information and the manner in which it may be conveyed covers a very broad spectrum, and is dependent on the characteristics of the subject and the purpose for which a particular picture is to be used. At one end of the spectrum are those pictures which are taken purely as a visible record of the subject. Photographs which illustrate a technical text book or a catalogue, for example, are often intended only to communicate to the reader factual information about the subject which it would be difficult or even impossible to convey by words alone. Usually such pictures are specially taken to reveal precisely the information which the author of a book or the manufacturer of a product wishes to pass on to the reader or prospective purchaser. In such instances the saying that a single picture is worth a thousand words is particularly appropriate. Record pictures of this nature often have little or no *artistic* merit,

In some respects the camera is to the photographer what paint and brushes are to the artist – a means of recording what he sees before him. There is, however, one great difference between the two media. The artist can use a certain amount of licence, and if painting the river scene, below, for example, can paint the foreground boats in whatever position he feels best suits the composition of his picture. The photographer has no such freedom, and can only record things as they actually are at the moment he presses the shutter release. If he wants a boat in the foreground he must wait until one comes along, or even arrange for someone to row to the desired position.

although they may well be technically excellent in that the exposure, lighting and the depth of detail they reveal have all been adequately controlled.

At the other end of the spectrum are those pictures which are intended to convey a much more subtle message, often not concrete factual information at all, but more of an abstract feeling or mood. The subject matter for such pictures may often be the most simple and unremarkable of objects, which most of us would pass by without a second glance. The artistic and creative photographer will see qualities in such objects which he may wish to record pictorially, and he will use his skills and talent to select the viewpoint and lighting which will best impart these qualities to the image he produces. The resulting picture is thus the photographer's own personal interpretation of the subject. Another person may see the same subject in a completely different way and may, therefore, create an entirely different picture of it. The photographer who produces pictures of this nature may be likened to the oil painter or water colourist, or indeed to almost any other artist. To him the camera is no more than the tool by which he commits his feelings and emotions to paper, and the technicalities of adjusting aperture, shutter speed and focusing are to him the same as, say, the oil painter's choice of the manner in which he applies his paint to the canvas.

Many photographic books and magazines have a tendency to concentrate very fully on the aspects of photography as an art form, aiming to instruct their readers in the taking of photographs for no specific purpose other than personal expression or as an exercise in artistic design. Lucky is the photographer who can devote all his time to the creation of such masterpieces, however. In practice, the majority of photography is involved to some degree in the recording and illustration of factual information, although an artistic approach to the subject is often desirable, as in fashion photography, for example. Consequently the nature of most photographs must of

The photographs on this page convey little factual information, nor are they intended to.

The composition of the picture of the arches is based on the repetition of a simple shape, and the pictures of the drain and the seat in the snow are just pleasing, almost abstract designs.

The remaining picture conveys a feeling of the isolation of the little house, a feeling which has been heightened by the choice of its position within the picture area, and by the almost total elimination of any tones intermediate between white and black.

necessity fall somewhere midway between the two extremes outlined in the previous paragraphs. The really successful photographer is one who can choose his viewpoint and lighting not only to reveal clearly all the required detail of the subject, but also to combine the subject elements – lines, shapes, areas of tone or colour – in such a way that the resulting photograph is artistically pleasing and satisfying to the eye.

Composition: the basic rules

The newcomer to photography, with little or no artistic training, may often find himself at a total loss about how to arrange, or 'compose', the various elements of his subject within the camera viewfinder to obtain the most aesthetically pleasing picture. By using the basic rules of composition outlined below he will gradually acquire the feel of composition and of what makes a well-balanced picture. Once experience has been gained the rules may be regarded only as guide lines, however, to be broken whenever circumstances demand it. If every photograph ever taken adhered rigidly to the rules of composition, books and magazines would be filled with a monotonous succession of pictures, almost uniform in design, and photographers would be unable to develop their own individual styles. In practice, many superb examples can be found of pictures in which the photographer has intentionally broken the rules to great effect. They should not be broken just for the sake of it, however, but only when the message or information conveyed by the picture will be emphasized or enhanced by so doing – it usually takes an experienced eye to recognize such a situation instinctively.

The first, and the most commonly quoted, rule of composition states that the main centre or centres of interest in a picture should be positioned on or near an intersection of thirds (see diagrams). The second rule states that some other element of the picture should lead the eye towards the main subject. In addition, the main subject or at least a part of it should contrast, either by virtue of tone or colour, with the background.

An example of a picture which complies with all three basic rules of composition. The main subject, the figure, is at an intersection of thirds, the river and the railings lead the eye towards the subject, and the subject contrasts well with the background.

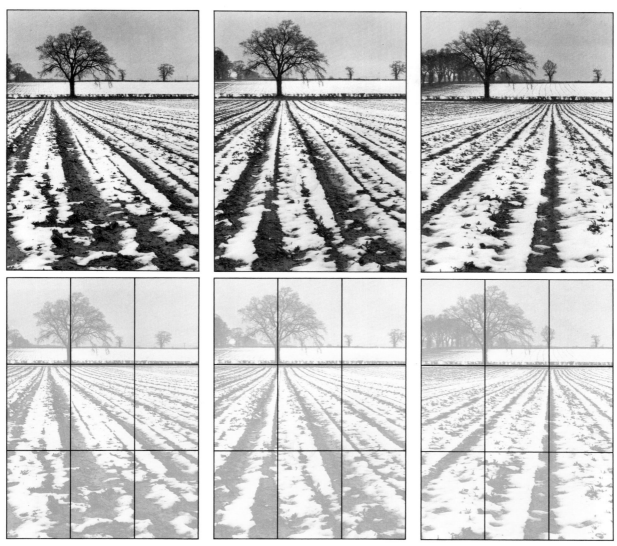

The ease with which the photographer is able to implement the above rules is totally dependent on the nature of the subject. In some instances, such as in still-life photography, he has total control, and can physically move the various components around at will until he achieves his desired result. Similarly in portraiture he is able to control the position of his model, and when photographing in domestic room settings he can often move furniture, vases of flowers, etc. In landscape photography, however, he usually has little or no control over the *actual* physical position of his subject matter. It is here that the painter has a considerable advantage over the photographer, as he can use a certain amount of 'artistic licence', painting the scene as he would like it to be, rather than as it actually is. The photographer, however, has to accept that he cannot physically move a church or a tree to improve the composition of his picture. What he can do is to move himself and his camera in relation to the subject matter until he finds a viewpoint from which

These pictures show how small changes in viewpoint considerably alter the balance of a picture. In each illustration the main feature, the large tree, lies roughly at an intersection of thirds.

In the picture, left, the viewpoint is such that the furrows lead the eye to the edge of the picture, which is consequently very unbalanced.

The centre picture is better, the furrows leading the eye towards the main feature, but even so the main weight of tone is to the left of the picture, which therefore still appears unbalanced.

In the picture, right, the furrows lead to a secondary point of interest, the more distant tree, and the balance of tone and picture is much improved.

In the picture, left, the inclusion of the punt in the foreground has considerably helped the composition. Note that the angle of the punt and that of the waterline of the red-brick building are similar, both leading the eye into the picture.

the *apparent* positions of the subject elements relative to one another are such that a satisfactory composition is attained.

Often the choice of viewpoint for a picture is the most important decision the photographer has to make before he finally presses the shutter release button. Before making his choice, he should carefully study the subject and analyse his reasons for photographing it, for in many instances only a small change in viewpoint can have a dramatic effect on the composition, even to the extent of transferring the emphasis entirely from one point of interest to another. All possible viewpoints should be examined in order to be sure of choosing the one which best meets the aims and requirements of the picture. The professional photographer will often photograph the subject from several different viewpoints to provide a choice of pictures, for he is well aware that his personal interpretation of the subject may not coincide with that of his client. The amateur, while he usually has only himself to please, can often benefit by doing likewise, so that he may study the effects of changes of viewpoint later at his leisure, after his film has been processed.

Framing the picture

Sometimes the combined effect of the lines, shapes and tones of the various elements of even a well-composed picture have a tendency to lead the eye away from the main points of interest and out of the picture area. An effective way of preventing this is to 'frame' the subject matter by including some additional object near the edge of the picture to act as a barrier. An example of the use of framing can be seen in the picture of Cologne, p. 112, where the overhanging leaves and the low wall have been included to confine the viewer's attention to the central area of the picture and thus to the main subject matter.

The object used to frame the subject should be almost entirely without detail, to prevent it from itself becoming of interest and diverting the attention from the main subject, and thus achieving

The picture, above, shows the use of tonal contrast as a means of isolating the subject from the background.

The diagrams, right, show the effect that small changes of viewpoint would have on the relative positioning of foreground and background subject matter in the picture, above.

The top diagram shows that by raising the viewpoint the vertical separation between background and foreground is increased. The centre diagram shows the converse, that by lowering the viewpoint the separation is reduced. The bottom diagram shows that by moving the viewpoint to the right the boats can be moved to the opposite side of the picture.

The choice of viewpoint is the photographer's most valuable tool in the construction of his composition. It can make or mar the picture. It can be used to emphasize one part of the subject matter in preference to another, and it can be used to conceal ugliness behind beauty. The photographer should always take the time to explore all the possible viewpoints before taking his picture. The extra effort is usually well worth while.

The picture, above, is pleasing enough but, as the diagrams show, could probably have been improved by the use of a slightly higher viewpoint, which would have separated the yacht from the railings.

exactly the opposite of its intended purpose. Overhanging foliage will often be sufficiently close to the camera for it to be recorded slightly out of focus if the chosen lens aperture is not too small. This is helpful in rendering any potentially distracting detail less obvious. In addition, by appearing less sharp than the more distant subject, the foliage will give the picture an improved sense of depth, which also assists in leading the eye towards the main area of interest.

Although the picture on the left is a satisfactory record of the ancient arena at Ephesus, the slight change of viewpoint for the picture on the right has allowed the inclusion of the poppies in the foreground, adding a splash of colour and interest to the picture.

Seeing as the camera sees

In certain respects the eye and the camera are alike. Both have a lens which projects an image on to a light-sensitive surface. In the eye this surface is the retina, in the camera it is the film. The lens of the eye focuses to produce a sharp image, and has an iris which adjusts to control the amount of light it passes. The lens of all but the cheapest cameras is also both adjustable in focus and equipped with an adjustable iris to control the intensity of the image. Here, however, the similarity ends, and the ways in which the camera and the eye actually perceive the same scene are often very different. The camera sees the scene objectively, and records everything within its

When absorbed in checking focusing and exposure and watching for just the right moment to press the shutter release it is all too easy to miss noticing some distracting item of background behind the subject.

In the picture, far left, the marquee appears directly behind the figure, and is very distracting. By changing the viewpoint by only a few feet – the girl herself has not moved – the much improved picture, left, is obtained.

view, without discrimination. The subject's surroundings can be recorded in just as much detail as the subject itself. We see subjectively, however, and the combination of eye and brain has the unique ability to concentrate on only that part of the scene which particularly attracts our attention, ignoring those parts which do not interest us. Consequently, when we take a photograph we may not even notice details of the subject's surroundings which will be recorded by the camera with distracting clarity.

This difference in the 'seeing' characteristics of eye and camera is the reason why the work of the inexperienced photographer often contains an excess of superfluous background detail which distracts the viewer's attention from the main subject, and therefore reduces the effectiveness of the composition. At the time of taking his picture the photographer was probably not even aware of the background, or at least not aware of its effect on the resulting pictures. For example, he may have been so engrossed in arranging his model into a suitable pose that he may not have noticed the telegraph pole or lamp post some distance behind her, but which on the resulting photograph appears to be growing from the top of her head. Or he may not have realized that the flowers in the background would appear so bright and distracting on his final print that they compete with the subject proper for the viewer's attention.

The aspiring photographer must train himself to see his subject and its surroundings in the same way as his camera will see them, so that he can recognize such potential distractions. Once he has done so he will be able to take steps to reduce or eliminate their effect on his picture. Sometimes he can physically remove the offending item from the camera's view, or he may be able to change his viewpoint so that it is either completely hidden behind the subject or falls outside the picture area. If there is no way of entirely eliminating the object from the camera's view the photographer can often reduce its distracting effect by using a large enough aperture setting for it to be recorded well out of focus. This technique of 'differential focus', as it is known, is very effective in reducing the visual influence of the subject's surroundings and giving greater emphasis to the subject itself, which, because it is recorded sharply, stands out in isolation against the out-of-focus background.

When using an SLR with a lens with an automatic diaphragm, i.e. one which remains fully open during viewing to give the brightest possible viewfinding image, the background will usually appear less distracting in the viewfinder than it will on the final picture. This is because of the increase in depth of field which results when the lens automatically stops down to the setting at which the picture is to be taken. The actual effect which will be obtained on film can be visually assessed, however, by manually stopping down the lens during the viewfinding operation. Most SLRs have a 'preview' button or lever for this very purpose. If the background appears too distracting at the chosen aperture a larger setting should be selected, remembering, of course, that this will require the exposure duration or illumination intensity to be altered accordingly.

Two examples of pictures with very out-of-focus foregrounds.

The top picture was taken looking through leaves which were so close to the camera lens that they have recorded only as a soft green veil over areas of the picture.

The out-of-focus geraniums provide an unusual framing to the lower picture. To ensure that the flowers were well out of focus the lens was set to infinity and the aperture was adjusted to a fairly large setting, f5·6, to give very little depth of field.

Although not the case in this instance, the use of fuzzy foreground matter can be to conceal other, more unsightly detail which would otherwise spoil a picture.

The picture left, of the Cathedral and Rhine at Cologne, West Germany, was taken as an example of bad photographic composition. The Cathedral has been positioned slap in the middle of the frame, and the large expanse of empty water provides little foreground interest.

The photograph below, taken from a point only two minutes' walk away, is a much more pleasing composition. The overhanging foliage and the low wall frame the picture, allowing the bridge to lead the eye to the main point of interest—the Cathedral. The picture was further improved by waiting for a passing Rhine barge to add interest to the foreground *Both pictures: Canon FTb, 1/125 sec, f6.3, Kodachrome 25.*

This picture is completely uncluttered and simple in its composition. The white stone has recorded in pastel, almost monochrome tones, with just sufficient contrast to reveal the S-shaped curve of the steps ascending into the distance. This has given the picture a sense of mystery which is heightened by the inclusion of the old lady scurrying along with her half-concealed package.

When a subject is moving across the field of view it is usual to frame the picture so that the subject has not yet reached the centre of the frame, i.e. so that there is more space in front of the subject than behind it. In this picture the movement of the little boy is emphasized by the lines of path and window sills converging in the direction of his travel.

The subject matter of pictures with a pleasing composition often fits into a basic geometrical shape. In this picture the boy, his yacht, and its wake together form a simple triangle.

The balance of a picture can often be improved by filling empty areas of foreground with other subject matter. In this instance a better picture has been obtained by waiting for a boat to pass by.

These pictures are almost abstract designs of shapes and colours, and were taken on a camping site from the inside of a caravan, with the camera focused on the drops of rain on the window. The picture, right, has the added interest of the figure hurrying through the rain.

Care should be taken to avoid shadows falling across the subject. Because of limitations in the contrast handling capabilities of the film, such shadows record much darker on a photograph than they appear to the eye at the time of taking the picture.

The picture, far left, is marred by the shadow of an overhead beam supporting a garden trellis. In the other picture this shadow has been eliminated simply by making the exposure while the sun was temporarily behind a cloud.

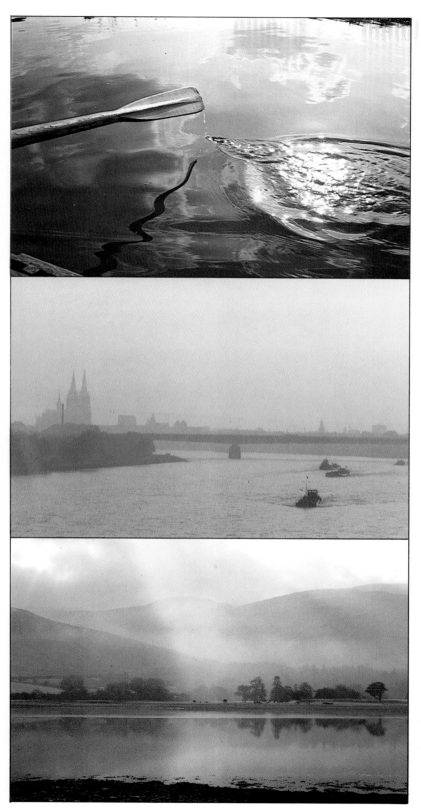

Although so simple in its content, this picture has really captured the atmosphere of a leisurely row through the still waters of a lazy summer afternoon.

Mist is a great creator of atmosphere in a picture, and gives a landscape a good sense of distance. In misty conditions distant objects appear much lighter in tone than nearer ones, and colours appear muted, sometimes taking on the yellow or orange tones of the rising or setting sun, as in this picture of the Rhine at Cologne.

Another picture in which mist has played a part in the creation of atmosphere and mood. On its own the landscape would have been relatively dull, but the shaft of sunlight breaking through a gap in the clouds to illuminate the mist and the distant shoreline has given the picture a point of interest.

Telephoto lenses have the unique ability to compress distance, an effect which can often be used to advantage by the imaginative picture maker. A busy but not crowded street scene, for instance, can appear to be almost jammed solid with people when photographed from a distance with, for example, a 300 mm lens. Another often useful property of these lenses is their limited depth of field, a feature which can be used to isolate the main subject interest from its surroundings.

The use of such a lens and the careful choice of aperture to give a restricted depth of field has given the picture, left, a feeling of the atmosphere of this colourful field, full of bright red poppies receding into the distance. The lens was focused on the blue flowers of a solitary viper's bugloss plant to give the picture a centre of interest. *Canon FTb, 135 mm lens, 1/125 sec, f8, Ektachrome 64.*

The picture above was taken with a 500 mm mirror lens to isolate the blue flowers from the poppies surrounding them. This fixed aperture, f8 lens was used at its minimum distance of 13 feet/4 m, at which the depth of field was so small that flowers only inches in front of or behind the subject were well out of focus. *Nikon F2, 500 mm Reflex-Nikkor, 1/125 sec, Ektachrome 64.*

By including the foliage on the right and the rocky outcrop on the left, the photographer has not only nicely framed this picture but also given a good impression of the great distance involved, both downwards to the river bed and outwards to the horizon. If the picture had been taken from a few paces forward, so that this foreground interest was not included, much of the picture's three-dimensional quality would have been lost.

This picture is an excellent example of lighting conditions chosen to suit the subject. The backlighting has clearly revealed all the texture and shape of the eroded arches and pillars of rock.

The shape and form of subjects which are of a single colour and tone can only be revealed by the careful choice of lighting position to create highlights and shadows to delineate the outlines of the subject. Had the sun been behind the camera for this picture all the shape and form of the rock would have been lost, and the picture would have been flat and uninteresting.

This picture would have lacked a centre of interest had it not been for the mule train slowly wending its way along the track.

Often the inclusion of some object of known size is useful to give the picture a scale by which the size of other objects may be judged. Without the figures here, for example, it would be impossible to make any accurate assessment of the height of the rock formations.

Successful composition outside the realms of accepted guide lines cannot be committed to formulation, but must be a matter of personal choice based on what the photographer is trying to convey about his subject. The choice of the positioning of the various picture elements within the photograph is used as an aid to expression rather than to produce just a harmonious, if sometimes bland, balance of tones and shapes. One can accentuate a feeling of sadness, loneliness, joy, etc., by moving the focal point of the picture away from the accepted norm, but still achieve a balance of shape and tone. The picture of the old lady may not have been so successful if it had been approached with fixed ideas about portraiture. The large area given to the trappings of her world is of great importance in complementing her candid expression and producing the desired atmosphere.

The graveyard landscape owes its effectiveness not only to breaking the rules of composition, but also to unconventional darkroom technique in producing the print. The dark tonal weight of the hill is necessary to balance the large headstone, and to have rendered it with detail would have only been distracting.

Pictures such as these are very personal views of the world, and it may benefit a photographer to delve more into his own mind than to pander to the ideas of the local photographic society.

In the picture, above, the sun appears to be setting above an area of water which is glistening in its orange light. In fact the picture has been intentionally reproduced upside-down, and the 'water' is actually cloud. *500 mm mirror lens, 1/125 sec, f8, Ektachrome 64.*

The horizon in the picture, left, has been positioned low in the frame to allow the inclusion of a large area of the dramatic evening sky. The photographer has waited until the position of the clouds was such that their shapes combine to lead the eye down the picture to the castle below. Note that the exposure for this picture was set to be correct for the sky, so that everything below the skyline was under-exposed, and therefore appears in silhouette.

The photographer who took the landscape, left, had previously realized that the scene had the potential makings of an interesting picture, if only he could capture it under the right lighting conditions. He returned on four separate occasions before he was rewarded by the stormy sky which has made the picture so dramatic.

This beach scene at Phuket, top, was exposed through a polarizing filter to darken the sky and water and to intensify the green of the foliage. *1/60 sec, f11, Ektachrome film.*

For the centre picture a large sheet of white paper was placed on the table, in front of the little girl and just out of the camera's view, to reflect soft, shadowless light into her face. *1/30 sec, f8, Ektachrome film.*

Because the main source of light for the lower picture had to be from behind the subject to record the umbrellas in intense, luminous colours, two large silvered reflectors were positioned in front of the subject, just out of the camera's view, to provide sufficient frontal light to give a balanced illumination. *1/30 sec, f11, Ektachrome film.*

The above pictures are examples of photographs which have been composed to fit an unusual format, in this case a slim, panoramic shape. The pictures are just three of a series taken in Thailand for a recent Kodak calendar. They were all exposed on 5 × 7 inch Ektachrome sheet film, balanced for daylight, and the resulting transparencies were subsequently masked down to the required area.

The art director for the Kodak calendar ▶ is **Paul Wigmore, A.S.I.A.,** and he has provided the following interesting insight into the conception and photography of this particular calendar.

'Every year, around November time, I get a prickling sensation at the nape of the neck; about a quarter of a million Kodak Calendars are being taken from their packs and hung on the walls of Kodak customers' offices, laboratories, schools, shops, factories and studios in some fifty countries round the world.

'The art direction of a calendar with an audience as varied as this is a daunting task. It is impossible to please everyone. The sophisticated art buyer in a Berkeley Square advertising agency will want something that is as *avant-garde* as he can get, and the photo dealer will want pictures that simply encourage his customers to take more photographs. The canteen manageress might want something that reminds her of the post-impressionists, and the laboratory technician could well be a kittens-in-baskets man. One thing is certain; the headmaster will not hang a girlie calendar in his office!

'The easy way out is to ring the changes. So one year, we aim at the top of the professional photographers' market with pictures that exploit the wit of the photographer and the interpretive ability of the camera. Another year, we shoot straight, colourful, unambiguous pictures that come of the chocolate-box family but with a pedigree of impeccable professionalism.

'Since 1970 we have followed one rule strictly: always shoot pictures specifically for the calendar. Never use pictures shot for another purpose. Someone else's shoes *must* be a bad fit somewhere.

'In the art-direction of the 1977 Kodak Calendar, I began with this thought: *panoramic pictures that look as if they have been waiting for just that format in which to exist.* Then I went on to: *pictures that leave no question unanswered, that are needle-sharp corner to corner, that are likely to delight a lot of people, to please many more, and to irritate none.* Last of all came the location – *Thailand.*

'Jack Oakley, F.S.I.A., was the natural choice as photographer. Meticulous in his planning ("I always bet on certainties"), with the rare combination of wit and precision, he had under his belt an impressive stack of superbly shot colour campaigns for Kodak's consumer and professional advertising, as well as three previous Kodak Calendars and many giant transparencies for Kodak buildings in the UK and the States.

'From the moment when I asked Jack to do the job and gave him the overall brief, we spent about three months on and off, planning the entire operation. Contacts with the Thai Embassy in London, talks with officials in Thai Airways, a visit to the BBC Television Centre to talk with the "Blue Peter" team who had just been to Bangkok to do a programme, letters to Kodak Bangkok to arrange for an interpreter, driver, minibus and hotel accommodation in the three centres we had decided upon (Chiang Mai, Bangkok and Phuket) . . . this kind of operation needs really detailed planning if you want to concentrate on photography when you arrive!

'We were in Thailand for just twenty-eight days. Ten were for photography, eight were for reconnaissance, five were for travelling, and five were for a combination of resting, packing and unpacking equipment – and acting as a buffer for the times when the schedule went for a burton.

'The first eight days were spent in reconnoitring up north in Chiang Mai and in Bangkok. In both places we fixed actual camera positions, found local people who would model for us and made dates with them, and obtained permission to work in temples and in other restricted or private areas. Then came three days photography in Chiang Mai, and a glow of satisfaction on the plane back to Bangkok at the knowledge that we had some pictures in the can.

'I had planned a day's rest for the crew back in Bangkok, but it didn't work out that way. Instead – racing along roads at dawn to catch sunrise 50 miles away, perching on the camera platform on top of the minibus to get a close-up on a temple façade, and holding on to Jack as he balanced on a narrow balustrade on a bridge over a canal while he shot for the best part of a day with a flower girl in her boat of flowers. (Ever tried lashing a 5×7 Sinar P to a bridge, pointing it downwards vertically, leaning out over the water to focus under a dark-cloth, and being told every five minutes that the boat was preventing other boats from passing and please move it?)

'There are a dozen stories to tell about the Thailand calendar locations. Many of them are hair-raising in one sense or another, but the last few days in the southern island of Phuket (that's pronounced Poo-ket locally) were sufficiently heavenly to eradicate all bad memories. Palm-fringed shores and ink-blue sea and sky, charming people, hot sun, good Thai food. It almost made us forget the approaching November day when a quarter of a million people would open up the calendar and say, hopefully, "Ahh!"'

Photographing architecture

Buildings are usually of an architectural style peculiar to the period in which they were designed and constructed. Most buildings are built with a particular purpose in mind, as a place to live or work in, to worship in or even to be buried in. The style and purpose of a building should be borne in mind when choosing the viewpoint and lighting and weather conditions for its photography.

When taking pictures of buildings in sunshine, the choice of the time of day, and hence of the angle of the sun, will considerably affect the way the shape of the building is recorded. With the sun behind the camera a building will appear flat and almost two-dimensional. It is much better to take the photograph when the sun is to one side, allowing shadows to reveal the building's shape.

By comparison with many other photographic subjects, buildings are large and often in a confined space, making the possession of a wide-angle lens almost essential if architectural photography is to be undertaken in earnest. When space around a building is not limited, allowing freedom of viewpoint, the choice of lens' focal length together with camera position can be used to control the perspective of the picture and the way the building appears in relation to objects in front of or behind it (see p. 83).

A common problem when photographing tall buildings is that of 'converging verticals', caused by tilting the camera to include the top of the building (see p. 78). This can sometimes be overcome by finding a higher viewpoint, perhaps from an adjacent building, or by using a perspective control lens or a 'view' camera with rising front.

When taking a series of pictures of a building, shots of details of the architecture such as doors, clocks or sundials, or carved figures

The choice of viewpoint and lens' focal length affects perspective and the way the shape of a building is recorded in a picture. The top diagram shows the effect of a long focus lens and a distant viewpoint, compared with a wide-angle lens and a much closer viewpoint, lower diagram.

This picture of Castle Raby, in County Durham, England, has been taken from a relatively distant viewpoint in order to include sufficient of the castle's surroundings to convey a good impression of its setting. The picture is well balanced, and complies with the basic rules of composition outlined in the previous chapter. The inclusion of the tree has provided framing, by virtue of the overhanging foliage at the top of the picture and the shadow at the bottom, which helps to lead the eye into the picture and towards the main subject, the castle itself.

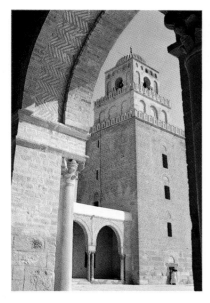

For the picture, far left, the camera has been tilted upwards to allow the top of the tower to be included in the picture, which consequently exhibits the phenomenon known as 'converging verticals'. To avoid this problem the film plane of the camera must itself be kept quite vertical. The picture, left, was taken with a perspective control lens, allowing the top of the building to be included without tilting the camera.

Below: When making panoramas by joining two separate pictures, changing the camera angle for each picture produces an unacceptable result, top, in which lines common to both pictures will not match when the pictures are joined. By keeping the camera body stationary and taking the pictures using a perspective control lens shifted first one way and then the other, a much more satisfactory result is obtained.

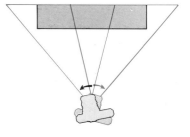

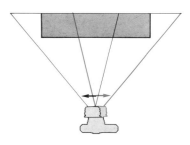

can be very effective as a supplement to one or two general views.

Interiors of buildings can often be photographed by the available light coming through the windows, and this is really the best way of taking them, as they will then be portrayed in the way in which they are designed to be seen, although due to limitations of the contrast-handling characteristics of the film this is not always possible, in which case resort to artificial lighting will be necessary.

Left: Although this picture was exposed mainly by the daylight coming through the windows, a fairly powerful electronic flash was fired upwards from the camera position to supplement the light falling on the paintings at the top of the dome, which, because of its position away from the windows, was not receiving as much illumination as other parts of the subject and would, therefore, have recorded too dark had the picture been taken by the available light only.

Centre: Even when the intended purpose of a visit to a building is to take a photograph which includes the whole building, it is well worth keeping an eye open for details of the architecture which might make additional pleasing pictures. A telephoto lens is often of benefit as some subjects may be too inaccessible to allow a viewpoint from which they will fill the frame using a lens of normal focal length. The carved stone face was photographed with a 135 mm lens, but for the sundial, which was immediately above a church doorway, a 50 mm lens was adequate.

Bottom: This picture of a sarcophagus at Tyre, Lebanon, was photographed with the sun in a position to give a strong side-lighting. The harsh shadows have given shape and modelling to the carved stone figures.

Opposite: Traditional churches and cathedrals, built before man had devised ways of providing abundant artificial lighting, were designed to make the best use of daylight to reveal the shape, texture and beauty of their interiors. Any attempt by the photographer to light such a building by artificial means, apart from requiring a large amount of equipment, would destroy this carefully created atmosphere. In many cases the natural light within the building is so weak that the exposure required is in the order of several seconds, and may be as much as half a minute or even longer. At these exposure durations most daylight colour films suffer from reciprocity law failure, resulting in unexpected colour casts. Film balanced for tungsten lighting, however, is designed for exposures of this length, and when used in conjunction with a suitable daylight to tungsten conversion filter (see p. 98), will usually give satisfactory results at exposure times of up to several minutes.

People and portraits

The inexperienced photographer often gets the erroneous impression that in order to make photographic studies of people he needs some form of studio and some complicated lighting equipment. In fact nothing could be further from the truth. Although some simple-to-construct lighting equipment for indoor portraiture is shown at the end of this chapter, the majority of the pictures appearing in these pages, even those taken indoors, have been exposed using only available daylight, albeit in many instances with the aid of a reflector to throw light into areas of the subject which are less well lit than others.

 People are photographed for a variety of reasons, for instance because they are famous, or because they are our loved ones, or as a record of a particular occasion in their lives, or simply to create a pleasing picture. When taking posed pictures the reasons behind the pictures, along with some plan of operation and likely posing positions, should be established before starting the photographic session. The relationship between photographer and model will often dictate the success or failure of the session. The model must be completely at ease if the results are to appear perfectly natural.

 Informal pictures of people often have to be taken without the subject's knowledge, as awareness of the camera's presence may cause self-consciousness on the part of the subject. This is particularly relevant when photographing children, satisfactory pictures of which rarely result from a formal photographic session. With young children it is usually best to leave a child to its own devices for a while, and then to start taking pictures when he has become absorbed in his activity and oblivious of the photographer's presence.

Pictures of people are taken for a variety of reasons, for instance as a formal record, far left, as an informal and charming record of some activity in a child's school-life, centre, or simply as a pleasing and humorous picture, below.

The picture, above left, has an almost luminous quality, achieved by positioning the little girl in a small patch of sunshine sufficiently large to illuminate only her and not her surroundings, producing an intentionally high-contrast effect. Care is needed when assessing the exposure required for such a subject, as a general meter reading taken from the entire picture area would lead to over-exposure of the subject itself, due to the influence on the meter of the large areas of dark shadow. The solution is to ensure that the reading is taken only from the subject and not from the surroundings. *1/125 sec, f11, Ektachrome 200.*

For the picture, above, the photographer has gone in really close and filled the frame with just the girl's hands and her recorder. The picture is included here to make the point that, whatever the subject, all possible viewpoints and aspects should be explored, as unplanned pictures may be there just for the taking, if only the photographer is sufficiently aware to notice them. *1/125 sec, f8, Ektachrome 200.*

Although having the appearance of a 'candid' shot, the picture, left, was in fact carefully arranged. The lighting was only the bright sunshine coming through the windows, with silvered reflectors positioned to the left of the picture to throw light into those parts of the subject which would otherwise have been in shadow. *1/30 sec, f11, Ektachrome 64.*

Humorous pictures of people must usually be taken without their knowledge and must therefore be taken quickly, before the subject becomes aware of the camera's presence. In the picture, left, however, the subject was fast asleep, so the photographer had plenty of time to compose and take the picture.

Moments like this, left, last only a second or even less, so the photographer must be ready, with camera focused and exposure set, if he is to capture them before they are gone. This picture was taken using electronic flash, so there was no problem in 'freezing' any subject or camera movement.

Had any of the children in this picture, left, realized that they were being photographed, the spontaneity and naturalness of the picture would have been lost.

Opposite: This picture of a trader in a Tunisian market was taken with a 135 mm telephoto lens. Although the man was aware that a picture was being taken, because of the longer working distance of the telephoto lens the camera was so far from him that he would not have realized that the picture was really just of him alone, but would have thought that the photographer was taking a general scene, of the market, in which he happened to be included.

Pretty girls are best photographed in a soft, diffused lighting with no harsh shadows, so when working outdoors it is usually best to shoot on an overcast day. To compensate for the slightly colder colour of the light on such days it may be necessary to use a very pale correction filter over the camera lens. A Wratten 1A 'skylight' filter is usually quite sufficient, as shown by the picture, left, which was taken in soft daylight using such a filter. In addition, a soft-focus attachment was also used, the effect of which has been to 'bleed' the highlights into the adjoining darker tones.

Note the unusual, but very effective composition of this picture, in which the main subject elements have been positioned across a diagonal of the frame. The main weight of tone is below the diagonal, and has been nicely balanced by the inclusion of the foliage at the top left of the picture. *1/60 sec, f8, Wratten 1A filter, Ektachrome 64.*

The rough, textured surface of the wall in the picture, left, is in direct contrast to the smoothness of the girl's skin and the gentle, rounded lines of her face and body, and its use as a background has served to emphasize the girl's beauty and femininity. *1/125 sec, f8, Ektachrome 64.*

The picture, above left, was taken using only the light coming through the window to the left of the picture, although a silvered reflector was used to reflect light into the shaded side of his face. *1/30 sec, f5·6, Ektachrome 200.*

The picture, above right, was also taken using only available light from a window, which in this picture was on the wall behind the girl, just off the right-hand side of the frame. A large silvered reflector was positioned to the left of the camera to reflect sufficient light to almost balance the 'backlighting' effect of the direct light from the window. A soft-focus attachment was used over the camera lens and this, in conjunction with the soft lighting, has produced an image with very low contrast and with no sudden tonal changes, and which is in perfect keeping with the softness and delicacy of this lovely girl's features. *1/30 sec, f4, Ektachrome 64.*

A problem which often arises when photographing people is that of what to do with the model's hands. Giving her something to hold, such as a scarf or loose belt, can solve the problem in some instances. In the picture, left, it seemed quite logical for the girl to play with the flowers and grasses among which she was being photographed, and the resulting picture appears quite natural and unposed. Note the use of a large aperture to give a restricted depth of field, concentrating attention on to the subject herself.

The outdoor portrait, above left, was photographed with the sun directly behind the model, giving a pronounced backlighting effect. To prevent under-exposure of the girl's face and arms a silvered reflector was positioned immediately to the right of the camera to throw light into the areas of the subject which were in shadow. *1/125 sec, f8, Ektachrome 64.*

The picture, above right, is a studio portrait taken by electronic flash. The main light, positioned just to the right of the camera, was an umbrella light, giving a very diffused illumination which casts only soft shadows. The lighting was further softened by a reflector placed to the left of the picture to throw light back into the shadows. The highlight on the hair was provided by a single additional light above and behind the model's head. *Electronic flash, f32, Ektachrome 64.*

The picture, left, was taken indoors by very weak available light using a relatively long exposure, which necessitated the use of a tripod and required the models to keep quite still during the exposure. A white reflector was used to lighten the shadow areas. *1/15 sec, f8, Ektachrome 64.*

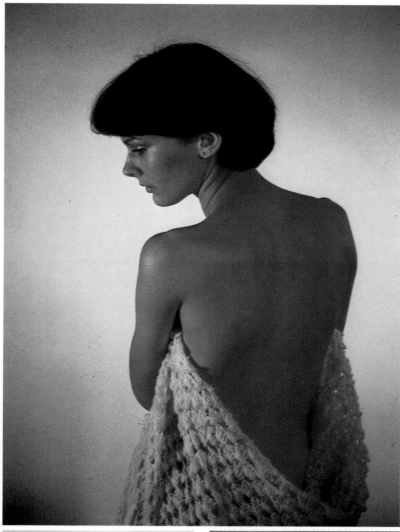

The picture, above, was made in two distinct stages. Firstly, artwork consisting of many thin, parallel white lines on a black background was drawn, and subsequently photographed to produce a 35 mm transparency of the lines. Secondly, this transparency was projected directly on to the girl, who was standing against a very dark blue background. The result was photographed with a camera positioned close to the projector's optical axis. The exposure was set to be correct for the lines falling on the dark background, so those falling on the girl's body are considerably over-exposed, and are completely white on the result.

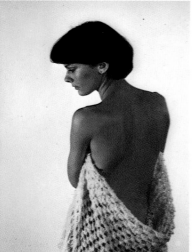

The picture, above left, was created by sandwiching together the two separate transparencies shown left. One is a picture of the girl herself, photographed against a plain white background. The other transparency, bottom right, was produced by photographing a carefully chosen area of a modern abstract painting from a distance of about 6 inches, but with the camera's focusing set to infinity, with the result that the detail of the painting has recorded only as fuzzy blobs and shapes. In addition, the picture was intentionally over-exposed to produce a very light transparency with muted, pastel colours.

The illustrations, left, show the effect the characteristics of the light source have in portraiture, not only on the intensity and harshness of shadows, but also on the tonal value of the background.

The picture, far left, was taken with a spotlight as the light source, while the other was taken with the umbrella-light shown below. The background distance and material is the same in both instances, as was the exposure level at the subject, as is shown by the grey scale attached to the subject. Because the light from the spotlight is more concentrated and falls off less with distance than that from the umbrella-light, the background has recorded lighter in the picture taken with the spotlight. Unless the background for a portrait is illuminated separately from the subject, the material chosen should be lighter in tone than it is required to appear in the final photograph.

The following diagrams show a simple and easily made lighting set-up for portraiture. The pictures appearing on the following page were taken using this lighting and demonstrate its capabilities.

The white reflector, above, consists simply of a large sheet of white expanded polystyrene attached to a suitable stand.

Above: The spotlights used to create highlights on the hair are reflector spots intended for the illumination of shop-window displays. Theoretically the colour temperature of these lamps is too low for them to be used in the same picture with the photofloods, but in practice the warmth given to the highlights on the hair is not objectionable.

Cheap, adjustable telescopic stands, as shown below, are ideal for supporting main light and spotlights.

The main light, above, is made by attaching to the stem of a photographic umbrella the unit shown, right, which consists of four No. 1 Photofloods in batten lampholders secured to a wooden panel. The shield, of folded metal sheet, surrounding the bulbs is necessary to prevent light from reaching the subject directly from the bulbs, in addition to by reflection from the umbrella.

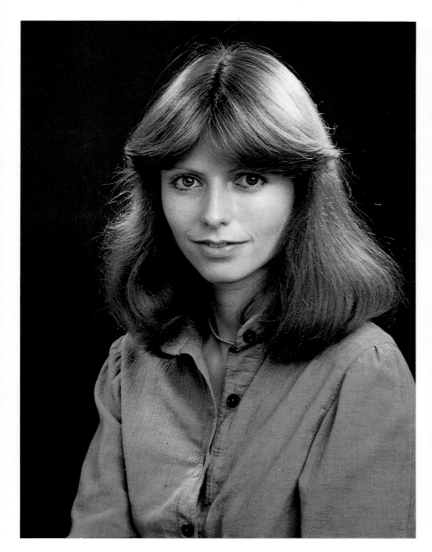

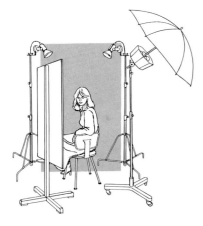

The small picture, top right, shows the effect of the main light only. While this may be sufficient lighting on its own for a portrait of a man, it is much too harsh for a picture of a pretty girl.

The picture, centre right, shows the effect of adding the white reflector to soften the shadows produced by the main light.

The picture, bottom right, was taken using the same lighting as the previous picture, but with the addition of a single spotlight to produce a single highlight on the hair.

The large picture, above, shows the effect of the complete lighting set-up, with main light, reflector, and two spotlights on the hair.

The diagram, left, shows the positioning of the lights and reflector relative to the model.

Natural history photography

The subject of natural history photography makes use of almost all of the techniques described in this book. By virtue of the subject, which covers all natural and living things in many different environments, it is impossible to deal with each individual situation in a book of this size. However, an attempt has been made to describe techniques for the photography of the more popular subjects.

When considering the photography of natural history, especially wildlife, particular attention must be paid to the disturbance that may be caused. In many countries there are laws protecting the environment and it may be necessary for the photographer to obtain a licence before attempting photography of certain species. Even so the rule that should be observed at all times is that *the welfare of the subject and its environment should be considered above anything else.* This applies in the main to bird and animal photography where it is possible not only to disturb them from their normal habits, but unwittingly to damage plants in seeking them out.

The photographer should be familiar with the natural history of his subject; the more complex the life-form and the rarer the species, the greater his knowledge ought to be. Photography of scarce animals and plants by people who know nothing of the risks involved should be discouraged at all costs.

To get close to some subjects it may be necessary to remove surrounding vegetation to obtain a clear view. This should be carried out by tying back rather than cutting and the vegetation restored to its original natural condition as soon as possible after each photographic session. This prevents undue exposure to predators and adverse weather conditions.

Should photographs of rare plants and animals be published or exhibited, the location should be kept secret in order to protect the subject from over-enthusiastic people who have interests in seeing it, photographing it or even collecting it.

Bird Photography

Birds are very easily disturbed by man which makes photography difficult because not only has he to consider photographic techniques, he has to get close to his subject.

Either he has to go to the bird or, alternatively, encourage it to come to him. He may see birds at regular feeding, watering or roosting places and here he may photograph them either by stalking or from a hide, but also he may know of nesting sites where he can predict the presence of breeding birds. It is particularly important that photography of birds on the nest should only be undertaken by people with a good knowledge of the birds' breeding behaviour. A hide should always be used when there is reasonable doubt that the birds would subsequently discontinue their normal activities.

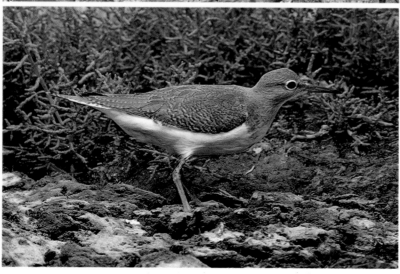

This puffin was photographed near its burrow on the rocky cliffs of Fair Isle. Many of the less timid species of birds can be stalked. It may be necessary to crawl slowly up to them, lying on your stomach. A very low tripod or some other firm support is helpful.

The gull in flight, top left, was photographed from the stern of a boat at sea. A white bird against a blue sky is a considerably lighter-than-average subject, and an exposure meter reading taken directly from the subject would lead to under-exposure, see pages 57, 58. *135 mm lens, 1/1000 sec, f4, Ektachrome 64*

Photographing birds at the nest requires a good knowledge of their breeding behaviour. It is very easy for an otherwise competent photographer unwittingly to cause disturbance and even desertion of the nest. This picture of an oystercatcher was taken from a hide using a 135 mm lens on a 35 mm SLR.

The common sandpiper is a bird which habitually frequents the banks of rivers and streams. A hide positioned in a suitable spot on the river bank can be ideal for 'wait and see' photography. You can often get a good clue to the places frequently used by birds by looking for their footprints in the sand.

Positioning of a hide is very important as not only has the photographer to consider the photographic technique, he should not disturb the regularly used approach lines to the nest or draw the attention of the public or predators. Hides should not be left unattended in daylight in locations with public access. Any tracks to hides should be devious and inconspicuous and undergrowth returned to its original condition between sessions. The positioning of a hide should be undertaken in several stages, starting at some distance away and slowly moving up to the final photography position. The maximum possible time should be allowed between consecutive stages of hide movement. Each stage should be fully accepted by the birds before the next is started. If any stage of movement should cause undue disturbance the procedure should be reversed by at least one stage. Should any sign of disturbance remain attempts at photography should be abandoned. It is undesirable to cause any disturbance in the late evening when the birds' movements are becoming less frequent.

While the best photographs are often obtained at about the time of hatching, this is no time to start erecting a hide. Early preparation is necessary but not until there is a full clutch of eggs and the parents' reaction to the situation has been fully established.

When the hide is in its final position, it is better to use the bird's first visits to the nest to check its behaviour and approach routes than for determining exposures. No part of the occupants should be visible from outside the hide nor silhouettes be thrown against inadequate material. Birds can be disturbed by noisy shutters, so the quieter this is the less chance there will be of the birds objecting to it. The longer the focal length of the lens, the more distant the hide can be and the less risk that the birds will not accept it.

Should it be necessary to change the photographer in the hide or create any disturbance it should not take place during bad weather or very hot sun.

Some birds found near water do not come to the water until after daybreak. When photographing such birds the photographer should enter the hide before daylight in order to be already out of sight and ready for photography when dawn breaks and the birds arrive.

Birds away from the nest usually congregate in places where there is little disturbance, whether it be for feeding or roosting. The erection of a hide in this situation should be carried out with the same caution as for nesting birds. Even though they may not be nesting, frequent disturbance of roosting birds may affect their behaviour so causing undue stress.

There are places where the erection of a hide may attract the attention of irresponsible shooters and trappers, particularly in countries where the laws of protection are not stringent.

It is possible to attract birds to an area by playing back sound-recordings or using stuffed predators. These stimulate territorial and alarm reactions and should be used with caution particularly during the breeding season. However, they are effective where conditions are right and so it is advisable to study the species in relation to its behaviour and preferred habitat to avoid unnecessary disappointment.

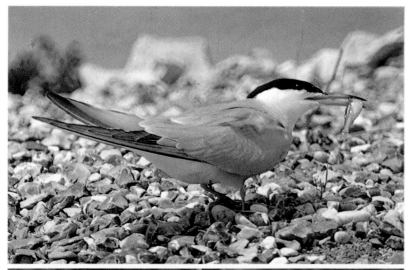

By careful observation from a distance it is usually possible to decide the optimum position for a hide to suit your photographic technique, without causing disturbance to the birds.

This common tern was seen regularly at a prospective nest site on a small island a short distance from the bank of a flooded gravel pit. *Nikon F, 500 mm Reflex Nikkor, 1/250 sec, Kodak Ektachrome 64*

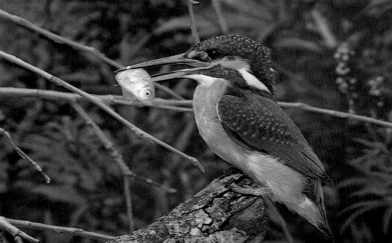

Watch for birds or animals making frequent visits to the garden for food.

This kingfisher was photographed from the comfort of the living room when it was making one of its regular forays to rob the goldfish pond. *Canon F1, 300 mm lens, 1/250 sec, f6·3, Kodak Ektachrome 64*

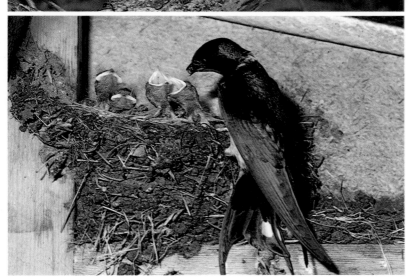

Many species of birds nest in buildings, and in most cases you will need flash to photograph them satisfactorily. The sudden flash, along with any shutter noise, may disturb the bird and may result in its leaving the nest before it has finished feeding its young. To avoid undue stress restrict your photography to about one in four visits of the parent bird to the nest. Keep yourself well hidden from the birds. This picture of a swallow feeding its young was taken from behind a partly open door, using a 135 mm lens on a 35 mm SLR. The camera was mounted on a tripod, which is advisable even when electronic flash is used, as it relieves the tedium of holding the camera in position for long periods while waiting for the birds to adopt exactly the right positions.

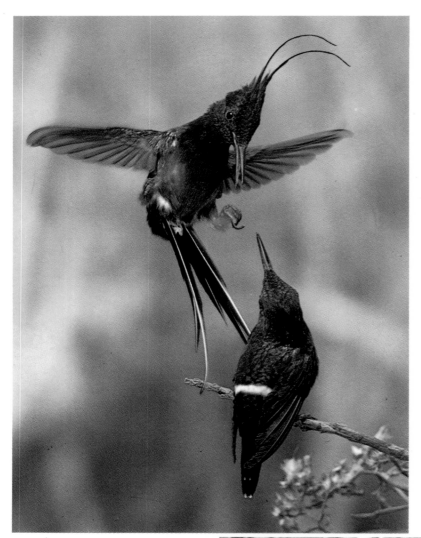

For most of us it is not possible to visit far-away places to photograph exotic birds in their natural habitats. So why not make the most of the opportunities provided by local aviaries, at which excellent pictures can often be taken?

These hummingbirds were photographed in a small privately owned aviary. The background was an out-of-focus colour print of foliage, placed in a suitable shaded corner. The wings of hummingbirds beat extremely quickly, and in order to 'freeze' this motion electronic flash with a very short flash duration was required. We used 'automatic' flashguns of the type which have an additional facility permitting the manual selection of the flash duration when they are used in the non-automatic mode. The duration was set to 1/3000 second, and because of this two flashguns were needed to give sufficient light for the fairly small lens aperture required to give a reasonable depth of field. They were positioned above the camera so that no shadows of the birds would be cast on the background. Ambient light was kept to a minimum as the camera had a maximum shutter speed for electronic flash of 1/60 second, at which any strong ambient light would have produced a blurred image of the wings and other fast-moving parts of the birds, superimposed on the sharp image produced by the electronic flash.

After much perseverance and more than a little luck the birds eventually displayed in front of the background. *Canon F1, 135 mm lens + 9 mm extension tube. Sunpak Auto Zoom 4000 flashguns, f11, Kodak Ektachrome 64*

This Californian quail was photographed through the wire fence of its enclosure. A 100 mm lens was used on a 35 mm camera to obtain a reasonably sized image of the bird in the format. The holes in the mesh of the fence were approximately 20 mm in diameter. The camera was held against the fence, attempting to line up the lens with one of the holes in the mesh. Many of the resulting slides had evidence of the very out-of-focus mesh cutting across part of the picture, but on this particular slide no mesh was visible.

Stalking birds on foot is often frustrating, particularly when trying to get just that one step closer. Success is often more rewarding when photography from a car is attempted. Parking near some water or puddle often brings many opportunities to photograph birds drinking or bathing.

Animals

The photography of animals in the wild requires a considerable amount of patience and, above all, a good knowledge of their habits and of the places they frequent. If it is known that an animal frequently visits a certain site, then this is the place to wait in readiness. As with bird photography a hide is often necessary to conceal the photographer from his subject. Many animals have an extremely acute sense of smell, and can detect the presence of man by this means alone. It is important, therefore, that the photographer takes into consideration the prevailing wind conditions when choosing the position for his camera, in order that he may keep himself and his equipment downwind from the animal's likely path of approach to the site. Nocturnal animals will usually need to be illuminated by flash, and the equipment should be set up well in advance, preferably during the hours of daylight.

Hides

Even with telephoto lenses wildlife subjects often appear very small in the picture and the only answer is to get closer, but then stalking

With photography in mind, the bird feeder in the pictures above was suspended outside a convenient window. The camera was set up inside the room, looking out through the small gap between the almost closed curtains. Because of the proximity of the feeder to the house the best lighting which could be achieved by natural sunlight only was the harsh sidelighting evident in the picture, left. In the picture, above, the natural light has been supplemented by the use of fill-in flash, positioned immediately above the camera.

For some reason the tit shown in these pictures remained in the same position for long enough for several almost identical pictures to be taken.

The diagram, above, illustrates a poorly designed hide. The sides have no support at the top and can flap about in the wind, frightening timid birds or animals and thus completely ruining the photographic session.

The diagram, above, shows an improved design. Note in particular the addition at the top of the hide of the cross-members to hold the vertical poles quite rigid, and that the fabric forming the sides is stretched firmly over the frame, reducing any tendency for the fabric to flap in the wind. Pockets sewn in the material near the base can be filled with earth to weigh down the sides. The material should be camouflaged to break up the outline of the hide, according to the terrain in which it is to be used.

Sometimes it is necessary to erect a hide above ground level, perhaps on a conveniently positioned tree. Angle iron can be bolted together to form the rigid frame shown above, onto which the hide itself can be securely attached. Bolting the frame together allows it to be taken apart for ease of transport and storage. The floor can be 20 mm resin-bonded plywood also bolted to the frame. The top and bottom of the frame should be securely roped or chained to the tree trunk as shown. The hide may be made doubly secure by running guy-ropes from the top corners to the ground.

The diagram, below, shows a low-profile hide which can be used on the ground or placed in a boat. Foliage can be placed around it to improve its camouflage.

the animal generally frightens it off. The answer is to use a simple hide. It is possible to use natural materials to disguise one's presence but far more convenient if a ready-made unit is available. By using a hide it is possible to get far closer to the subject so that a shorter focal length lens and possibly extension tubes can be used.

The hide disguises the human form from animals and can be as simple as an old tarpaulin draped over the photographer leaving a hole for the lens, or perhaps a white sheet for use in snow conditions. Whatever is used, comfort and portability are important considerations. Frequently the photographer will find that he has to wait for long periods to get that really good shot and that he may have to trek a long way to find his subject.

The basic requirements for a hide are a rigid lightweight framework with a fairly opaque covering. The covering must be taut when erected to stop movement in the wind.

The colouring should be natural to blend in with the surroundings as closely as possible. Browns, greys and greens are usually the most suitable. It is often advantageous to make the top from some waterproof material like nylon-reinforced P.V.C. sheet but it must be kept taut and sloping to prevent water collecting on top. The whole covering should be pegged down to the ground and guy-ropes provided to prevent the hide from being blown away. The frame can be made of any material, often wood poles are used with fabricated corner pieces, but there are ready-made corner pieces available which do the job admirably – Kee Klamps from Gasqoyne, Gush & Dent (Industrial) Ltd, Reading, England. These will fit on $\frac{3}{4}$ inch (19 mm) diameter poles made of wood or metal. The sketch gives the approximate dimensions for a one-man hide, but this can be modified to suit the individual's requirements. As a general guide, the hide should be kept as small as possible to make it inconspicuous.

The camera hole in any hide needs to be large enough to allow a clear view through the lens and positioned to suit the seated position of the photographer. Several holes should be provided around the hide but when they are not in use, their coverings must not be allowed to blow around in the wind. It is not always convenient to view the subject through the lens due to the narrow field of view so it is wise to have a second peep hole in each side.

A most suitable hide can be made from a converted toilet tent as used for camping. Generally these are too tall but are easily modified.

A low-profile hide may be found to be necessary, either to allow one to crawl up to the subject or to cover a small boat as a floating hide.

This can be purpose built from odd materials but the size is dependent on requirements, however, the dimensions shown on the sketch are a guide. The front can be a piece of $\frac{1}{2}$ inch (12 mm) plywood and the remainder of the frame made from metal conduit. The covering material can be hessian, canvas or even denim.

Zoos and Wildlife Parks

Zoos and wildlife parks provide us with an opportunity to observe and photograph animals which most of us would otherwise never see.

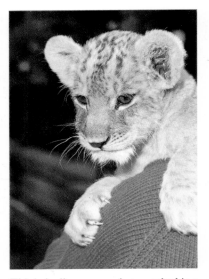

This baby lioness was photographed in a children's zoo, with the keeper holding her over his shoulder to keep her still for long enough for the picture to be taken. Photographed in the shade with automatic electronic flash.

The iguana, top left, was photographed through the glass of a zoo vivarium. The camera lens was held close to the glass to avoid including reflections of the flash, which was held slightly to one side of the camera.

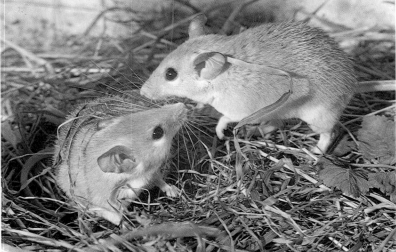

The spiny mice, centre, were photographed in their glass-fronted cage in a similar manner to the iguana.

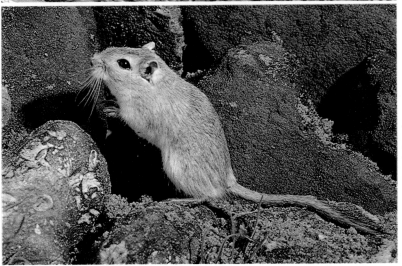

This pet gerbil was photographed in a specially made wooden box with a glass front. Rocks and sand were placed in the box to provide a natural-looking setting. The camera lens was held close to the glass with the electronic flash positioned just above the camera to simulate natural light.

Small animals such as this can move very fast, so have someone to help you to transfer them between their normal living quarters and the box, and back again.

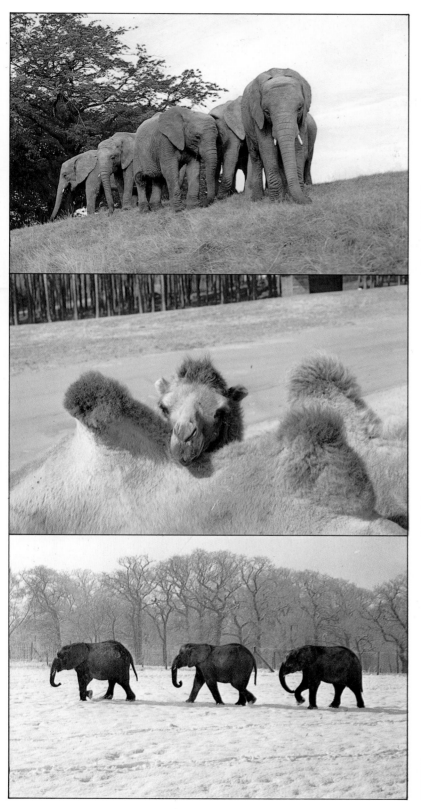

This group of elephants was photographed from a low viewpoint, resulting in a picture which might well have been taken in their natural habitat.

Just beyond the skyline is the fencing of their compound, which has been concealed from view by the careful choice of camera position.

Always be on the lookout for the picture with a difference, such as this baby camel resting its head between its mother's humps.

Another unusual picture. These African elephants look particularly out of place marching in line through the snow of the English countryside.

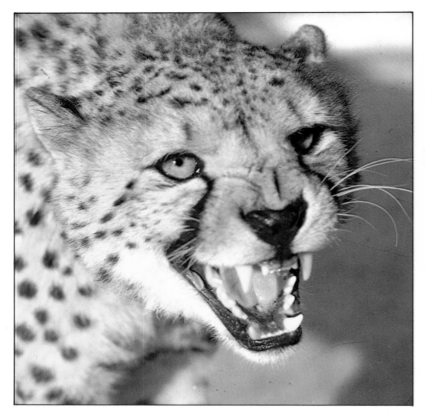

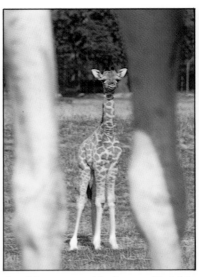

Careful camera positioning provided this picture of a baby giraffe framed between the legs of an adult member of the group.

When looking for pictures of this nature, always have your exposure set beforehand, leaving only the focusing to be quickly adjusted before pressing the release to catch what may be only a fleeting glimpse of an interesting happening.

Unfortunately, in most zoos the animals are enclosed in artificially made surroundings which bear only a token resemblance to their natural habitat, and natural-looking pictures are almost impossible. Pictures of animals in wildlife parks, where the enclosures are usually much larger can, if taken with care, look much more authentic. Any tell-tale fences or distant buildings can usually be avoided by careful choice of viewpoint and subject framing. Where this is not possible the use of a large aperture to give a limited depth of field may be used to render the background out of focus and less obvious. In most instances a telephoto lens is advisable to enable you to fill the frame with the subject.

For your own safety, always observe the rules and instructions displayed at the wildlife park. If you are visiting one of the parks where you can drive through the animals' enclosures, never get out of your car or wind down the windows to obtain a better view. Animals in captivity may appear quite tame but their behaviour is often unpredictable. In many parks the animals are in enclosures with a fence surrounded by a safety barrier, from behind which the animals are viewed. Never cross the safety barrier in order to get your camera closer to the inner fence. The problems involved in taking pictures from behind fencing or bars is discussed in the section on depth of field, see p. 73.

The cheetah, left, was photographed using a 100 mm lens on a 35 mm camera through the closed window of the photographer's car.

Plants

The photography of plants is one of the most rewarding of all forms of nature photography. For much of the year suitable subjects abound almost everywhere, and many can be satisfactorily photographed with a minimum of specialized equipment.

Although plants are relatively static subjects, their photography is often neither easy nor straightforward. If a plant photograph is to be correct both photographically and *botanically* the subject should be photographed where it is growing, particularly if the entire plant is to be shown. This may pose problems of camera position, lighting angle and suitability of background. Small plants often require very low viewpoints, and may necessitate the use of a miniature tripod or of one with the facility for mounting the camera *under* the central column. If sunlight is to be used as the sole illuminant it may be necessary to wait for the sun to reach a suitable position. If the natural light is never sufficient or at the right angle it may be necessary to supplement it with flash, but this must be attempted with moderation to avoid giving the picture an unnatural appearance. The background which will appear directly behind the plant must also be taken into consideration. If large areas of colour or light tone are included these may distract from the subject itself. If a suitable viewpoint which also avoids such distractions cannot be found it may be possible to use a lens aperture large enough to record only the plant in sharp focus, to reduce their effect to a minimum.

This fly agaric, *Amanita muscaria*, was photographed in a dark woodland glen, using electronic flash to supplement the weak available light. The direction of the flash was carefully chosen to simulate sunshine. *Pentax, 55 mm lens, daylight and electronic flash, 1/30 sec, f8, Kodachrome 25.*

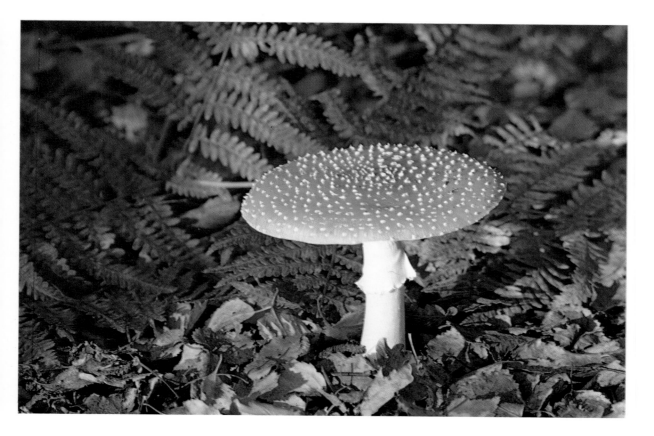

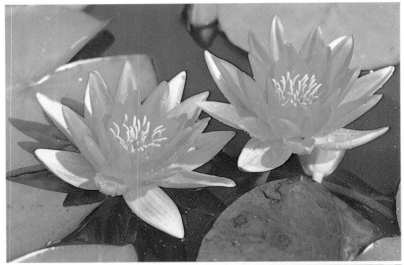

When the subject is fairly large, like these water-lilies, many cameras will focus sufficiently close without the use of close-up attachments of any kind.

Note that the camera viewpoint has been chosen so that the position of the two blooms within the frame creates a balanced and pleasing composition.

When photographing flowers which can be found growing together in large numbers, such as these tulips, a more pleasing picture can often be obtained by including a large area of blooms, rather than by concentrating on just one or two isolated flowers.

Even relatively mundane subjects such as the leaves, far left, should be explored from all angles if their full potential is to be realized. By photographing them from the other side, so that they are illuminated by the sunlight passing through them, their appearance has been transformed to produce the much more colourful and interesting picture, left.

Tall-stemmed flowers, such as these Michaelmas daisies, sway from side to side at the slightest breath of wind. Usually the requirements of depth of field demand the use of a fairly small aperture and consequently of a relatively slow shutter speed. If the flowers are to be recorded sharply when using such a speed their movement must be stopped before the picture is taken. Often it is helpful to erect a windbreak to the windward side of the flowers and perhaps to the rear of the camera as well, below left. Care should be taken to ensure that no part of the windbreak encroaches into the camera's field of view.

Below: For photographing from viewpoints very close to the ground many tripods offer the facility for mounting the camera and pan-and-tilt head beneath the central column, between the tripod's legs.

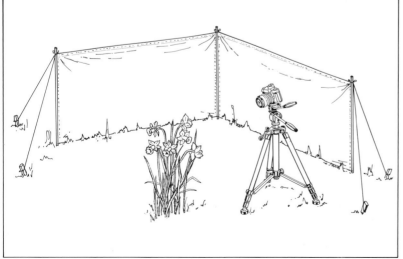

Underwater photography

Underwater photography is one of the most demanding fields that the photographer can attempt. It requires considerable physical effort combined with mental agility in an environment that is cold, wet and often with a clarity that is far from ideal. Success comes only with understanding the limitations of one's equipment and adherence to the few basic rules.

Optical limitations

It is important to understand the optical characteristics of the water and the restrictions thereby imposed. Water has a higher refractive index (1·34) than air, and this greater density has the effect of narrowing the angle of view of any camera lens when used with a flat interface between the camera and water. Objects will appear about one-third closer than they are in reality and, therefore, seem larger. The camera will be affected in the same way as the eye, so focus settings will need to be made at the apparent distance rather than the actual measured distance.

Clear water can also be regarded as a cyan colour filter. The strength of this is four colour compensating units per foot of light path – that is light source to subject plus subject to camera. Another factor also affects the colour, as well as restricting visibility – the plankton and sediment in suspension. As a general rule when the visibility is less than 30 feet (9 m) the colour of the water is green rather than cyan. It can be seen that with increasing depth from the surface there is progressively less red light present, and if it is required to retain surface colour, a CC filter of equal and opposite effect to the water colour can be used. However, in practice compensation with filters is only satisfactory within a few feet of the surface due to the rapid numerical build up of filter requirement and subsequent speed loss at around one stop for each 30 CC units used. CC red filters should be used in clear water and CC magenta filters in turbid conditions.

In the more turbid conditions, light loss by absorption can be severe and it is not unusual to have insufficient light for photography at depths of 30 feet (9 m) or less. When this occurs additional light has to be supplied. This is usually in the form of electronic flash

Colour correction on subject A, with a total light path of 7·5 feet (2·25 m) requires the use of a CC30R filter. Subject B, with a light path of 5 feet (1·5 m), requires the use of a CC20R filter whether the surface light or the flash is used as the main source.

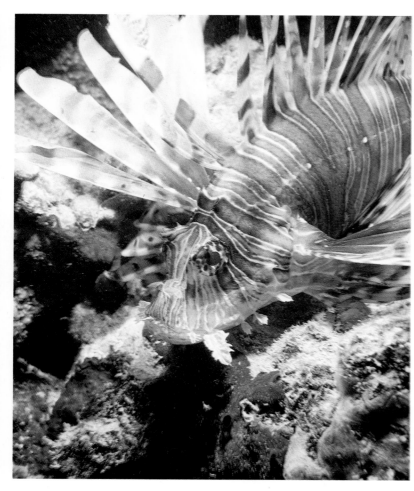

This lionfish was photographed in the Red Sea. *Mamiya RB67, electronic flash, f22, High Speed Ektachrome.*

mounted on the camera. Several benefits arise from the use of flash, firstly it frees the photographer from reliance on surface light penetrating with sufficient intensity to give realistic exposures; secondly, the speed of the flash at around 1/1000 second helps minimize subject and camera movement; and thirdly, missing colours are replaced. Even when flash is not required to provide total illumination it can be used to add the missing colours.

The presence of suspended matter in the water not only cuts down visibility but has another effect. Contrast is greatly reduced and it becomes necessary to approach as close as practical to the subject to preserve clarity and sharpness. To this end, wide-angle lenses are the norm, for the majority of underwater subjects. With black-and-white films the use of a yellow filter can assist the contrast and also a slight increase in development with a corresponding reduction in exposure can help. Beware of too much development as the large areas of even tone, common in underwater photographs, does nothing to hide grain which can become objectionable.

A golden rule is that satisfactory photographs can be obtained within one-third of the visibility, and when flash is used up to a quarter of visibility is the recommendation.

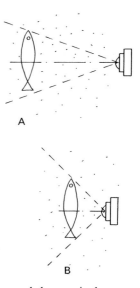

The suspended matter in the water produces a loss of image contrast A. The use of a wider angle lens allows closer approach and reduces the amount of degradation B.

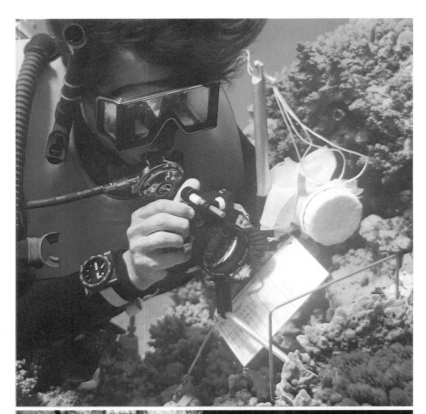

Left: A diver equipped with Nikonos camera with close-up attachments including a frame finder. Note the slate for recording data.

Below: A Nikonos camera with macro tube and frame finder.

Left: This moray eel was also photographed in the Red Sea. *Mamiya RB67, electronic flash, f22, High Speed Ektachrome.*

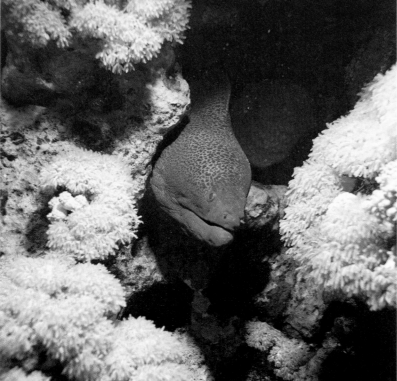

Below: A commercial alloy housing, designed for Nikon F2 or Canon single-lens reflex cameras, fitted with a powerful electronic flash unit.

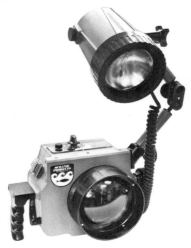

Equipment

Equipment available ranges from the true submersible camera of which there is only one practical specimen, the Nikonos, through to housings of plastic and metal for most land cameras. There is even a housing made by an American firm, Ikelite, for the Polaroid SX70.

The Nikonos camera is by far the most widely used under water, and with the lenses and attachments supplied by Nikon and other manufacturers it is a comprehensive system. It does, however, require a reasonable amount of practice and experience to achieve optimum results, due to the rather basic specification of the camera. Viewfinding and distance estimation are the drawbacks and various devices are used in conjunction with the camera to achieve good framing and focus, particularly so in the close-up field where zone frames are the order of the day. The advanced specifications of the modern single-lens reflex are employed by more aspiring photographers and the variety of housings available today cater for the most demanding user. Many housings are available with correction optics for wide-angle lenses retaining the optical correction and angle of view. In the simplest form such a corrector can be a dome, usually made of perspex, through which the camera lens operates. Viewfinding with an SLR can be a problem due to an inability to get the eye close enough to the eyepiece to see the whole screen.

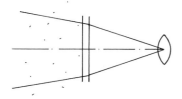 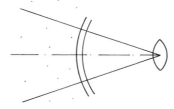

A reduction in lens angle is produced by a flat porthole and can be corrected with the use of a concentric dome.

The action finder of the Nikon and the similar finder for the Canon are most desirable features allowing ease of focus and viewfinding not available from other camera systems.

Electronic flash units are also available in a range of powers from the small units by Philips and Oceanic Products to larger guns also by Oceanic and See and Sea. The design of purpose-made flash units is such that extreme wide-angle lenses of 90° angle or more are covered and several units are endowed with built-in slave sensors to ease the problems with multiple flash photography. It is quite possible to use surface units housed in perspex or polycarbonate and the majority of underwater photographers are so equipped. Indeed

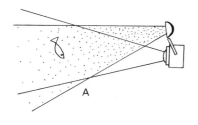 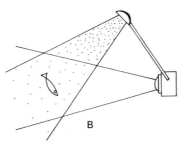

The flash close to the camera lens A illuminates the suspended particles intensely. Dramatic improvement can be achieved by mounting the flash well off the lens axis B.

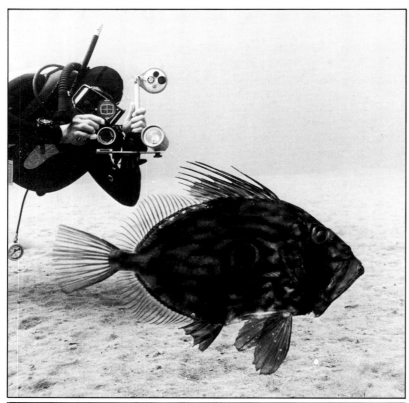

A diver equipped with Nikonos camera and electronic flash, photographing a John Dory.

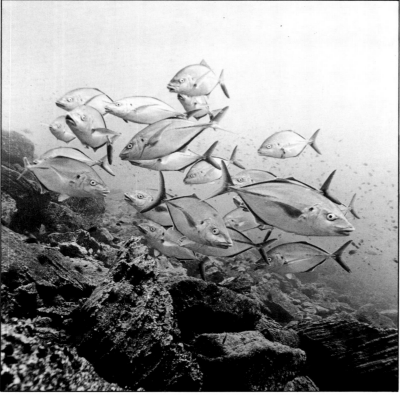

A school of jacks at a depth of 100 feet. *Mamiya RB67, 50 mm wide-angle lens, 1/60 sec, f5·6, Tri-X Pan.*

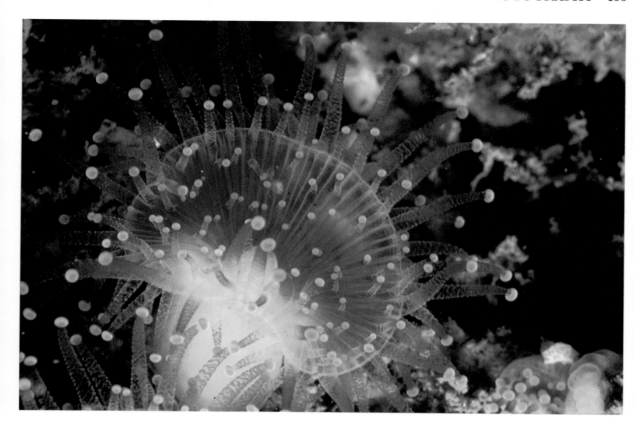

many flash housings and some camera housings are hand-made by the user. There are firms who cater for the D.I.Y. photographer.

Exposure meters are most desirable and there are two commercially available, the Sekonic marine, a robust, purpose-designed CdS instrument, and a polycarbonate housing for a selenium Sekonic. However, many photographers use other meters in home-made housings the simplest being a screw-top jam jar, which can be most effective and often used in an emergency. A word of caution here, the popular cadmium sulphide cell meter can be a trap. The spectral response of the CdS cell is biased towards the red end of the spectrum and because there is an abundance of blue-cyan the indications of an uncorrected CdS cell can lead to severe over-exposure. The selenium cell meter, such as the Weston, does not suffer from this effect and the response more closely matches the photographic emulsion.

On the practical side the underwater photographer has to spend a great deal of time on equipment maintenance, all seals require inspection and greasing each time the equipment has been used and meticulous care with electrical connections will assist reliability. The mechanics of diving require strenuous activity and it is all too easy to neglect some detail in photographic equipment with the subsequent disaster of flooding or malfunction just at the critical moment. The underwater photographer who does not have equipment problems does not exist!

This jewel anemone was photographed off the coast of Devon using a Nikonos camera with extension tubes, and is shown here approximately twice life-size.

Photography after dark

Photography after dark usually implies the taking of pictures by some form of artificial lighting. Sometimes, as when photographing neon illuminations and fireworks, it is the light source itself which is the subject of the picture. In other instances, as when photographing floodlit buildings, the picture is of an object illuminated by the light source. In both cases exposures are longer than those encountered in daytime photography, and a tripod is often essential to prevent movement of the camera during the exposure.

Included at the end of this chapter is a section on photography at the circus, as many of the principles of low-light photography apply to this and to the photography of other stage shows.

The most obvious difference between photography during the hours of daylight and photography after dark is, of course, the considerably slower shutter speeds and/or larger aperture settings which the latter requires to compensate for the much lower light levels involved. The picture, left, for instance, was exposed in bright sunshine at 1/250 second at f5·6. The same scene photographed at dusk, below left, was taken at 1/4 second at f4, an increase in exposure of just over 100 times.

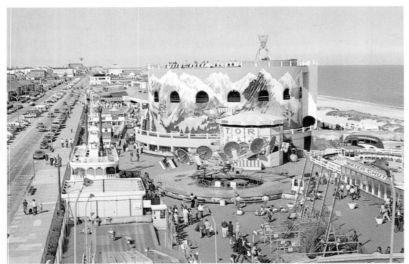

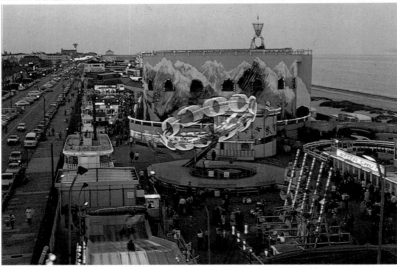

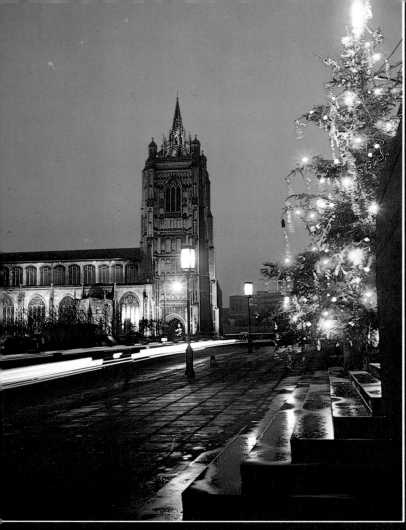

The picture, left, taken in Norwich, England, was exposed at dusk while there was light still remaining in the sky. Unlit areas of the church, such as the nave roof and the tips of the pinnacles, stand out well against the blue sky. Compare this with the picture below, taken half an hour later, when all the daylight had gone. The unlit areas have merged into the black of the sky and the outline of the building is lost. *Both pictures: Nikkormat, 8 sec, f5·6, Kodachrome II.*

The picture, bottom, is a reminder to pop a small torch into your gadget bag before setting out on a night photography session. You may need it to set the aperture and shutter speed of your camera.

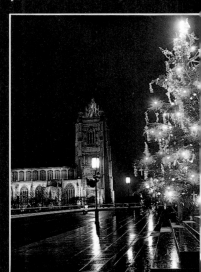

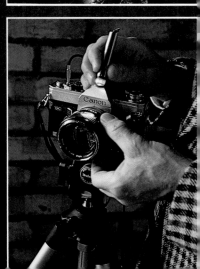

When photographing floodlit buildings and illuminations it is usually best to make the exposure at dusk while there is still sufficient light for the outline of unlit buildings to stand out against the sky. When it is completely dark, buildings and sky merge and the picture becomes a contrasty record of the illuminated parts of the subject, with no detail in the unlit areas.

Many of the best night pictures are taken after rain has fallen, when the streets and sidewalks are glistening with water. Photographs of places such as Times Square or Piccadilly Circus with their colourful neon advertising signs can often be improved by allowing reflections of the signs in the wet surface to complement the composition.

Film balanced for daylight or tungsten lighting may be used. Daylight film will accentuate the warmth of the artificial light, while film for tungsten light will emphasize the blueness of any remaining daylight. Both films give effective results.

Subject	*Suggested* exposures on 64 ASA film
Home interiors at night	
– brightly lit	1/15 sec, f2
– average lighting	1/4 sec, f3·5
Candle-lit close-ups	1/2 sec, f2·8
Brightly lit street scenes	1/30 sec, f2
Very brightly lit theatre districts	1/30 sec, f2·8
Shop windows at night	1/30 sec, f2·8
Floodlit buildings	4 sec, f5·6
Fairs, amusement parks	1/15 sec, f2
Brightly lit illuminations	1/30 sec, f2·8
Skyline, 10 minutes after sunset	1/30 sec, f4
Floodlit football matches	1/30 sec, f2·8
Bonfires	1/30 sec, f2·8
Firework displays	f8, keep shutter open on 'B' for several bursts
Circuses, stage shows	
– average lighting	1/30 sec, f2
– spotlighting	1/60 sec, f2·8

Some less-sensitive exposure meters are ineffective when working in dim light. The exposure table, left, gives an indication of the exposure required for some of the more commonly encountered 'available light' situations.

The longer shutter speeds required after dark cause moving subjects to be recorded as a blur. Moving lights appear as streaks on the film, rather than as single points of light. In the picture, left, the photographer has deliberately set out to obtain this effect to give the picture a good impression of the roundabout's movement. *1/15 sec, f5·6, Ektachrome 64.*

When photographing firework displays the shutter should be opened on 'B' and left open for several successive bursts if pictures like the one, below left, are to be obtained. The long exposure allows each burning fragment of the firework to record as a highly coloured trace as the firework explodes in the air. With 64 ASA film a suitable aperture to experiment with is f8, although, ideally, additional exposures either side of this should also be made.

The picture, below centre, shows the effect of using a fast shutter speed, in this case 1/60 second. The exploding firework has recorded only as minute points of light.

The picture of the little boy, below, was taken by the light of a bonfire at an organized firework display. The exposure was made on daylight film, so the low colour temperature of the illumination has caused the picture to have a reddish cast, which has given the picture a feeling of the warmth of the fire. *1/15 sec, f1·4, Ektachrome 200.*

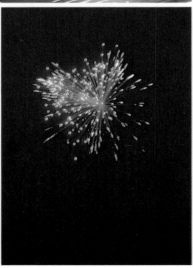

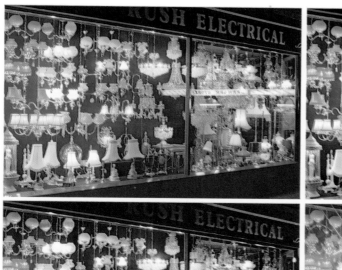

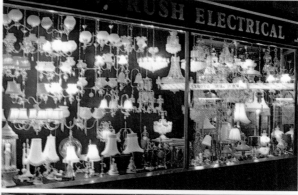

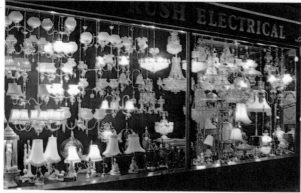

Shop-window displays are best photographed after dark, so that the effects of the window dresser's carefully arranged illumination can be seen, and so that reflections in the window glass may be kept to a minimum. All the above pictures were taken on daylight colour film. The picture, top left, was taken without a filter and, because the lights were tungsten lamps, is too warm in colour. The picture, top right, was taken using a Wratten 80A filter to achieve a more correct colour balance. The picture, centre left, also with the 80A filter, had the addition of a polarizing filter to eliminate the reflection of a shop sign across the road. The final picture, above, was exposed as the previous one, but with the addition of a 'starburst' filter to produce a star-shaped halo from each bright highlight of the scene.

The picture, left, of the Warkworth satellite transceiving station in New Zealand was achieved by a double exposure, and was carefully planned in advance. The moon was photographed into its correct position in the frame using a telephoto lens with an exposure of 1/125 second at f5·6. The antenna was exposed on the same frame several days later at dusk at 1/8 second at f8. *Photo by Robin Smith Photography Limited.*

Circus photography can result in exciting and spectacular pictures, full of colour and atmosphere, but success is often fraught with many difficulties.

In most circuses the illumination, although it may appear bright to the eye, is really quite low in intensity, and the use of flash is normally forbidden. In addition, the subject matter is usually moving fairly briskly. Together these factors demand the use of a high-speed film, a fast shutter speed, and a large aperture, often the largest your lens has available. This last requirement itself poses another problem – very small depth of field. With many acts the position of the artists is fairly predictable, e.g. trapeze and horse-riding acts, and it is possible to focus carefully on a particular spot and wait for the entertainers to reach it.

Movement can often be minimized by waiting for the correct instant, such as the split second a trampolinist is at the top of his trajectory, just before he begins to fall again.

The picture above was taken with a long focus lens to obtain a reasonable image size of the trapeze artist, who was swinging alternately towards and away from the camera. The lens was focused on a spot at one end of his travel and the shutter fired as he reached this point. *Nikkormat, 85 mm lens, 1/125 sec, f2, Kodak Ektachrome 160.*

The clown was seen to be coming round the ring towards the camera and the lens was quickly focused on a mark on the mat and the photograph taken as he reached it. *Nikkormat, 85 mm lens, 1/250 sec, f2, Kodak Ektachrome 160.*

Both the pictures on this page were taken on Ektachrome 160 tungsten film, uprated by modified processing to 320 ASA. For the unicycle troupe a meter reading was taken from the floor, which was receiving the same general lighting as the performers themselves. For the girl swinging by her hair advantage was taken of the Canon's spot-metering system to take a reading from the girl's body and legs only. *Both pictures: Canon FTb, 50 mm lens. Left: 1/250 sec, f1·8. Below: 1/125 sec, f1·8.*

One frequent cause of disappointing circus pictures is excessive lighting contrast. The human eye is so adaptable that we can look at a performer illuminated by a spotlight and still see all the detail in the shadow areas. Photographic films, particularly colour, are incapable of recording such extreme contrast. For this reason it is generally best to avoid photographing acts in which the artists are only partially illuminated by strong spotlights and to concentrate on those with more even illumination.

Flash photography

In the early days of photography, when electric lighting was in its infancy and many towns were as yet without mains electricity, photographers requiring to take pictures by lighting other than natural daylight often used magnesium ribbon, which burns in air to give an intense white light. It is difficult to light, however, and burns slowly. Exposures were long, particularly as the emulsions of those days were slow compared with the films of today. These difficulties were overcome to some degree by the development of the 'flash lamp', in which a tube positioned adjacent to the flame of a spirit lamp was filled with powdered magnesium. By squeezing a pneumatic bulb connected to the tube the photographer could propel the powder into the flame, where it ignited to give a flash of light.

By the turn of the century photographers were using specially prepared flashpowder, consisting of magnesium powder mixed with an oxidizing agent such as potassium perchlorate. The oxidizing agent was necessary because a pile of magnesium powder on its own burns on the outside only, combustion within the pile being prevented by lack of oxygen. The addition of the oxidizing agent produced an explosive mixture which would ignite even from a spark, a pile of the mixture burning in a fraction of a second to produce a brilliant flash.

The exact quantity of flashpowder required for a picture was decided according to the speed of the film or plate, the distance from the subject, and the lens aperture to be used. After being carefully measured out, the powder was poured into a specially designed tray. As soon as the camera shutter had been opened the flashpowder was ignited, either by lighting a fuse paper, firing a percussion cap, or by spinning an abrasive wheel against a flint in a way similar to an old-fashioned gas lighter. Flash photography indoors was usually limited to only one exposure, as immediately after the flash the room would be filled with white smoke, which would take some time to clear. There was also a considerable fire risk, as particles of hot ash would rain down around the photographer, the more cautious of whom would by fully prepared, equipped with hat and turned-up collar.

Flashbulbs

Flashpowder was in common use until the 1930s, the early years of which saw the introduction of the first commercially available flashbulbs, the basic principle of which remains unchanged today. A modern flashbulb consists of a quantity of fine magnesium, aluminium or zirconium wire contained in a sealed, oxygen-filled glass bulb. Two wires pass through the glass and terminate at the centre of the bulb, where the ends are smeared with a small quantity of explosive paste and are electrically connected together by a filament. Outside the bulb the wires terminate in some form of cap or terminals. When

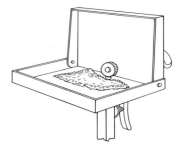

A flashpowder tray of a type used in the early part of this century. A clockwork mechanism, mounted on the outside of the lid, was wound by the key just visible to the rear of the lid. The trigger adjacent to the handle released the mechanism, allowing the serrated wheel to spin against a flint to produce sparks which, hopefully, ignited the flashpowder in the tray.

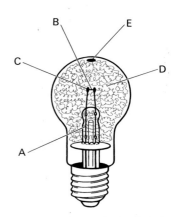

A large, powerful flashbulb, of similar size to a domestic lightbulb.
A: lead-in wires
B: filament
C: explosive paste
D: fine magnesium, aluminum or zirconium wire
E: safety indicator

these are momentarily connected to an electrical power source –
usually battery powered – a current passes through the filament, and
the heat produced detonates the explosive paste, throwing hundreds
of burning particles throughout the bulb. These ignite the
magnesium or zirconium wire, which burns instantly to give a very
bright flash of light. A considerable amount of heat is also produced,
causing the glass to break into many pieces. To keep the pieces
together each bulb is dipped during manufacture in a lacquer which
dries to form a tough transparent skin. It is quite rare for a bulb to
explode, and on the odd occasion when this does happen it is usually
due to the glass being cracked or imperfectly sealed before use,
resulting in air entering the bulb. The intense heat produced when
the bulb fires causes this air to try to expand to many times its
original volume, and the pressure within the bulb becomes too great
for the protective lacquer to withstand. To minimize the chances of
explosion, most bulbs include an indicator to show if air has entered
the bulb. This consists of a small blob of cobalt chloride, which in
the dry atmosphere of a perfectly sealed bulb remains blue in colour.
If any air finds its way into the bulb the small amount of water
vapour present in the air is sufficient to change this colour to pink.

A flashcube, containing four bulbs, each
with its own built-in reflector.

The colour temperature of the light produced by burning
magnesium or zirconium in oxygen is about 3800 Kelvins. The
majority of colour films are balanced for 5500 Kelvins, however, and
the colour temperature of the light output of most flashbulbs is
converted to this value by the inclusion of a blue dye in the
protective lacquer coating of the bulb.

Flashbulbs are used extensively with the cheaper pocket cameras
and with most instant picture cameras, both of which have a socket
which accepts either a flashcube or a flashbar. Flashcubes each
contain four bulbs, one on each of four of the sides of the cube, and
each with its own built-in reflector. When the camera shutter
operates the bulb on the side of the cube facing the subject fires.
When the film advance lever is operated the flashcube rotates a
quarter of a turn, bringing a new bulb into position in readiness for
the next picture. There are two types of flashcubes – the original
type containing conventional flashbulbs which are fired electrically
by a battery contained within the camera, and the more recent
version in which the bulbs are not fired electrically, but contain a
percussion detonator fired by a spring-loaded mechanism, contained
within the casing of the flashcube. This is released by a pin that
projects from the camera as the shutter is operated.

If a flashcube is plugged directly into the socket on top of the
camera the light it produces is very flat and gives little modelling,
due to the close proximity of the flashcube to the camera lens. An
additional problem which results from this close proximity is the
phenomenon known as 'red-eye', which occurs when photographing
people and animals and is caused by reflection of the flash from the
retinas of the subject's eyes. This can be avoided, and modelling
improved, by the use of a flashcube extender which fits between
flashcube and camera, extending the distance between light source
and lens.

Very close proximity of the flash to the
camera lens produces the phenomenon
known as 'red-eye', caused by reflection
of the flash from the subject's eyes,
which can be avoided by increasing the
separation between flash and lens.

A more recent development is the flashbar, containing eight or ten flashbulbs, which also plugs directly into the camera, sitting vertically above it. The bulbs within the flashbar are fired electrically, but the energy is supplied by a piezo-electric device within the camera, rather than by a battery. The device is similar to those used in some 'electronic' cigarette lighters, and produces a high voltage pulse when it is suddenly flexed mechanically by a part of the camera's shutter mechanism. The flashbar is divided into halves, each half having its own plug-in connector. Once the first bulb has been fired, selection of the next is automatic, the heat from the first having fused a special compound, making it electrically conductive and thus completing the electrical connection to the next bulb. When all the bulbs in one half have been used the bar is inverted, bringing those in the second half into operation. The bulbs in use are always those in the half furthest away from the camera lens, thus giving the maximum separation possible between bulb and lens.

Flashbulbs for professional use are usually much larger than the amateur varieties – some are as large as domestic light bulbs – and give a considerably higher light output. Even so, the bulbs and the equipment required to fire them are small in size compared with other forms of artificial lighting, and this makes them an ideal choice for photographing subjects requiring a lot of artificial lighting, such as large interiors of buildings, particularly when lights are required in several different positions to ensure even illumination. Unfortunately, however, the demand for professional flashbulbs is becoming insufficient for the manufacturers to sustain production, and in many countries supplies are often difficult to obtain.

A flashbar containing ten bulbs, each with its own reflector. The plug-in connectors, which fit directly into a socket on the camera, are each connected to the five bulbs at the opposite end of the flashbar, thus ensuring maximum separation between flash and camera lens. When the first five bulbs have all been fired the flashbar is reversed to bring the remaining five into operation.

Electronic flash

In the late 1930s a completely different form of flash lighting was developed. Known as 'electronic' or 'strobe' flash, this relies on the sudden discharge of electrical energy through a gas-filled tube to produce a brief yet very intense flash of light. Unlike the flashbulb, which can be used once only, the electronic flash tube will last for many thousands of flashes. Although the initial cost of the equipment is higher than that for flashbulbs, the cost per flash is much lower.

The heart of any electronic flash unit is the flash tube itself. This consists of a glass or quartz tube, sealed at both ends, from which all the air has been evacuated, and into which has been introduced a small amount of xenon, one of the rare gases. When an electrical current is passed through it, xenon emits a white light which is a reasonable approximation of daylight and which requires a minimum of filtration to achieve a satisfactory colour balance when used to expose a colour film balanced for daylight. Inside the flash tube are two metal electrodes, one at each end, the electrical connections to which pass through the glass seals to the outside, where they connect to a capacitor, a device which has the ability to temporarily store a large amount of electrical energy. The capacitor is charged to a voltage – about 250 to 350 volts in most modern flashguns – which in itself is not sufficiently high to initiate an

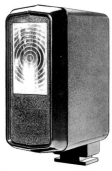

A small, non-automatic electronic flashgun.

electrical discharge through the gas, this being achieved by additional circuitry described later. In battery-operated units this voltage is derived by stepping-up the low voltage supplied by the battery. Batteries produce direct current (DC), which cannot be directly transformed to a different voltage, this being possible only with alternating current (AC). Consequently the DC from the

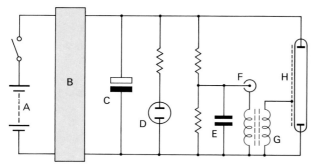

battery is converted to AC by a transistorised oscillator within the flashgun, and it is this AC which is supplied to the primary winding of the flashgun's transformer. High voltage AC is induced in the transformer's secondary winding and is rectified to produce the high voltage DC which charges the main capacitor, the voltage across which rises until it reaches the peak value of the voltage charging it. A neon indicator connected across the capacitor lights when the voltage is almost at its maximum, to show that the flashgun is ready for use.

We have already seen that the voltage across the charged capacitor is insufficient to make the gas in the flash tube conduct initially, and this is achieved as follows. A second, much smaller capacitor, known as the trigger capacitor, is charged simultaneously with the main capacitor, but for safety's sake usually to a lower voltage, often between 100 and 200 volts. The trigger capacitor is connected via the flashgun's synchronizing cable, and hence via the synchronizing contacts in the camera shutter, to the primary of another, but smaller step-up transformer known as the trigger coil. When the camera shutter operates, the synchronizing contacts close, acting as a switch to allow the small amount of energy stored in the trigger capacitor to discharge into the primary of the trigger coil, with the result that a very high voltage is induced in the secondary of the coil. This voltage, usually of the order of several kV (1 kV = 1000 volts), is applied to a third electrode – the trigger electrode – on the flash tube. Unlike the two main electrodes, the trigger electrode does not actually enter the tube, but is simply a wire running the length of the outside of the tube or, more commonly nowadays, a transparent, electrically conducting coating deposited on the outside of the tube. The presence in such close proximity to the flash tube of the high voltage generated by the trigger coil causes the gas within the tube to become ionized. Because ionized gas is a good conductor of electricity this results in the electrical energy stored in the main capacitor discharging through the flash tube, producing a brilliant white flash. A fraction of a second later the voltage across the

The diagram, left, shows the basic circuit of a simple, non-automatic electronic flashgun.

Low voltage DC from the battery, A, is stepped up to a higher voltage – usually just over 300 volts – by the convertor, B, which is basically an oscillator comprising a transistor, a step-up transformer, and a few other components. The resulting energy is stored in the flash capacitor, C. When the capacitor is almost fully charged the neon lamp, D, lights to indicate that the flashgun is ready for use. During this period the much smaller, trigger capacitor, E, has also become charged, but to a lower, safer voltage – usually about 150 volts. The socket, F, is connected via the synchronizing cable to the camera's flash socket, and thus to the electrical contacts within the camera's shutter. When the shutter opens these contacts close, and the energy stored in the trigger capacitor is discharged through the primary of the trigger transformer, G. A very high voltage pulse – several kV – is induced in the transformer's secondary winding, which is connected to the trigger electrode of the flash tube, H. As a result the xenon gas inside the flash tube becomes ionized and, therefore, electrically conducting, and thus offers an electrical path to the energy stored in the main flash capacitor, C, which rapidly discharges through the flash tube to produce an intense flash of white light.

capacitor will have fallen to a level – usually something a little less than 100 volts – at which the gas can no longer maintain conduction, and light emission ceases. The actual time for which the flash tube emits light varies from unit to unit, but for most 'non-automatic' flashguns is between 1/500 and 1/2000 second. It is this very short flash duration which gives electronic flash its unique ability to 'freeze" the movement of the subject.

Once the flash tube has ceased to emit light, the gas inside it ceases to be ionized, and is, therefore, unable to conduct again until the next trigger pulse, so the main capacitor begins to recharge in readiness for the next flash. The time which elapses between one flash and the neon indicator lighting to show that the flashgun is ready for the next is known as the flashgun's recycling time, and determines the maximum rate at which pictures can be taken. This is often an important consideration in many situations, such as photo-journalism and wedding photography. The recycling time is partly dependent on the type of batteries used and on their state of exhaustion. Flashguns fitted with dry batteries often have recycling times longer than do those using rechargeable batteries, although the use of manganese alkaline dry batteries will usually give faster times than the cheaper carbon-zinc variety. There are two types of rechargeable batteries used in flashguns – nickel cadmium and lead acid. The nickel cadmium battery is the more common nowadays, and is more robust and less prone to leakage than the lead acid type. One advantage of the lead acid battery, however, is that the specific gravity of the liquid electrolyte – sulphuric acid – is dependent on the battery's state of charge. Manufacturers make use of this property by incorporating into each cell of the battery a sight tube containing small coloured balls of different densities, all or some of which float or sink to indicate the state of charge. Nickel cadmium batteries do not usually have any such provision, and it is difficult for the photographer to assess the state of charge, although the flashgun's recycling time does become extended when the battery is almost fully discharged.

Most flashguns with rechargeable batteries have provision for recharging the battery from the mains supply without removing it from the flashgun, although some makes require it to be removed and fitted into a special external charging unit. The time taken to fully recharge a completely exhausted battery is usually about 12 to 14 hours, although some flashguns have fast chargers which give a full recharge in about 3 hours. When there is a doubt about the state of charge of a nickel cadmium battery and it is essential that the flashgun has a fully charged battery, e.g. when expecting to take a large number of pictures, it is usually permissable to charge the battery for the full period, even though this will probably be longer than actually necessary. Excessive overcharging should be avoided, as it may eventually reduce the life of the battery. Rechargeable batteries often deteriorate fairly quickly if they are left in a fully discharged state for more than a few weeks. It is always good practice to put the flashgun away with a fully charged battery if it is not used for some time. If the period runs into months it is advisable

to give the battery a charge every month or so, as a fully charged battery does not remain so indefinitely, the charge gradually leaking away due to internal electrical leakage within the battery.

Because of the regular attention required by rechargeable batteries, photographers requiring a small, low-power flashgun for occasional use only would do best by buying one which operates from dry batteries. The batteries should be removed when the flashgun is not in use, as dry batteries have a tendency to leak if left for long periods, particularly when they are near to exhaustion. Any leakage of the batteries' highly corrosive electrolyte within a flashgun can be disastrous, as the battery contacts can be eaten away and, if the leakage remains unchecked for long enough, the electrolyte may creep into the works themselves, corroding printed circuit board conductors and component leads.

Many battery-operated flashguns have a facility which allows them to be powered from the mains supply, without the use of the batteries. In some flashguns with rechargeable batteries this facility is provided by the battery charging unit, in others a separate mains adaptor is required.

We have seen that in a basic electronic flashgun readiness for use is indicated by a neon lamp which lights when the voltage across the main capacitor has reached a useful level. This voltage is not the maximum to which the capacitor will finally charge, however. The reason for this is that the voltage rises rapidly initially, but as it approaches the maximum the rate of increase becomes progressively slower, the last 10% of rise taking about as long again as the preceding 90%. If the manufacturer were to adjust the circuitry such that the neon lights at a voltage very near to the maximum, the recycling time would appear unacceptably long. In addition, when the batteries had become partially exhausted the maximum voltage might fall to a level lower than that to which the neon lamp is set, and the lamp would not light at all. Consequently most manufacturers adjust the circuitry so that the neon lights when the voltage reaches something between 80% and 90% of the maximum. This can result in there being a noticeable difference in the exposure levels received by a picture taken immediately after the neon lights and one taken a considerable time after it lights, when the voltage is nearer its maximum. The difference is particularly evident when reversal colour film, with its comparatively small exposure latitude, is used. Although the difference in voltage between, say, 85% of maximum and 100% may seem fairly small, the difference in the corresponding light outputs is considerable. This is because the amount of energy stored in the capacitor – and hence the light output – is proportional to the *square* of the voltage. The difference is made even more by the usable energy being restricted to that part which is discharged before the capacitor voltage has fallen to a level at which the flash tube ceases to conduct, i.e. typically a little under 100 volts. With cheaper flashguns it is common for the above exposure difference to be half a stop or even more. For this reason many of the more expensive flashguns incorporate additional voltage sensing circuitry which switches off the power from the battery

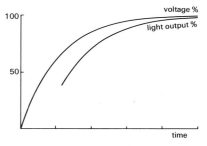

After switch-on, the voltage across a flashgun's main capacitor at first rises rapidly, but then tails off, taking a considerable time to reach its maximum. To prevent the recycling time from appearing unduly long the manufacturers of most inexpensive flashguns set the neon to light at some point before the voltage reaches maximum. The light output of a flashgun is roughly proportional to the *square* of the voltage, however. The graph, above, shows that if the neon is set to light when the voltage has reached, say, 80% of maximum, the light output obtained if the flash is fired at precisely this moment will be only about 60% of maximum, compared with just over 90% if the flashgun is not fired until about as long again after the neon lights. In terms of exposure the difference is just in excess of half a stop, sufficiently great to be noticeable if reversal colour film, with its comparatively small exposure latitude, is being used.

when the capacitor voltage has reached a preset level. Ideally the voltage would then stay at that level until the flash has fired, but in practice it slowly falls, due to internal electrical leakage within the capacitor and additional leakage through the components to which the capacitor is connected, and when it has dropped to a value slightly lower than the preset level the sensing circuitry turns the battery power on again. The capacitor voltage again rises to the preset level, and battery power is again turned off. This intermittent switching off and on of the battery power continues until the flash is fired. By this means the voltage across the capacitor is held to a very close tolerance, ensuring that the light output is consistently the same.

Expensive flashguns often incorporate additional circuitry to regulate the capacitor voltage. In the example, above, the regulator circuitry turns off the power as soon as the voltage reaches the preset level at which the green indicator lights, and consequently the voltage ceases to rise. As soon as the voltage falls back below the preset level the power is turned on again until the preset level is again reached. This procedure continues, the power turning intermittently on and off, until the flashgun is fired. In this way the voltage is held virtually constant, ensuring that the light output is always consistently the same.

Assessing the correct exposure

When using flashbulbs or electronic flash it is important to ensure that the camera's shutter and its synchronizing contacts, if adjustable, are set correctly, so that the shutter is fully open when the flash is producing its maximum light output. When using electronic flash with between lens shutters this requires the contacts to be on the X setting – the shutter speed can usually be any convenient value (see p. 28). Electronic flash used with focal plane shutters also requires the X setting – most modern cameras with focal plane shutters have no other setting anyway – but the shutter speed must be set to a speed at which the shutter blinds are exposing the entire area of the film gate when the contacts close (see p. 32). This usually means that the fastest speed which can be used is between 1/30 and 1/125 second, depending on the make of camera (see manufacturer's instructions). When using flashbulbs with between-lens shutters, speeds of up to 1/25 or 1/30 may be used with the contacts on the X setting, for faster speeds the M setting, if available, must be used, although this will result in some of the flashbulb's light output being wasted (also see p. 28). Flashbulbs with focal plane shutters usually require a shutter speed of no faster than 1/25 or 1/30.

Flash photography, whether by flashbulb or electronic flash, requires the aperture of the camera lens to be adjusted according to the speed of the film, the distance between flash and subject, and the power of the flash. This last parameter is indicated by a number, known as the guide number or flash factor, and is quoted by the manufacturer in feet or metres at a particular film speed. To find the lens aperture required for an average subject, i.e. one with an average balance of light and dark tones, when using a film of that particular speed it is necessary only to divide the guide number by the distance between the flash and the subject. Thus, for a flash with a guide number of 80 (in feet) used at a distance of 20 feet from the subject, the lens aperture needed is 80/20=f4, or if used at 10 feet from the subject the aperture required is 80/10=f8.

The method of calculating flash exposures using guide numbers is made possible by the similarity between the fall-off of light with distance, known as the inverse square law, and the standard series of numerical values given to the aperture settings of a lens. The inverse

square law states that, for a point light source, the intensity of the light falling on an object is inversely proportional to the *square* of the distance between the light source and the object. If, for example, we consider objects at 10 feet and 20 feet from a light source, the object at 10 feet, being only half as far from the light as the object at 20 feet, will receive $2^2 = 4$ times as much light. As we have seen (p. 21), altering the setting of the lens aperture changes the light intensity falling on the film by an amount equal to the *square* of the factor by which the numerical value of the aperture has been changed. Therefore, if it is found that f8 gives the correct exposure using a particular flashgun at a distance of 10 feet from the subject, then at 20 feet, at which the light intensity will be reduced to $1/4$, the lens aperture must be opened to f4, at which it passes four times as much light, in order that the correct exposure may be maintained. Note that in both instances the number resulting from multiplying the flash to subject distance by the aperture value is the same, i.e. 80, and this is the guide number of the flash.

Although the manufacturers of flash equipment usually quote the guide numbers of their products at only one film speed, it is easy to calculate the guide number for film of a different speed, although here a little care is necessary, as the guide numbers do not bear a simple numerical relationship to film speed due to the way in which they are derived. The known guide number must be modified by a factor equal to the square root of the simple numerical relationship between the film speeds. For a flash with a guide number of 80 at 100 ASA, for example, the guide number at 50 ASA is $80/\sqrt{2} = 56$, or $80/\sqrt{4} = 40$ at 25 ASA, or $80 \times \sqrt{2} = 113$ at 200 ASA. This non-linear relationship also applies when comparing the relative output powers of two flashguns. If at the same film speed one flashgun has a guide number twice that of another, the one with the higher output will produce four times the light output of the other.

Most flashguns incorporate as a part of their casing a simple calculator disc or table that indicates the correct lens aperture for various distance/film speed combinations.

When using a flashgun for the first time it is advisable to make a few test exposures and evaluate the results before using the flash on anything of importance. Although the manufacturer quotes a nominal guide number, in practice the actual guide number may be different from this, due to tolerances allowed during manufacture in the electrical characteristics of the electronic components within the flashgun. The difference between the actual guide number and that stated may be sufficient to produce noticeably incorrectly exposed pictures, particularly when reversal colour film with its small exposure latitude is being used.

As with any method of exposure evaluation, the determination of exposure for flash photography must be effected with care. Consideration must be given to the light-reflecting properties of the subject, and if the subject is lighter or darker than average some modification of the calculated exposure must usually be made to ensure a correctly exposed result. An additional factor affecting the

exposure, and one which is often overlooked, is the presence or otherwise of light-reflecting surfaces within the vicinity of the subject. A photograph taken by flash in a small room with white walls would require less exposure than one of the same subject with the same flash to subject distance taken in a very large room with few reflecting surfaces, or outdoors with no reflecting surfaces.

An ideal method of evaluating the required exposure with non-automatic flashguns is to use a flashmeter, of which there are several types available. Most take a reading by the incident light method, i.e. the meter is positioned as close to the subject as possible, such that it measures the light falling on the subject, rather than that reflected from it (see p. 58).

Most flashmeters operate by allowing the current passed by a photo-cell to charge a capacitor, the two components together forming a light integrator. The voltage across the capacitor at the end of the flash is a function of both the intensity and the duration of the flash, and thus simulates the response of the film. The voltage is usually measured by a galvanometer which is calibrated in lens aperture settings, although some flashmeters have a digital display which indicates the aperture required directly, with no moving parts. In order to prevent ambient light, i.e. light from sources other than the flash, from influencing the reading either before or after the flash, it is necessary for the integrator to be made operative only for the period of the flash itself. Many flashmeters achieve this by requiring the flashgun's synchronizing lead to be plugged into the flashmeter, so that the flash may be fired by a button-operated switch on the flashmeter itself, this switch also initiating the operation of the integrator. A timing circuit turns the integrator off a millisecond or so later, by which time the flash will have ended. Some flashmeters do not require an electrical connection between the flashmeter and the flashgun, but incorporate some additional very fast-acting circuitry which detects the sudden increase in light level as the flash begins to fire, and initiates the operation of the integrator. On a few flashmeters the period during which the integrator operates is adjustable, and can be set to be the same as the shutter speed being used on the camera. This facility is particularly useful when a picture is being taken by a mixture of flash and some other form of lighting, such as daylight, as an accurate indication of the exposure required to the combined lighting can be obtained.

Because they measure the incident light falling on the subject, flashmeters automatically allow for the reflective qualities of walls and other surrounding objects, but not for the subject itself, for which exposure adjustments may still be necessary.

As we have seen, the majority of flashmeters indicate the correct exposure by measuring the *total* light output of the flash, taking into account both the intensity and the duration of the flash. Because of this the exposure required for flashes of almost any duration can be accurately measured. This is particularly important when a flashmeter is used to check the lens apertures required with automatic flashguns, which, as we shall see in the next few pages, automatically maintain the correct exposure by changing their flash

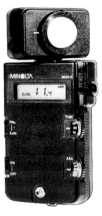

The excellent flashmeter, above, has a digital display which directly indicates the lens aperture to be used. Readings may be taken by the incident and the reflected light methods (the translucent dome for taking incident light readings is shown). A feature of this particular meter is that the period during which the light is measured can be set to be the same as the shutter speed of the camera. It is thus possible to measure not only the exposure for the flash but also that of any ambient lighting – useful when pictures are to be taken by a mixture of flash and some other form of lighting such as daylight. The response of the photo-cell is sufficiently fast to accurately measure the very short duration flashes produced when an automatic flashgun is used at small flash to subject distances.

duration according to the amount of light reflected back by the subject. A few flashmeters, mostly older models, measure the *peak* light output of the flash, and these are unsuitable for accurate use with automatic flashguns, as flashes of considerably different durations, and hence with different total light outputs, may have similar peak outputs.

Automatic flashguns

A considerable advance in electronic flashgun design in recent years has been the development of 'automatic' or 'computer' flashguns, which automatically adjust their output to give the correct exposure. This is achieved by adding to a basic manual flashgun circuit some additional fast-acting components which measure the total amount of light reflected back by the subject, and cut off the light output of the flashgun when this amount is just sufficient to give the correct exposure with the lens aperture and film speed in use.

The light reflected by the subject is measured by an integrator, similar to that in a flashmeter, consisting of a photo-cell, which looks at the subject, and a capacitor. As soon as the flash tube begins to emit light at the beginning of a flash the voltage across the capacitor begins to rise, at a rate proportional to the intensity of the reflected light. When this voltage reaches a preset level the flash tube is prevented from emitting any further light, and the exposure is terminated. The sensitivity of the light integrator is adjusted by the manufacturer so that the preset level is reached, and the flash tube turned off, at a moment which should coincide with that at which the film in the camera has received precisely the correct exposure. The duration of the flash is thus inversely proportional to the intensity of the light reflected back by the subject – the brighter the light the shorter the flash duration, and vice versa. The brightness of the reflected light is dependent on the distance between flash and subject and the light-reflecting qualities of the subject and its surroundings.

There are two methods by which the flash tube may be switched off when the integrator's preset voltage is reached. The original method, still used in most cheaper automatic flashguns, uses an additional but special flash tube, known as a 'quench tube', which is connected across the main flash tube, but which has its own trigger circuitry operating at the instant the integrator's preset voltage is reached. The quench tube is physically shorter and fatter than the main flash tube, and when triggered offers a much easier path to the energy stored in the main capacitor. Thus, any energy remaining in the main capacitor at the instant the quench tube is triggered chooses to pass through the quench tube in preference to the main flash tube, and the latter ceases to emit light. The quench tube itself emits light when the energy passes through it, but as it is contained within a light-tight part of the flashgun's casing this light is prevented from reaching the subject.

A disadvantage of automatic flashguns of the quench tube type is that the energy remaining in the main capacitor at the end of the exposure is wasted, being dissipated in the quench tube when it

A small automatic flashgun. The photocell which reads the light reflected from the subject can be seen on the front panel, immediately below the model number.

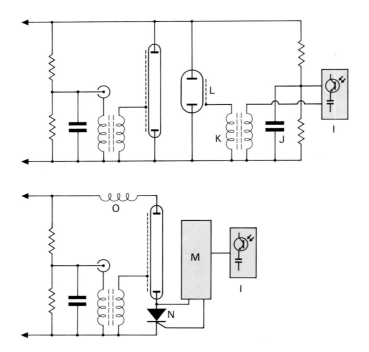

conducts to terminate the flash. If the flash to subject distance is small, requiring only a very short duration flash for the correct exposure, the energy wasted can be a considerable proportion of the total available in the capacitor at the beginning of the flash.

The other method of turning off the flash tube when the integrator voltage has reached its preset level is that used by flashguns advertised as being of the 'thyristor' or 'energy saving' type. In these a thyristor, which is a very fast-acting electronic switch, is connected between the main capacitor and the flash tube. The thyristor is in the 'on' condition when the flash tube is triggered, and the energy in the main capacitor begins to discharge through the flash tube, which emits light. When the light reflected back by the subject has been sufficient for the integrator voltage to reach its preset level the thyristor switches off, terminating the supply of energy to the flash tube, and light emission ceases. Any energy remaining in the main capacitor at this time is not lost. Consequently, for the flashgun to be ready for the next flash, the battery has to supply only sufficient energy to supplement that remaining from the previous flash, rather than having to charge the capacitor from an almost fully discharged state, as is necessary with flashguns of the quench tube type. The advantages of this are twofold. Firstly, the reduced energy demand on the battery allows a greater number of flashes before the battery becomes exhausted, and secondly, the recycling time between flashes is reduced. Obviously these advantages are most apparent at small flash to subject distances, at which the flash duration is very short and only a small amount of energy is discharged per flash. A typical thyristor flashgun used at its minimum distance for correct automatic operation has a flash duration of 1/50,000 second, a recycling time of 0·25 second, and will give 1000 flashes before its

These diagrams show the additional circuitry of the two different types of automatic flashguns. In both types the circuitry to the left of the flash tube is identical or similar to that of the basic flashgun shown on page 165, and so only a part of this has been included in these diagrams.

The upper diagram shows the additional circuitry of an automatic flashgun of the 'quench tube' type. The sensor, I, consists basically of a photo-cell, which as soon as the main flash tube fires allows a small capacitor to charge at a rate dependent on the light reflected by the subject, and a few additional components which detect when the voltage across this capacitor has reached a preset level. Components J and K are an additional trigger capacitor and trigger transformer, similar to those used to trigger the main flash tube. When the voltage across the small capacitor in the sensor reaches its preset level the additional trigger capacitor is allowed to discharge through the trigger transformer, producing a very high voltage pulse which is applied to the trigger electrode of the quench tube, L, causing it to conduct. When conducting, the quench tube has an electrical resistance much lower than that of the main flash tube, so the energy remaining in the main flash capacitor is dissipated through the quench tube rather than through the main flash tube, and the latter, therefore, ceases to emit light.

The lower diagram shows an automatic flashgun of the 'thyristor' type. The automatic function is controlled by the control circuitry, M, which is too complicated to be shown here in full and is, therefore, represented simply as a box. At the moment the flash tube is triggered the thyristor, N, which may be regarded as a very fast-acting electronic switch, is in an 'on' condition, so the flash tube is allowed to conduct and, therefore, emits light. The sensor, I, measures the light reflected back by the subject and when the preset level is reached sends a signal to the control circuitry which then turns off the thyristor, cutting off the supply of current to the flash tube which, therefore, ceases to emit light. Any energy remaining in the main flash capacitor at this moment is not lost, but is saved for the next flash. The inductance, O, is necessary to restrict the current passing through the flash tube when it is conducting to a value which the thyristor can safely handle, and also to facilitate the turning-off of the thyristor.

freshly charged nickel cadmium battery becomes exhausted. If the
flash to subject distance is increased to the maximum for automatic
operation the duration increases to 1/400 second, the recycling time
rises to about 9 seconds, and the number of flashes per battery
charge falls to only 60.

The control circuitry required to turn off a flash tube by the
thyristor method is considerably more complicated than that
required to control a quench tube, and consequently thyristor
operation is usually found only in flashguns in the medium to high
price bracket.

When using automatic flashguns of either type care must be taken
to ensure that the flash to subject distance is not greater than the
maximum possible for correct automatic operation, i.e. the distance
beyond which the integrator voltage will never reach its preset level,
with the result that the flashgun gives a flash of maximum duration.
With cheaper flashguns one usually has to rely on the manufacturer's
information as to what this distance is, but on many automatic
flashguns of professional quality there is an indication that the
maximum distance has not been exceeded and that the automatic
exposure circuitry has functioned. On some flashguns this indication
is provided by an additional neon lamp which pulses briefly after the
flash has fired if the automatic circuitry has functioned, on others an
audible 'ping' is produced.

All but the very cheapest automatic flashguns offer the user a
choice of lens aperture settings at which the correct exposure will be
automatically given. The choice is usually made by adjusting a
control, calibrated in f-numbers, which brings neutral density filters
of various values in front of the photo-cell. A typical flashgun might
have three or four possible aperture settings, the actual values of
which depend on the film speed in use. For example, with a 50 ASA
film the largest aperture possible for automatic operation may be
f5·6, and with the control on this setting the photo-cell would have
no filter over it. If the camera lens is set to f5·6 correct exposure of
the film should result. The next setting would be f8, and on this
setting the photo-cell would have over it a filter which cuts down the
light reaching it by half. Consequently the integrator voltage will
take twice as long to reach its preset level, and the flash duration,
and hence the flashgun's light output, will be doubled, requiring the
camera lens aperture to be closed by one stop, i.e. from f5·6 to f8, if
correct exposure of the film is to be maintained. Similarly, the next
setting of the flashgun's control, f11, would place over the photo-cell
a filter which cuts down the light falling on it by half again, forcing
the flashgun to again double its light output. On some flashguns
the settings are continuously variable rather than in one stop
increments, thus allowing the selection of intermediate aperture
settings.

Often the smallest aperture setting possible for automatic
operation with slow- or medium-speed films may not be small
enough for the requirements of the photography being undertaken.
In close-up photography, for example, apertures as small as f16 or
even f22 may be necessary to obtain sufficient depth of field. The

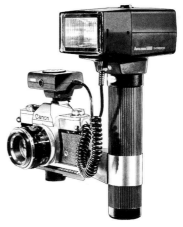

A powerful electronic flashgun of the
'thyristor' type. Note the remote sensor
which fits in the accessory shoe of the
camera. At each film speed setting the
choice of lens apertures in the automatic
mode is continuously variable within a 4-
stop range. This particular flashgun also
has the facility known as 'power ratio
control', which allows the light output in
the manual mode to be adjusted from
full power, through half power, quarter
power, etc., right down to 1/128 power.

flashgun's aperture range may be extended beyond that normally possible by taping additional neutral density filters over the sensor window, to fool the flashgun into giving a higher light output. The universally accepted scale of optical density is logarithmic, each 0·3 (=approx. log 2) increment cutting the light by half. One might expect, therefore, that a 0·3 N.D. filter must be added for each extra stop by which the light output is to be increased. This is not exactly the case, as the values marked on neutral density filters only indicate their optical density to *visible* light. The photo-cells of most automatic flashguns exhibit quite a high sensitivity to infra-red, in addition to their sensitivity to visible light, however, and infra-red also constitutes a considerable proportion of the radiant energy emitted by the flashgun. Consequently the flashgun's automatic exposure circuitry decides the correct flash duration by measuring a mixture of both visible light and infra-red, even though the photograph itself is taken almost entirely by the visible content of the light emitted by the flashgun. The density of a N.D. filter to infra-red is not so high as the visible-light density marked upon it, and consequently the value required over the flashgun's photo-cell for a given increase in light output is higher than might at first be expected. In practice a filter of 0·4 density, or even slightly higher, must be added for each one stop increase in light output required.

An important point to remember when deciding to which setting to adjust the flash, either with the flashgun's normal control or by attaching additional N.D. filters, is that the smaller the lens aperture chosen the longer, and therefore the nearer to the maximum, will be the flash duration. Consequently the smaller will be the maximum distance over which the flashgun will maintain its automatic exposure facility. For every two stops by which the light output is increased the maximum distance is halved.

On most cheaper automatic flashguns the light sensor is built into the body of the flashgun, and its position is fixed at manufacture such that it measures the light reflected back by the subject only when the flash is pointing directly at the subject. As we shall see later, there are occasions when the lighting effect may be more pleasing if the flashgun is not pointed directly at the subject. For this reason many flashguns in the medium to high price range incorporate some means whereby the sensor can look at the subject while the flash itself is pointing in another direction. This is achieved either by providing a 'remote sensor', which can be fitted in the camera's accessory shoe and is connected to the flashgun via a cable, or by incorporating the sensor in the body of the flashgun but providing a means of swivelling the flash head, i.e. the assembly containing the flash tube and reflector, independently of the sensor.

Although automatic flashguns relieve the photographer of the necessity of calculating his lens aperture according to the subject distance, care must still be exercised to ensure that the exposure given is correct. The flashgun's sensor and its associated circuitry are adjusted at manufacture to give the correct exposure only with a subject of average reflectance, i.e. one which reflects about 18% of the light falling on it. The one and only capability of the automatic

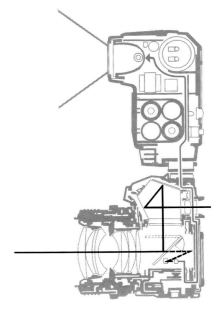

Several cameras offer a fully automatic flash system which reads the light level at the film plane during the exposure. Because such a system measures light reflected from only those parts of the subject to be included in the picture, exposure metering is accurate even in difficult situations such as when using bounce flash or off-camera flash.

The Minolta X-700 camera with the 280PX flashgun, above, provides totally automatic flash metering. When the flashgun is fully charged and ready for use a signal appears in the camera's viewfinder and the shutter speed is automatically set to 1/60 second, the correct speed for X synchronization. When the shutter release is pressed the shutter opens and the flash fires. A very sensitive photocell within the mirror compartment senses the light reflected from the surface of the film. When sufficient light has been received to correctly expose the film the flash tube is turned off so that no further light is emitted, and the shutter closes.

Below: In the X-700 the photocell measuring the light reflected from the film is situated at the side of the mirror compartment.

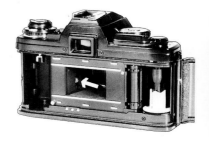

Automatic flashguns are adjusted by the manufacturer to give the correct exposure for a subject of average tonal values. If a subject is lighter or darker than average the flashgun cannot know this, and will give an exposure based on the assumption that the subject is an average one. Consequently, lighter subjects will be under-exposed and darker subjects over-exposed. The photographer must, therefore, make allowance for such subjects by setting his lens to a slightly different aperture from that for which the flashgun is set.

The pictures, left, illustrate this point. The upper pictures show the subject as it really was, and the lower pictures show the result obtained using an automatic flashgun if no compensation is made for the nature of the subject.

The left-hand pictures are of a white cat against a white background. In the lower picture the flashgun has assumed that the subject is of normal tonal value, but the white subject has reflected more light than would a subject of average tonal values, with the result that the flash has switched off too soon, giving a dark, under-exposed picture. The correctly exposed picture, top left, was obtained by opening the lens aperture by one stop to allow double the amount of light to reach the film.

The right-hand pictures are of a dark grey cat against a black background. In the lower picture the subject has reflected less light than would a subject of average tonal values, with the result that the flash has provided too much light, giving a light, over-exposed result. The correctly exposed picture, top right, was obtained by closing the lens aperture by one stop and thus halving the amount of light reaching the film.

exposure circuitry is to turn the flash tube off at the instant when the total reflected light received by the sensor exceeds the preset level. If the subject is darker than average, i.e. it reflects less light, the flashgun cannot know this and the duration of the flash is continued until it is cut off in the normal way when the preset level is exceeded. Consequently the subject receives sufficient light for its tonal values to be recorded on film as though it were of average reflectance, with the result that it is over-exposed and appears too light on the final picture. Conversely, a lighter-than-average subject will be under-exposed and appear too dark. The photographer must compensate for this limitation of the flashgun's ability by altering his lens aperture to a value other than that for which the flash is set. Darker-than-average subjects require the lens to be stopped down by a half stop or so, while for lighter-than-average subjects it must be opened by a similar amount (see accompanying illustrations).

Exposure problems with automatic flash can also arise when the subject itself occupies only a small area of the frame, and is some distance in front of the background. In such an instance the flashgun's sensor may take a reading not solely from the subject but partly from the background as well. Because the background is some distance behind the subject the intensity of the light it reflects back will be less than that reflected by the subject itself. The flashgun will give an exposure of sufficient duration to partially compensate for this, and the subject proper will be over-exposed.

In all instances such as the above, when the light reflected by the subject's surroundings is of considerably different intensity from that reflected by the subject itself, great care must be taken to ensure that the sensor is aimed as accurately as possible at the subject itself. With flashguns in which the sensor is incorporated in the flashgun body this requires very careful alignment of the flashgun as a whole. When using the camera and flashgun hand-held, the use of a flash bracket to attach flashgun to camera is almost essential to maintain this alignment. When using a flashgun with a remote sensor which

mounts in the camera's accessory shoe the aiming of the sensor is automatically correct, and alignment of the flashgun is less critical.

Most automatic flashguns have a facility for rendering the automatic exposure circuitry inoperative, enabling their use in a purely manual mode. Usually this is achieved simply by sliding a built-in opaque cover over the sensor window, so that the photo-cell can receive no light. This forces the flashgun to produce a flash of its maximum duration. When the flashgun is used in this mode exposure evaluation must be carried out in the same way as for any manual flashgun, and is based on the guide number indicated by the manufacturer.

Some automatic flashguns of the thyristor type have an additional facility whereby the duration, and hence the total light output, of the flash can be varied when the flashgun is used in the manual mode. This is achieved by incorporating in the automatic circuitry an electrical switch which, when operated, replaces the photo-cell with a variable resistor. The time taken for the voltage across the integrator capacitor to reach its preset level, and therefore the duration of the flash, is then dependent on the value of this resistor, and not on the intensity of the light falling on the photo-cell. In some flashguns with this facility the value of the resistor is continuously variable within its limits by the rotation of a knob, in others it is variable in steps controlled by a rotary switch. In a typical flashgun of the latter type the switch has eight positions, providing a range of output powers from full power, at which the flash duration is $1/400$ second, to $1/128$ power, at which the duration is a mere $1/50,000$ second. Flash durations as short as this can be used to photograph and 'freeze' very fast-moving subjects, some examples of which are shown later in this chapter.

When using automatic flashguns at settings which give a very short flash duration, either in the manual mode described above or in the automatic exposure mode, a problem may arise with colour film due to reciprocity failure, which may not be equal in all three colour layers, resulting in the processed pictures exhibiting a colour cast. Once encountered, this problem can be overcome when taking further pictures by the use of a filter complementary in colour to the cast produced. The filter can be placed over the camera lens or over the flashgun itself. If placed over the lens the filter should be of optically flat glass or be a gelatin 'colour compensating' filter designed to be used over a lens. If used over the flashgun the filter can have no adverse effects on the resolving power of the camera lens, and can therefore be of the less optically flat 'colour printing' type designed for colour correction when making colour prints. In addition, if the filter is used over the flashgun it can have no effect on any exposure to light other than that given by the flash, an important consideration when the flash is being used only to supplement existing lighting.

Flash position and lighting effect
Many cameras are equipped with an accessory shoe into which most of the smaller size flashguns can be fitted. On modern cameras the

Light intensity falls off rapidly with increasing distance from the light source. This can lead to noticeably uneven lighting when subjects such as that above are photographed using flash. For the upper picture the flashgun was positioned close to the camera and the exposure was calculated to be correct for the person nearest the camera. The intensity of the illumination, and hence the exposure, received by the people further along the table was progressively less the greater their distance from the camera. For the lower picture the flash was detached from the camera and moved to the right of the table to a position where it was roughly equidistant from each person, and from which it gave a much more even lighting.

The picture, far left, was taken with the flash mounted on the camera. The lighting is flat and has given little modelling. The other picture was taken with the flash held above and to one side of the camera, giving considerably more modelling.

In the picture below, which was taken in the middle of the day, a pseudo-moonlight effect has been achieved by under-exposing for the daylight by three stops and illuminating the flowers with flash, for which the correct exposure has been given. The lower picture shows the scene as it appeared to the eye.

accessory shoe is usually of the 'hot-shoe' type which, in addition to physically supporting the flashgun, provides the necessary electrical connection between the camera and the flashgun, eliminating the need for a separate synchronizing cable. For the majority of general purpose photography, however, the lighting effect produced when the flashgun is mounted in the camera's accessory shoe is far from ideal. The closeness of the flash gun to the lens axis produces very flat and uninteresting lighting and, when people or animals are being photographed, often gives rise to 'red-eye', a phenomenon caused by reflection of the flash from the subject's eyes. On small pocket cameras using flashcubes this problem is particularly acute due to the very small separation between flashcube and lens axis, and may be partially alleviated by the use of a flashcube extender, which fits between flashcube and camera, thus extending the distance between flash and lens.

For most general-purpose flash photography the best place for the flash is above and to one side of the camera. This gives a lighting which looks more natural, and provides a reasonable degree of modelling and feeling of depth.

The effective size of the light source provided by a flashgun is dependent on the physical size and optical design of the flashgun's reflector, and is usually quite small, giving rise to shadows which are hard and well defined and which may appear objectionable for those subjects which demand a softer, more gentle lighting. This problem can be alleviated to a large extent by use of a diffuser – perhaps just a rectangle of tracing paper or even a white handkerchief – positioned in front of the flash head such that the diffuser itself becomes the effective source of light. Another approach is to use the technique known as 'bounce flash', whereby the light from the flash is reflected from a convenient surface, giving a much softer illumination with less pronounced shadows. For colour photography the chosen surface must be as neutral in colour as possible, otherwise the reflected light will take on the colour bias of the surface, and unwanted colour casts will result. A white emulsioned wall or low ceiling is usually quite effective. Some flashguns make provision for the use of bounce flash by incorporating a facility whereby the flash head can be tilted in relation to the main body of the flashgun, so

that even with the flashgun mounted on the camera the light can be aimed upwards or sideways towards the chosen reflecting surface. One manufacturer provides as an accessory a holder which clips on to the flashgun, and into which a rectangle of white card can be fitted, from which the flash is bounced towards the subject.

Another method of implementing bounce flash, and one used a great deal in studio photography, is to use a photographic umbrella, the underside of which is finished with a suitable light-reflecting surface. The flashgun, mounted alongside the stem of the umbrella, is aimed at this reflecting surface, from which the light is reflected back towards the subject. Photographic umbrellas are made with two commonly available surfaces – matt white, which gives a very diffuse lighting, and metallized, which gives a harder but brighter light, producing shadows which are slightly more sharply defined.

Exposure determination for bounce flash using non-automatic flashguns is difficult without the use of a flashmeter, as the exposure required depends so much on the reflective qualities of the surface from which the flash is bounced. One method is to replace the flashgun temporarily with a tungsten lamp and to use an ordinary exposure meter – if the camera has a built-in meter this will be ideal – to measure the difference between the lens aperture settings required for direct lighting and bounce lighting. The aperture values can be read against any shutter speed setting as long as the same speed setting is used for both readings. If, for example, with the lamp aimed directly at the subject the meter indicates an exposure of 1/30 second at f8, and with the lamp repositioned so that the light is bounced from the ceiling or wall the reading is 1/30 at f4, the exposure increase necessary due to the light lost by the bounce technique is the difference between f4 and f8, i.e. two stops. If the tungsten lamp is removed and the flashgun replaced in the identical bounce lighting position the correct lens aperture can be determined by initially setting the aperture to the value which would be required if the flash were illuminating the subject directly – calculated simply by dividing the guide number by the flash to subject distance – and then opening the aperture by the number of stops difference previously indicated by the ordinary exposure meter, e.g. two stops in the above example.

These pictures compare the effects obtained by the use of bounce flash and direct flash. The picture, far left, was taken by bouncing the light from the ceiling. Care was taken to shield the flashgun so that light could reach the subject only after reflection from the ceiling and not directly from the flashgun. Although there are no clearly defined shadows the lighting has provided sufficient modelling to reveal the shape of the model's face. The other picture was taken using direct flash, and shows the much harsher effect of this lighting.

Bounce flash is particularly suited to pictures, such as portraits, which require a soft and gentle lighting with no hard shadows.

When using automatic flashguns of the type in which the sensor can remain pointing at the subject even when the flash head itself is not, i.e. those with swivelling heads or remote sensors, the exposure determination for bounce flash remains automatic, as the sensor will still measure the light reflected by the subject and will automatically compensate for the light lost by the use of the bounce technique. Automatic flashguns in which the sensor is fixed in relation to the flash head will not automatically give the correct exposure for bounce flash, as the sensor will read the light reflected from the surface from which the flash is bounced rather than that reflected from the subject. Because of this such flashguns should be switched to the manual mode when used for bounce flash photography.

Flash as a supplement to other lighting

In addition to its frequent use as a main light source for indoor photography, flash offers a convenient and easy means of supplementing other forms of lighting, such as daylight, and is often used to illuminate areas of the subject which are not satisfactorily illuminated by the main lighting. Inside a building, for example, daylight coming through the windows is often sufficient to illuminate most of the room, but there may be areas which do not receive as much light as others, and which would appear dark and lacking in detail on the photograph. Because our eyes are able to cope with a very large brightness range, automatically adjusting to suit the illumination level of the fairly limited field on which we can concentrate at any one time, any lighting imbalance between various parts of a room may appear to the eyes to be only small. Such imbalances will be exaggerated on film, which does not have the ability of the eyes, and can cope with subjects of only limited contrast. Consequently it is advisable to check the illumination of each area of the room with an exposure meter. Flash can be used to supplement the daylight in any dark areas. As a general rule, the lens aperture required for the flash's contribution to the exposure should

A single flash was used to illuminate this market stall, which was shielded from the sun by the canopy above it. The lens aperture and shutter speed were chosen to balance exactly the flash exposure for the stall with the available light exposure for the sunlit background. If the picture had been taken by the available light only, the exposure could have been set to be correct either for the shaded stall, in which case the sunlit areas would have been considerably over-exposed, or for the sunlit areas, in which case the stall and its customers would have been very dark and under-exposed.

Apart from the small amount of light coming through the entrance, the inside of this cave was in darkness. An exposure calculated to record correctly the daylight outside the cave resulted in the cave interior recording totally black, far left. For the other picture the interior was illuminated by a small electronic flashgun. The aperture required for the flash was first calculated, and the shutter speed was selected to give the correct exposure at that aperture for the daylight outside.

Note how the inclusion of the figures has given a scale to the picture, allowing the viewer to gauge the height and width of the cave.

be assessed first, after which the shutter speed should be selected to give the correct exposure at that aperture for those parts of the room which are to be illuminated by daylight only. If the meter reading of the daylight in the darker areas, i.e. those to be assisted by flash, is only about one stop less than that of the areas to be illuminated by daylight only, allowance should be made for the effect of the daylight in these areas by selecting a lens aperture slightly smaller than that calculated for the flash alone.

The use of flash to illuminate local areas of the subject which are not sufficiently illuminated by the main lighting is known as 'fill-in flash'. When used outdoors in sunlight to illuminate shadow areas of the subject the technique is often referred to as 'synchro-sun', and can be particularly effective when used for outdoor portraits. A picture of a pretty girl, for example, can be especially pleasing if she is positioned with the sun behind her, so that her hair is illuminated by the sunlight passing through it. With the sun behind her, rather than shining into her eyes, the model will feel more relaxed and will find it much easier to adopt a natural expression. A girl illuminated solely in this manner cannot be satisfactorily photographed, however, as the film is unable to cope with the extreme lighting contrast between her face, which is in shadow, and her surroundings, which are in sunshine. If the exposure is correct for her face the surroundings will be over-exposed, and if correct for the surroundings her face will be under-exposed. Some improvement is possible by the use of a reflector, such as a large sheet of white paper or card, to reflect some additional light on to her face. A more convenient method of obtaining this additional illumination is to use an electronic flash as a fill-in light. As a general guide the flash exposure should be half that which would be required if the girl was to be illuminated by flash only. More exposure than this may look unnatural, and less may not illuminate the shadows sufficiently. When using a manual flashgun the lens aperture should first be calculated as though the flash was being used as the sole

The pictures, below, illustrate the use of fill-in flash outdoors. The picture, far left, shows the effect of the ambient lighting, with no flash at all. The exposure was chosen to be correct for the grass. Because the girl was positioned with the sun behind her, her face is in shadow and consequently has recorded too dark. The centre picture was taken with about the correct amount of fill-in flash. The flash exposure was approximately half that which would have been required had the picture been taken by flash only. The exposure for the daylight was the same as for the previous picture. Although noticeable if looked for, the effect of the flash is not over-conspicuous, and the picture appears quite natural. The right-hand picture shows the effect of an excessive amount of fill-in flash. The exposure for the daylight was still the same but the flash exposure was too great, with the result that the lighting appears unnatural and artificial.

illumination, bearing in mind that outside with no reflecting surfaces the guide number may be lower than that indicated by the manufacturer. The camera lens should then be set to an aperture one stop smaller than that calculated. Thus, if the effective guide number outdoors is 40 (in feet) and the distance from flash to subject is 5 feet, the exposure required for a flash only exposure would be 40/5=f8, so for fill-in flash the aperture should be set to f11. The shutter speed should then be adjusted to the setting which will give a correct exposure for the surroundings at the chosen lens aperture. This shutter speed must also be no faster than the maximum at which electronic flash can be satisfactorily used with that particular shutter. The use of fill-in flash will only be possible if the flashgun is sufficiently powerful to allow the use of an aperture which, for correct exposure of the surroundings, requires a shutter speed no faster than this maximum. With between-lens shutters any speed up to the shutter's fastest can normally be used, and consequently fairly large apertures may be used, permitting the use of comparatively low-powered flashguns. With focal plane shutters, however, the speed can usually be no faster than about 1/125 second with vertically running shutters or 1/60 with horizontally running shutters (see p. 32). In bright sunshine the use of such speeds will require the selection of a relatively small aperture to maintain correct exposure of the sunlit surroundings, and such an aperture will require the use of one of the more powerful flashguns to provide sufficient fill-in of the shadows. Thus, with focal plane shutters fill-in flash is not normally possible with the cheaper and less powerful flashguns.

Automatic flashguns can be used for syncro-sun photography by setting the sensor control to a value one stop *larger* than the aperture in use. If the correct exposure for the subject's sunlit surroundings is 1/60 second at f11, for example, the flashgun's control should be set to f8. This will fool the flashgun into giving only half the light output which would be required if the subject was illuminated by flash alone. It is advisable to prevent direct sunlight from shining into the flashgun's sensor, as failure to do so may result in the flashgun giving less than the required exposure, as at the actual instant of the flash the sensor cannot differentiate between light reflected back by the subject from the flash and light from any other source.

If more or less fill-in than that provided by half the normal flash exposure is required, this can be easily obtained by adjustment of the flashgun's sensor control. For the above example of an exposure to the sunlit surroundings of 1/60 at f11, setting the flash to f5·6 would give a flash exposure only one-quarter of the normal, and will thus give less lightening of the shadows. If a different amount of fill-in is required when using a manual flashgun the lens aperture of the camera must be altered to give the required fraction of the normal flash exposure, and the shutter speed adjusted accordingly to maintain the correct daylight exposure of the sunlit surroundings.

Automatic flashguns with the facility for adjusting the light output in the manual mode are an ideal choice for synchro-sun

The picture, above, was taken by a combination of sunlight coming from behind the subject and electronic flash positioned just above the camera. Because the little girl was swinging quite fast the daylight exposure, which was at a shutter speed of 1/30 second, has recorded both her and the swing as a blurred image. Superimposed on this image is a sharp image produced by the electronic flash exposure, the duration of which was fast enough to 'freeze' all movement.

This picture was taken mainly by electronic flash, which has recorded the fairground car and its occupants sharply. A slow shutter speed – 1/15 second – was used, and the camera was panned with the moving subject, resulting in the lights in the background recording as streaks, giving a good impression of the exhilaration and speed of the ride.

photography, as they offer an easy and precisely controllable means of adjusting the light output to a level which will give the required amount of fill-in for the flash to subject distance and lens aperture in use.

Multiple flash

Many photographic situations require the use of 'multiple flash', which involves the simultaneous use of two or more flashguns. When photographing the interiors of buildings, for example, several flashguns may be required, each lighting a different area, to ensure that the whole subject is evenly illuminated. Similarly, separate flashguns may be employed as main, fill-in and background lights in portrait photography.

A particular prerequisite of multiple flash photography is that all the flashguns must fire during the period within which the camera shutter is open. This usually means that they must be linked together by some means, so that to all intents and purposes they fire simultaneously. There are two ways in which this may be achieved. The first is to use a special adaptor into which the synchronizing leads of the flashguns are plugged and thus electrically connected together, the common connection being taken to the camera's synchronizing socket. This method has two disadvantages. Unless the flashguns are of identical type, the trigger circuitry and the voltages present on the trigger lead of each flashgun may be different, and interconnecting them in this way may prevent one or more of the flashguns from firing reliably, or possibly from firing at all. In addition, the synchronizing contacts in a camera shutter are of a fairly delicate nature and, while they will happily switch the trigger current of a single flashgun, subjecting them to the combined trigger currents of two or more flashguns may considerably shorten their life, and in extreme cases may actually cause them to weld together. The second and the more satisfactory method of linking together two or more flashguns is to use slave units. These are photo-electric

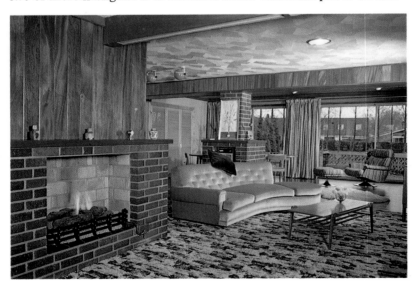

To obtain even lighting over the whole area of the large room, the picture, left, was taken using three separate flashguns, one beside the camera, one half-way along the room, and one at the far end of the room. The three upper pictures, above, show the individual contributions of the three flashguns. After calculating the lens aperture required for the flash exposure the shutter speed was chosen to give the correct exposure at that aperture for the daylight outside, in order to record some detail of the garden beyond the windows. The lower picture shows only the effect of this daylight exposure, which has also recorded the ceiling light and the flames of the fire.

All pictures: 1/8 second, f11, Ektachrome 64 film. Outside conditions dull and overcast.

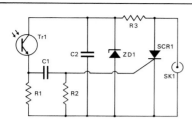

The diagram, left, shows the circuit of a simple, easily constructed slave unit. The phototransistor Tr1, in conjunction with resistors R1 and R2 and capacitor C1, detects a *sudden* increase in light level, such as that produced when an electronic flash is fired, and triggers the thyristor SCR1 which consequently fires a second flashgun, the synchronizing lead of which is plugged into the socket SK1. The delay between the first flash firing and the firing of the second flash by the slave unit is so small as to be of no consequence in normal photographic applications. The slave unit requires no battery, but is powered by a very small amount of current taken from the synchronizing lead of the flashgun to which it is connected. Resistor R3 and zener diode ZD1 reduce the voltage to 20 volts and sufficient energy is stored in capacitor C2 to provide the necessary pulse to trigger the thyristor. The socket is shown the correct way round for the majority of flashguns on the market. If the slave unit fails to operate with a particular flashgun it may be because the polarity of its synchronizing lead is opposite to the normal, in which case the connection to SK1 should be reversed. Strong ambient light will not cause the slave unit to trigger, but it may reduce the unit's sensitivity to the light from a flash. It is, therefore, advisable to shield the phototransistor from ambient light. If the recommended phototransistor (TIL78) is used this can be achieved by sliding a short length of opaque sleeving of suitable diameter over the phototransistor to make its sensitivity more directional.

PARTS LIST

R1	56k
R2	10k
R3	5·6 Megohms
C1	0·02 μF
C2	0·1 μF
Tr1	Phototransistor TIL78 or similar
ZD1	20 volt 400 mW zener diode
SCR1	C106D or similar
SK1	3 mm female flash socket

devices which will detect a very sudden increase in illumination, such as that produced by the firing of a flashgun, and will fire other flashguns to which they are connected. Usually the flashgun nearest to the camera is connected to the camera shutter and fired in the normal manner. Each additional flashgun is connected to a slave unit and is fired by it when the first flash fires. The electronics of the slave unit respond so quickly that for all normal applications the delay between the firing of the flashguns is insignificant. Most slave units have no batteries, but derive the small amount of power necessary for their operation from the synchronizing lead of the flashgun to which they are connected. Slave units are usually sufficiently sensitive that they do not need to be illuminated directly by the flash from which they are triggered, but will operate satisfactorily from light reflected by walls or ceilings. Therefore, when photographing interiors, flashguns and slave units may both be positioned behind pillars or furniture so that they are out of view of the camera. The advantages of using slave units are particularly evident when there is some considerable distance between flashguns, as the purely optical coupling means there are no interconnecting cables to intrude into the picture or for people to trip over.

Using 'open flash'

When the available lighting is very low, such as when photographing a very dark interior of a building, there is often no need to synchronize the flash to the camera at all, and the photograph can be taken using a technique known as 'open flash'. The camera is set up on a tripod and everything is prepared for the photograph to be taken. The shutter is opened on B, the flash fired by hand, and the shutter closed again. This technique can also be used to achieve multiple flash photography with only one flashgun, fired consecutively from different positions. To work well, it is advisable to have an assistant to hold and fire the flash. The flash positions are decided in advance, and the assistant holds the flash in the first position. The shutter is opened on B and the flash is fired. The assistant now moves to the second position, fires the flash again,

Building a slave unit. The constructional details of the slave unit, above, are included in the hope that even if the reader himself is not an electronics hobbyist he may know someone who is and who would be prepared to build it for him. The components are all commonly available types. Component layout is not critical, and the slave unit can be assembled on a small piece of 'Veroboard' or similar material, after which it may be housed in any suitably sized box.

A typical slave unit, shown here about life-size. It requires no batteries, and derives the small amount of power it needs from the flashgun to which it is connected. This model is fitted with a hot shoe which allows it to be attached to the base of most flashguns. Some models are fitted with a suction cup which permits them to be mounted on a convenient smooth surface.

moves to the next position, and so on. While the assistant is changing his position between flashes it is advisable to hold a piece of black card over the camera lens to reduce the effect of any available light, being careful not to knock the camera. As soon as the flash has been fired from the final position the shutter is closed.

Checking for reflections etc.

One of the problems of flash photography is that, unless the flashgun is of the studio type with a modelling light, its lighting effect is rather difficult to predict. In particular, care must be taken to ensure that reflections of the flash head itself will not be visible in windows or other highly polished surfaces. This can be checked by looking at the subject from the exact camera position while an assistant points a torch or other light source at the subject from the exact position of the flash. If any reflections of the light are visible the flash must be moved to a position at which none are apparent.

Special types of flash

In addition to the types of manual and automatic flashguns commonly available for general-purpose photography, there are several types made for specialized applications. The most common of these are the powerful units for studio photography, designed to run from the mains supply only, with no facility for operation from batteries. These fall into two categories – those in which the flash head itself contains the capacitors and charging circuit, each head forming a self-contained unit which connects directly to the mains supply, and those in which the capacitors and charging circuitry for several heads are contained in a single, floor standing box to which the separate flash heads connect. In both types the heads usually incorporate a tungsten modelling lamp which enables the lighting effect and balance to be visually assessed. Usually the flash output power is switchable and on most units adjustment of the power also alters the brightness of the modelling lamp so that the visual indication of lighting effect and balance is maintained. The recycling time is very short, an important feature for fashion and glamour photography, when many pictures are often taken in rapid succession to ensure that at least one with just the right expression and pose is obtained. For maximum versatility the heads are usually made without built-in reflectors, most manufacturers offering a range of separate interchangeable reflectors of different sizes, along with umbrellas, diffusers and similar accessories, all of which clip on to the basic head.

A problem often encountered in extreme close-up photography is that of satisfactorily lighting the subject. Frontal lighting is often impossible because of the physical restrictions imposed by the subject being in very close proximity to the camera lens. The lighting usually has to be at such an angle that, if the subject is three-dimensional, the picture is spoilt by areas of dark shadow in which all detail is lost. In many instances this problem can be overcome by the use of a ringflash, which has a specially designed circular flash tube and reflector which fit around the camera lens to

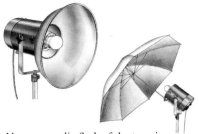

Above: a studio flash of the type in which the head itself is a completely self-contained unit which connects directly to the mains. It is shown here fitted with both a reflector and a photographic umbrella.

Below: a studio flash of the type in which the capacitors and charging circuitry for several heads are contained in a floor-standing box to which the separate heads may be connected. Three heads are shown, one fitted with a small reflector and the others with large diffusers. *Photo kindly supplied by the manufacturers, Bron Electronik AG.*

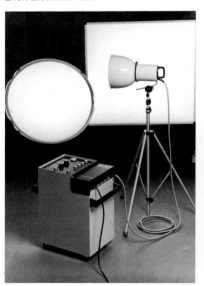

A typical ringflash, consisting of a separate power pack and a flash head which fits around the camera lens.

give an even, almost shadowless lighting which illuminates all the nooks and crannies of the subject. The ringflash is often used in medical photography to provide shadowless lighting of subjects such as the inside of the mouth, which would be almost impossible to illuminate by any other means.

As we have already seen, a fair amount of the radiant energy produced by a flash tube is emitted as infra-red. For normal photography this is not used, but its presence can be exploited for certain applications, such as forensic and surveillance photography. For these purposes the plastic window of the flash head is covered by a suitable filter, such as a Wratten 88A, which absorbs virtually all the visible radiation but allows the infra-red content to pass almost unimpeded. With an infra-red sensitive film in the camera, photographs can be taken using this infra-red energy as the illuminant. In forensic applications this can be used to reveal characteristics of the subject which are not visible to the naked eye. In surveillance photography flash pictures can be taken without the subject's knowledge, as to the naked eye the only indication of the firing of the flash is a dull, deep-red flash, which will almost certainly pass unnoticed. One manufacturer produces a version of one of their more popular visible light flashguns in which the plastic window has been replaced by a fixed, visible-light absorbing, infra-red transmitting filter. Almost any flashgun can be used in this manner, however, by the simple expedient of taping the necessary filter over the flash head.

Some manufacturers produce electronic flashguns for use as a light source for underwater photography. These are units with specially designed casings which are physically strong enough to withstand the considerable pressures found at the depths at which they may be used, and which are carefully sealed to ensure that they are completely watertight.

A word of warning

Electronic flashguns, although mostly powered by low-voltage batteries, all rely on the discharge of electrical energy at a high voltage to produce their light output. This energy is stored in a capacitor which is usually charged to a potential of several hundred volts, and which is capable of supplying a current which is potentially lethal. For this reason the casing of a flashgun should never be opened or removed to expose any of the normally concealed internal parts, unless this is done by a person who is fully experienced in the working principles and repair of electronic flashguns. In addition, care should be taken at all times to prevent water from entering the casing. Failure to observe this will invite internal damage to the flashgun due to electrical discharge through the ingressed water, and will considerably increase the likelihood of the user receiving an electric shock. If a flashgun must be used in wet conditions it should be completely enclosed in a transparent polythene bag, which will keep it dry but will only slightly reduce its light output.

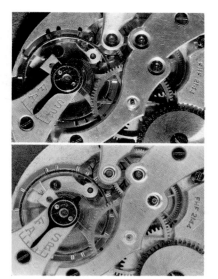

The pictures, above, show the same subject illuminated by a small conventional flashgun, upper picture, and by a ringflash, lower picture. Because of the close proximity of the camera lens to the subject the conventional flashgun had to be positioned well to the side of the subject, resulting in harsh shadows which have concealed much of the watch mechanism. The ringflash, which completely encircled the camera lens, has provided an almost shadowless lighting which has reached into even the deepest parts of the subject.

This tulip was illuminated solely by a ringflash mounted around the camera lens, and the picture further illustrates the almost shadowless lighting which is a characteristic of this equipment.

The pictures, above, illustrate the use of electronic flash to arrest subject movement. The picture of the cat intercepting a stream of milk from the cow's udder is a superb example which has been published many times before, and was taken over thirty years ago using an early make of electronic flashgun.

The hummingbird was photographed with a much more modern flashgun, in fact one incorporating 'power ratio control', which allows the duration, and hence the light output, of the flash to be manually adjusted. In this case the duration was about 1/6400 second, sufficient to 'freeze' the movement of this tiny bird, the wings of which beat up to fifty or more times a second. The bird was attracted to the feeder, just visible to the right of the picture, behind which was placed a background of blue card to simulate the sky.

Building a flash delay unit. As with the slave unit described previously, the constructional details, below, may not mean much to someone who is not acquainted with electronics, but are included in the hope that the reader, if unable to make use of the information personally, may know someone who would be prepared to build the unit for him.

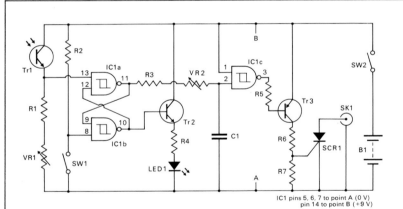

IC1 pins 5, 6, 7 to point A (0 V)
pin 14 to point B (+9 V)

CMOS integrated circuit, and the usual precautions should be taken to avoid damage to its inputs during handling. Socket SK1 is shown correctly connected for the majority of flashguns but, as with the slave unit described previously, some makes may require the connections to the socket to be reversed.

The unit, above, provides a variable delay between a light beam being broken and the firing of a flashgun, and allows sequences such as that shown on the opposite page to be taken.

Switch SW2 is the on/off switch. Switch SW1 is a push-button which 'arms' the unit in readiness for a picture to be taken. LED1 lights to indicate that the unit is armed and ready for use, and extinguishes as soon as the light beam is broken. VR1 is a sensitivity control and is adjusted according to the intensities of the light beam and the ambient light. If the sensitivity is set too low the LED will extinguish as soon as SW1 is released, if set too high the unit may fail to trigger when the beam is broken. VR2 adjusts the delay between the beam being broken and the flash being fired. The precise range of delays obtainable is dependent on the characteristics of the actual integrated circuit used, and will vary from sample to sample, but for the values of VR2, R3 and C1 quoted is typically from 11 mS to 200 mS. Longer delays can be obtained by increasing the value of C1, shorter delays by reducing it. For maximum consistency of delay, C1 must be a non-electrolytic type. IC1 is a

PARTS LIST

R1	4k7
R2	100k
R3	5k6
R4	2k2
R5	22k
R6	1k
R7	1k
VR1	47k potentiometer
VR2	100k potentiometer
C1	2·2 μF polycarbonate or polyester
Tr1	Phototransistor TIL78 or similar
TR2	BC109 or similar
TR3	BC479 or similar
SCR1	C106D or similar
LED1	TIL209 or similar
IC1	CD4093B or equivalent
SW1	Push-button switch (momentary action, push-to-make)
SW2	SPST on/off switch
SK1	3 mm female flash socket
B1	9 volt battery

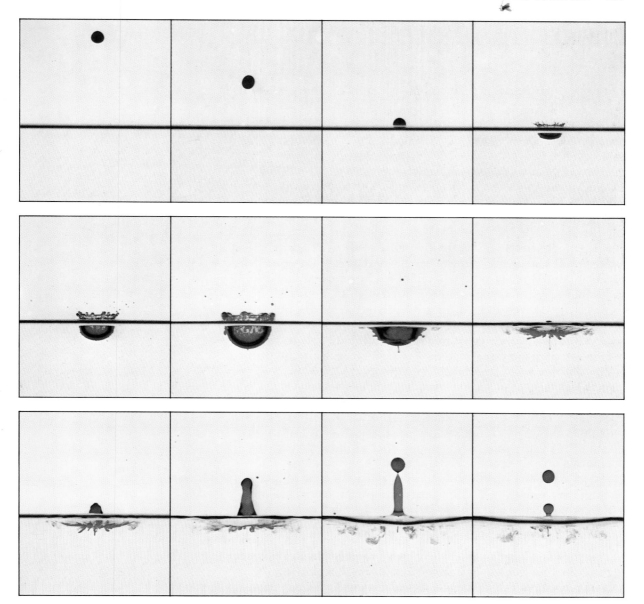

The pictures, above, were taken using the flash delay unit described on the previous page, and show what happens when a drop of ink falls into a tank of water. As can be seen, the drop initially produces a 'crater' in the surface of the water, but then bounces out again before finally dropping back in. Although the pictures give the impression of being a sequence taken in very rapid succession, each is in fact of a different drop. For each picture the drop itself triggered the delay unit by breaking a light beam as it fell. The value of the delay was increased between pictures to make the flash fire progressively later each time.

The ink was dropped from a medicine dropper held firmly in a laboratory clamp about 30 cm above the surface of the water. The phototransistor of the delay unit was positioned about 10 cm above the surface. The light beam was produced by a lens-ended torch bulb positioned a few centimetres from the phototransistor and aimed horizontally at it. Both torch bulb and phototransistor were also firmly clamped, their lateral position having been adjusted so that the falling drop would pass through the light beam and thus trigger the delay unit. The tank was specially made using thin picture-frame glass and aquarium sealer, and measured approximately 5 cm from front to back.

A sheet of opal acrylic sheet was placed behind the tank, and behind this was the flashgun, a Sunpak Auto Zoom 5000, which was used on 1/32 power, giving a flash duration of only 1/12,500 second, sufficiently short to 'freeze' the movement of the falling drop. A large quantity of water to which yellow dye had been added was prepared in advance. Because the ink drop itself coloured the water the tank was emptied and refilled after each picture. The delays used ranged from about 30 mS for the first picture to about 150 mS for the last.

Close-up photography

There are no hard and fast rules to specify the camera to subject distance below which ordinary photography becomes close-up photography, but the term is usually applied to the photography of subjects at distances less than the normal minimum focusing distance of the camera lens, and which therefore requires some modification of normal camera operation if a sharp image of the subject is to be obtained. There is more than one way by which this modification may be achieved, and these are discussed later in this chapter.

Firstly, it may help the reader if we endeavour to clear up some of the confusion surrounding the terminology relating to close-up photography, which is often referred to by the photographic magazines as **macrophotography**. Strictly speaking this is incorrect, as the true meaning of this word is 'the making of large photographs', such as photomurals. The word that really should be used is **photomacrography**, and this term should only be applied to close-up photography which results in an image which on the film is the same size as, or larger than, the subject itself, i.e. the magnification is × 1 or greater. Another area of confusion is that surrounding the terminology relating to photography through the microscope. Here the correct word is **photomicrography**, which is sometimes confused with **microphotography**, which really means 'the making of very small photographs' such as the reduction of documents on to microfilm. To be absolutely correct, 'photomicrography' should only be used when referring to photography with the aid of the **compound** microscope, i.e. one using both objective and eyepiece lenses. If the photography is performed using only the microscope objective lens the technique is really photomacrography.

There are two basic methods by which a camera lens can be made to focus on a subject which is closer than its normal minimum focusing distance. The first method is to use supplementary close-up lenses which fit in front of the camera lens, and is suitable for use with almost any type of camera. The second method is to increase the separation between lens and film by using extension tubes or bellows. This method can only be achieved when using cameras with interchangeable lenses.

Using supplementary close-up lenses
Supplementary close-up lenses fit over the camera lens in the same way as filters and other lens attachments. Their effect is to shorten the focal length of the camera lens. Consequently rays of light from an object which is so close to the camera lens that they would normally be brought to a focus behind the film plane are bent more acutely, so that they may be brought to a focus at the film plane, thus enabling a sharp image of the object to be obtained.

A supplementary close-up lens, supplied in a mount which screws into the filter thread on the front of the camera lens.

To enable the camera to focus sufficiently close for this caterpillar to appear fairly large in the frame, a + 3 supplementary close-up lens was fitted over the camera lens. A small aperture (f16) was used, resulting in a fairly large depth of field.

Depending on the type of camera used, the photography of subjects of similar size to this arrangement of old bottles may or may not require the use of close-up attachments. If photographed with a 'viewfinder' camera a + 1 dioptre supplementary close-up lens would probably be necessary. If photographed with an SLR, the lens of which usually focuses closer than does that of a viewfinder camera, it is likely that no attachments would be required.

Close-up lenses are simple convex meniscus lenses, and they function over the camera lens in exactly the same way as the spectacles used for reading by a person suffering from hypermetropia – long sightedness. They are commonly available in three strengths, + 1, + 2 and + 3 dioptres. The dioptre is the unit of the optician's measure of the refracting power of a lens. The + sign indicates that the lens is convex, i.e. converging (a — sign would indicate a concave lens, normally never used over a camera lens). The power of a lens expressed in dioptres is the reciprocal of its focal length in metres:

$$\text{power in dioptres} = \frac{1}{\text{focal length in metres}}.$$

Thus a + 1 dioptre lens is a convex lens with a focal length of 1 m, a + 2 lens has a focal length of 0·5 m, and a + 3 has a focal length of 0·3 m.

To avoid frightening away this timid frog it was photographed from a relatively large distance (about 1·5 m) by using a 35 mm SLR camera with a 135 mm telephoto lens to which an 8 mm extension tube had been fitted. The lens was used at its maximum aperture, f2·8, to intentionally produce a picture with a very limited depth of field, the effect of which has been to concentrate the viewer's attention on to the subject itself.

When a supplementary lens is used over a camera lens of *any* focal length, with the camera lens set to infinity, a sharp image will be produced on the film plane of an object at a distance *equal to the focal length of the close-up lens*. This distance is measured from the close-up lens itself. By adjusting the focusing of the camera lens to distances less than infinity, sharp images of objects at distances less than the focal length of the close-up lens can be obtained. A table is supplied with each close-up lens to indicate the actual distance on which the close-up lens/camera lens combination is focused for each setting of the camera's focusing scale. Most modern camera lenses focus down to less than 1 m, and as the table, right, shows, with such a lens the range of subject distances possible with each strength of close-up lens overlaps the range given by the next. Thus, the photographer equipped with close-up lenses of all three strengths can work at any subject distance between infinity and the shortest distance possible with the + 3 lens.

Supplementary close-up lenses are the only practical means of reducing the minimum focusing distance of cameras with fixed, i.e. non-interchangeable, lenses. Such cameras are mostly of the viewfinder or twin-lens reflex types, and when using these for close-up photography care must be taken to ensure that adequate compensation is made for the parallax error which results from the difference in the viewpoints of viewfinder and taking lens, as the effect of any error becomes more acute as the camera to subject distance is reduced. Even when the camera incorporates automatic parallax correction this is usually only effective down to the camera's normal minimum focusing distance.

One way of overcoming the parallax problem is to make a focal frame to indicate the subject area which will be included in the picture with a particular close-up lens/focusing scale combination. The frame should be made sufficiently large to be just outside the field of view. The length of the arm connecting it to the camera

These stamps, which occupied an area of about 10 × 15 cm, were photographed using a standard lens fitted with a +3 dioptre supplementary close-up lens.

should be such that the frame itself is at the intended camera to subject distance.

The use of supplementary close-up lenses has a slight but noticeably detrimental effect on the quality of the image produced by the camera lens. The close-up lens becomes in effect an additional lens element, the presence of which partly nullifies the careful endeavours of the camera lens designer to reduce aberrations to a minimum. The resulting slight loss of quality is noticeable mainly as a fall-off in sharpness towards the edges of the picture.

Two or more close-up lenses can be used simultaneously to allow the camera lens to focus on subjects at less than the minimum distance possible with a single close-up lens, although the practice is not to be recommended when a high degree of sharpness is required, as it may result in a considerable loss of image quality. This loss can be kept to a minimum by not using more than two close-up lenses together, and by ensuring that the stronger of the two is nearer the camera lens.

This table shows the distance, in centimetres, between subject and supplementary close-up lens at the various combinations of close-up lens strengths and camera lens settings. Note that with the camera lens set to 1 m the lens to subject distance given with any of the close-up lenses is the same as that given by the next stronger close-up lens used with the camera lens set to infinity.

lens focusing scale setting in metres	distance from subject to supplementary lens in centimetres				
	+1	+2	+3	+4 (1+3)	+5 (2+3)
∞	100·0	50·0	33·3	25·0	20·0
10	91·0	47·6	32·3	24·4	19·6
5	83·3	45·5	31·3	23·8	19·2
3	75·0	42·9	30·0	23·1	18·8
2	66·7	40·0	28·6	22·2	18·2
1·5	60·0	37·5	27·3	21·4	17·6
1·2	54·5	35·3	26·1	20·7	17·1
1	50·0	33·3	25·0	20·0	16·7
0·8	44·4	30·8	23·5	19·0	16·0
0·7	41·2	29·2	22·6	18·4	15·5
0·6	37·5	27·3	21·4	17·6	15·0

Using extension tubes and bellows

Close-up photography with single-lens reflex cameras is easier than with any other camera type, as both subject framing and accuracy of focusing can be visually assessed on the viewfinder screen. Supplementary close-up lenses can be used to reduce the normal minimum focusing distance, and will give acceptable results for moderately close subject distances. An alternative method of reducing the focusing distance which allows the use of smaller lens to subject distances than is possible with close-up lenses, and which is made possible by the facility on most SLRs to remove the camera lens physically, is to increase the separation between the lens and the camera body. The greater this separation is, the smaller will be the lens to subject distance required to produce a sharp image on the film. The cheapest way of obtaining this separation is to use extension tubes, which fit between the camera lens and body. The tubes must have the same lens fitting mechanism as the camera with which they are to be used. Most manufacturers of SLR cameras make extension tubes for use with their own brands of cameras, and tubes in most of the more common lens fittings are also made by independent manufacturers. They are available singly or, more usually, in sets. A typical set for use with a 35 mm SLR contains three tubes of different lengths, perhaps 12 mm, 20 mm and 36 mm (the actual lengths vary according to the make), which can be used singly or in any combination, the three thus allowing seven permutations of length. The focusing mechanism of the camera lens remains operative, so each combination of tubes provides a limited range of subject distances over which the lens can be focused.

Extension tubes are often supplied in sets of three different sizes.

Many makes of extension tubes are of the 'automatic' type, having a mechanism which maintains the mechanical coupling between lens diaphragm mechanism and camera body, and thus retains automatic diaphragm operation of the lens. Some extension tubes also have the additional coupling required to retain the full-aperture metering facility in cameras equipped with TTL metering of this type. When such cameras are used with extension tubes which do not have this additional coupling the metering must be performed in the stopped-down mode.

A limitation of extension tubes is that the limited ranges of lens to subject distances given by adjustment of the camera lens focusing mechanism with the various combination of extension tube lengths often do not overlap, with the result that the photographer finds there are gaps in the overall range of lens to subject distances at which he can work with his set of tubes. The largest gap is usually that which occurs between the nearest distance possible without any extension tube and the largest distance possible with the shortest tube. When the subject distance required to fill the frame nicely with the desired area of the subject falls within one of these gaps the photographer must settle for the next possible distance further away from the subject, and compensate for the smaller image size by enlarging the negative a little more at the printing stage. Alternatively, if the subject distance required is within the range offered by the use of supplementary close-up lenses he can use these instead.

An additional problem with extension tubes becomes apparent when several subjects of considerably different sizes are to be photographed at a single session. This can be made very tedious by the frequent changes of extension tube length necessary to permit the various lens to subject distances required. A solution to this problem may be to use a bellows unit instead of extension tubes. Bellows units are considerably more expensive than extension tubes, but have the advantage of providing a continuously variable separation between camera lens and body, allowing any lens to subject distance within certain limits to be easily obtained. The maximum lens to subject distance possible is imposed by the inability of the bellows themselves to compress to less than an amount which gives a lens to body separation of about 30 mm (this varies according to the make). The minimum subject distance is imposed by the maximum lens to body separation possible, which on a typical bellows unit is about 150 mm.

A typical bellows unit. The graduated rule facilitates the measurement of the lens extension, a factor which must be known for the calculation of magnification and of any exposure modification which may be required.

Calculation of magnification

Up to now we have been referring to the use of close-up lenses, extension tubes and bellows units as a means of reducing the lens to subject distance to less than the camera's normal minimum. While this is indeed their function, it is not in itself their sole objective, but only a means to an end – the obtaining on film of an image which is larger than would normally be possible.

The relationship between image size and subject size can be expressed in two ways – as a **magnification**, or as a **magnification ratio**. When the relationship is expressed as a magnification the actual figure quoted is the number of times by which the image obtained on film is larger than the subject. For example, if the image is twice as large as the subject the magnification is × 2, if image and subject are the same size it is × 1, and if the image is half the size of the subject the magnification is × 0·5. When the relationship is expressed as a magnification ratio two figures are quoted, the first representing the image size and the second representing the subject size. Thus, at a magnification of × 2 the magnification ratio is 2:1, at × 1 it is 1:1, and at × 0·5 it is 1:2.

Of the two methods of expressing the image size/subject size relationship, quoting the magnification offers the most versatility, and this is often abbreviated to the letter **m**. Instead of saying 'the magnification is × 2' it is often more convenient simply to say '**m** = 2'.

The magnification **m** obtained at the time of taking the picture is often referred to as the **camera magnification** to distinguish it from the **final magnification**, which refers to the relationship between subject size and the size at which its image is finally seen. It should be noted that the two are not usually the same, as the image produced on the film is usually viewed several times enlarged, either as a print or projected on to a screen. The final magnification – usually represented by **M** – is the product of the camera magnification and the amount by which the negative or transparency is enlarged to the final viewing size.

In practical close-up photography the position of the camera relative to the subject and the extension tube or bellows length are usually adjusted so that the required area of the subject nicely fills the frame. Sometimes the actual magnification resulting from these adjustments is of little interest. Often, however, it may be useful to present this information with the picture in order that the viewer may be given an indication of the actual size of the subject. If a note of extension tube length, lens focal length, and focusing scale setting is made at the time of taking the picture the magnification can be easily calculated with the aid of the simple formulae detailed below.

In optical calculations the distance between a lens and the image it produces is usually represented by the letter \mathbf{v}. In photographic applications this distance must also be the lens to film distance in order that the image may fall precisely in the plane of the film so that a sharp picture of the subject is obtained. When the lens to film distance is known the magnification can be calculated from the equation:

$$\mathbf{m} = \frac{\mathbf{v} - \mathbf{F}}{\mathbf{F}}$$

where \mathbf{F} = the focal length of the lens. Note again that \mathbf{v} is the lens to *film* distance. When a camera is used to photograph a distant object, with the lens focusing scale set to infinity, the value of \mathbf{v} is exactly equal to the focal length of the lens, i.e. $\mathbf{v} = \mathbf{F}$. If the lens focusing scale is left on infinity, but the value of \mathbf{v} is increased by separating lens and camera body by using extension tubes or bellows, the following relationship will exist:

$$\mathbf{e} = \mathbf{v} - \mathbf{F}$$

where \mathbf{e} = the lens to *body* distance, i.e. the extension tube or bellows length. By combining this equation with the previous one the following easy-to-use equation results:

$$\mathbf{m} = \frac{\mathbf{e}}{\mathbf{F}}.$$

As an example, if a 50 mm lens with its focusing scale set to infinity is used with a 25 mm extension tube the magnification is given by:

$$\mathbf{m} = \frac{25}{50} = 0 \cdot 5$$

i.e. the image on the film will be half life-size.

In practical close-up photography using extension tubes or bellows the focusing scale of the camera lens is often set to distances other than infinity. This is particularly so with extension tubes, when the focusing mount of the lens can be used to provide magnifications intermediate between those given by the basic combinations of a set of tubes. In addition, after the preliminary setting up of the camera prior to taking a picture, adjusting the smooth, high-quality mechanism of the focusing mount provides a much more precise means of making final adjustments to the sharpness of the image on the focusing screen than is possible by moving the camera relative to the subject or by adjusting the

comparatively coarse rack and pinion mechanism of a bellows unit.

When the lens focusing scale is set to a distance which is less than infinity the magnification will be greater than that calculated using extension tube or bellows length only, as the focusing mount of the lens itself provides additional separation between lens and camera body. If this additional separation is called **x**, the exact magnification can be calculated from the equation:

$$m = \frac{e+x}{F}.$$

Tables showing the value of **x** at different focus settings with several of the more common lens focal lengths appear below.

Sometimes a photographer's brief may state that a certain picture is to be taken at a specified magnification, requiring the photographer to calculate the extension tube or bellows length required to obtain this magnification. This can be achieved by transposing the previous equation such that it reads:

$$e + x = m \times F.$$

Let us assume, for example, that an object is to be photographed with extension tubes such that the image on film is exactly one-quarter of life-size, i.e. **m** = 0·25, with a 50 mm lens. The total separation required between lens and camera body is given by:

$$e + x = 0·25 \times 50 = 12·5 \text{ mm}.$$

Let us also assume that no combination of the available extension tubes will give exactly this separation and that the next shorter length possible is 10 mm. In order to obtain exactly the required magnification the focusing scale of the lens must be set so that the focusing mount provides the additional extension required, i.e. such that **x** = 12·5 − 10 = 2·5 mm. Reference to the table for a 50 mm lens shows that this value of **x** is achieved when the focusing scale is set to slightly over 1 m.

focusing scale setting in metres	Values of x in millimetres with various lens focal lengths (mm)						
	24	28	35	50	85	100	135
∞	0	0	0	0	0	0	0
10	0·06	0·08	0·12	0·25	0·73	1·01	1·85
5	0·12	0·16	0·25	0·51	1·47	2·04	3·75
3	0·19	0·26	0·41	0·85	2·48	3·45	6·36
2	0·29	0·40	0·62	1·28	3·78	5·26	9·77
1·5	0·39	0·53	0·84	1·72	5·11	7·14	13·35
1·2	0·49	0·67	1·05	2·17	6·48	9·09	17·11
1	0·59	0·81	1·27	2·63	7·90	11·11	21·07
0·8	0·74	1·02	1·60	3·33	10·10	14·29	27·41
0·7	0·85	1·17	1·84	3·85	11·75	16·67	32·26
0·6	1·00	1·37	2·17	4·55	14·03	20·00	39·19
0·5	1·21	1·66	2·63	5·56	17·41	25·00	49·93

A table of the values of **x** at various focusing scale settings of most of the more common lens focal lengths. Note that with some lenses, particularly those of the larger focal lengths, the focusing scale may not be adjustable to the smallest distances included in the table. Also with the shorter focal length lenses set to the longest distances the values of **x** may be so small as to be of no significance, particularly when the extension provided by extension tubes or bellows is fairly large.

Choice of lens for close-up photography

The newcomer to close-up photography will almost certainly begin his exploration of this absorbing field of photography by using his standard lens, i.e. the one normally supplied with the camera, either with supplementary close-up lenses or extension tubes, or, if his pocket will allow it, with a bellows unit. By working in this manner he will usually obtain results which are perfectly acceptable for the majority of purposes. There is no reason, however, why close-up photography should not be undertaken using lenses of focal lengths other than the standard. Indeed, in some instances a more pleasing result may be obtained by so doing, and in others a picture which would not be possible with a standard lens may be made possible. When taking close-up pictures of very recognizable subjects such as flowers, for instance, a more pleasing picture can often be obtained by using a lens of focal length longer than the standard, for example a 100 or 135 mm lens on a 35 mm camera. The reason for this is that even when we examine a single small bloom to see detail as fine as the unaided eye will allow, the limitation imposed by the minimum distance on which our eyes will focus prevents us from viewing the flower from much less than our normal minimum reading distance, which for most people is something between 10 and 15 inches. If when photographing the same flower the lens to subject distance required to fill the frame with the flower is much less than this, and when using a lens of standard focal length it probably will be, the camera will see the flower from a viewpoint which is normally denied us, and the perspective may seem unnatural. By using a lens of longer focal length the lens to subject distance will be greater, and the camera viewpoint will be similar to that of our eyes, with the result that the perspective will appear more natural. In addition, the extent of the background included within the frame will be smaller with a lens of longer focal length, due to the narrower angle of view. This can be an important consideration when areas of the background are of a distracting nature, as the use of a longer focal length lens may permit the selection of a viewpoint from which these areas are excluded.

An additional advantage of using longer focal length lenses is that the larger lens to subject distances which they allow considerably facilitates the satisfactory illumination of the subject. When photographing by sunlight it is easier to prevent the camera itself from casting shadows on the subject, and when using artificial lighting there is more room to position the lights to give the desired lighting angle.

Lenses of focal length shorter than the standard, for example wide-angle lenses, can be used with extension tubes or bellows to give magnifications greater than would otherwise be possible. For instance a bellows unit which when fully extended provides a maximum magnification of × 3 with a 50 mm lens would give a magnification of just over × 6 with a 24 mm lens. Lighting of the subject will be more difficult, however, due to the much shorter lens to subject distance required.

Sometimes lenses other than those specifically designed for

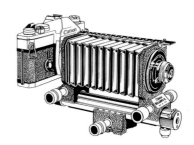

Several manufacturers offer macro lenses of short focal length for use when high magnifications are required.

The example, above, is a 20 mm macro lens which provides magnifications of up to × 10 when used with the appropriate bellows.

photographic applications can be adapted for use in close-up photography. A low-power microscope objective mounted on the end of bellows unit or extension tubes will permit pictures to be taken at quite high magnifications. Most (although not all) microscope objectives are not fitted with an iris diaphragm, however, and consequently must be used at full aperture, which limits their use to flat subjects where little depth of field is required.

The integrated circuit, top, shown here 28 × actual size, was photographed using a discarded cardboard packing tube and a 1 in./25 mm microscope objective lens. The tube, cut to a suitable length, was slid over an extension tube fitted to the camera body. The lens was mounted on the metal screw-on end cap of the packing tube. Fine focusing was achieved by adjusting the distance between the subject and the lens. *Canon FTb, electronic flash, Kodachrome 64.*

Macro lenses

In the language of optics the points on opposite sides of a lens at which the subject and its image are positioned are known as **conjugate foci**, and the distance between these points and the lens are known as **conjugate distances**. As one conjugate distance is decreased the other is increased, and vice versa. Camera lenses designed for general-purpose photography are intended to be used so that the conjugate distance in front of the lens, i.e. the lens to subject distance, is considerably greater than the conjugate distance behind the lens, i.e. the lens to image distance. The lens designer will have calculated the refractive indices and the shapes of the various elements of the lens so that the correction of optical aberrations and, therefore, the performance of the lens, is at an optimum when the lens is used at the comparatively large working distances that general-purpose photography involves. When such a lens is forced to focus on a distance less than its normal intended minimum, the careful endeavours of the lens designer are no longer fully effective and the image quality suffers. The deterioration of quality occurs as a loss of sharpness, mainly at the edges of the picture. For many applications this loss of sharpness may be insufficient to have any *noticeably* detrimental effect on the quality of the resulting pictures. When photographing flowers, for instance, the camera is usually positioned so that the main interest, the blooms themselves, falls mainly in the central area of the picture. Any slight loss of sharpness at the edges will probably not be noticeable, particularly as the subject matter which appears at the edges of the frame is likely to be foliage or even background, and will probably be recorded out of focus anyway, due to the very restricted depth of field experienced in close-up photography. When photographing subjects which are confined mainly to a single flat plane, such as postage stamps, however, sharpness is expected to be equally good over the entire frame, and for this type of subject the result obtained using a general-purpose camera lens will usually be noticeably inferior to a result obtained by the use of a special 'macro' lens.

Macro lenses are available to fit most of the leading makes of SLR cameras, and are specially designed to give their optimum results at the comparatively short lens to subject distances which close-up photography demands. In addition to this superior optical performance at close range, an advantage of the macro lens is that the range of distances covered by its focusing mount is much greater than that of a general-purpose lens. Most macro lenses will focus from infinity right down to a distance that gives an image which is half life-size, i.e. $m = 0.5$, in a continuous range, without the addition of any of the close-up attachments which would be necessary with a general-purpose lens.

Many of the modern zoom lenses currently available for use with 35 mm SLR cameras offer a 'macro' facility whereby the operation of an external control alters the spacing within the lens of the various optical components to permit the lens to focus at close distances, allowing magnifications of up to about $\times 0.5$ to be

obtained. Although when used in this mode such lenses will give results which are acceptable for some purposes, their performance is usually not even as good as that of a standard lens used with close-up attachments, and, unless initial tests indicate otherwise, any attempt to use them for high-quality close-up photography is not to be recommended.

Reversing the lens

In the previous paragraphs we have seen that camera lenses intended for general-purpose use are designed to give their optimum performance when the conjugate distance in front of the lens is much greater than the conjugate distance behind the lens, and that image quality deteriorates when the front conjugate distance, which for normal use is the lens to subject distance, is reduced below the intended minimum. The more this distance is reduced the more the conditions of use deviate from those for which the lens was designed, and the more the image quality suffers.

In close-up photography the lens to subject distance remains larger than the lens to image distance provided the image on film is smaller than life-size, i.e. **m** is less than 1. When image and subject are exactly equal in size, i.e. **m** = 1, the lens to subject and lens to image distances are also equal. When the image is larger than the subject, i.e. **m** is greater than 1, the lens to image distance becomes *greater* than the lens to subject distance, and unless suitable action is taken the lens will be operating under conditions which are so remote from the lens designer's intentions that optical performance may be dramatically impaired. Fortunately the remedy is simple. All that is required to improve lens performance *at magnifications greater than 1* is to reverse the lens, so that the front element faces the film and the rear element faces the subject. The front of the lens will then again face the longer of the two conjugate distances, and the lens will operate under conditions nearer to those for which it was designed. In addition to its benefit with conventional lenses designed for general-purpose photography, the technique of reversing the lens for magnifications greater than 1 can also be used to advantage with macro lenses, except when they are specifically designed to be used unreversed even at these magnifications. Most leading SLR manufacturers produce lens reversing adaptors for use with their products. These usually secure the lens to the extension tube or bellows unit by means of the screw thread which for normal use is intended to accept screw-in filters or lens hood.

When a lens is used in the reversed mode the mechanical coupling of camera body to lens diaphragm is no longer possible, and consequently automatic diaphragm operation is lost. Some manufacturers get over this problem by offering an attachment which fits on to what is normally the rear of the lens, and by use in conjunction with a special double cable release automatically stops down the lens just before the camera shutter fires.

An additional problem of reversing the lens is that the facility for fine adjustment of the lens to film distance by means of the lens focusing mount is also lost. This is because with the lens reversed

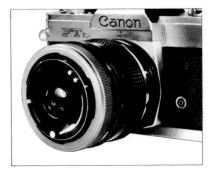

Use of a reversing adaptor enables the camera lens to be mounted backwards on the camera, and provides better quality at higher magnifications.

the actual lens assembly is secured directly to the extension tube or bellows unit, instead of having the focusing mechanism in between. Although the focusing ring will still turn, all that happens is that the focusing mount itself moves in relation to the lens assembly, which remains static. Consequently, fine focusing can be achieved only by adjustment of the bellows unit itself, or, if extension tubes are used, by very carefully adjusting the position of the complete lens/camera assembly relative to the subject. In addition, due to the non-symmetrical construction of the optical and mechanical components of the lens, the position of the optical assembly relative to the extension tube or bellows unit is different when the lens is reversed from when it is mounted conventionally. Consequently the magnification **m** cannot be calculated directly from the extension tube or bellows length. A way round this problem is to find by experiment the difference in extension required to produce the same magnification with the lens mounted conventionally and reversed. The difference thus found will be the same for any other magnification and can be used to modify the value of **e**. This modified value can then be used in the standard equation for the calculation of **m**, i.e. **m**=**e**/**F**.

Calculating the exposure

In the earlier section of this book dealing specifically with lenses (p. 20) we have seen that the f-number of a lens at each of its aperture settings is derived by dividing the focal length of the lens by the effective diameter of the aperture at that setting. Unfortunately, aperture values derived purely in this manner do not always represent the *effective* values as far as illumination at the film plane, and therefore exposure of the film, is concerned. No transparent material allows all the light which enters it to pass through to the other side. Some light is absorbed, even by the highest quality optical glass. In addition, further light is lost by reflection at each air-to-glass surface, even though modern lens coatings reduce this loss to a minimum. Light losses of this nature are usually allowed for by the manufacturer, however, and the aperture values marked on the lens have usually been modified accordingly. Even so, these marked values are correct, exposure-wise, only when the lens to film distance exactly equals the focal length of the lens, i.e. when the lens is focused on infinity. Because of the inverse square law which relates intensity to distance, increasing the lens to film distance to allow the lens to focus on objects closer than infinity results in a reduction of the intensity of the illumination at the film plane, and thus introduces a discrepancy between the marked aperture value and the effective value. This discrepancy increases the more the lens to film distance is increased. For general-purpose photography, when the subject is a comparatively large distance from the camera, the increase in lens to film distance is so small that the discrepancy in aperture values can be ignored, as the exposure error it causes will not be sufficient to be noticeable on the processed film. When the lens to subject distance is reduced to less than about ten times the focal length of the lens, however, the increase in lens to film distance

required to maintain the subject in sharp focus on the film becomes sufficient to produce noticeable under-exposure of the film unless an adequate exposure increase is allowed.

When the exposure required is assessed using TTL metering, which measures the light *after* it has passed through the lens and therefore sees the same intensity as will the film at the moment of exposure, allowance for any discrepancy between marked and effective aperture values is automatically made. When the camera is not equipped with TTL metering and the exposure must be assessed using a separate meter, or when using flash, there is no automatically made allowance and the exposure required must be assessed using the effective value rather than the marked value.

The effective aperture value for a particular magnification on film, **m**, can be calculated from the equation:

effective aperture value=marked aperture value \times (**m**+1).

For example, if a picture is to be taken at a magnification of \times 1, with the lens aperture set to a marked value of f16, the effective aperture is 16\times(1+1)=f32, and it is against this value on the exposure meter scale that the exposure duration must be read, or, if flash is used it is for this value that the flash to subject distance must be calculated.

It should be noted that when a camera lens is made to focus on a subject nearer than its intended minimum distance by the use of supplementary close-up lenses instead of by increasing lens to film distance with extension tubes or bellows, no exposure modification is necessary and the marked aperture values remain correct.

Depth of field

In an earlier section of this book dealing specifically with depth of field (p. 68) we have seen that the depth of field, i.e. the zone of acceptable sharpness which extends in front and behind the plane on which the lens is focused, is dependent not only on the lens aperture but also on the distance between lens and subject, and decreases as this distance is decreased. When the lens to subject distance is reduced to the comparatively small values encountered in close-up photography and photomacrography the depth of field becomes very small indeed, often much smaller than the unwary photographer may expect.

We have also seen that if two lenses of different focal lengths are used to photograph the same subject, and the lens to subject distance for each lens is adjusted so that the resulting images on the film are identical in size, the depth of field obtained with each lens will for all practical purposes also be the same if the same aperture value is used in both instances. This characteristic can be put to good use in close-up photography, as it allows depth of field to be related directly to **m**, the magnification on film, regardless of the focal length of the lens used.

The accompanying graphs can be used to determine the depth of field prevailing for magnifications of from \times 0·1 to \times 10, and graphically illustrate just how small the depth of field is in close-up

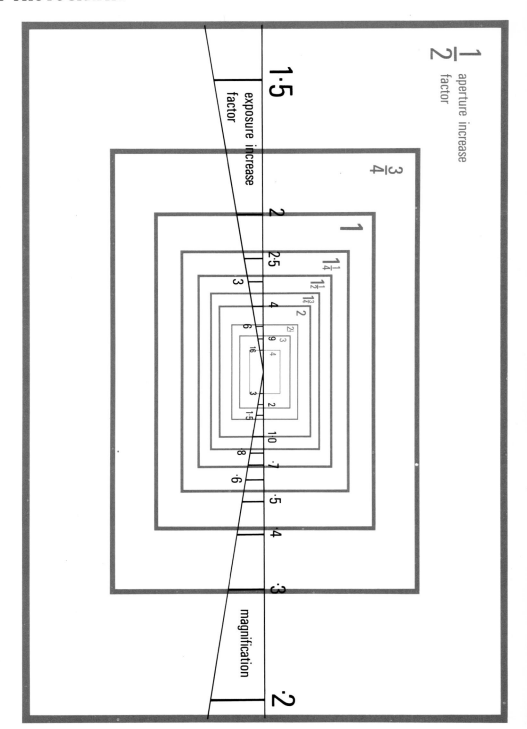

This chart enables magnification, aperture increase factor, and exposure increase factor to be easily found.

The subject to be photographed should be framed in the camera viewfinder as required, and the camera focused on the subject. Taking care not to disturb the

focus setting, the camera should then be aimed at the chart and moved closer to or further from the chart until the lines and numbers come into sharp focus. With the chart centred in the viewfinder the required information can be read at the edge of the viewfinder.

photography and photomacrography, particularly at the higher magnifications. The graphs have been compiled using a circle of confusion diameter of 0·02 mm. As explained on p. 70, this value is suitable for use with full-frame 35 mm cameras, and is chosen on the assumption that the entire area of the negative or transparency will be enlarged to produce a 10 by 8 inch print which will be viewed from normal reading distance or, if a different size print is made or if the transparency is projected, that the final result will be viewed from a correspondingly suitable distance. If this is not the case the information contained in the graphs should be used only as a guide to be modified accordingly.

If desired, the depth of field for conditions other than those indicated in the graphs may be calculated by inserting the *marked* aperture value in the equations which appear on p. 70. The lens to subject distance, **u**, to be inserted in these equations is difficult to measure physically when it is so small, as one is never sure exactly which part of the lens to measure from, but may be calculated from the magnification on film, **m**, by the equation:

$$\mathbf{u}=(\frac{1}{\mathbf{m}}+1)\mathbf{F}.$$

When deciding which aperture to use to obtain an adequate depth of field it should be borne in mind that as the aperture is reduced in size so the effects of diffraction become greater (see p. 23) and result in an increasing loss of sharpness over the *entire* picture area. In photomacrography diffraction can considerably limit the optical performance of the lens even at relatively large marked aperture values. This is because the extent to which the image is degraded by diffraction is dependent on the effective aperture at which the picture is taken, and, as we have seen in the paragraphs dealing with exposure calculation, the effective aperture becomes more and more remote from the marked value as the magnification is increased. The requirements for large depth of field and a diffraction-free image are thus in opposition to each other, and a compromise must usually be made when selecting which aperture to use. Generally speaking, the largest aperture which will just allow sufficient depth of field should be selected.

As a point of interest, the initial test exposures for the pictures of crystals which appear on pages 238 to 241 were exposed using a marked aperture of f16. As the tests were made at a magnification of ×3 the effective aperture was in fact 16×(3+1)=f64, and the effects of diffraction caused the resulting transparencies to lack the overall sharpness required. Because the crystals were confined to a very thin layer the depth of field necessary was only very small, so the pictures were retaken using a marked aperture of f8, i.e. an effective aperture at **m**=3 of f32, and this time the resulting transparencies were much improved in sharpness.

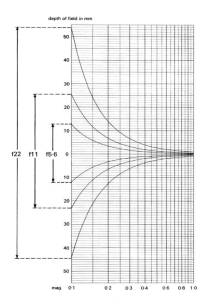

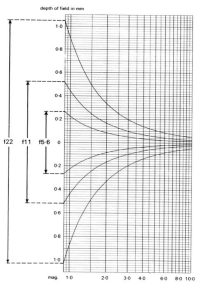

The above graphs illustrate how drastically depth of field is reduced as magnification is increased.

In both graphs the figures below the central zero line indicate, in mm, the depth of field in front of (e.g. nearer to the camera than) the plane of sharpest focus, and those above the zero line show depth of field beyond the plane of sharpest focus. Figures for three aperture settings are given.

In the top graph the horizontal scale indicates **m**, the magnification on film, from 0·1 to 1·0. The lower graph shows magnification from 1·0 to 10.

The figures have been calculated for a circle of confusion of 0·02 mm diameter.

Photomicrography

Photomicrography – photography with the aid of the compound microscope – is a very specialized field of photography, for which extremely expensive equipment is available, and cannot be fully explored in a book of this nature. It is possible, however, to give sufficient information to enable the reader who has access to a microscope of fairly good quality, such as those to be found in most school science laboratories, to produce photomicrographs of a reasonable quality using a general-purpose camera of either fixed lens or interchangeable lens type. The reader who experiments with the basic techniques described in the following pages and discovers that he wishes to delve deeper may then refer to one or more of the several books available dealing specifically with the subject.

To understand fully the way in which the image is formed in photomicrography it is first necessary to have some knowledge of the construction of the basic microscope and the way it operates to enable us to perceive detail too small to be seen with the unaided eye.

The basic microscope, and how it works

Unlike the camera, in which focusing is achieved by a mechanism which moves the lens nearer to or further from the film plane, focusing of the eye is performed by the ciliary muscles, which squeeze the lens from its edge to alter its focal length. This process, known as *accommodation*, is learned by experience in early childhood, and soon becomes automatic, requiring no conscious effort on our behalf. The accommodation mechanism permits the focusing to be adjusted to any distance from infinity, at which the eyes of a person with normal eyesight are in a fully relaxed condition, down to about 250 mm – often termed *the minimum distance of distinct vision*. This near limit of vision imposes a limit on the fineness of detail which can be seen by the unaided eye. When detail smaller than this limit is to be observed some form of optical magnifying aid must be used. The most basic of these is the simple convex lens. The object to be viewed is positioned at a distance from the lens equal to or slightly less than the focal length of the lens, so that an enlarged *virtual* image is formed behind the object (see diagram). The eye, looking through the lens from the other side, sees this image. The precise distance between lens and object is adjusted so that the distance between image and eye is within the eye's focusing range, i.e. less than infinity and more than 250 mm. The magnifying power of the lens is the number of times by which the image appears larger than it would if viewed unaided at a distance of 250 mm from the eye.

The distinction between a *virtual* image and a *real* image should be noted. A real image is formed by converging light rays, and can be seen by allowing it to fall on to a convenient reflecting surface,

This picture of a section of skin, showing part of a hair follicle reproduced here sixty times life-size, i.e. **M** = 60, is typical of the quality which can be achieved using relatively inexpensive equipment with the techniques described in this chapter. Note: as explained on p. 193, **M** is the final magnification, as opposed to **m**, the camera magnification.

such as a piece of white paper. Examples of real images are those formed on the film in a camera, on the retina of the eye, and on the cinema screen. A virtual image does not actually exist – it only appears to do so. Light rays from the object are bent by the lens system so that they appear to diverge from the point at which the image appears. Almost every optical instrument which is held to the eye in use produces a virtual image. Even when looking at a virtual image, however, the image formed within the eye is real.

When the object to be viewed is very small, or the detail in a larger object is extremely fine, the simple magnifying glass provides insufficient magnification, and some means of obtaining even more is required.

The compound microscope caters for this need by providing two stages of magnification, giving a total magnification ranging from around × 20 to in excess of × 1000, and consists basically of two lenses, one at each end of a hollow tube which is known as the microscope's *body tube*. The first lens, known as the *objective* lens, projects a real and magnified image of the object into the body tube. The magnifying power of the objective lens is the number of times by which this image, known as the *primary image*, is larger than the object, and is usually inscribed on the lens mount. Objectives are commonly available with magnifications ranging from × 4 to × 100. The second lens, known as the *eyepiece*, acts as a simple magnifying glass, and magnifies the primary image formed by the objective to produce a virtual and further enlarged image of the object being viewed. It is this virtual image, known as the *secondary image*, which the eye perceives. In common with the objective, the eyepiece is also marked with its magnification, which may range from × 5 to × 20 or even × 25. The total magnification of the microscope is the product of the separate magnifications of the objective and eyepiece. For instance, a × 20 objective used with a × 10 eyepiece gives a total magnification of × 200.

Although the diagram shows objective and eyepiece as simple lenses, in practice both are compound lenses with several elements and are corrected for lens aberrations, although the extent of this correction is reflected in the price of the lens.

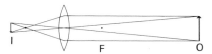

When the distance between an object, indicated here by the arrow O, and a lens is greater than the distance between the lens and its focal point, F, i.e. greater than the focal length of the lens, light rays from each point of the object pass through the lens and converge to form a real image, I, on the other side.

If the distance between object and lens is greater than twice the focal length of the lens, as it is here, the image is smaller than the object. If the distance is between one and two focal lengths the image is larger than the object.

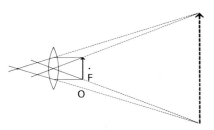

If the distance between object and lens is reduced to less than one focal length the light rays from each point of the object pass through the lens and *diverge* on the other side. To an eye looking through the lens the rays appear to come from a magnified *virtual* image positioned behind the object. This is the principle of the simple magnifying glass.

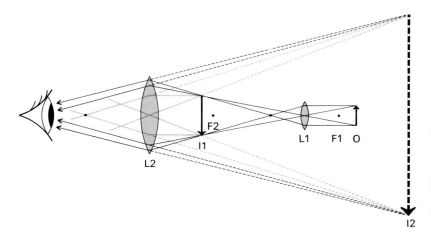

In the compound microscope the object is magnified in two distinct stages. The objective lens, L1, forms a real and magnified image, I1, known as the primary image. The eyepiece lens, L2, acts as a simple magnifying glass and produces a virtual and further magnified image, I2, the secondary image. The total magnification of the microscope is the product of the individual magnifications of each stage.

Most microscopes have a platform, or *stage*, on which the object to be viewed is positioned. Focusing of the microscope is achieved by adjusting the distance between object and objective, usually by a mechanism which moves either the stage or the body tube. Objective and eyepiece remain a fixed distance apart, determined by the length of the body tube. By adjusting the object to objective distance the effect of the focusing mechanism is to alter the position of the primary image relative to the eyepiece, and in use the focusing mechanism is adjusted until the virtual image produced by the eyepiece appears at a distance from the eye of between 250 mm – the minimum distance of distinct vision – and infinity, i.e. at a distance to which the eye can accommodate.

There are two main ways of illuminating the object to be viewed – by transmitted light and by reflected light. Because of the high degrees of magnification involved, both methods require the level of illumination at the specimen plane to be fairly intense if the visible image is to be of reasonable brilliance. In general-purpose microscopy the more common method is the use of transmitted light, often referred to as *transillumination*. Most specimens to be viewed by this method have to be specially prepared by a technique known as microtomy, the result of which is the production of a very thin slice of the specimen which is subsequently mounted on a glass microscope slide, and through which light can be shone for viewing. Often the slice of specimen is stained with one or more coloured dyes before mounting, to improve visual contrast. Most microscopes are fitted with an optical condenser system which concentrates light from the illuminating source on to the underside of the specimen. Some microscopes have the illuminating lamp built into their base, others have an adjustable mirror which permits light from a separate lamp unit to be reflected up towards the condenser system.

Microscope objectives and eyepieces are available in several different qualities, determined by the extent to which they are corrected for lens aberrations. The cheaper objectives such as those fitted to most microscopes intended for school or student use, are corrected for spherical aberration for one colour only, usually yellow-green, and are not corrected for chromatic aberration throughout the entire visible spectrum, but for only two of the three primary colours. These lenses are known as *achromats*, and also exhibit a certain amount of curvature of field, i.e. the entire field of view of the lens cannot be brought simultaneously into sharp focus. Flat-field achromats, in which the curvature of field has been almost entirely corrected, are available from several manufacturers. These lenses are known as *planachromats*, and are more expensive than the ordinary achromats. *Apochromats* are corrected for spherical aberration for two colours and for chromatic aberration for all three primary colours, and are consequently considerably more expensive. Even so they will exhibit curvature of field unless they are *planapochromats*, the finest and most expensive objectives available. Eyepieces are also available in different qualities, those fitted to most cheaper microscopes being of either the *Huygenian* or *wide-field* type. Both suffer to some extent from colour fringing and other

Transverse section of apple root, photographed using a combination of student microscope and SLR camera with its lens removed. **M** = 90.

aberrations, particularly when used at high magnifications. The main advantage of wide-field eyepieces is that their field of view is larger, with the result that they allow a larger area of the specimen to be viewed than do other eyepieces of the same magnification. *Compensating* eyepieces are designed to compensate for certain residual chromatic aberration of the objective, and give the best result when used with apochromats, although they can also be used to advantage with the higher power achromats. Special *photo* eyepieces are available for photomicrography, and when used with planapochromats give the highest possible picture quality. Because of the very high cost of objectives and eyepieces of this superior quality, it seemed unfair to use such lenses to illustrate this section on photomicrography, as most readers would have relatively easy access only to microscopes of school or student quality. It is for this reason that, with just one exception, all the photomicrographs appearing in these pages have been taken using only ordinary achromat objectives with a Huygenian eyepiece.

There are two basic methods of taking photographs through the microscope. In the first method the camera lens performs a function similar to that of the lens in the eye, and projects on to the film a real image of the virtual image seen through the microscope eyepiece. This method is the only one suitable for use with cameras with fixed, i.e. non-interchangeable lenses. The second method, suited to cameras with interchangeable lenses, involves removing the camera lens and adjusting the microscope so that the eyepiece itself forms an image directly onto the film.

Photomicrography with cameras with fixed lenses

Because this method of photomicrography does not require the removal of the camera lens, it permits the use of almost any general-purpose camera. Results of quite reasonable quality can be obtained with the cheapest of cameras, even those with fixed-focus lenses, although cameras of this type usually have a very limited selection of shutter speeds, intended only for photography outdoors in bright light or indoors with flash, and consequently will require the microscope illumination to be very bright for the correct exposure to be obtained. The more expensive fixed-lens cameras with a range of shutter speeds and focus settings offer more versatility, particularly in the control of exposure, and are therefore more suitable for photomicrography. Cameras with fully automatic exposure determination with no facility for manual control are not suitable.

The camera should be mounted securely, either on a tripod or held by some other means, such as a laboratory stand, so that its lens occupies the position adopted by the eye for normal microscope viewing. Care should be taken to ensure that the lens is positioned centrally over the microscope eyepiece so that microscope and camera share a common optical axis. Ideally, the provision for mounting the camera should incorporate some means whereby the camera can be easily removed from the microscope and just as easily replaced. This is necessary because most cameras with fixed lenses are of the non-SLR type and consequently the only method of

This section of the compound eye of a locust clearly shows the array of light-sensitive cells, or ommatidia, which provide the insect with its sight. At the ends of the ommatidia can be seen the transparent crystalline cones which, together with the lenses in the cuticle, project light from the insect's surroundings on to the ends of the cells. (Note that the cuticle has become displaced during the sectioning procedure.)

For photomicrographs such as this, with large areas of light background, it is particularly important that the illumination should be even across the field. **M** = 45.

positioning the specimen and focusing the microscope prior to photography is by viewing the image in the normal way, with the eye looking directly into the microscope eyepiece. When mounting the camera, the distance between the eyepiece and the camera lens should in most instances be set such that the *eyepoint* of the eyepiece is at or very near to the front surface of the camera lens. The eyepoint is the position above the eyepiece to which light rays converge after leaving the microscope, and can be found by holding a piece of white paper over the eyepiece and gradually raising it. As the separation between paper and eyepiece is increased the bright circle of light which appears on the paper gradually becomes smaller and then larger again. The position at which the circle is at its smallest is the eyepoint. The distance between eyepoint and eyepiece varies according to the make and design of the eyepiece, and the camera may have to be repositioned accordingly if the eyepiece is changed. If the position of the camera lens relative to the eyepoint is incorrect the area of the microscope field seen by the camera will be reduced, and only a small image will be recorded. The iris diaphragm of the camera lens plays no part in photomicrography and should be left in its fully opened position. Using the lens with the aperture stopped down causes the recorded area of field to be limited in a manner similar to that experienced with incorrect camera lens to eyepoint positioning. Very inexpensive cameras often have a small fixed aperture situated *behind* the camera lens. When using such cameras for photomicrography, positioning of the eyepoint at the front surface of the camera lens will also result in the aperture restricting the field size, and these cameras should, therefore, be positioned so that the eyepoint falls in the plane of the aperture. With some combinations of eyepiece and camera this may prove to be impossible, as the eyepoint may be insufficiently distant from the eyepiece to allow it, in which case some restriction of field size must be accepted or, if a choice of eyepieces is available, one with a higher eyepoint may be selected.

Focusing the microscope to achieve a sharp image on the film in the camera can present a minor problem when using cameras with fixed lenses. When a microscope is focused visually in the normal manner, the operator adjusts the focusing mechanism until he sees a sharp image of the specimen, i.e. until the virtual image produced by the eyepiece appears to be at a distance within the range of his eye's accommodation, which, as we have seen, could be anything between 250 mm and infinity if his eyesight is normal. The problem arises because there is no easy way of determining precisely what this distance is, and it is essential that the camera focusing is adjusted to the same distance if a sharp photomicrograph is to be obtained. This difficulty can usually be overcome by relaxing the eyes by staring at a distant object for a short while before focusing the microscope. If the relaxed state is maintained during the focusing operation, the virtual image produced by the eyepiece can be considered to be at infinity, and by setting the camera focusing also to infinity a sharp picture will be obtained. Most experienced microscopists make a habit of adjusting their microscopes in this way, as they find that

long periods of gazing into a microscope with the image at infinity, and therefore with their eyes in a relaxed condition, are less tiring than if the image were closer, which would require their eyes to be in a more accommodated state.

When attempting photomicrography with a fixed lens camera for the first time, a person with little experience of using a microscope should first practise the above focusing technique. Spectacles, if normally worn for distant vision, should be left on. Subsequently a few test exposures should be made, with the camera focusing set at various intervals throughout its range. After processing, the film should be inspected to find which setting gave the sharpest image. This procedure should be repeated a few times to ensure that the microscope is being consistently focused, after which any further pictures may confidently be taken with the camera focusing set to the optimum distance indicated by the processed test results.

The magnification obtained on film when using a camera with a non-interchangeable lens will normally be less than that seen visually through the microscope, and is given by the formula:

$$\mathbf{m} = \text{microscope magnification} \times \frac{\mathbf{F}}{250}$$

where \mathbf{F} = focal length of camera lens in mm. (It should be noted that, as indicated earlier in the pages dealing with close-up photography and photomacrography, \mathbf{m} is the magnification *on film*. The final magnification, \mathbf{M}, is equal to \mathbf{m} multiplied by the number of times by which the negative is enlarged to produce the final print for viewing.)

Photomicrography with cameras with interchangeable lenses

The SLR with interchangeable lenses makes an ideal choice for photomicrography, as the reflex viewing system allows both focusing and assessment of the required area of the subject to be performed visually on the camera's viewfinder screen. Many manufacturers of modern SLRs make microscope adaptors which fit on to the microscope, usually sliding on to the tube containing the eyepiece. The camera lens is removed, and the camera body, with extension

These pictures of a head louse were taken using a camera with a fixed, non-interchangeable lens, and show why the aperture of the camera lens must be set to its fully open position. For the picture, far left, the aperture was between 1 and 2 stops down from fully open. This has had no effect on the exposure level but has considerably restricted the field of view. The other picture was taken with the lens fully open, but even so the field was not quite large enough to fill the entire film area.

Looking at the shape of their claws it seems little wonder that these creatures are such tenacious little pests. $\mathbf{M} = 20$.

tubes or bellows unit attached, is coupled to the microscope adaptor. As there is, in this configuration, no camera lens to form an image on the film in the camera, the optical relationship between object, objective and eyepiece must be slightly modified, so that the eyepiece itself projects a real image on to the film plane, instead of producing a virtual image as it does when the microscope is adjusted for normal viewing. This can be achieved simply by increasing the distance between object and objective, thus causing the primary image to be formed nearer to the objective and, because the objective to eyepiece distance remains unchanged, further away from the eyepiece. When the primary image to eyepiece distance is greater than the focal length of the eyepiece, light rays leaving the microscope converge to form a real image above the eyepiece instead of diverging to give a virtual image as they do for normal viewing (see diagram). The precise distance between specimen and objective is adjusted so that this real image falls exactly on the film plane of the camera. With reflex cameras this can be achieved by viewing the image through the camera's viewing system while adjusting the microscope's focusing mechanism for maximum sharpness. Theoretically, if the objective is one designed for normal viewing, adjusting the microscope to produce a real image in this manner will result in some loss of image quality, as the optical correction of such objectives is optimized for the formation of the primary image at a specified distance from the objective. Causing the primary image to be formed at less than this distance will impair the correction, and an increase in lens aberrations will result. In practice, because the lenses normally fitted to student microscopes are not so highly corrected and aberration-free as those often fitted to much more expensive research models, it is unlikely that the increase in lens aberrations due to the use of the above technique with student microscopes will have any noticeable effect on the image quality

These diagrams show the possible configurations of camera and microscope.

In the left-hand diagram the camera is used with its lens attached and photographs the virtual image produced by the microscope eyepiece. The settings of the microscope are the same as when it is used with the eye for normal viewing.

In the other diagrams the camera is used with its lens removed. This requires some modification of the settings of the microscope so that the eyepiece itself projects a real image directly on to the film. The centre diagram shows the ideal way of achieving this, which is to leave the object to objective distance the same as for normal viewing, so that the primary image to objective distance is that for which the objective was designed, and to increase the eyepiece to objective distance until a sharp image is produced on the film. The eyepiece to objective distance is usually fixed by the length of the microscope tube, however, and a much more convenient method is to increase the object to objective distance (right-hand diagram) simply by adjusting the microscope's focusing mechanism, so that the primary image is formed closer to the objective and therefore further from the eyepiece. Theoretically this configuration will give inferior results, as the primary image to objective distance will be less than that for which the lens was designed. When using a microscope of student quality, however, it is unlikely that the difference will be discernible.

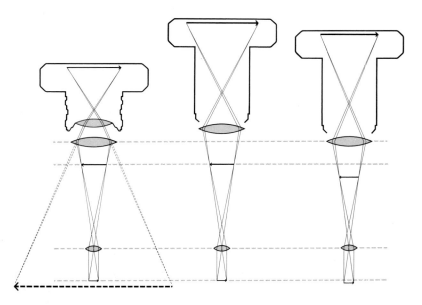

recorded on film, so long as the primary image to objective distance is not reduced excessively.

As mentioned earlier, high quality objectives, such as planachromats, and eyepieces designed specifically for photomicrography are available, and these will give superior results when image quality of the highest order is required. Results which are quite acceptable for most purposes can be taken without the benefit of such lenses, however, as is illustrated by the photomicrographs included in these pages, all except one of which are taken using a student microscope with its normal objectives and eyepiece.

The magnification obtained on film when using a camera with its lens removed depends partly on the separation between microscope eyepiece and film, and is therefore controllable by suitable selection of extension tube or bellows unit length, which thus permits the amount of the microscope field which is recorded on film to be varied for control of picture composition. The magnification is given by the formula:

$$\mathbf{m} = \text{microscope magnification} \times \frac{\mathbf{k}}{250}$$

where \mathbf{k} = separation in mm, between eyepoint and film.

For the best results \mathbf{k} should not be reduced to less than about 125 mm, as values less than this will require the deviation from the lens designer's intended objective to primary image distance to be so great that the increase in lens aberrations mentioned earlier may have a noticeably detrimental effect on image sharpness.

Some difficulty may be experienced in focusing the image on the viewing screen of the camera when photomicrography is undertaken using the above technique. When using cameras with viewing screens which incorporate a microprism or split-image device, these normally highly satisfactory focusing aids will almost certainly be found to be unusable. To work correctly they require the image-forming, conical beam of light projected towards the viewing screen by the lens to have a relatively large diameter at its narrowest point, i.e. at the point, at or near the lens, from which the light rays diverge towards the film. In normal photography this diameter is sufficiently

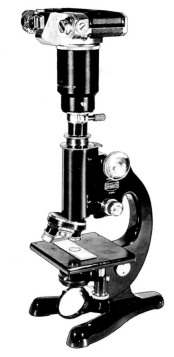

A combination of SLR camera and student microscope, as used for the majority of the pictures in this chapter.

At particularly large magnifications the limitations of the optics of the student microscope become apparent. These pictures show cell division in the growing tip of an onion root, and are reproduced here at \mathbf{M} = 500. The picture, far left, was taken using a microscope of student quality, and colour fringing due to chromatic aberration is apparent on the result. The other picture was taken on a much more expensive research microscope, using one of the most expensive objectives available, i.e. the planapochromat.

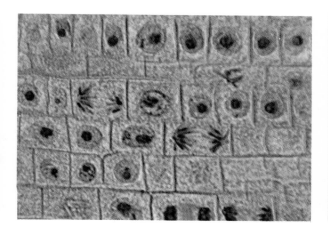

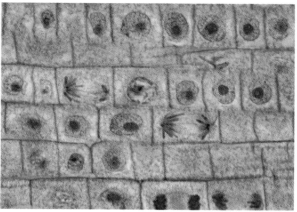

large when the camera lens is at its wider aperture settings, but reduces as the lens is stopped down, with a point being reached at which the microprism or split-image device can be seen to 'black out' and become useless as a focusing aid. In photomicrography the smallest diameter of the beam occurs at the eyepoint and is usually much too small for the microprism or split-image device to operate. Focusing on the fresnel area of the screen may also be difficult, due to the breaking-up of the image detail by the fresnel surface. Many cameras, however, have viewing screens which incorporate a small area with a plain matt surface. This usually provides the best focusing aid for photomicrography, but even so the focusing operation must be performed with great care if the sharpest picture possible is to be obtained. There can be no stopping down of the lens after the focusing operation to provide sufficient depth of field to take care of any minor focusing inaccuracy, as is possible in conventional photography.

The limits of magnification in photomicrography

A conventional photographic lens has its effective aperture quoted as an f-number which, as we have seen in an earlier chapter (p. 20), is derived from the relationship between effective diameter and focal length, and is an indication of its light-gathering ability. Microscope objectives are not classified in this manner, however, but by a number derived by multiplying the sine of half the *angular* aperture of the lens by the refractive index of the medium between objective and specimen. This number is known as the *numerical aperture* or *N.A.* of the objective, and is engraved upon its mount. Although the N.A. of an objective does have a bearing on the light-gathering power of the lens, its main purpose is to provide an indication of the objective's resolving power, which determines the ability of the objective to distinguish very fine detail in the specimen.

In microscopy the size of the specimen is often not a great deal more than the wavelength of the light by which it is being viewed, and resolution is considerably affected by diffraction, the physics of which are too involved to be explained within the confines of these pages. Suffice it to say that the larger the angle of the cone of light accepted by the objective, and hence the larger the N.A. of the lens, the greater will be its resolving power. High magnifications obviously require high resolving power, and consequently the higher the magnifying power of an objective the higher must be its N.A. A typical $\times 4$ objective, for example, has an N.A. of 0·1, while for a typical $\times 10$ objective the N.A. is 0·25, and for a $\times 40$ it is 0·65.

Objectives with magnifications of less than $\times 100$ are normally designed for use with air as the medium between objective and specimen, and these are known as *dry* objectives. Objectives with magnifications of $\times 100$ or more cannot be made with an N.A. high enough to give satisfactory resolving power when used in air. Because of this, objectives of this magnification are designed as *immersion* lenses, to be used with a liquid medium between objective and specimen. The liquid has a refractive index higher than that of air, and consequently a higher N.A. is possible. Usually the liquid is

a specially formulated 'immersion oil', the refractive index of which is about 1·5 (air = 1·0). The distance required between the lower surface of the objective and the specimen is very small, and the immersion technique is achieved simply by placing a drop of the oil on the specimen slide and gently lowering the objective into it, by using the microscope's focusing mechanism, until the image becomes sharp. An objective intended for use in this manner is marked accordingly on its mount.

The usable limit of magnification of a microscope is determined by the N.A. of the objective in use, and can be approximately calculated from the equation:

maximum usable magnification = N.A. of objective × 1000.

(Although only approximate, results calculated using this equation are sufficiently accurate for all practical purposes.) The operative word here is *usable*. When the usable limit has been exceeded, further magnification is possible in the sense that the image can be made yet bigger, but the lens will have reached the limit of its resolving power, and no further increase in subject detail will be obtained, making the increase in magnification pointless. An increase in magnification beyond the usable limit is known as *empty magnification*.

Microscope objectives are designed so that their N.A. is sufficient for the magnifications at which the microscope is likely to be used for normal viewing. A typical × 40 objective with an N.A. of 0·65, for example, allows a maximum usable magnification of 0·65 × 1000 = 650. When such an objective is used with a × 10 eyepiece the visual magnification obtained is 40 × 10 = 400, well within the usable limit. When the image is to be recorded on film, however, the degree of enlargement to which the negative or transparency will be subjected to produce the final print must also be taken into consideration, as it is the final, or total, magnification which must fall within the limit imposed by the N.A. of the objective. For example, if a photomicrograph is taken using the above objective/eyepiece combination with a separation between eyepoint and film (**k**) of 250 mm, the magnification on film will be

$40 \times 10 \times \dfrac{250}{250} = 400$, within the usable limit. If the resulting negative is itself enlarged by × 2 when making the final print, however, the final magnification will be 400 × 2 = 800, above the usable limit for that objective, and a condition of empty magnification will exist. If the maximum usable magnification is exceeded by several times, the print will exhibit very poor quality.

Illuminating the specimen

In photomicrography, correct illumination of the specimen is a requirement which is often somewhat neglected, but which is essential if the maximum possible quality is to be achieved in the resulting pictures. For reflected light work at low magnifications the requirements are not so very demanding, but consideration must be given to the texture of the specimen, and the direction and angle of

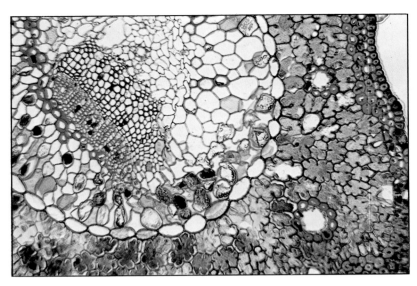

Transverse section of a pine needle.
M = 120.

the illumination should be chosen accordingly, in much the same way as is necessary for larger objects photographed by more conventional means. For specimens to be photographed by transmitted light, and this includes the vast majority of photomicrographic work, the quality of the illumination is particularly important if the maximum resolution and image contrast possible with the available objectives and eyepieces are to be obtained. This is especially true at higher magnifications. The required quality of illumination is not difficult to achieve, however, although some care is necessary in the setting-up of the sub-stage optics and the illuminating source. In an ideal situation the rays of light from the illuminating source converge on leaving the sub-stage condenser lens to form a cone of light, at the apex of which is the specimen. After passing through the specimen the light rays diverge again to form an inverted cone between specimen and objective. The condenser lens usually has some form of focusing mechanism to allow adjustment of the distance between condenser and specimen so that the light rays cross precisely in the specimen plane. Usually an iris diaphragm, known as the *aperture diaphragm*, is fitted immediately below the condenser lens. The function of the aperture diaphragm is to restrict the incoming beam of light, and, for reasons explained later, it is adjusted for the objective in use such that the inverted cone of light between specimen and objective just fills the objective's full diameter. In some cheaper microscopes the aperture diaphragm is not a continuously adjustable iris, but a rotatable disc containing several apertures of different fixed sizes.

Many microscopes are intended for use with a separate illuminator, and have a mirror mounted beneath the condenser and aperture diaphragm assembly to deflect light from the chosen source upwards into the condenser lens. Some microscopes have an illuminator built into their base. In both cases the most common light source is a tungsten lamp, usually a low-voltage type operated from the mains through a suitable transformer. For the purposes of

photomicrography, the use of a separate illuminating source offers the most versatility in the setting-up of the illumination.

The main requirements of an illuminating source for photomicrography are that it should be powerful enough for the light reaching the specimen to be of high intensity, so that exposure times may be kept to a minimum, and, if colour pictures are to be taken, that the colour of the light should match the colour sensitivity of the film. Microscope illuminators which have a tungsten halogen lamp as the light source usually meet the first requirement fully, and when used with a film balanced for tungsten lighting require a minimum of colour filtration to meet the second requirement, and thus to achieve a result with a satisfactory colour balance. It should be noted that even if the colour temperature of the lamp exactly matches the colour sensitivity of the film some filtration may still be required, as the optical elements of the microscope itself may impart a slight colour cast.

One of the most common methods of specimen illumination for photomicrography is that known as *Köhler illumination*, which produces good image quality and the highest possible resolution. It does, however, require the use of one of the more expensive types of microscope illuminator which, in addition to the lamp, contains another condenser lens and iris diaphragm, known respectively as the *field condenser* and *field diaphragm*, although the terms *lamp condenser* and *lamp diaphragm* are also used. The field condenser to lamp distance is adjustable, and for Köhler illumination is set so that a sharp image of the lamp filament is projected on to the microscope's aperture diaphragm. The focusing of the microscope's condenser lens is adjusted so that a sharp image of the illuminator's field diaphragm is projected on to the specimen plane (see diagram). The opening of the field diaphragm is adjusted so that it is just large enough to permit illumination of the entire area of the specimen to be included in the photomicrograph. Too large a setting of the field diaphragm may allow extraneous light to produce flare within the

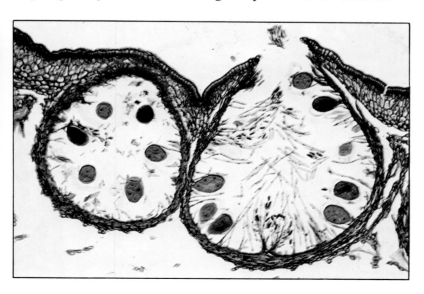

This picture shows a section through the ripe conceptacles of a brown seaweed of the genus *Fucus*. The right-hand conceptacle has ruptured in readiness for releasing its eggs, the oogonia, into the water. **M**=60.

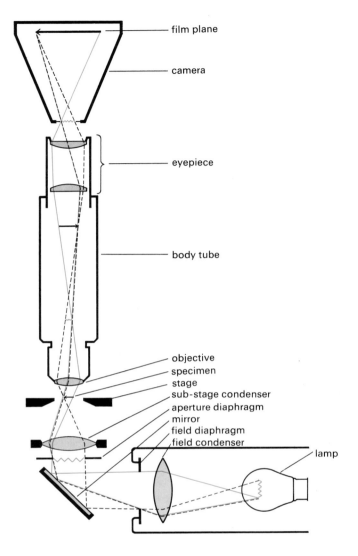

film plane

camera

eyepiece

body tube

objective
specimen
stage
sub-stage condenser
aperture diaphragm
mirror
field diaphragm
field condenser

lamp

This diagram shows a microscope and separate illuminator adjusted for Köhler illumination.

Although, in practice, an infinite number of light rays leave the lamp, pass through the specimen and eventually arrive at the film, only four have been shown in this diagram. Two of these may be considered as 'illuminating' rays, and are shown here in red. The other two, one of which is identical to one of the 'illuminating' rays, may be considered as 'image-forming' rays, and are shown as dotted black lines.

Looking at the 'illuminating' rays first, rays leaving the lamp are collected by the field condenser, pass through the field diaphragm and form an image of the lamp filament in the plane of the aperture diaphragm. After passing through the sub-stage condenser the rays pass through the specimen itself. An additional image of the lamp filament is formed just above the objective, with another just above the eyepiece. Note that although the 'illuminating' rays drawn here both leave the same point of the lamp filament they spread out to encompass the entire width of the specimen and of its subsequent images, and that although the 'image-forming' rays leave opposite ends of the filament they coincide at the same point on the specimen and its subsequent images. It is these characteristics of Köhler illumination which provide very even illumination from a non-uniform light source.

Note also that the diameter of the field diaphragm is set to limit the illuminated area of the specimen field to just that area which is to be included in the picture, and that the diameter of the aperture diaphragm is set to limit the diameter of the cone of light which enters the objective.

microscope's objective or body tube which will reduce image contrast, while too small a setting will restrict the field of view. Adjustment of the field diaphragm should have no effect on image brightness. The aperture diaphragm is adjusted so that the working diameter of the objective is just completely illuminated by the inverted cone of light formed between specimen and objective. Too large a setting of the aperture diaphragm may also cause flare within the microscope, with a resulting loss of image contrast, while too small a setting will restrict the N.A. of the objective, causing inferior resolution and the appearance of interference fringes around the detail of the specimen.

When lamp and microscope are both correctly adjusted for Köhler illumination the specimen field should be evenly illuminated, even though the lamp filament itself is a non-uniform source. Uniformity of the illumination of the specimen field for normal visual use of the microscope is not very critical, as the eye tends automatically to

adjust for any minor unevenness of intensity over the field, but for photomicrography it is essential, as the film does not share the eye's capabilities and any unevenness will be apparent on the resulting pictures.

The benefits of Köhler illumination over more simple methods are most evident when the photomicrograph is being taken at a high magnification, say with a × 100 objective. At lower magnifications, with objectives of × 40 or less, the benefits are less apparent, if indeed they can be seen at all. All the pictures taken by transmitted light appearing in these pages were photographed using a simpler method of illumination which does not require the use of a special microscope illuminator. Instead, a standard slide projector was used as the light source, although any of the above adjustments for Köhler illumination which remained possible with this simpler illumination were still made. The slide projector was one equipped with a tungsten halogen lamp, and thus gave an illumination of the high intensity needed for short exposures, and of a colour temperature well matched to the sensitivity of the film, so that a minimum of colour filtration was required.

The projector was positioned with its lens pointing directly towards the microscope's sub-stage mirror. A piece of the plastic tracing 'paper' available from drawing office suppliers was taped to a small glass plate and the assembly was positioned vertically between projector and microscope mirror, to act as a diffuser to ensure evenness of illumination. When the objective required for the first picture had been selected the following procedure was carried out to optimize the adjustment of the sub-stage optical components:

1. With the microscope's aperture diaphragm fully opened, the microscope was visually focused on the specimen by looking through the eyepiece in the normal manner, i.e. with the camera removed.
2. A piece of black paper with a small hole (about 2 mm diameter) was taped over the tracing paper diffuser so that the hole was in line with the centres of both the projector lens and the microscope mirror. (The hole simulates the field diaphragm of a high quality microscope illuminator.)
3. While looking through the microscope, the angle of the mirror was adjusted to centre the image of the hole in the microscope's field of view.
4. While still looking through the eyepiece, and with the microscope still focused on the specimen, the focusing of the sub-stage condenser lens was adjusted to give the sharpest possible image of the hole, thus ensuring that the condenser was imaging the simulated field diaphragm precisely in the specimen plane. (In practice stages 3 and 4 must usually be carried out in conjunction with one another, as completion of stage 3 is not possible until a reasonably sharp image of the hole can be seen through the microscope.)
5. The black paper was removed from the tracing paper diffuser.
6. While looking down the microscope body tube from a distance with the eyepiece removed, the microscope's aperture

diaphragm was adjusted until the bright circle of light (the image of the aperture diaphragm formed in the objective) filled about 4/5 of the total diameter of the objective's rear surface.

7. The tracing paper diffuser was masked down on all four sides until only the area of the specimen actually included in the picture was illuminated, to ensure that flare within the microscope was kept to a minimum. (When using a reflex camera this stage is facilitated by observing the image through the camera's viewing system and moving each piece of black paper in turn until it is just visible at the edge of the viewfinder frame and then moving it out again until it is just out of view.)

When photomicrography is to be undertaken using a fixed-lens camera, the microscope focusing should be checked by viewing the image directly through the eyepiece, after the above procedure has been completed and before the camera is positioned over the microscope. When an SLR is used with its lens removed, the camera should be installed on the microscope between stages 6 and 7, and the microscope focusing readjusted to give a sharp image on the camera's viewing screen.

The above procedure for optimizing the illumination should be repeated whenever the objective is changed for one of a different magnification. If, when using a camera with its lens removed, the magnification is changed by altering only the separation between eyepoint and film (\mathbf{k}) only stage 7 need be repeated (in addition to re-focusing the microscope, of course).

Assessing the exposure
Determining the exposure required for photomicrography with cameras equipped with TTL metering is usually possible by using the camera's built-in meter. If the metering is of the 'full-aperture' type, it must be used in the stopped-down mode for an accurate reading to be obtained (see p. 62).

When using cameras without TTL metering, exposure determination must initially be by trial and error, but once the correct exposure has been found for a particular magnification the exposure required for a different magnification can be calculated from the following formula, in which the conditions prevailing at the time of the initial test have been called 'standard'.

New exposure $=$

$$\text{Standard exposure} \times \left(\frac{\text{Standard N.A.}}{\text{New N.A.}} \right)^2 \times \left(\frac{\text{New magnification}}{\text{Standard magnification}} \right)^2.$$

The formula only holds good when the source of illumination remains the same and, if an objective of different N.A. is used, when the aperture diaphragm has been readjusted as described earlier, so that its image, seen by looking down the body tube with the eyepiece removed, again fills about 4/5 of the visible area of the objective's rear surface. Although in theory the formula provides a good indication of the exposure required for the new conditions, in practice it is advisable to make additional exposures at durations which are both longer and shorter than that calculated, to ensure

that a picture with precisely the correct exposure is obtained. This is particularly important when the specimen has also been changed, as the optical density of each specimen, and hence the amount of light it transmits, is so dependent on its physical nature, its thickness and the degree of staining used in its preparation.

Taking the picture

Movement of the camera/microscope combination during the exposure is a common problem in photomicrography, and is evident on the results as a double image or general lack of sharpness. Even minute movements of the microscope body tube relative to the specimen produce a considerable movement of the image across the surface of the film, due to the high optical magnifications involved. Often the vibration produced by the camera's shutter as it operates is sufficient to spoil the sharpness of the image. For this reason the shutters of cameras specially designed for photomicrography are often mounted in shock absorbing rubber, which prevents any vibration from being transmitted to the camera body and hence to the microscope. When general-purpose cameras are used for photomicrography the problem of vibration is particularly acute with SLRs, as the vibration produced by a focal plane shutter mechanism is usually much greater than that produced by a between-lens shutter. Other causes of camera movement at the moment of exposure are the mirror of an SLR as it suddenly flips out of the light path immediately before the shutter operates, which can be prevented on some cameras by locking up the mirror just prior to making the exposure, and accidental jolting of the camera caused by the use of the camera's shutter release button to fire the shutter, which can be avoided by the use of a cable release or by using the camera's delayed action mechanism. Any vibration remaining after these precautions have been taken will be due to the action of the shutter itself and, although nothing further can be done to reduce it, its effect on image sharpness can be kept to a minimum by ensuring that any slight movement of the camera which it may cause cannot be transmitted to the microscope itself. This can be achieved by dispensing with the conventional microscope adaptor and mounting the camera by some other means so that it is in the correct position over the microscope but does not actually make physical contact with it. One drawback of this method is that the alignment of camera and microscope eyepiece, which is fairly critical if the best results are to be obtained, must be performed manually rather than being automatic as it is when using a microscope adaptor. Another difficulty is that the lack of mechanical coupling between camera and microscope requires the use of some kind of light baffle to ensure that the only light to reach the film is that which has passed through the microscope optics and will, therefore, contribute to the formation of the image. This is particularly important when using a camera with its lens removed. When using cameras with fixed lenses, however, this method of mounting the camera is usually normal practice anyway, as few manufacturers of cameras of this type include a microscope adaptor in their list of

accessories. The lens housing itself is light-tight and, if a lens hood is used to prevent extraneous light from directly reaching the space between camera lens and microscope eyepiece, no further light baffling will be necessary provided the general light level in the room is kept to a minimum.

Another approach to the problem of movement during the exposure is to use the camera shutter not as a direct means of controlling the exposure duration, but only to uncover the film in readiness for the exposure to be commenced and terminated by other means. When all the preliminary setting up of camera, microscope and illumination has been completed and everything is ready for the picture to be taken, this can be achieved by holding a piece of black card over the light source so that light can no longer reach the microscope optics. The camera shutter should then be opened on B and locked open by the use of a locking cable release. A few seconds should be allowed to elapse to allow any vibration caused by the shutter opening to die away, after which the exposure can be made by removing the black card from in front of the light source for the required duration. As soon as the exposure has been terminated the camera shutter should again be closed. To avoid any movement of the camera and microscope during the exposure care should be taken to ensure that the black card itself does not accidentally come into contact with the microscope as it is being manœuvred. Because of the difficulty of controlling exposures of less than about 0·5 second with sufficient accuracy by this method, it may be necessary to reduce the intensity of the illumination so that exposures of this duration or longer are required. This can best be done by introducing neutral density filters into the light beam. N.D. filters are calibrated in a logarithmic scale, and each 0·3 increase in density reduces the light reaching the film by half and thus requires the exposure duration to be doubled. The filters (and any required for the correction of colour temperature) should always be placed between the specimen and the light source rather than between specimen and film, so that any optical defects, such as lack of flatness, which the filters may possess cannot have any detrimental effect on image sharpness.

Photomicrography using electronic flash

The very short exposure durations which are an inherent characteristic of electronic flash make this form of lighting especially useful for the photomicrography of minute living organisms that move across the microscope field too quickly to be recorded sharply using the longer exposure durations necessary with tungsten lighting. In addition, this high-speed characteristic can be used to advantage with non-moving subjects as yet another way of reducing, if not entirely eliminating, unsharpness of the image due to movement of the camera or microscope.

Because the light given by any type of flash unit is produced only at the actual moment of exposure, some form of continuous lighting must be provided for viewing the specimen and setting-up the microscope and camera in readiness for the picture to be taken. It is

important that this setting-up illumination gives a visual lighting effect which very closely simulates the lighting given by the electronic flash on the picture when it is eventually taken. With the lighting system described earlier this can be achieved by fixing the electronic flash in the position normally occupied by the slide projector, which may now be positioned beside the flashgun, so that it also illuminates the diffuser, but for setting-up purposes only.

Almost any flashgun can be used, but if it is of the so-called 'computer' variety, which automatically gives the correct exposure when used for normal photography, it should be set to operate in the manual mode. An ideal choice is the type of computer flashgun which offers the facility referred to on some models as 'power ratio control' (see page 176), in which the flash duration, and hence the total light output, is adjustable when the flashgun is used in the manual mode. This type provides the easiest method of varying the light output to obtain the correct exposure (when using electronic flash for photomicrography the only way of adjusting the exposure is by some means of altering the amount of light passing through the microscope, and this can be achieved by altering either the duration or the intensity of the flash). When using flashguns without the facility for altering the duration, the intensity can be varied by placing neutral density filters in front of the flashgun.

If the relative positions of flashgun and setting-up illumination are kept constant, exposure determination when using electronic flash can be achieved by using the camera's TTL metering to measure the intensity of the setting-up illumination. Once the flash exposure for a particular magnification/specimen combination has been established by initial test exposures, the amount by which the flashgun's light output must be increased or decreased for a different combination can be calculated by comparing the readings obtained from the camera's meter for the two combinations. Let us assume, for example, that the best result from a series of test exposures was made with the flash set to one-quarter power, and that the exposure meter reading taken from the setting-up illumination was 1/30 second. If the relationship thus established between flash and setting-up illumination is now applied to a different picture to be taken with a different magnification and/or specimen for which the exposure meter reads, say, 1/60 second, it will be obvious that only half the exposure required for the test exposure will be necessary, and that the flash must, therefore, be set to one eighth power.

When using electronic flash for photomicrography in colour a film balanced for daylight may be used, although film balanced for tungsten lighting, if used with a suitable conversion filter (Wratten 85B or similar), will also give satisfactory results. Additional colour filters may be required to compensate for any colour bias imparted to the illumination by the microscope optics, in the same way as is necessary when photographing by tungsten lighting.

Depth of field

In the earlier sections of this book which deal with the basics of normal general-purpose photography we have already seen that

depth of field may be defined as the distance between the nearest and most distant points between which all parts of the subject will be recorded with an acceptable degree of sharpness, and that the depth of field obtained in a picture is partly dependent on the relationship between subject size and image size, such that as the image size increases the depth of field decreases. In general-purpose photography the image is usually many times smaller than the subject being photographed, and the depth of field can often be measured in metres or even tens of metres. In close-up photography and photomacrography the image may be only slightly smaller than or even bigger than the subject, and the depth of field is comparatively small and is measured in centimetres or even millimetres. In photomicrography, however, the image is many times larger than the subject, and depth of field is consequently extremely small and must be measured in micrometres ($1 \, \mu m =$ $1/1000$ mm). When a microscope is used for visual purposes this minute depth of field is not too great a problem, as the accommodation mechanism of the viewer's eye allows him to focus on different planes of the specimen at will. Any parts of the specimen falling outside the range of the eye's accommodation can be brought into focus by a slight adjustment of the microscope's focusing control. In photomicrography the image can only be recorded at one focus setting at a time, however, and if the thickness of the specimen exceeds the depth of field some parts of the specimen will appear unsharp on the resulting picture.

In general-purpose photography depth of field is dependent also on the effective aperture of the lens. This is equally true in photomicrography, and an objective of low N.A. will give greater depth of field than one of high N.A. when both are used to give the same magnification. We have already seen, however, that the overall sharpness obtained in photomicrography is also dependent on the N.A. of the objective, and that the higher the N.A. the better is the resolving power of the lens. Thus the requirements for high resolution and large depth of field are in opposition to each other, and a compromise must be made in which the two factors have been carefully balanced, one against the other. When the required magnification is considerably less than the maximum imposed by the N.A. of the objective, i.e. considerably less than N.A. \times 1000, some reduction of the N.A. to obtain greater depth of field is possible without too great a loss of overall image sharpness. Unlike camera lenses, however, very few microscope objectives have iris diaphragms, so their effective diameter must be limited by other means. When the illumination and sub-stage optics have been correctly set-up as described earlier, this can be achieved by adjusting the microscope's aperture diaphragm so that the inverted cone of light between objective and specimen does not illuminate the full diameter of the objective. The extent of this adjustment can be monitored by viewing the image of the aperture diaphragm formed in the objective by looking down the body tube with the eyepiece removed. When using an SLR camera the resulting increase in depth of field can be seen through the viewfinder, but the loss of

resolution which will be evident on the resulting picture if the N.A. is reduced excessively will probably not be seen, due to the coarseness of the focusing screen. The optimum setting of the aperture diaphragm for a particular magnification must, therefore, be found by trial and error. On some microscopes the diaphragm is calibrated, so that once the optimum setting has been established the scale reading may be noted for future use. Metering of the exposure should be performed after the required setting of the aperture diaphragm has been selected.

The lighting technique described in the previous pages is a form of brightfield illumination, so called because the specimen appears against a brightly illuminated background. Brightfield is the most common illumination in microscopy, and is the easiest to set up with simple equipment. For certain subjects it does have its limitations, however, and more sophisticated forms of illumination are necessary for these if the required detail of their structure is to be revealed.

Darkfield illumination, in which the specimen appears bright against a dark background, is useful for revealing detail in unstained transparent or semi-transparent specimens which are not visible by brightfield illumination.

A great advance in microscopy was achieved by the development of the phase contrast system. This is also used with transparent specimens, but has the advantage of allowing the visualization of the internal details of cell structures, which the darkfield method does not. Consequently, the phase contrast system is used extensively in the field of tissue culture, where it permits living cells to be studied. The phase contrast system uses special condensers and objectives, and relies on light which passes through the specimen being retarded slightly, so that when it is recombined with light which has not passed through the specimen there is a phase difference between the two beams, causing interference which renders the specimen visible.

Polarized light is often used to reveal the detail of crystalline structures such as rock samples and certain chemicals, often with spectacularly colourful results (see p. 238 for examples of chemical crystals photographed by polarized light).

The reader whose appetite is whetted by his initial experiments in photomicrography, and who wishes to pursue this absorbing field of photography still further, will find available a number of specialist publications which deal with the subject much more fully than has been possible within the confines of these pages.

Special techniques

The following pages give details of various photographic applications which, in addition to demanding a certain amount of basic photographic skill, mainly in the field of close-up photography, also require some specialized, although often home-made, additional equipment or materials.

Photographing small living creatures under controlled conditions

The first of these special techniques is that of photographing small creatures, such as insects and small amphibians or reptiles, under controlled conditions using props and carefully arranged lighting to give the impression that the pictures have been taken outside in the wild. This is a technique which is commonly used, although infrequently admitted to, in the preparation of illustrations for books and in the making of natural history television programmes. Although one's first reaction may be to condemn the use of such techniques as 'cheating', often it is the only way to be sure of satisfactorily recording certain aspects of a creature's habits, development, or life-cycle.

The essential equipment for the technique is some form of 'box' in which the creature may be confined during photography, and into which may be placed props such as foliage or stones, which for authenticity should be of types commonly found in the creature's natural habitat. Some form of authentic background, either drawn or photographically produced, is often also required.

The well-being of all living creatures should be considered while they are held in captivity, and they should be returned unharmed to their natural habitat as soon as the photographic session is over.

The edible frog, below left, was photographed in a box similar to that shown below. The foliage and stones were arranged, with a little water, before the frog was introduced. In this instance the picture has been taken looking down on the subject, so no artificial background was necessary.

The simple box shown below is suitable for photographing a variety of small creatures. It may be constructed from transparent plastic sheet or thick foil. A hole just large enough for the camera to look through should be cut in the front panel. The back should be left open to accept the selected background, which can be either a suitably coloured wash of paint on a stiff card or a photographic colour print of leaves or other foliage typical of the creature's natural habitat. When photographing foliage to produce suitable backgrounds the camera's focusing should be set to produce an unsharp result, so that when the print is used as a background, the foliage appears well out of focus, simulating the effect obtained had the picture been taken outside in the wild. Note that the background is angled. This is to allow it to be evenly illuminated by the single light source, which in the diagram is electronic flash diffused by a sheet of opal acrylic plastic. Electronic flash is an ideal light source for the purpose, as its very short duration 'freezes' any movement of the subject.

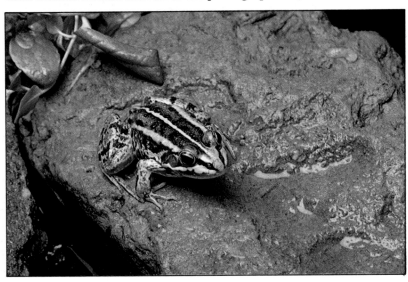

The box shown above is a development of the simple one described on the previous page, and has a few sophistications which allow easier manipulation of subject and lighting. The main improvement is the use of three small flashguns for illumination, one from the top and one from each side. This facilitates obtaining an even lighting. Panels of opal acrylic plastic diffuse the light from the flashguns at the sides of the box, which serve mainly to

illuminate the background. The top flashgun illuminates the subject and is positioned fairly high to ensure that no shadow of the subject is cast on the background, and its actual position is adjustable to suit the particular subject. The inside surfaces of the box are painted white, which also helps to ensure that the lighting is soft and diffused. A hinged door in one side panel allows easy access to the subject, and the turntable in the base allows the subject to be rotated

to just the right angle for photography. The backgrounds, again either photographic colour prints or drawn on card, fit into a rebate around the open end of the box.

The pictures below were all taken using the box described above.

Photographing fish in aquaria

Fish in aquaria are difficult subjects to photograph due to certain problems caused by the nature of both fish and tank, the most obvious of which is the appearance of reflections of lights and camera in the glass surfaces of the tank.

The information contained in this and the following page show how these problems can be fairly easily overcome.

The picture, left, was taken using the very simple arrangement shown above. A single electronic flash illuminates the fish from a fairly high angle. A sheet of clear glass, invisible in the final picture, is used to confine the fish to a fairly narrow plane at the front of the tank. To avoid reflections, light from the flash must be prevented from illuminating the camera. The diagram, below, shows a simple modelling lamp, folded from sheet metal and using a small tungsten lamp, which can be attached to the flashgun and used to check for reflections and general lighting effect.

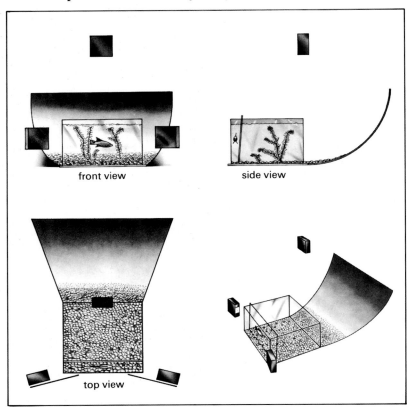

front view

side view

top view

A drawback of the simple set-up described above is that the area well behind the fish records almost black and without detail. The diagrams, left, show an improved set-up which allows the inclusion of an artificial background. This can be a piece of card with a suitably coloured wash of paint, laid under the tank and bent up behind it. Stones matching those in the tank can be placed at the base of the background, immediately behind the tank, to give the effect of a river bed receding into the distance. In the pictures on the following page three small electronic flashguns have been used, one from each side to illuminate the fish, and one from the top, towards the rear of the tank, to illuminate the background. Quite satisfactory results might well have been obtained using only two lamps, both from the top, one well forward to illuminate the fish, as in the simple set-up described previously, and one to the rear to illuminate the background. Pieces of black card fixed between flash and camera prevent illumination of the camera which might cause reflections in the glass. The flash units should be positioned so that the corners of the tank do not cast shadows on the fish or background.

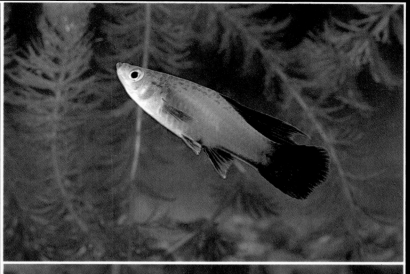

These pictures show the effect of varying the relative strengths of the illumination of fish and background. In the picture, top left, the three flash units, which were of identical type, were all used at their full light output. Because the flashguns at the front are nearer to the fish than the flashgun at the rear is to the background, setting the correct exposure for the fish has led to under-exposure of the background, which consequently appears too dark.

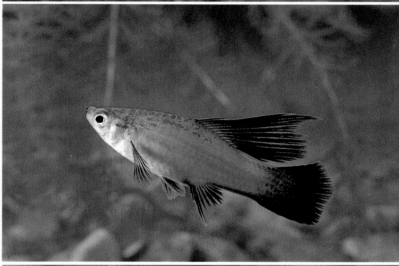

To reduce their light outputs for the picture, centre left, a single sheet of tracing paper was placed over both of the flashguns illuminating the fish. To maintain correct exposure of the fish the lens aperture had to be opened one half stop, which has allowed the background more exposure, and thus caused it to record lighter.

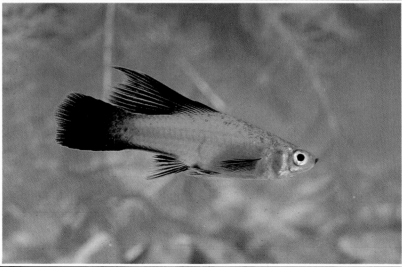

For the final picture two sheets of tracing paper were placed over each of the flashguns illuminating the fish, reducing their light output even further. The lens aperture had to be opened yet another half stop to maintain correct exposure of the fish, further increasing the exposure of the background.

Photographing small pond organisms

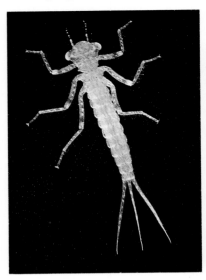

The main difficulty encountered when photographing small living creatures such as this fresh-water damsel-fly nymph, *Coenagrion*, shown here 4× life size, is that of keeping them in focus and within the camera viewing frame.

Two pieces of flexible transparent foil, about 3 in./7.5 cm square, were joined together on three sides by ½ in./1 cm strips of double-sided tape, to form an envelope. To ensure that the envelope was watertight, strips of waterproof self-adhesive tape—PVC insulating tape is ideal—were folded around the three edges held by the double-sided tape. The problems of focusing and framing were considerably reduced by gently placing the creature in the centre of the water-filled envelope. *Canon F1, 50 mm macro lens with bellows, extension 3.1 cm, electronic flash, f16, Kodachrome 64.*

Photography of the mosquito larva, *Culex*, reproduced here 6× life size, presented similar problems to those encountered with the damsel-fly nymph. Because the mosquito larva is a surface breather it was important to show the surface of the water. Had the foil envelope been used, the surface would not have been perfectly straight, due to surface tension and the irregular cross section of the envelope. As a straight water surface was required, a modification of the envelope technique was necessary. A length of round section, rubber-covered electrical flex was sandwiched between two pieces of thin glass to form a small tank, the sandwich being held firmly together by three large paper clips. *Canon F1, 50 mm macro lens with bellows, extension 8.3 cm, electronic flash, f16, Kodachrome 64.*

This pond skater, *Gerris*, shown here life size, was photographed on the surface of water contained in a shallow laboratory beaker. The bottom of the beaker was covered with sand and the leaves of the water-plant were floated on the water surface.

Two small flashguns placed either side of the beaker were used as the light source. Pieces of tracing paper in front of each flashgun diffused the light and reduced its intensity to a usable level. *Canon F1, 50 mm macro lens, electronic flash, f22, Kodachrome 25.*

Important: As a code of practice all living creatures should be handled with consideration for their well-being and returned to their natural habitat immediately after photography.

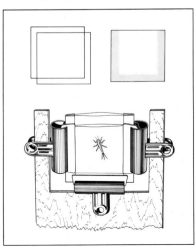

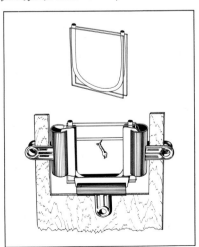

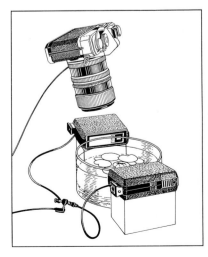

Photographing coins and medals

Most coins and medals are made by a die-stamping process in which they are pressed from flat metal blanks, causing the required features and inscriptions to be represented purely as a shallow raised relief image on the metal surface. The difficulties encountered when photographing coins are almost entirely due to the problems of lighting the subject so that the raised areas photograph as tones which are different from that of the rest of the surface.

Old coins which over the years have acquired a dull and tarnished appearance may be photographed in much the same way as other similar-sized objects and may be illuminated directly, the lighting position being carefully chosen to achieve a satisfactory tonal contrast between the various levels of the relief image.

New coins and commemorative medals often have a highly polished surface which reflects light much as does a mirror. A ray of light falling on such a surface is reflected away with very little scatter, the angle of incidence being equal to the angle of reflection (see p. 11).

In many fields of photography reflections from shiny surfaces are an unwanted nuisance, and care is needed to find a lighting position which avoids them, e.g. reflections in windows and polished furniture. The secret of successfully photographing highly-polished coins and medals, however, lies in the use of lighting techniques which exploit the characteristics of their mirror-like surfaces and permit the contours of the raised features and inscriptions to be recorded as tones which are lighter or darker than the non-raised areas. This can be achieved not by avoiding reflections, but by illuminating the coin or medal to purposely introduce *controlled* reflections from the metal surface. Only by so doing can we record the slight variations in surface level by which the features and inscriptions are delineated.

The pictures on the following page were taken using a lighting technique which effectively allows the direction of the illumination of the subject to be parallel to and coincident with the axis of the

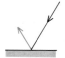
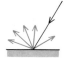

When light falls on a dull, unpolished surface, scattering takes place and the light is reflected in a haphazard manner. Light falling on a well-polished surface behaves in a similar way to a ball which is bounced on a smooth floor, and is reflected away at an angle which is equal, but opposite to, that at which it struck the surface.

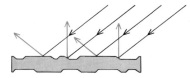

The picture, below left, was taken using a single lamp positioned to the right of the coin. As the diagram above shows, only the right-hand edges of each raised area are at the correct angle to reflect light towards the camera lens. Light falling on the rest of the surface is reflected away from the lens, resulting in a picture in which much of the coin's detail is missing. In addition, scratches and blemishes in the surface have been accentuated by the harshness of the lighting.

The picture, below, of a very old and worn gold coin, was taken using the technique described on the following page, and has fairly successfully recorded the shallow detail of the coin's surface.

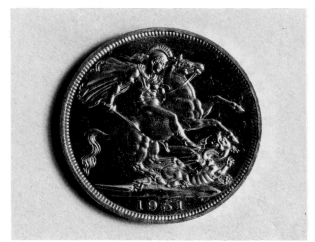

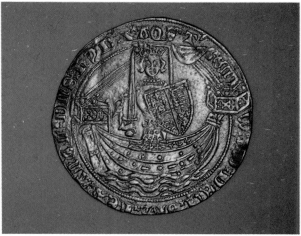

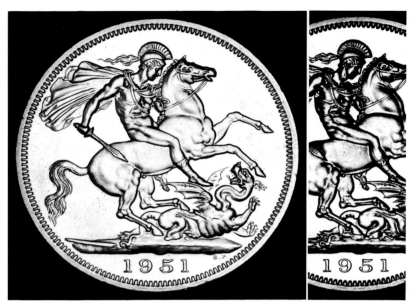

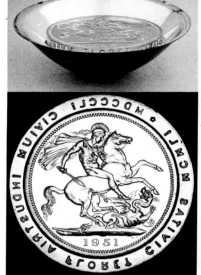

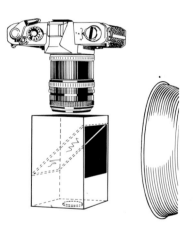

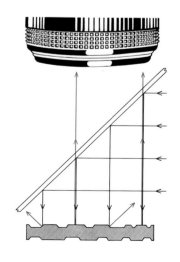

The diagram, right, shows the set-up used to take the pictures on this page. The diagram, bottom right, drawn out of scale for clarity, shows that only those light rays reflected from areas of the coin's surface which are at right angles to the lens axis actually enter the lens.

The picture, top left, was taken using a photoflood in a reflector with a piece of tracing paper as a diffuser, positioned about 12 inches (30 cm) from the angled glass. The effect of moving the lamp further away is shown in the section alongside.

Top right: By supporting the coin within the highly polished reflector removed from a torch it is possible to record the coin's edge inscription, albeit back to front, at the same time as the face of the coin is photographed.

camera lens. Light falling on areas of the coin's surface which are at right angles to the lens axis is reflected back into the lens, resulting in these areas recording on film as a light tone, while the contours of the features and inscriptions reflect light away from the lens and record as a darker tone.

The use of a direct lighting technique would require the lamp to be placed behind the camera, in line with the lens axis – an impossible situation as the camera itself would prevent light from reaching the coin. This problem can be overcome by positioning the lamp at right angles to the lens axis and placing a piece of clear glass between the lens and the coin at 45° to the axis. Most of the light from the lamp will pass through the glass and be wasted, but some will be reflected towards the coin. The majority of the light reflected back from the coin towards the camera lens will pass through the glass to expose the film.

The glass may be held in a cardboard frame, the inside surfaces of which should be painted black to prevent reflections of them from appearing in the coin's surface. The frame should also serve to prevent direct light from the lamp reaching the coin. The width of the recorded contours is dependent on the size of the light source and the distance it is from the coin. If a single-lens reflex is used the lamp distance may be adjusted to give the most pleasing effect through the camera viewfinder. Through-the-lens metering will give

a guide to the exposure required, but a series of test exposures should be made.

Because the photograph is taken through the glass it is important that the piece chosen is as optically flat as possible, or some loss of sharpness may be apparent. We used an old photographic plate from which the emulsion had been removed using household bleach, but the local glass merchant should be able to supply a suitable piece of thin blemish-free picture-frame glass.

The pictures on this page were taken using a lighting technique resulting in the contours of the raised features appearing as light tones against the darker tone of the flat areas.

The coin is placed on a small circle of background paper on a sheet of glass positioned above the light source. This paper circle should be just large enough to prevent any direct light from the lamp from entering the camera lens. An open-ended cone of white paper, with a base which is larger than the background circle is placed centrally over the coin. Light from the lamp falling on the inside surface of the cone is scattered, and some of the reflected light will fall on the coin. That striking the flat areas of the surface will be reflected away from the lens, while some of that which falls on the contours of the raised areas will be reflected into the camera lens.

The effective width of the contours can be controlled by adjusting the depth of the white paper cone. The picture, bottom left, was taken using a deep cone, while the section alongside shows the effect of using a very shallow cone. The cone must not be so deep that its top may be seen reflected in the flat areas of the coin's surface. We found it best to make a deep cone of black card into which the shorter white cones may be inserted.

The exposure required should be assessed from a series of tests, although some guide can be obtained by using the camera's through-the-lens metering system.

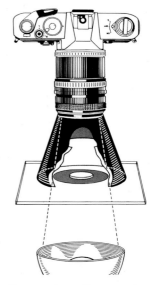

The diagram, above, illustrates the set-up used to take the pictures on this page.

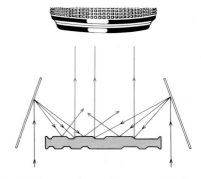

The diagram, above, drawn out of scale for the sake of clarity, shows that the angle at which light reflected from the cone falls on to the coin is such that only the rays which are reflected from the edges of the raised areas of the coin's surface enter the camera lens.

This diagram shows the approximate proportions of the cones used in the taking of the pictures, left. The larger picture was taken using the deeper cone, and shows the contours of the coin's surface as much wider areas of tone than does the section alongside, which was taken using the shallower cone.

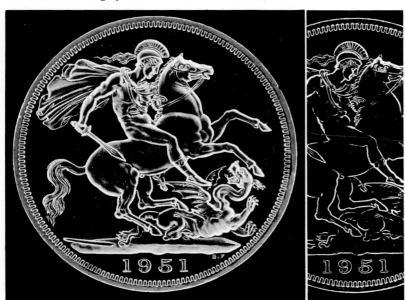

Photographing fluorescence

Fluorescence is a phenomenon whereby certain substances, when exposed to radiation outside the visible spectrum, emit light which is visible to the human eye. Often the colour of this visible emission bears no apparent relationship to the colour of the substance when viewed normally. Fluorescent displays are often to be seen in shop windows and theatres. Many of these use a special fluorescent tube designed to emit mainly ultra-violet radiation which, as its name implies, falls just outside the blue end of the visible spectrum. The glass envelopes of these tubes incorporate a filter which transmits the ultra-violet but absorbs nearly all the visible light which the tube also produces. To the naked eye these lamps appear to emit only a deep violet glow, but the ultra-violet they produce will cause many objects to fluoresce, and the visible light thus generated, although very dim by comparison with the light levels encountered in conventional photography, can be photographed by using suitably long exposure times.

Colour film balanced for daylight or for tungsten lighting may be used, although the use of daylight type will minimize any tendency towards a bluish colour cast.

Exposure determination is best effected by trial and error, as the visible light produced by the fluorescence is so weak that many exposure meters will not even register a reading. Photography should be carried out in a well-darkened room, as any visible light falling on the subject will dilute the effect of the fluorescence.

These rock samples, ordinary looking when photographed by electronic flash, take on an almost magical quality when exposed to the radiation from a UV-emitting fluorescent lamp, lower picture.

Most of the UV falling on an object is reflected back, in the same way as is visible light. Most films are sensitive to UV, so this reflected radiation must not be allowed to enter the camera lens, or the film will receive a UV image which will swamp the visible light image, producing a picture with a bluish cast and poor colour saturation. This can be prevented by placing a filter, such as a Wratten 2B, over the lens to absorb the UV while transmitting the visible light. *Lower picture: 16 minutes, f22, Kodachrome 64, Wratten 2B filter over lens, 8 watt 'Blacklight Blue' fluorescent tube approximately 6 inches (15 cm) from subject.*

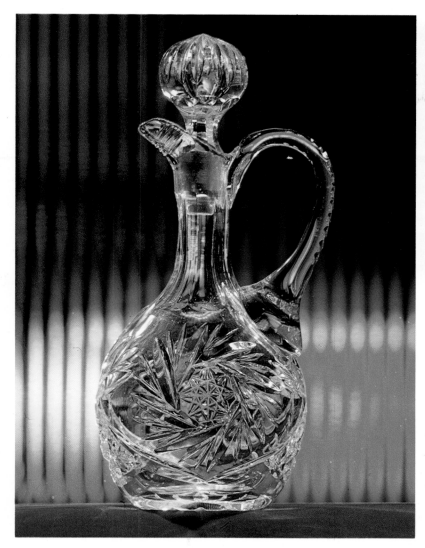

The wine decanter above was photographed approximately 10 inches/25 cm in front of a square of opal acrylic sheet which was illuminated from behind. The black background was achieved by taping to the acrylic sheet a piece of black paper just big enough to fill the picture area and allowing the light spilling around the edges of the paper to illuminate the decanter. *Canon FTb, 1/8 sec, f11, Ektachrome 50.*

Two spotlights, one with a red filter and one with a blue filter, were the light sources for the colourful picture, left, of the same decanter. Ribbed glass was used as the background. Only the red spotlight was allowed to light the background immediately behind the decanter. The blue spotlight was positioned to illuminate the area of background to the left, just out of the picture area. *Pentax, 1/15 sec, f8, Kodachrome 25.*

Photographing glassware

The golden rule when photographing glassware is not to try to light the subject directly, but to illuminate the background and to allow reflected or transmitted light from the background to be refracted and reflected by the glass objects arranged in front of it.

Colour may be introduced into pictures of non-coloured glassware by using coloured backgrounds or by placing coloured filters over the light source. An effective technique is to light the background not from the front but from behind, using transparent or translucent glass or plastic as the background material. Most dealers in glass will cut suitably sized pieces of ribbed or dimpled glass of the type used in door panels or bathroom windows.

Reflector spotlight bulbs used in shop window displays make cheap yet effective light sources. Alternatively pieces of coloured filter or cellophane may be mounted in slide mounts and put in an ordinary slide projector, which may then be used as a coloured spotlight.

Water-colour technique

The pictures on this and the following page were taken by an interesting but easy technique giving an unusual result which resembles a delicate water-colour painting.

The cut flowers are arranged on a piece of tracing paper taped to a sheet of glass fixed horizontally above the camera. An additional piece of glass laid over the flowers and separated by spacers from the first glass gently holds them in position without flattening them. A lamp positioned above illuminates the subject, casting a sharply defined shadow of the flowers on to the tracing paper. Light reflected from the paper on to the underside of the flowers where they are not actually in contact with the paper is reflected back, taking on the actual colour of the flower. This reflected light, with any transmitted by the more translucent areas of the petals and leaves, partially illuminates the shadows. The camera, looking at the underside of the tracing paper, observes a clearly defined shadow within which a soft, diffused impression of the detail of the flowers and leaves may be seen.

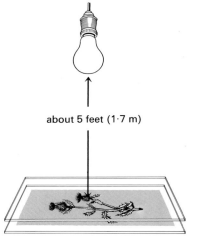

about 5 feet (1·7 m)

The diagram above shows the arrangement used to create the pictures on these pages.

A sheet of tracing paper – the plastic variety available from most drawing-office suppliers is best – was taped to the upper surface of a horizontal sheet of glass. The flowers were arranged on the tracing paper and constrained by a second sheet of glass to a fairly shallow depth, without bending the petals or leaves to an unnatural-looking position.

The lamp, a No. 1 Photoflood, was suspended about 5 feet (1·7 m) above the flowers. It was used without a reflector, providing a fairly small light source which cast a sharply defined shadow of the flowers on to the tracing paper.

A film balanced for artificial light was used, although daylight film could have been used with a suitable conversion filter. The exposure must be determined by trial and error as it is dependent on the transmission and reflection characteristics of the petals and leaves, and the optical density of the tracing paper.

Papaver rhoeas

Oil painting technique

The pictures above and opposite were made using a technique whereby an ordinary small-format colour transparency is converted into a simulated oil painting.

The chosen original transparency is copied through a piece of 'non-reflecting' picture-frame glass placed a few millimetres from the transparency. The surfaces of this glass have an irregular, dimpled finish which breaks up the image of the original picture to give an effect resembling the brush strokes of an Impressionist painting.

The camera should be equipped with either bellows or extension tubes to allow the lens to focus close enough to fill the frame with the required area of the original slide. The size of the dimples in the glass is just about right for the technique to work well with the area of a full-frame 35 mm original. If a larger original is used, the size of the simulated brush strokes will be less in relation to the picture size, and the 'painting' effect will be less pronounced. The extent to which the detail is broken up by the glass is also determined by the distance separating the glass from the original. The main examples on these pages were made by copying almost the full area of the original 35 mm slides with the glass spaced from the original by a distance of about ¼ inch (6 mm). Coins, one on top of another, make ideal spacers.

The original may be illuminated by either tungsten lighting or by

The diagram, above, shows the sandwich of non-reflecting glass, transparency, and opal acrylic diffuser. Note that the area of diffuser surrounding the transparency has been masked off with black paper to prevent extraneous light causing flare within the camera lens. Note also the use of coins as spacers to separate the non-reflecting glass from the transparency.

flash, the light being diffused by a piece of opal acrylic sheet. The colour balance of the film in the camera must match the chosen light source, or the correct conversion filter used.

For the sharpest rendering of the simulated brush strokes, the lens should be focused on a point between the glass and the original slide, and stopped well down to bring both the glass and the original into sharp focus. A few frames should be exposed at varying exposure settings and the film processed to establish the optimum exposure and any additional colour filtration required to correct any unforeseen colour casts.

The technique works best with subjects with plenty of crisp detail. Large areas of even tone appear almost unaffected on the copy and should be avoided. When copying transparencies in this simple manner some increase in contrast is inevitable but in some cases this actually helps to accentuate the brush-stroke effect.

The picture, below, shows a section of the original transparency used to create the simulated oil painting, left. The flowers were arranged and photographed with the sole intention of subjecting the resulting transparency to the technique as described, in order to produce a picture reminiscent of a still-life oil painting.

Photographing crystals by polarized light

As we have seen in the first chapter of this book, light is a form of electromagnetic radiation, and may be considered as a series of waves radiating from the light source. If the source is an ordinary one, such as a light bulb, the waves vibrate in a haphazard manner, and the plane of vibration of each wave can be in any direction relative to its axis. Such light is *unpolarized*. Polarizing filters have the property of passing only those waves which are vibrating in a plane which is parallel to its own plane of polarization, see diagram. Waves which are vibrating in any other plane are unable to pass. The light emerging from the filter is *polarized*, with all its constituent waves vibrating in the same plane. If this polarized light is presented to another polarizing filter, whether or not any light passes through the second filter depends on whether or not the planes of polarization of the two filters are parallel. If they are parallel light is allowed to pass, if they are not no light can pass. This can be demonstrated by placing together two polarizing filters and looking through them, while rotating one filter relative to the other. The appearance of the combined filters alternates between light and dark as the filter is turned. When the combination appears at its darkest the planes of polarization of the two filters are at right angles, and the filters are said to be 'crossed'.

Certain materials exhibit the property of rotating the plane of polarization of light. When such substances are placed between crossed polarizers they rotate the plane of polarization of the light passing through the first filter, with the result that some of this light passes through the second filter. Consequently when filters and substance are viewed as a sandwich, the substance appears as a light object on a dark background. Some substances rotate the plane of polarization by different amounts for different colours. When such an object, even if normally colourless, is placed between crossed polarizers it appears multi-coloured. The celophane wrapped around the packets of some brands of cigarettes is an example of such a substance, and if crumpled or folded to produce various thicknesses appears quite brightly coloured when placed between crossed polarizers.

A light ray passes unimpeded through a polarizing filter only if its plane of vibration is exactly parallel to the plane of polarization of the filter.

If two polarizing filters are positioned with their planes of polarization at right angles, a ray of light passing through one filter cannot pass through the other unless its plane of vibration is rotated by some suitable object placed between the filters.

When photographing crystals by polarized light it is important that the planes of polarization of the two filters are exactly at right angles. The desaturated and flat result, below left, was taken with the planes of polarization of the two filters at about 45° to each other, whereas the much more contrasty and colourful picture, below right, was taken with the planes at exactly 90°.

The crystals of many commonly available, colourless chemicals exhibit the above property, and make ideal subjects for producing spectacularly coloured, almost abstract pictures. The crystals may be formed in two ways – either by evaporating a solution, or by melting the chemical and allowing it to cool. Which method is best depends on the nature of the chemical itself. In either case the crystals should be allowed to form in a very thin layer on a piece of thin glass – a microscope slide or a glass from a transparency mount is ideal. If the crystals are to be formed by evaporation a drop of a solution of the chemical should be placed on the glass, which should then be covered and left undisturbed while the liquid dries. If the crystals are to be formed by melting an easy way of heating the chemical is to clamp an ordinary domestic iron upside-down in a vice and to place on the hot, upturned surface the piece of glass on which a small amount of the chemical has been placed. As soon as the substance melts a second piece of glass should be dropped over the molten liquid and gently pressed down to squeeze the liquid into a thin film. The sandwich thus formed should be quickly removed from the heat and allowed to cool. The timing of the above procedure is quite critical, and several attempts may be necessary to get it just right. If the second glass is dropped too soon the chemical may not be sufficiently molten to flow out freely, if it is left too long bubbles may form in the liquid and become trapped between the glasses. The crystals may take several hours to form and, depending on the chemical used, may continue changing their shape over a period of days or even weeks. The pattern of the formation is quite unpredictable and unrepeatable. Apart from the geological specimens, all the pictures in these pages are of citric acid crystals formed by melting, and, as can be seen, each pattern is different. As the crystals are colourless when viewed normally, the progress of their formation can be seen only by placing them between crossed polarizers.

When the crystals are ready for photography the sandwich of filters and crystals should be placed on a diffuser, evenly illuminated from the rear. For the pictures of the crystals in these pages a slide projector was used as the light source, with colour film balanced for tungsten illumination. Electronic flash could have been used with daylight film, but some form of pilot lamp would have been necessary for focusing and framing.

Because of the small physical size of the crystals, extension tubes or bellows will be required, and the magnification on film is likely to be greater than 1, in which case the best results will be obtained by reversing the lens (see p. 199). The lens should not be stopped down excessively, or loss of sharpness may result due to diffraction.

The optical quality of the polarising filter between crystals and camera lens must be excellent – a glass filter must be used – otherwise image quality may be adversely affected. The filter between crystals and light source is not so critical and can be of the cheaper, plastic variety.

Care must be exercised if the camera's TTL metering is used to assess the exposure required. The optics of the viewfinder of some

The shapes and forms into which the thin layer of crystals grows is usually totally unpredictable, as is shown by the pictures above, all of which are of citric acid crystals prepared by melting the chemical, squeezing it into a thin layer, and allowing it to cool.

SLRs themselves tend to polarize light to some degree, and if the plane of this polarization is different from that of the light coming through the filter and crystal sandwich, some of the light will be stopped and the meter will read less light than there really is, and over-exposure of the film will result. The camera can be checked for this characteristic by placing a single polarizing filter over the lens, looking through the viewfinder at a diffused, unpolarized light source, and rotating the filter while watching the meter needle. If the reading alters as the filter is turned then extreme caution will be needed when metering from the crystals, and a series of exposures continuing up to one or two stops less than that indicated should be made as a test.

Be careful when experimenting to find chemicals suitable for crystal photography. In particular, take care when forming crystals by melting, as some normally quite harmless substances can give off poisonous fumes when heated.

The crystal formations often continue to change and develop for some time after they are first prepared. The picture, above, is of citric acid crystals, shown here about four times life-size, and was taken four days after preparation. The picture, opposite, shows the same growth, this time at ten times life-size, as it appeared about seven weeks later.

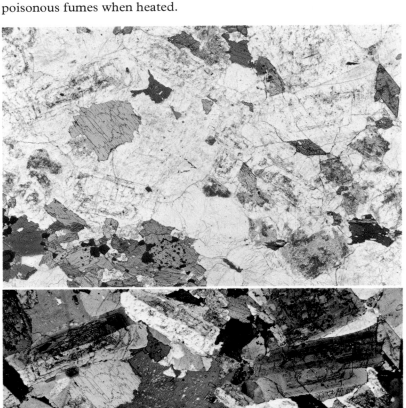

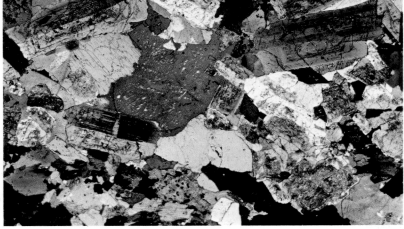

Many geological specimens, when specially prepared as very thin slices, make suitable subjects for photography by polarized light. The pictures, left, show a slice of granodiorite as it appears under normal illumination, upper picture, and as it appears when placed between crossed polarizers, lower picture.

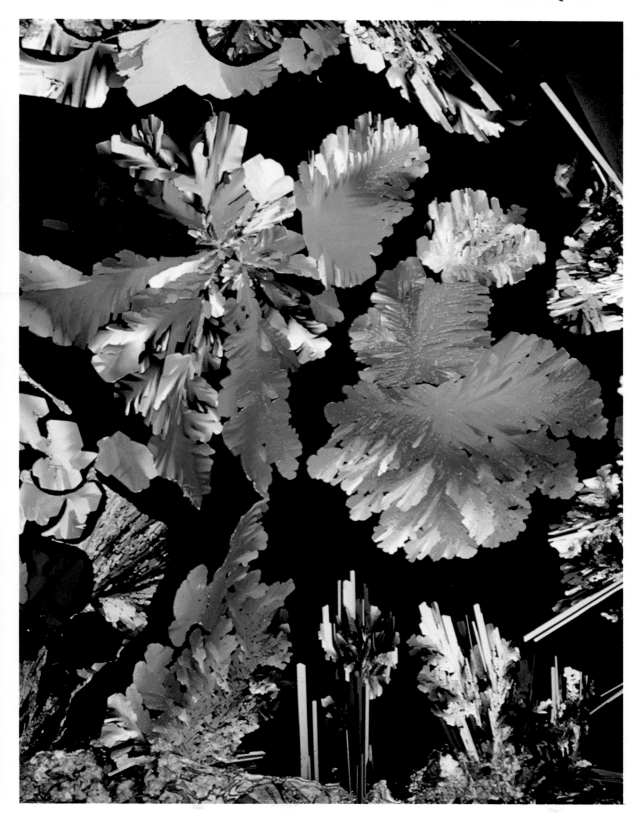

Filters

This diagram shows that a filter passes only those wavelengths of light which constitute the colour of the filter itself. Light of other wavelengths is blocked.

Note that colours opposite each other on the diagram are complementary colours, e.g. cyan is the complementary colour to red and vice versa. For a brief description of light and colour see pages 9–16.

Filters are used in photography for one basic reason – to produce a better picture. There are, however, two opposing ways in which filters may be employed to achieve this goal. Traditionally the term 'filter' has been applied to a device placed in the optical path between light source and film to filter out, or remove, certain components of the light considered by the photographer to be undesirable, in order to achieve a more accurate rendition of the colours and tones of the subject. For example, a colour correction filter may be used to correct for a mis-match of light source and colour film (this application is dealt with more fully in pages 96–103). However, filters can also be used to intentionally distort the way in which the film records the subject, in order to produce a creative effect which will enable a photographer the better to convey his personal and unique interpretation of the subject. With this in mind, the term 'filter' is now loosely applied to any device used over the camera lens to modify the way in which the camera sees the subject. Much of this chapter is devoted to a description of the various devices available and examples of their use.

Coloured filters offer the photographer a means of selectively modifying the intensities of the various wavelengths of the light which passes through the camera lens to form an image on the film. Generally speaking a filter allows the constituent parts of light of its own colour to pass unimpeded, but absorbs all other colours, either wholly or partially, depending on the density and purity of the coloured dyes within the filter. A strong red filter, for example, allows

Left: This picture was taken on a normal black-and-white film without a filter, and shows that the film's high sensitivity to blue results in poor contrast between light-toned objects and blue sky. Normal exposure.

Centre: Taken with a yellow filter which has absorbed some of the blue light from the sky, giving better contrast between subject and sky. 2 × normal exposure.

Right: Use of a red filter has allowed even less blue light to reach the film, giving a more dramatic darkening of the sky. 7 × normal exposure.

red light to pass unimpeded, but almost entirely stops the blue and green. A pale red filter would also allow red light to pass unimpeded, but would permit a larger proportion of light of other colours to pass.

Filters for colour correction purposes can be used at any convenient point within the light path, but the usual position is immediately in front of the camera lens. Here the light path is contained within a relatively small diameter, and the filter needs only to be large enough to adequately cover the front element of the lens.

Depending on the particular type of filter in use it may be necessary to give an increase in exposure to compensate for the light absorbed by the filter. With single lens reflex cameras where the metering is performed through the camera lens this is relatively simple, as the camera meter will itself automatically allow for any light loss. With other types of camera the user must make any necessary compensation manually, and most filter manufacturers provide a 'filter factor' which indicates the number of times the exposure must be increased, e.g. × 2, × 3, etc.

Filters with black-and-white film

Colour filters have been used almost from the earliest days of photography to modify the tones of grey by which the colours of the subject are represented in a black-and-white photograph.

The sensitivity of the human eye peaks in approximately the middle of the visible spectrum, that is in the yellow-green area. The sensitivity of a typical panchromatic black-and-white film extends beyond the blue end of the spectrum and into the ultra-violet region. The film's sensitivity to blue light in relation to the other colours is considerably greater than that of the eye, and consequently the film perceives blue objects as being lighter in tone than does the eye. Clouds which to the observer appear to stand out well against a blue sky will not be so apparent on a normal black-and-white photograph. By using a coloured filter to absorb some of the blue light the blue sky can be darkened in the photograph, giving much improved contrast

between sky and clouds. A yellow filter is normally sufficient to ensure a pleasing rendition of a sky, but orange or even red filters can be used for more dramatic effects. There are many similar situations where colour filters can be used to increase the tonal separation between colours which would otherwise appear as similar tones of grey. Conversely there are situations where filters can be used to intentionally record different colours as the same shade of grey. An example of this is the use of a yellow or orange filter to reduce the conspicuousness of stains on an old manuscript.

Filters with colour film

The use of colour filters with colour film has traditionally been to correct the colour balance of a picture by compensating for some discrepancy between colour of light source and the colour sensitivity of the film, e.g. to allow daylight film to be used with tungsten lighting, or tungsten film to be used in daylight.

Filters for colour correction purposes range from the colourless UV filter to the quite strongly coloured filters such as the amber 85B or the blue 80A.

UV filters are mainly used to absorb the ultra-violet content of daylight. The human eye is not sensitive to ultra-violet light but the film is, and will reproduce it as a bluish cast. Problems with excessive UV are particularly evident when photographing at the seaside, high-up in mountains, or anywhere the air is clean and free from dust. A popular variation of the regular UV filter is the 'skylight' filter which has a slightly pinkish colour and absorbs some of the visible blue as well as the ultra-violet, and thus has a slightly more warming effect on the picture. Either filter can be left on the lens permanently to protect the lens surface from accidental damage. It is much cheaper to replace a damaged filter than a damaged lens front element.

Colour balancing and colour correction filters are available in a range of strengths, and offer the facility to correct the colour of most light sources to match the colour sensitivity of the film in use. A useful nomograph for calculating the filter required for a particular light source/film combination can be found on page 98.

A useful addition to any photographer's equipment is the polarizing filter. These filters appear to be just a neutral grey piece of glass, but have the property of passing only the light which is polarized in the same direction as the axis of the filter. This property can be exploited to reduce unwanted reflection from the surfaces of the object to be photographed. Because of the wave-like nature of light, light reflected from a shiny non-metallic surface tends to be polarized, with the axis of polarization parallel to the surface from which it has been reflected. By rotating the polarizing filter on the camera lens until the axis of the filter is at right angles to the axis of polarization of the reflected light the unwanted reflections can be considerably reduced. This can be very useful when photographing objects behind glass, such as a shop window display (see example on page 159). The effect of the polarizing filter can be seen through the viewfinder of a single lens reflex camera, and the filter rotated to obtain the optimum effect. When photographing foliage, the colour saturation of the leaves can be dramatically improved by using a

polarizing filter, which will reduce reflections of the sky from the shiny surfaces of the leaves, producing a much cleaner green than would otherwise result. Reflections from the surface of water can also be reduced by the use of a polarizing filter, and can be particularly effective when attempting to photograph objects beneath the surface, but can result in a rather flat, dead-looking result when used with large expanses of open water. A polarizing filter can also be used to increase the contrast between white clouds and blue sky in a colour photograph. This is because the light coming from the blue sky is already polarized by its passage through the atmosphere, while light reflected from the clouds is not. Consequently the polarizing filter will have a darkening effect on the light from the sky, but not on the light reflected from the clouds. Care must be taken when metering with a polarizing filter on a single lens reflex camera. The viewfinder optics themselves rely on the reflection of light within them to present an image of the subject to the user, and on many cameras these reflections will polarize the light before it reaches the metering system. If this is the case the meter may give erroneous results, usually indicating that there is less light than there really is, resulting in an over-exposed picture. The camera can be checked for this phenomenon by pointing it at a uniformly illuminated *matt* surface and rotating the polarizing filter on the camera lens while watching the meter display in the viewfinder. If the reading changes as the filter is rotated then any readings taken through a polarizing filter should be regarded with suspicion and not relied on to produce a correctly exposed result. In such circumstances additional frames should be exposed using exposure settings either side of that indicated by the meter.

In the picture, far left, the sky is reflected in the glass frontage of the building. The use of a polarizing filter, left, has enabled the reflections to be almost entirely eliminated, resulting in a much stronger picture.

Using Filters Creatively

In this section the term 'filter' is used loosely to include not only colour filters but also diffusers, star filters, fog filters, multi-image filters, vignetters, etc. They create a wide range of effects, some subtle, others dramatic.

Filters are generally used to correct or balance a predominant colour or cast in a picture, and to this end have played and always will play an important part in achieving accurate realism and precise tonal rendition. However, they can also be used for an opposite reason, that is, to increase or even introduce a colour cast or other effect to enhance a picture. An example is the use of an orange filter to add warmth to a sunset, possibly also with a diffuser to add a sense of timeless tranquillity.

It has been said many times that 'a picture is worth a thousand words', but photographs can convey even more than this – they can create a strong emotional impact on the viewer. Whether it be to capture a portrait of mother and baby softly lit and gently vignetted and diffused to give a feeling of tenderness, or the power of a skyscraper building silhouetted against a deep red sky, filters can be used to extend the photographer's concept of 'feeling'.

Colour alone has a strong effect on all of us in our everyday lives. We even say we are 'feeling blue', when we are angry we 'see red', we get jealous and 'feel green with envy', or we feel good and are 'in the pink'. Colour is all around us and influences the way we react to our surroundings. In our home we may have a bright cheerful kitchen, relaxing tones in the living room, pastel shades in the bedroom, and 'aqua' colours in the bathroom. The choice of colours is equally if not more important in other situations. Imagine a hospital with bright red walls or an ocean liner with turquoise green decor! Equally, the use of predominant colours in photography can have a resounding effect on the viewer.

When used creatively, filters are like an artist's palette. They provide colours and shapes which can be applied to the film in the depth and intensity required by the photographer to produce his interpretation of the image before him. Technically they are very simple to use. Some require exposure compensation and this is usually outlined in information supplied with the filter. When using colour filters with colour film the best material to use is reversal film. Strong colour effects reproduce better on direct reversal film. The automatic printers used by processing firms to make prints from colour negatives are set up to print an 'average' picture, that is a typical 'snap' with roughly equal quantities of red, blue and green. They are unable to recognise that a colour cast was intentional, and will partially or wholly compensate for it, and the required effect will be lost. In extreme cases where a particularly strong colour filter has been used, the printer may even reject the picture as being unsuitable for printing. If prints are required, satisfactory reversal prints can be obtained from transparencies, as the printing technique is different, resulting in more accurate colour rendering. Experimentation is essential when using colour filters to create an effect. Bracketing of the exposure may be necessary as a particular effect may be

When using reversal film some slight colour correction may be necessary when subjects are back-lit. Here an 81A filter was used to prevent the skin tones taking on a green cast from light reflected from the surrounding grass.

This picture was taken in the early evening in mid-winter. The warm yellow cast has been accentuated by using an 85 (orange) filter, with a diffuser to give the impression of a hot summer's evening.

heightened in some cases by under-exposure. With colour negative film the automatic printer will partially compensate for over- or under-exposure and again the effect may be lost. Also, it may work out cheaper to use reversal film and have prints made only from the selected slides.

The use of those filters such as ultra violet, soft focus, stars, polarizers, etc, which have little or no effect on the colour or tonal balance of a picture, present no problem to colour negative film.

The use of filters creatively is limited only by the user's imagination. Let your creative sense override the constraints imposed by tradition and you will see many alternatives to the 'normal' picture. Have fun!

Multi-Filter Systems

In recent years the use of filters has increased considerably with the advent of 'square filter systems'. The Cromatek Effects Filter System is one such system. It was designed and developed by Ron Stillwell, a British professional photographer who realised the problems of having many different screw-on filters of the same type for the many different cameras and lenses he used. By using a square filter system with an SLR camera it is now possible to build up a large range of filters in the knowledge that a change of camera or lens will require, at most, only the purchase of an additional inexpensive adaptor to fit the filter thread of the new lens.

The Cromatek system, in common with other makes, consists of a filter holder in which there are a number of slots to hold the filters. The assembly attaches to the filter thread of the lens via an adaptor. The filters themselves are generally made of CR39, an optical resin plastic which has similar optical properties to glass but is cheaper, virtually unbreakable, and accepts coloured dyes more readily.

These systems offer a much larger range of filters than previously available in screw-on filters and provide almost unlimited creative possibilities when two or more filters are used simultaneously in the filter holder.

Most square filter systems have an instruction book explaining the general creative use of the many filters available. They are relatively easy to use with a single lens reflex camera. Fixed lens (viewfinder type) and twin lens reflex cameras are not really suitable as it is not possible to see the effect of the filters through the viewfinder. The illustrations on the following pages were taken with the Cromatek Effects Filter System using a wide range of cameras and lenses. These included a Pentax MX with 35–100 mm macro zoom lens, Canon AE1 Program with 50 mm lens, Nikon FM2 with various lenses, and a Bronica ETRs with 75 mm and 150 mm lenses. Films used were Ektachrome 64, Ektachrome 200, and Kodachrome 25. In all cases the film was used at the rated setting and processing was normal.

By using a diffuser with an oval clear centre, the edges of this picture have been softened but the subject itself has remained sharp.

This type of picture using more than one filter is easy with a multi-filter holder. A magenta colour filter was used with an 8-point star filter.

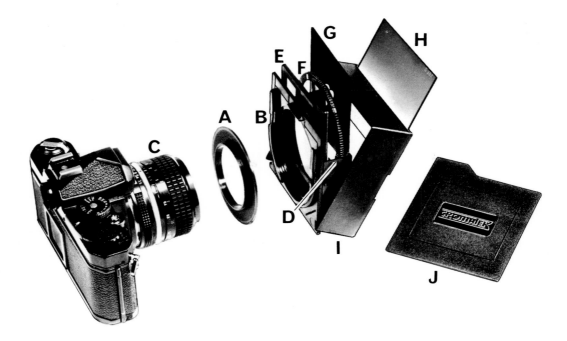

Above: Adaptors (A), available in thread sizes to fit most lenses, are attached to the rear of the filter holder (B) and then screwed into the filter thread of the camera lens (C). Filters are placed in the various slots (D). Square filters (E) can be used in the same slots as round filters which need to be rotated (F), such as polarizers or star filters. Masks (G) can also be used for vignetting or multiple exposures. When the filters are in place the outer hood (I) is closed and acts as a filter/lens shade. A slot on the front of the outer hood allows graduated filters (H) to be moved up and down for pictorial composition. The front dust cover also uses this slot when the filter holder is not in use.

The list below left and opposite shows the more popular types of filters available with most systems, and their general uses. They can of course be combined to give an almost infinite number of different effects.

Solid colours. Generally a wide range of colours for use with black and white and colour films. They have many uses and combine well with other filters.

Stars. Clear filters with patterns of lines to give various star effects from any strong point source of light, e.g. the sun, street lamps at night, etc.

Fogs. These filters give a misty appearance to the picture and generally reduce the contrast.

Diffusers. Very useful for portraits. They soften the image and combine well with other filters.

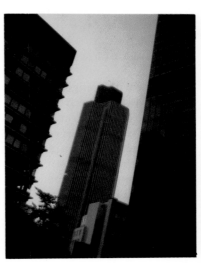

Any city has a wealth of opportunities for striking photographs. This picture was taken in mid-afternoon with a tabac coloured filter to give the impression of sunset.

Graduated. The filter is clear on one half and coloured on the other. By moving the filter up and down in the holder it is possible to add colours and density to only part of the picture. Ideal for intensifying weak skies. Most colours are available in two densities.

Holographic. These filters have very finely etched lines which create a coloured pattern around bright light sources.

Colorsoft. Also called colour spot filters. These are colour filters with a clear centre. The coloured area usually has a fine diffusion pattern which also softens the image, but leaves the centre sharp.

Vignetters. There are basically three types of vignetters:

1. Low key – a dark texture pattern used to darken and soften the outer areas of the picture. Normally used with dark tones.

2. High key – a white patterned filter used with very light pale colours, especially in portraiture, to give a white surround to the picture.

3. Mask vignetters – solid card or plastic vignettes for completely shading parts of the picture.

Sunset. Similar to a graduated filter in its use, this filter is orange overall, with increased density in one half. Used to simulate or strengthen sunsets. Usually available in two different densities.

Masks. Black plastic or card, these are available with a range of shaped centres to create different shaped surrounds to the picture. Can be used with most other filters.

Also available. Colour correction and colour conversion filters, close-up filters, neutral density filters, prism and multi-image lenses, polarizers and various other 'trick' filters and lenses. The selection available is enormous and increasing all the time. Most systems also have a range of filters and masks for multiple exposures.

Holographic filters are very effective when used with a night scene such as this. Try and choose subjects with one or more strong point sources of light. Too many create a 'busy' picture.

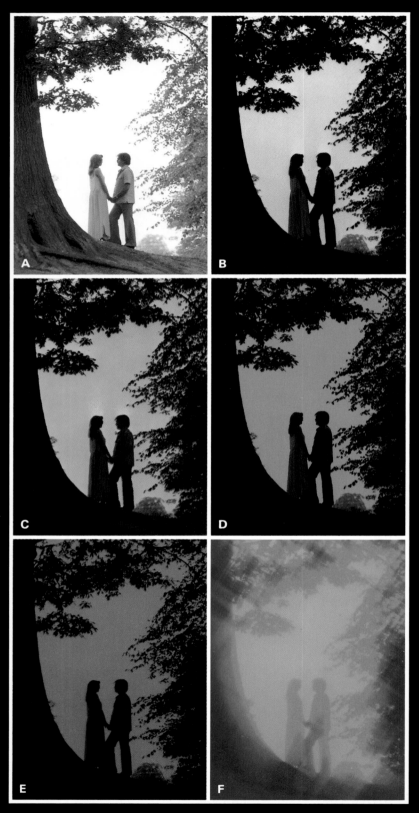

Different moods can be created by different colours. All the pictures on this page were taken in mid-afternoon.
Picture A was taken at the normal exposure, using no filters. Note the rather blank sky and lack of pictorial impact.

Picture B was taken with 1½ stops less exposure. The picture now has some interesting lines and shapes, but the sky still does nothing to help the picture.

By adding a tabac colour filter (picture C) the scene takes on an atmosphere of early evening, complementing the young couple.

When a blue filter is used the scene appears more like a meeting at midnight, picture D.

In picture E the scene has even more impact when a red filter is used.

For picture F a blue filter, a diffuser and a 4-point star filter was used to suggest a romantic moonlight meeting.

Left: A snow scene taken in late afternoon. Most pictures like this are best taken when the sun is low to accentuate the contours of the snow.

Right: Back-lit portraits are always pleasant. However, in many cases the surrounding background often overpowers the subject, even when a fill-in reflector is used.

Left: A holographic filter adds colour and impact – to some it suggests a rising rather than a setting sun.

Right: By using an oval colour vignetter the background is darkened and the colour changed to complement the subject. A tabac colour vignetter was used for this picture.

Left: Add a blue filter and a diffuser and the scene becomes colder, the diffuser softens the sun and makes it appear like the moon.

Right: The background colour can be completely changed by using a blue oval vignetter.

At first glance this picture did not seem worth taking as it was a late afternoon in winter and the ground was covered in snow, so the scene appeared rather grey and lacking in life.

However, a second look through the camera with an orange filter plus a moderate fog filter transformed the picture entirely.

The setting sun in this picture was strengthened by using a dark red graduated filter over the sky to add impact to an otherwise pale sunset.

The picture, above, can be given more 'atmosphere' by the addition of a fog filter, right.

Sometimes the surrounding background can distract from the subject, above. This can be softened with a clear centre diffuser to draw the attention of the viewer to the subject itself, right.

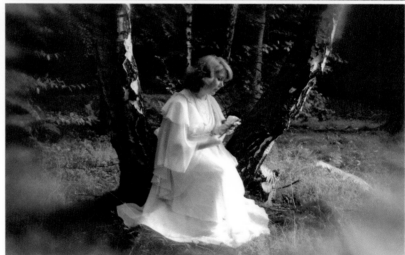

Skies in landscapes can be given extra emphasis or more impact by using a graduated filter.

The illustration above shows the use of a clear centre diffuser to soften the edges of the picture.

Diffusers and vignetters can be used effectively for all types of portraiture. Just as the type of lighting used is important in creating the right modelling of the subject's features, so too is the correct choice of filter. High key vignetters can be used with a white background and a light-coloured subject, as shown in the picture above. To achieve the brightness for this type of picture the background must be white and well and evenly lit to give an exposure reading at least $1\frac{1}{2}$ stops higher than the reading from the subject's face. The high key vignetter will soften the edge of the subject image and fade it gently into the background.

The picture, right, was taken using a low key vignetter to darken the image around the subject and obscure any bright distracting areas in the background.

By using an oval vignetter the background tone is keyed down and bright reflections from the foliage in the corners of the picture are obscured.

Landscapes at sunset can take on many different moods according to the choice of filter. The picture, above, was taken without filters.

Top right: The same scene with a dark red graduated filter over the sky. Exposure was increased by $\frac{1}{2}$ stop to give a little more detail in the foreground, without over-exposing the sky.

Centre right: A dark tabac graduated filter increases the warmth of the setting sun, and the holographic filter adds sparkle.

Bottom right: The same tabac graduated filter was used here, but the addition of a fog filter has transformed the scene completely. The picture has 'atmosphere' which is in keeping with its setting.

Graduated filters can be useful for all kinds of landscapes. Very often a bright overcast day presents problems in achieving an exposure for detail in both foreground and sky. Exposing correctly for the foreground results in a washed out, over-exposed sky, while correct exposure for the sky gives a dark, under-exposed foreground. This is due to the brightness range of the subject being greater than the film can satisfactorily handle (see pages 92–96). In many cases excessive contrast in landscapes can be controlled by using a graduated filter. A grey graduated filter will simply darken an area of the picture without changing the colour. The filter can be moved up and down to allow creative adjustment to achieve the desired effect. Graduated filters are available in several colours, each colour generally being available in light and dark densities. The lighter density filters, particularly those with a fairly neutral colour, tend to give a balancing effect which will improve the picture without necessarily being conspicuous. The darker versions will produce a more dramatic and noticeable effect, and are used to achieve a special effect not otherwise possible. Open landscapes and seascapes are subjects which particularly lend themselves to the creative interpretations possible with these filters.

All the pictures on this page were taken at the same exposure setting in the late afternoon.

Top left: Picture taken with no filters.

Top right: A dark blue graduated filter was used over the sky area.

Bottom left: A dark mauve graduated filter was used.

Bottom right: The illusion of sunset was created by using a special two-density sunset filter.

Left: The ship has been emphasised by the use of a neutral density diffused vignetter to soften and darken the surrounding scenery.

Below: Using an oval vignetter gives a bold outline to the picture.

A reminder that the use of filters does not have to be apparent.

A polarizer was used to increase the colour saturation in the water while also reducing reflections and haze. An 81A correction filter was used to correct the bluish cast caused by the haze.

Audio-visual work

It is a sad fact that many an excellent colour transparency, in the making of which much effort and skill may have been expended, is destined never to be seen to its full potential because the conditions under which it is viewed are less than ideal. This is a situation which can be easily remedied, and it is to this end that the first part of this chapter is devoted to the factors involved in presenting slides to an audience.

The second part of the chapter deals with the production and presentation of slides to be used specifically as visual illustration of topics discussed in a talk or lecture.

Viewing and projecting colour slides

One of the worst, yet probably the most common, methods of viewing colour slides is to hold them up to a lamp or window. Often the colour of the light is quite wrong, resulting in the slides appearing too warm or cold in colour. Light spilling round the edges of the mount appears bright in comparison to that passing through the slide, causing the picture to appear less colourful and brilliant than it really is.

Large format transparencies are usually viewed on an illuminated viewing table or light box. Extraneous light can be masked out by positioning pieces of black paper or card around the transparencies. A light box is also useful for the initial sorting and editing of 35 mm slides when they are first returned from the processing house, or when selecting those to be included in a slide presentation. Such a light box will have either tungsten lamps or, more usually, fluorescent tubes as the light source.

By far the most effective method of presenting slides is to project them, in a darkened room, on to a plain white surface. Colours literally glow and the full tonal range of the pictures can be seen. With little else visible in the darkened room, the attention of the audience is held by the images on the screen before them.

Before presenting his pictures to an audience, the photographer must ruthlessly edit them to weed out any which are less than technically perfect by way of under- or over-exposure, being scratched, accidentally out of focus, etc., or are repetitious or irrelevant to the subject in hand. This process may be somewhat painful as if often means leaving out pictures for which, at the time of taking, the photographer had high expectations, or which may have involved some element of danger or expenditure. Nevertheless it must be done, for there is little more boring than to be subjected to a seemingly endless procession of inferior and repetitive slides.

The final selection should be limited to about forty or fifty really excellent transparencies. It is always best to finish the show with the audience wishing there were a few more slides to come – that

Two different makes of projectors. The model, top, uses linear magazines, which are available to hold up to 50 slides. The lower model accepts a rotary magazine holding 80 slides. This model is particularly strongly made and is thus suitable for heavy-duty professional use.

A few pictures framed to include large areas of plain tone can be taken while on holiday, to be used later to make very effective title slides by combining them with suitable lettering.

If the area on which the lettering is to be superimposed is light in tone the lettering can be added simply by sandwiching with the transparency either another transparency, prepared by photographing on reversal colour film suitably prepared artwork of dark lettering on a white background, or a piece of clear foil to which the lettering has been added by drawing or transferring instant lettering directly on to the foil. If the area on to which the lettering is to be superimposed is dark in tone, as in the example, left, the original transparency should be copied by photographing it with a camera fitted with a suitable close-up attachment and the lettering added by photographing it on to the same frame of film by making a double exposure. In this instance the lettering must be drawn light in tone on a black background.

way they'll be pleased to be invited back to see next year's masterpieces.

The final selection should be arranged to form a logical sequence. Chronological order is best for most subjects. Transparencies of a Mediterranean cruise, for example, could be arranged in the order of the ports visited. Added continuity could be provided by inserting slides of a map, suitably marked to show the progress of the ship, at relevant points within the sequence. Incidentally, it is well worth considering the requirements of a future slide show while actually on holiday. Afterwards title slides may be made by superimposing lettering on to pictures of locations that have been visited. A few suitable pictures should be taken with the subject positioned in the frame to leave an area of sky, sea or mountainside on to which the lettering can be added later, either by duplicating the transparency and superimposing the lettering by making a double exposure, which is suitable for instances where the title is to appear light on a dark background, or by sandwiching with the transparency a piece of clear film on which the lettering has been drawn or rubbed-down with 'instant lettering', suitable for use when the title is to appear dark on a light background.

Although not absolutely necessary, it is good practice to mount the final selection of slides between glass. This protects them during handling from fingermarks, scratches and dust, and prevents them from suddenly 'popping' out of focus a second or so after they appear on the screen. Mounting between glass used to be a fiddly and time-consuming task, involving separate glasses, masks and gummed paper tape. Nowadays plastic mounts with integral masks and glasses, such as the excellent 'Gepe' mounts, reduce the job to a fairly quick and easy exercise. Care should be taken to remove all dust from the transparency and the glasses before closing the mount. A small speck of dust in an otherwise empty sky can appear most disconcerting when enlarged by 30× or more on the screen. The unmounted transparency and glasses should be gently wiped with a

A transparency of a map which has been suitably marked with the route taken will provide continuity and added interest to a sequence of holiday slides.

soft brush or lint-free cloth, just sufficiently to remove the dust. Too much wiping will create static electricity which will attract dust to the transparency like paper to a comb. The transparency could end up with more dirt than it started with. Several firms make anti-static cleaning fluids to assist with this problem.

It is a good idea to 'spot' the slides to make it easy to see which way they should be inserted into the projector. With the transparency the correct way up and the right way round, a mark is made at the bottom left corner of the mount. If, when the projectionist is behind the projector and facing the screen, the slide is loaded into the magazine with the mark in the top right corner, it will appear correctly orientated when projected. If one of those little self-adhesive paper circles which are made for the job is used, the spot can be easily located in a darkened room by touch alone.

If the slides are to be accompanied with a narrative and, perhaps, some recorded music, adequate rehearsals are necessary beforehand.

The projector, screen, seating, etc. should be arranged before the guests arrive. Then all they have to do is sit down and enjoy the presentation.

After the final slide in the show, the performance should be ended by switching off the projector. The final slide should not be allowed to return to the magazine to be replaced by an empty slide carrier. A screen suddenly totally illuminated by brilliant white light can be most uncomfortable to eyes accustomed to the darkened room. It is also easier on the eyes if there is a little additional light in the room during the show to ease the sudden fraction of a second of blackness as the slides change. In an average domestic room the stray light from the projector is usually sufficient. Too much light will spoil the brilliance of the slides, desaturate the colours, and make any shadow detail difficult to see.

Many of the better makes of slide projectors have facilities for connecting a 'slide synchronizer' which, when coupled to a tape recorder, allows the slides to be changed by pulses recorded on magnetic tape. Some synchronizers enable a stereo tape recorder to be used, the slide change pulses being recorded on one track and narrative and music on the other. The best of all allow two or more projectors to be run together, permitting slide changes to be made by fading one slide into another. The speed of the fade may be adjusted so that each image gently dissolves into the next, or is suddenly replaced by another, all controlled by the pulses on the tape. When several projectors are used simultaneously the screen may at one moment carry several small pictures and at the next be filled with just one. Because the pulses and the sound track are recorded on a common tape, synchronization of the slide changes to the music or narrative is so precise that they can be programmed to occur exactly in step with changes in the mood or tempo of the music.

The production of a really good slide presentation using such equipment is truly a work of art, and will have been choreographed to the last minute detail, the final result being a breathtaking spectacle of incredible beauty and colour.

A correctly 'spotted' slide will facilitate correct insertion in the slide magazine and will reduce the chances of pictures appearing on the screen upside down or back-to-front.

A projector which is really two projectors in one, and comes complete with an infra-red control unit.

This model has two separate lamps and optical assemblies. Slides are automatically presented to each assembly in turn, and an integral electronic 'fade' unit dims one lamp as the other is gradually turned on. The effect on the screen is of one picture gently dissolving, or fading, into the next. This gives a much more pleasing presentation than that offered by a conventional projector where the slide suddenly disappears from the screen, to be followed first by a brief period of total darkness and then by the abrupt appearance of the next slide.

Illustrating talks and lectures

It is a well-known fact that the learning process is more efficient when more than one of the senses are used to transfer the information to the brain. The following section discusses the use of colour transparencies to make visual clarification of information delivered aurally at a talk or lecture.

Most people have experienced a lecture in which the slides were either poorly made or poorly presented, or perhaps even both. Most of the faults can be easily avoided by a little forethought and planning. It is hoped that the information and examples given below will pinpoint some of the pitfalls to avoid, and enable one to make lecture slides in which the data is presented in a legible and concise manner.

One of the most important considerations when arranging a hall for lecture purposes is that the screen should be large enough for the information projected on to it to be legible, even from the very back row. A good rule is that the screen depth should be no less than one-eighth of the maximum viewing distance. Thus, a 6 feet (2 m) high screen would be suitable for a hall in which the viewing distance is anything up to 48 feet (16 m).

To ensure legibility at the maximum viewing distance the size of the lettering projected on to the screen must also be considered. A guide when using the above screen height/viewing distance rule is that the height of an individual upper case (capital) letter should be no less than one-fiftieth of the screen height, and preferably in the order of one-twenty-fifth.

For fairly simple title and text slides typewritten lettering will be quite adequate. A template can be drawn as a guide to the area in which the lettering must be contained to comply with the one-twenty-fifth guide above. The depth of the template should be equal to twenty-five times the height of a capital letter (see below). The width should be one and a half times the height. The line spacing of

IF ALL COPY IS TYPED TO FIT WITHIN

THIS TEMPLATE AND PHOTOGRAPHED SO

THAT THE BORDER JUST FILLS A 35MM

SLIDE THE LETTERING WILL BE CLEARLY

READABLE BY THE ENTIRE AUDIENCE.

Close-up lens data

Close-Up Lens	Focus Setting in Feet	Lens-to-Subject Distance in Inches	Approximate Field Size for Picture Area in 2 x 2-inch Slide	
			44 to 46mm Lens	50mm Lens
1+	Inf	39	21×30	18×26½
	15	32¼	17½×24¾	14¾×22
	3½	20½	10½×15	9×13¼
2+	Inf	19½	10½×15	9×13¼
	15	17¾	9¼×13⅝	8×12
	3½	13⅛	6½×9⅝	6⅛×9
3+	Inf	13	6⅞×10	6×8⅜
	15	12¼	6¼×9¼	5¾×8½
	3½	9¾	4⅞×7¼	4½×6⅜
3+ plus 3+	Inf	6¾	3⅞×5¼	3⁷⁄₁₆×4⅞
	15	6½	3⅝×4⅞	2⅛×4⅞
	3½	5¾	2⅞×4¼	2⅝×3⅛

Close-up lens data
(50mm lens set for 3½ feet)

Close-up lens	Lens-subject (inches)	Field size (inches)
1+	20½	9 ×13¼
2+	13⅛	6⅛× 9
3+	9¾	4½× 6⅜
3+ Plus 3+	5¾	2⅝× 3¹⁵⁄₁₆

The table, left, contains too much information to be incorporated in a single slide. The data must be reduced to the bare essentials or, if it cannot be cut, presented in several smaller groupings such as that, right.

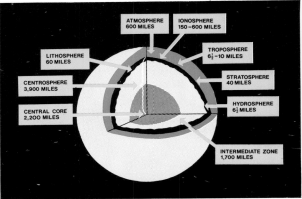

Illustrations in books are often very detailed. This is quite satisfactory, as the reader usually has time to study them at leisure. As a lecture slide, however, the illustration, left, would be much too fussy to be easily absorbed by the audience. Bearing in mind that information omitted on a slide can be presented verbally, a slide of the diagram, right, would present the information much more clearly.

the typewriter should be adjusted so that the vertical space between lines is at least equal to the height of a capital. Both capitals and lower case letters can be used, but the use of capitals only will give legibility at slightly increased viewing distances. If possible a carbon ribbon should be used to give a really black and sharp impression.

Slides in which the lettering appears white out of a black or coloured background are more restful on the eye than those with black lettering on a white background, and have the added advantage that any dust or dirt on the slide is less apparent. Details of how this effect may be achieved, even from typewritten copy, are given later in this section.

Although typewritten copy is adequate for many slides, more professional results will be obtained by using an instant rub-down lettering, such as Letraset. This is made in a large range of type faces and sizes, most of which are available in white as well as black, permitting the direct production of artwork with white lettering on a coloured background. An easily read face should be chosen. If

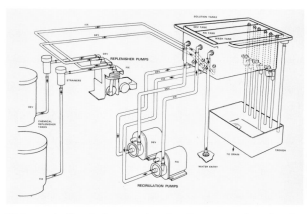
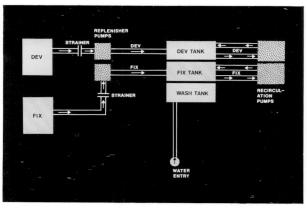

Slides made directly from engineering diagrams such as that shown, left, are usually far too complicated. The diagram, right, is much simpler yet still contains all the vital information.

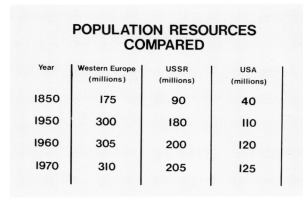

POPULATION RESOURCES COMPARED

Year	Western Europe (millions)	USSR (millions)	USA (millions)
1850	175	90	40
1950	300	180	110
1960	305	200	120
1970	310	205	125

Data can usually be absorbed more easily in graph form than in tabular form. Figures and captions should be kept large enough to be easily read.

keeping within the one-twenty-fifth guide, both upper and lower case letters should be used. Because most written matter is printed this way, the brain assimilates information in upper and lower case more easily than capitals alone, provided the eyes are not straining to read the lettering. (Road signs in many countries are in upper and lower case to allow instructions and directions to be quickly absorbed by the passing motorist.)

It is a good idea to standardise the size of the artwork – a 6 × 9 inch (15 × 22·5 cm) rectangle is a convenient size. This also allows the size of the lettering, the width of any lines used in tables or graphs, and the set-up used to photograph the completed artwork to be standardized.

One should not try to cram too much information on to a single slide. Instead, it should be broken down to make two or more simpler slides. The sequence should progressively disclose the information to be conveyed. A nice way of doing this is to prepare the artwork for a diagram or text slide in stages, each stage adding

only an amount of information which can be discussed within a minute or so. The artwork is photographed after each stage is added, to produce a series of slides, each of which is identical to the one before it, except for the small amount of information added after the previous stage.

Data can usually be absorbed more quickly from a graph than from a table, so whenever possible tabular information should be converted to graph form.

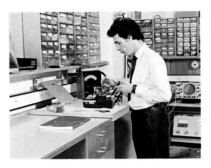
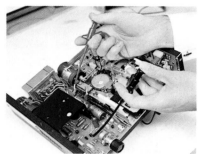

When photographs are used to illustrate particular points in a lecture, only the essential information should be shown. If the picture, far left, is to show a typical electronics workshop it is quite satisfactory, but if it is to show a printed circuit board being tested it is not, as for this purpose it contains far too much superfluous surroundings. The close-up picture, left, would be much more satisfactory.

Photographing completed artwork

Once the coloured artwork is prepared all that is necessary to produce a slide is to photograph it on a reversal colour film. A single-lens-reflex camera, while not absolutely essential, will considerably facilitate focusing and framing. The viewfinders of most SLRs include a little less of the subject than is actually obtained on the film, but this is more or less compensated for by most slide mounts, which mask off a similar amount of the transparency. If there is any doubt, and framing of a particular slide is critical, or if using a non-SLR camera, the area included in the frame should be checked before loading. This may be done by opening the camera back, with the shutter held open on B, and observing the image on a piece of greaseproof paper held across the film guide rails. The camera should be firmly mounted on a tripod.

The artwork may be illuminated by daylight, tungsten lighting or flash, although flash will produce the least predictable results, as it will be difficult to check for reflections or flare from the surface of the artwork, unless there is access to studio flash units with modelling lamps. It is essential to use a colour film balanced for the light source chosen (p. 96). Tungsten lighting will provide the most repeatable results. Ideally two lamps should be used, one either side of the camera, to ensure even illumination. The use of a polarizing filter over the lens will help to reduce flare and ensure good colour saturation and tonal separation of the lettering from the background. The filter should be rotated to the angle which gives the best visual effect.

If the artwork consists of black lettering on a white background and it is desired to convert it to white on a coloured background, the photographic procedure is a little more involved, but really not at all

difficult to achieve. The first step is to make a high-contrast black-and-white negative. This can be on ordinary slow black-and-white film, under-exposed and given extended development to gain contrast, or on a special lith film which gives white or black images with no intervening tones (p. 49). The resulting negative should then be photographed on to reversal colour film using a light box as illumination. Two exposures should be made, one to the negative and the other through a coloured filter to the light box with the negative removed. The first exposure produces a latent image on the film which, if developed at this stage, would produce a straightforward copy of the negative, i.e. white lettering on a black background. The exposure through the coloured filter partially or completely fogs one or more of the three colour layers of the film in the black background areas, but has no effect on the white lettering, which is already fully exposed in all three layers. Blue is probably the most pleasing and restful colour to choose for the background, in which case a Kodak 'Wratten' 47 or 47B filter is ideal for the second exposure. The exposure times are best found by trial and error, but will be found to be not very critical. If using a camera which does not have the facility for making more than one exposure on the same frame, the camera shutter should be opened on B and a piece of black card used as a shutter over the lens.

If it is required to show the same slide twice in the talk, with other slides in between, a duplicate should be made. This will avoid having to skip back through the magazine to find a slide for its second showing.

A slide should not be left on the screen once its topic has been fully discussed. If there is a pause before the next slide is needed, the projector should be turned off or, better still, in the preparation of the slide sequence a slide mount containing opaque card or similar material should be inserted at the point where the pause is required.

It should be ensured that all the slides for the talk are in the same type of slide mounts. Different makes of mounts have different thicknesses, which if mixed may require the projector focus to be adjusted each time a different one is encountered.

If the hall has its own projectionist, he should have the slides as early as possible before the talk, along with any special instructions. Each slide should be 'spotted' to ensure that it is correctly orientated in the projector, and numbered to indicate its position in the sequence. This is advisable even if the slides are taken along already loaded into a magazine. Then any accidental spilling of the slides can be easily rectified. If there is no remote control lead for operating the projector from the lectern a silent signal should be arranged with the projectionist.

Glossary

Aberration Defect of a lens causing it to form an image which is less than perfect. The commonest aberrations are astigmatism, chromatic aberration, coma, distortion, and spherical aberration.

Absorption When light falls on an object some of it is absorbed by the object and is usually converted to heat. The remainder either passes through the object or is reflected from it. The overall proportion of the incident light which is absorbed determines whether the object appears light or dark in tone, and the absorption characteristics at the various wavelengths of the visible spectrum determine its colour.

Actinic Of a wavelength which will cause a latent image to be formed in a photographic emulsion.

Additive colour mixing The synthesis of coloured light by the mixing of various proportions of light of the three primary colours; red, green and blue. The colours in the pictures on a colour television screen are re-created by additive colour mixing, the screen being covered by very narrow dots or lines of phosphors which glow either red, green or blue. The majority of photographic colour processes re-create the colours of the subject by *subtractive* colour mixing.

Anamorphic lens A special lens, which, when used on a camera, distorts the image in one direction only, squeezing a wide horizontal angle of view into a standard picture format. A similar lens on the projector expands the image to its correct proportions, producing a wider than normal projected image. Much used in wide-screen cinematography.

Angle of incidence A ray of light falling on a surface forms an angle with an imaginary line drawn at right angles to the surface. The imaginary line is known as the normal and the angle between it and the incident ray is known as the angle of incidence.

Angle of reflection A ray of light reflected from a surface forms an angle with an imaginary line drawn at right angles to the surface. The imaginary line is known as the normal and the angle between it and the reflected ray is known as the angle of reflection. The angle of reflection is always equal to the angle of incidence.

Angle of view The maximum angle between rays of light passing through the lens from those parts of the subject which will just be included within the picture format. Usually quoted as the angle given by the diagonal of the picture.

Ångstrom The unit used to measure the wavelengths of electromagnetic radiation. 1 Ångstrom = 0·0000001 mm. Largely superseded by nanometre (1 nm = 10 Ångstroms).

Anti-halation backing Dye or other substance coated on the back of the film (or sometimes contained within it) to absorb light which has passed right through the emulsion, preventing it from being reflected back and degrading the image.

Aperture Hole positioned concentrically with the optical axis of a lens to restrict the area of the lens through which light can pass. Usually adjustable in size, formed by an iris diaphragm. Main purpose is to regulate the strength of the light reaching the film. Also plays a part in controlling depth of field.

Artificial light Illumination other than natural daylight. The main sources of artificial light for photographic use are tungsten lamps, flashbulbs and electronic flash.

ASA The American Standards Association rating of film speed (sensitivity of the emulsion to light). The scale is a simple arithmetical progression, double the ASA number indicating twice the film speed. Thus a film of 100 ASA (a medium speed film) is twice as fast as one of 50 ASA and half as fast as one of 200 ASA.

Aspherical A lens with the term 'aspherical' attached to its name is usually one of particularly large maximum aperture, e.g. f1·2, and has one or more of its glass surfaces ground to a curvature which deviates from the spherical to compensate for the spherical aberration inherent in lenses with all spherically ground surfaces and which is particularly apparent at large apertures. Aspherical surfaces are much more difficult to produce than spherical ones, consequently lenses using them are usually very expensive.

Astigmatism A lens aberration which prevents a lens from bringing both vertical and horizontal lines to a focus on a common plane.

Automatic camera A camera in which the exposure is automatically selected by the inbuilt metering system, according to the lighting conditions. In some automatic cameras the system selects both shutter speed and aperture, others require the user to select one function and the metering system selects the other.

Auto winder A camera attachment which employs an electric motor to automatically advance the film after each exposure. Useful for action sequences requiring pictures to be taken in rapid succession, and to reduce any likelihood of the camera being accidentally moved as the film is advanced when taking pictures requiring accurate camera positioning, such as in close-up photography. Auto winders are a simplified form of motor drive, usually with a maximum operating speed of two frames per second.

Available light photography A term applied to photography using only the existing lighting conditions, without the introduction of any supplementary lighting. Usually infers that the light level is low, requiring the use of a fast film.

Average reading metering An exposure metering system in which the photo-cell or cells look at a large area of the subject, the reading obtained thus representing an average of the subject's tonal values. The term is usually applied to a TTL metering system in which the cells are positioned such that the meter's sensitivity is substantially even over the whole of the viewfinder screen.

Back projection A system by which a transparency or film is projected on to a translucent screen from behind. Sometimes used in both still and cine photography to project a suitable background in a studio shot, saving the expense and inconvenience of photography on location.

Ball and socket head Attachment fitted between tripod and camera to permit the easy positioning of the camera at almost any angle.

Barn doors Hinged flaps fitted to photographic flood and spot lights to control the width and direction of their light beam.

Barrel distortion Lens aberration, a form of curvilinear distortion. Straight lines on the subject are reproduced curving away from the centre of the picture.

Base The support of a photographic film or paper, on which the light-sensitive emulsion is coated.

Bas-relief A pseudo-relief effect, achieved by making a positive from an original negative (or vice versa) and sandwiching the two together with a slight lateral displacement between the two images. The effect can be modified by varying the density and contrast of the positive relative to the negative and the direction and amount of the displacement between the images.

Bellows Flexible light-tight sleeve between lens panel and camera body. Used a great deal in the past in folding cameras, but nowadays its use is confined almost exclusively to view cameras, in which it permits a high degree of articulation between lens and film plane, and to certain makes of enlargers.

Bellows unit A camera attachment which, when positioned between the lens and body of a camera with a removable lens, provides a means of increasing the lens to film plane distance, thus allowing the lens to focus on objects much closer than the minimum distance marked on the lens focusing scale. The lens to film distance is adjustable, usually by means of a rack and pinion mechanism, and the lens is connected to the camera body by a light-tight bellows.

Between lens shutter Shutter, usually comprising thin spring-loaded metal blades, positioned between the lens elements, next to the iris diaphragm. The fastest speed is usually limited by the inertia of the blades and operating mechanism to 1/500 sec. Electronic flash can be used at all speeds. Also known as the leaf shutter.

Blooming The coating on glass-to-air surfaces of a lens, which reduces reflection and increases transmission, thereby reducing flare and increasing lens efficiency. The coating is deposited by evaporating a fluoride, usually of sodium or magnesium, and allowing the vapour to condense on the lens elements, which are contained in a vacuum chamber. The process is stopped when the coating has reached a thickness usually equal to one-quarter of the wavelength of green light.

Blur Unsharpness of image due to movement of camera or subject at the moment of exposure.

Bounce flash Flash lighting technique whereby the illumination is reflected on to the subject from a conveniently positioned and suitably reflective surface, such as a ceiling, in order to obtain a soft and diffused illumination of the subject. The technique can often be used to advantage with other forms of artificial light.

Bracketing The technique of taking additional pictures of a subject at exposures greater and less than the estimated exposure, in order to be certain of obtaining one picture with precisely the correct exposure.

Brightness range The difference in luminance between the lightest and darkest tones of a subject. If all the subject tones are to be satisfactorily recorded, the brightness range must not exceed that which the film can handle.

B setting A setting of the speed ring of a shutter, at which the shutter remains open for as long as the shutter release is depressed.

Cable release Bowden-type cable system for operating the camera shutter. One end screws into a threaded socket on the camera body or shutter, the other end is fitted with a plunger which allows smooth release of the shutter. Used with camera mounted on a tripod or other steady support and eliminates need for direct contact between hand and camera, thus reducing likelihood of camera shake.

Cadmium sulphide (CdS) cell A type of photo-cell commonly used in exposure meters, and of which the electrical resistance is inversely proportional to the intensity of the illumination. Very sensitive at low light levels, but takes some time to adapt to the level of illumination, particularly when transferred from bright to dim light.

Camera movements see *View camera.*

Cartridge Pre-loaded film container, usually made of plastic, which simply drops into the back of cameras designed to accept them, and considerably facilitates film loading.

Cassette Film container, usually of metal but sometimes plastic, designed for use with small-format film (mainly 35 mm). Usually pre-loaded by manufacturer, but empty, re-loadable versions also available.

Catch lights Specular reflections of the illumination source appearing in the surface of the subject, e.g. the pinpoint reflections in a portrait model's eyes.

Centre weighted metering A through-the-lens (TTL) metering system in which the exposure reading is taken from the entire subject area included within the viewfinder, but with the sensitivity biased such that the intensity within the central area most affects the reading.

Changing bag A light-tight fabric bag with elasticated arm-holes which can be used as a portable darkroom, e.g. for loading dark slides, loading film into a developing tank or rescuing a film from a jammed camera.

Characteristic curve Graph line plotting the relationship between the various exposure levels to which an emulsion may be subjected against the corresponding optical densities which each level will produce in the processed emulsion.

Chromatic aberration The inability of a lens to bring light of different colours to a common point of focus, due to the refractive index of the glass being different for different wavelengths of light. High quality camera lenses are 'colour corrected' to reduce chromatic aberration to a minimum.

Circle of confusion Each minute point of an object is imaged by a lens as a small circle, known as a circle of confusion. A photographic image may be considered to consist of many such overlapping circles. The smaller these circles are, the sharper the image. The largest diameter which the circles can have without the image becoming noticeably unsharp is an important factor in the calculation of depth of field.

Close-up lens A lens of simple design usually consisting of just a single element, correctly called a supplementary close-up lens. When fitted in front of a camera lens it permits that lens to focus on objects closer than the minimum which the focusing mechanism normally allows. Available in various strengths, marked in 'dioptres' (q.v.).

Coated lens A lens which has its air-to-glass surfaces coated with a thin layer of special material, usually magnesium fluoride, to improve transmission and reduce flare (see *Blooming*).

Colour compensating filters Filters available in various strengths of the primary colours: red, green, blue and the secondary colours: yellow, magenta, cyan, and which may be used over the camera lens to compensate for factors which would otherwise result in a *slight* colour error in the result.

Colour conversion filters Filters specifically designed to effectively convert the colour temperature of an illuminant to that for which the film is designed, e.g. to allow artificial light film to be used in daylight. Bluish filters raise the colour temperature, amber ones lower it.

Colour mixing The mixing of coloured dyes or light in various proportions to produce other colours. Almost all colour film and print materials reproduce the colours of the original subject by the subtractive colour mixing of dyes of the secondary colours: yellow, magenta, cyan. Colour television works by the additive mixing of the primary colours: red, green, blue.

Colour negative film Film which produces an image which is negative both in tonal values and colour, the colours of the subject being represented by their complementaries on the negative, i.e. blue appears as yellow, red as cyan, etc. When colour prints are made from the negative the print material reverses the tones and colours back again to give the positive final image on the print.

Colour printing filters Filters designed specifically as a means of adjusting colour when making colour prints, when they are inserted between light source and negative or transparency. Their optical flatness and homogeneity are not sufficiently good to enable their use over a lens.

Colour reversal film Film which gives a positive result directly, with no separate intermediate negative stage. The resulting image is a transparency which is viewed either against a suitable diffused light source or by projection on to a screen.

Colour sensitivity The relative response of a photographic emulsion to the different wavelengths of the visible spectrum.

Colour temperature A measure of the colour quality of a light source. Indicates the temperature, in Kelvins, of a black body radiating light of the same colour.

Coma Lens aberration which causes an off-axis point of light to be recorded as a comet-shaped image.

Complementary colours Two colours which by additive colour mixing produce white light. If a colour is subtracted from white light its complementary colour is left. Colour filters absorb the complementary colour to that which they transmit. Thus a blue filter absorbs yellow, a red filter absorbs cyan, and a green filter absorbs magenta.

Compound lens A lens consisting of two or more elements.

Computer flash Electronic flash unit which eliminates the need to measure the flash to subject distance and set the camera lens aperture accordingly. Very fast-acting photo-electric circuitry begins to measure the light reflected back by the subject as soon as the flash fires, and turns off the flash tube when sufficient light has been reflected for the film in the camera to have received the correct exposure.

Concave lens A lens which is thinner in the middle than at the edges and which, therefore, causes rays of light which are parallel on entering the lens to diverge on leaving it.

Contrast Degree of tonal separation in an image. A picture with large tonal differences is said to be contrasty, one with only a small tonal range is said to be flat.

Converging lens A lens which causes rays of light which are parallel on entering the lens to converge on leaving it.

Converging verticals Apparent distortion caused by tilting camera upwards to include the top of a tall building. Can be avoided by the use of a view camera or perspective control lens.

Convex lens A lens which is thicker in the middle than at the edges and which, therefore, causes rays of light which are parallel on entering the lens to converge on leaving it.

Curvature of field A lens aberration which causes the plane of sharp focus to be curved rather than flat.

Curvilinear distortion A lens aberration resulting from an inability of the lens to maintain a constant magnification across the image plane. Straight lines on the subject are reproduced curving away from the centre of the picture (barrel distortion) or towards it (pincushion distortion).

Cyan Complementary colour to red. A cyan object reflects blue and green light, and absorbs red.

Daylight colour film Colour film balanced for use in light with a colour temperature of 5500 K. Designed for use in daylight or with electronic flash, but can be exposed with light sources of other colour temperatures if suitable colour conversion filters are used.

Delayed action Mechanism which delays the operation of the camera shutter for several seconds after the release is operated. Allows photographer to include himself in the picture or can be used to minimize the likelihood of camera shake when camera is mounted on a tripod.

Depth of field Distance between the nearest and furthest points of the subject between which everything appears acceptably sharp on the photograph. Actual value depends on focused distance, lens focal length and lens aperture.

Depth of focus Very small distance over which the film plane of a camera can be moved without affecting the visual sharpness of the image. The term is sometimes incorrectly used when referring to depth of field.

Diaphragm Mechanical arrangement of thin, pivoted blades which overlap to leave a central, roughly circular aperture, the diameter of which can be adjusted by rotating the blades on their pivots. Fitted within a lens to regulate the strength of the light reaching the film. Also plays a part in controlling depth of field.

Diffraction Bending of light rays as they pass very close to the edge of an obstacle. Causes noticeable loss of sharpness when lenses are used at small apertures.

DIN (Deutsche Industrie Norm) European rating of film speeds. Logarithmic scale, each increase of three units indicating a doubling of film speed, e.g. 18 DIN = 50 ASA, 21 DIN = 100 ASA.

Dioptre Measure of the refracting power of a lens, equal to the reciprocal of the focal length in metres. A converging lens is given a positive value, and a diverging lens a negative value. Thus a + 2 dioptre lens is a converging lens of 0·5 m focal length.

Dispersion Variation of refractive index with wavelength, and therefore colour, of light. Responsible for the production of a spectrum by a prism and for chromatic aberration in lenses.

Diverging lens A lens which causes rays of light which are parallel on entering the lens to diverge on leaving it.

Electronic flash Artificial light source in which light is produced by the sudden discharge of electrical energy through a tube containing xenon gas. The colour of the light approximates to that of daylight.

Emulsion The light-sensitive coating of a photographic film or paper. Usually a suspension in gelatin of a silver halide plus other additives.

Exposure The total amount of light allowed to fall on a film to form the latent image, i.e. the product of the intensity of the light and the time during which it falls on the film. Intensity is controlled by the camera's lens aperture, time by the setting of the shutter.

Exposure latitude The amount the exposure of a film may be varied from the precisely correct value and still produce an acceptable result. Dependent on the characteristics of the actual film being used, colour reversal films allowing less exposure latitude than colour negative or black-and-white films.

Exposure meter Instrument used to measure the illumination of the subject and subsequently indicate the various combinations of shutter speed and aperture which will give correct exposure of the film.

Extension tubes Tubes used between camera lens and body to increase the lens to film distance for close-up photography. Usually

available in several different lengths, which can be used singly or in combinations. Suitable for use only with cameras with interchangeable lenses.

Fill-in light Additional light used to lighten the shadows caused by the main light source, thus reducing contrast to an acceptable level.

Film speed Numerical indication of a film's sensitivity to light. The two film speed scales in common use are ASA and DIN (q.v.).

Filter A piece of transparent glass, gelatin or other material used to modify the nature of the light passing through it. Filters selectively absorb certain wavelengths, allowing others to pass unimpeded, the effect of which is usually to alter the visual colour of the light. May be used over the light source or, more commonly, directly over the camera lens.

Filter factor Amount by which exposure must be increased to compensate for light absorbed by a filter. Usually marked on filter mount, e.g. $2\times$, $3\times$, etc.

Fish-eye lens Lens of very short focal length and, therefore, with a very wide angle of view – up to 180° with some lenses. A characteristic is gross distortion of the image, sometimes used for special effect.

Flare Non-image forming light which reduces the contrast of the image. Usually caused by reflections from insufficiently blackened surfaces within the camera or by reflections from the internal glass surfaces of the lens. In modern lenses flare is kept to a minimum by 'blooming' (q.v.) each glass-to-air surface.

F-numbers Numbers indicating the light-passing power of a lens. Derived by dividing lens focal length by the effective diameter of the aperture. In most lenses the aperture is calibrated in a standard series of f-numbers, e.g. f2, 2·8, 4, 5·6, 8, 11, 16, etc., each of which passes half as much light as the previous one.

Focal length A measure of the refracting power of a lens, focal length is the distance between the optical centre of the lens and the image it produces of an infinitely distant object.

Focal plane In a camera, the plane at right angles to the axis of the lens at which the image of the subject should be formed, and at which the film is located.

Focal plane shutter A shutter, immediately in front of the focal plane, consisting of two blinds of opaque fabric or thin metal which are positioned end to end but separated by a gap of variable width. Initially one blind covers the film, protecting it from light. When the shutter is released this blind moves rapidly to one side, and its position over the film is taken by the second blind. The exposure is made as the gap between the blinds passes across the film, the shutter speed being determined by the width of the gap.

Focusing Adjustment of the lens to film distance according to the lens to subject distance, in order to ensure a sharp image on the film.

Focusing screen Ground-glass screen in a reflex or view camera to facilitate viewing and focusing.

Grains The particles of silver halide in an emulsion, the size of which partly control the sensitivity of the film to light. Fast films have larger grains, which after processing may appear large enough to impart a visible coarseness to the image. Such an image is said to be 'grainy'.

Grey card A specially prepared card with an 18% reflectance, for exposure metering purposes the same as that of an 'average' subject. Can be used as a substitute for the subject when taking an exposure reading, particularly when the subject itself is lighter or darker than average.

Hot shoe A special accessory shoe which provides a direct electrical connection between the synchronizing contacts of the camera shutter and a flashgun fitted into the hot shoe,

thus eliminating the need for a synchronizing lead.

Hyperfocal distance The nearest distance at which the subject matter is acceptably sharp when the lens is focused on infinity. If the focusing is set to the hyperfocal distance the depth of field extends from half the hyperfocal distance to infinity.

Incident light reading Exposure meter reading taken by measuring the light falling on the subject, rather than that reflected from it. Usually requires a special diffuser – often built into the meter – to be placed over the photo-cell.

Infra-red Radiation, invisible to the human eye, falling just beyond the red end of the visible spectrum. Some films, both black-and-white and colour, are specially sensitized for photography by infra-red radiation, and are used in medical, forensic and other scientific applications.

Inverse square law States that the intensity of radiation is inversely proportional to the square of the distance from the radiation source. Explains the rapid fall-off of light intensity with distance from the light source, particularly noticeable when photographing by flash.

Inverted telephoto Design of wide-angle lens in which the distance between lens and film is greater than the focal length of the lens. This design is necessary with wide-angle lenses for SLR cameras to allow sufficient clearance for the operation of the mirror.

Kelvins (K) Formerly 'degrees Kelvin' (°K). Units of temperature on the absolute scale (same temperature intervals as the centigrade scale, but starting with 0 at absolute zero, i.e. -273 °C), used to measure the colour temperature of a light source.

Latent image The invisible image present in an emulsion between exposure and development.

Leaf shutter Shutter, usually comprising thin spring-loaded metal blades or 'leaves', positioned between the lens elements, next to the iris diaphragm. The fastest speed is usually limited by the inertia of the blades and operating mechanism to 1/500 sec. Electronic flash can be used at all speeds. Also known as the between-lens shutter.

Lens hood Accessory which fits in front of the lens to shade it from bright light coming from outside the field of view. Such light is a potential cause of flare within the lens.

Long focus lens Lens of focal length longer than that of the standard lens, and therefore having a narrower angle of view.

Macro lens Lens specially designed to focus and operate efficiently at the small lens to subject distances encountered in close-up photography. Most macro lenses focus unaided down to a distance which gives an image which is half life-size, but by the addition of extension tubes or bellows can be used to achieve images which are up to several times larger than life-size.

Magenta Complementary colour to green. A magenta object reflects red and blue light, and absorbs green.

Magnification Number of times image is larger than subject. Thus a magnification of $\times 2$ indicates the image is twice life-size, while a magnification of $\times 0.5$ indicates the image is half life-size.

Magnification ratio An alternative way of quoting magnification, by indicating the ratio of image size to subject size. A magnification ratio of 2:1 thus indicates the image is twice life-size, a magnification ratio of 1:2 indicates the image is half life-size.

Mirror lens A 'lens' in which the image is formed mainly by reflection by mirrors instead of by refraction as in a conventional lens. Very long focal lengths are achieved for a compact physical size. The aperture is fixed and not adjustable.

Motor drive Camera attachment which automatically winds on the film after each picture is taken. Allows pictures to be taken at a maximum rate of about five per second, useful for sports photography.

Negative Image in which the tonal values of the subject are reversed, black appearing as white and white as black. In a colour negative the colours of the subject are also reversed, each colour being represented by its complementary, e.g. red appears as cyan, green as magenta, etc.

Negative lens A diverging lens (q.v.).

Neutral density filters Filters, available in various strengths, intended to reduce light intensity without affecting colour, i.e. they attenuate light of all colours of the visible spectrum equally.

Open flash Method of flash photography, only possible in conditions of very low ambient light, whereby shutter is opened on 'B', flash is fired manually, and shutter is closed again. Its use is sometimes convenient when photographing large interiors of buildings.

Orthochromatic Sensitive to all colours of the visible spectrum except red. Orthochromatic film is only used nowadays for specialized applications.

Panchromatic Sensitive to all colours of the visible spectrum. All modern general-purpose films are panchromatic.

Parallax error Discrepancy between the framing of a picture as seen through the viewfinder and as recorded on the film, caused by the slightly different viewpoints of viewfinder and lens in some cameras. Most noticeable when such cameras are used for close-up photography. SLR cameras, in which both viewing and taking of the picture are achieved through the same lens, do not suffer from parallax error.

Pentaprism In a reflex camera, a specially shaped prism which allows the camera to be used at eye level while providing a right-way-up and right-way-round view of the subject.

Perspective control lens Special wide-angle lens in which the lens axis can be shifted from the normal, avoiding the necessity to tilt the camera in relation to the subject, which would cause distortion such as that known as 'converging verticals'. Mainly available for certain makes of SLR camera, and frequently used in architectural photography.

Photomacrography Extreme close-up photography, strictly speaking that which results in an image on film which is life-size or larger, i.e. photography at magnifications of $\times 1$ or greater. Frequently erroneously referred to as 'macrophotography'.

Photomicrography Photography through the compound microscope, i.e. using both microscope objective and eyepiece.

Pincushion distortion Lens aberration, a form of curvilinear distortion. Straight lines on the subject are reproducing curving towards the centre of the picture.

Polarizing filter Filter which passes only light rays which are vibrating in the same plane as the plane of polarization of the filter. Used to reduce the effect of reflections from certain shiny surfaces and to darken blue skies and enhance the green of foliage.

Positive lens A converging lens (q.v.).

Power winder see *Auto winder.*

Rangefinder Optical device in a camera, usually coupled to the focusing mechanism, which allows precise measurement of the camera to subject distance by the visual alignment of two superimposed images.

Reciprocity law States that exposure=light intensity \times time.

Reciprocity law failure Failure of an emulsion to obey the reciprocity law. At very low light levels halving the intensity may require the duration of the exposure to be more than doubled in compensation. Consequently at such light levels the exposure

required may be more than that indicated by an exposure meter. Reciprocity law failure may also occur with very short exposures such as those sometimes given by automatic flashguns.

Refractive index Numerical value indicating the light-bending properties of a medium. Derived from the ratio of the velocity of light in a vacuum to the velocity in the medium.

Reversal film Film which is processed to give a direct positive, usually in the form of a black-and-white or colour transparency, with no separate intermediate negative stage.

Ring flash Special electronic flashgun with a circular flash tube and reflector which can be fitted around the camera lens, giving an almost shadowless lighting which is very suitable for certain types of close-up photography.

Selenium cell Photo-electric cell used in some makes of exposure meter. Generates an electric current which is directly proportional to the light intensity. Meters using this type of cell require no battery, but are relatively insensitive at low light levels.

Silicon photo diode Photo-electric cell which, when connected in series with a battery, passes a current which is directly proportional to the light intensity. Very sensitive, with a much faster response than the cadmium sulphide cell. Used in the TTL metering system of some cameras.

Silver halides Silver bromide, chloride and iodide, one or more of which is the light-sensitive ingredient of most photographic emulsions.

Single-lens reflex Camera in which the lens performs both taking and viewfinding operations, the image being deflected on to the viewing screen by a mirror.

Spectral sensitivity The relative sensitivity of an emulsion to light of different wavelengths.

Spherical aberration Lens defect in which light rays passing through the lens near its axis are brought to a different focus from those which pass through near its perimeter.

Spot metering TTL exposure metering system with a narrow angle of view, which enables the reading to be taken from a small area of the subject which is precisely indicated in the centre of the viewfinder screen. Separate spot meters are also available which have an extremely narrow measuring angle – typically only 1°.

Standard lens Lens with a focal length approximately equal to the diagonal of the format for which it is intended. The lens which is usually supplied with the camera.

Stop Alternative term for the aperture of a lens.

Stopping down Decreasing the size of the lens aperture.

Subtractive colour mixing The synthesis of colours by the mixing of various proportions of pigments or dyes of the three secondary colours: yellow, magenta and cyan. Most photographic colour materials re-create the colours of the subject by this means.

Supplementary close-up lens Relatively weak converging lens used over the camera lens to effectively reduce its focal length, thus allowing it to focus closer than normal. Used in close-up photography and available in various strengths, e.g. +1, +2, +3 dioptres.

Synchronization Ensuring that the peak output of a flash coincides with the maximum opening of the shutter.

Telephoto lens Lens of longer than normal focal length and of an optical design which allows the physical length of the lens to be shorter than the focal length, thus producing a lens which is more compact than one of the same focal length but of conventional design.

Transparency Term usually applied to a positive image on a clear film base, such as that resulting from the processing of a colour reversal film.

T setting A setting of the speed ring of a shutter, at which the shutter opens when the release is pressed and remains open until the release is pressed again.

TTL (through-the-lens) metering Exposure metering system in an SLR camera in which the reading is taken by one or more photo-cells which measure the light at the focusing screen, after it has passed through the lens. This facility allows the user to see exactly the area of the subject from which the exposure will be assessed and automatically takes account of the setting of the lens aperture.

Twin-lens reflex Camera with two lenses of matched focal length, one for taking the picture and the other for viewing. The light path from the viewing lens is deflected by a mirror to allow the image to fall on to a horizontal focusing screen, on which an upright, but laterally reversed, view of the subject can be seen.

Ultra-violet Radiation just beyond the blue end of the visible spectrum and to which most films exhibit some sensitivity. When photographing in conditions in which a lot of ultra-violet radiation is present, such as when working on mountains or in large open landscapes, an ultra-violet-absorbing filter should be used over the camera lens to prevent this radiation from reaching the film.

View camera Large format camera in which the image may be viewed directly on a ground-glass screen at the rear of the camera. Most view cameras have 'movements' which allow the lens panel and back panel, which are interconnected by a flexible, light-tight bellows, to be moved in relation to one another and to the lens axis, giving considerable control of the geometry of the image. Much used in studio and architectural photography.

Viewfinder Part of a camera for viewing and framing, indicating the area of the subject which will be included in the picture. In some cameras also incorporates a means of visually checking the focusing of the lens.

Wide-angle lens Lens of focal length shorter than that of the standard lens and, therefore, having a wider angle of view.

X-rays Electromagnetic radiation of very short wavelengths, which possesses the ability to penetrate certain materials which are opaque to light. Used to enable the observation and photography of internal structures not normally visible by other means. Most general-purpose photographic films are sensitive to X-rays, and should, therefore, be kept well away from all sources of this radiation.

Zoom lens Lens in which the focal length, and hence the angle of view, is continuously variable over a certain limited range.

Index

Accessory shoes, 176–7
Action photography, 88
Additive colour mixing, 13
Angle of incidence, 11
Angle of reflection, 11
Angle of view, 75, 82
Animal photography, 141
 in zoos and wildlife parks, 143–6
Aperture, 16, 21
 calibration, 21
 related to shutter speed, 64–5
Aperture diaphragms, 214, 222
Apochromat, 206
Architectural photography, 78–9, 122–5
 details and interiors, 123
 floodlit buildings, 156
Artwork, photographing, 264–5
ASA, 44
Aspherical surface, 81
Audio-visual work, 258–65

'B' shutter settings, 27
Background, in composition, 111
Bellows units, see Extension bellows
Bird photography, 136–41
 attracting towards camera, 138
Blur, 84
Bounce flash, 177
Box cameras, 17
Brightfield illumination, 223
Brightness range, 94

Cable release, 86
Cadmium sulphide (CdS) cells, 54–5
Calendar photography, 121
Cameras
 basic principles, 17–19
 box, 17
 compared with the eye, 110–11
 housing, for underwater work, 153
 instant picture, 40
 reflex, 18
 shake, 84–8
 single-lens reflex (SLR), 38–40
 use in photomicrography, 209
 use of extension tubes, 192
 vibration, 87–8
 submersible, 153
 twin-lens reflex (TLR), 36–7
 view, 41–3, 123
 viewfinder, 34–6
Cartridge, 19, 52
Cassette, 19, 52
Characteristic curve, 49
Child photography, 126
Chromatic aberration, 16, 81
 absent in mirror lenses, 77
 in microscope lenses, 206
Circle of confusion, 68–9, 70, 74, 203
Circus photography, 160–1
Close-up photography, 188–203

apertures for depth of field, 173
 choice of lens, 196
 lighting problems, 184–5
 with SLR cameras, 38
Coins, photographing, 229–31
Colour, 12–14
 casts, 176, 177
 film limitations, 96–102
 mixing, 13
 printing, 13–14
 spectral sensitivity of eye and film,
 100, 101–2
 temperature, 96
 considerations for
 photomicrography, 215
 meters, 100–1
 of flashbulbs, 163
 under- and over-exposure, 54
Composition, 104–21
 basic rules, 106
 points of interest, 106, 108
Conjugate distances, 198
Conjugate foci, 198
Contrast, 92
 problems in circus photography, 161
 reduced in underwater photography,
 151
Converging verticals, 42, 78, 123
Coupled rangefinder, 20, 35
Creative photography, 105
Crystal photography, 203, 238–41
 use of polarized light, 223

Darkfield illumination, 223
Dark-slides, 53
Daylight colour film, 96
Depth of field, 67, 68–74
 calculation, 70–1
 effect of aperture setting, 23
 in close-up photography, 201–3
 in photomicrography, 221–3
 scales and tables, 69
Diaphragms, see Aperture diaphragms
 and Iris diaphragms
Differential focus, 111
Diffraction, 23
Diffusers, 177
DIN, 44
Direct reversal prints, 95
Dispersion, 81
Distortion of image, 78

Electric batteries
 recharging, 166–7
 used in electronic flash, 164–6
Emulsions, 44
Exposure
 assessment in photomicrography,
 218–20
 automatic control, 63

calculation for close-up photography,
 200–1
 control, 64–5
 for bounce flash, 178
 for flash, 168–71
 for fluorescence, 232
 in water-colour technique, 234
 latitude, 54
Exposure meters, 19, 54–63
 average reading system 60
 built-in, 59–60
 cadmium sulphide (CdS), 54–5
 calibration, 56
 centre-weighted system, 60
 flash, 170
 for underwater work, 155
 full aperture metering, 62–3
 in dim light, 158
 incident light method, 58–9
 reflected light method, 57–8
 selenium cell, 54
 silicon photo-diodes (SPD), 55
 spot reading system, 60–1
 stopped-down metering, 61–2
 through-the-lens (TTL), 39, 60–1
Exposure range, 94
Extension bellows, 75, 192–3
Extension tubes, 75, 192–3
 in crystal photography, 239
 magnification calculations, 194
Eye, compared with camera, 110–11
Eyepieces, microscope, 206–7

F-numbers, see Aperture
Fashion photography, 105
 use of flash, 184
Film, 44–53
 black-and-white, 44–5
 cassettes and cartridges, 19
 colour limitations, 96–102
 colour reversal, contrast range, 92, 94
 contrast limitations, 92–6
 fast, 45
 grain, 45
 high-speed, 67
 infra-red, 47–8
 instant picture, 50–1
 limitations, 92–103
 lith, 49–50
 negative colour, 47
 reversal colour, 45–7
 roll, 19
 sensitivity to IR and UV wavelengths,
 9
 sharpness limitations, 92
 sheet, 53
 sizes, 51–3
 slow, 45
 speed, 44, 92
 related to flash, 168–9
 X-ray, 49

Filters, 96, 99, 242–57
 colour compensation, 176, 242, 243
 effect of water, 150
 infra-red transmitting, 185
 neutral density, 173, 174
 polarizing, 159, 238, 239, 244, 245, 257
 systems, 247–257
 Uv absorbing, 242
Fireworks, 158
Fish, photography of, in aquariums,
 226–7
Flare, 25, 96
Flash, 11, 162–87
 as supplement to lighting, 179–81
 automatic ('computer'), 103, 140,
 171–6
 exposure for bounce flash, 179
 limitations of flashmeters, 170–1
 manual control, 176
 synchro-sun photography, 181
 bar, 164
 bounce, 177
 brackets, 175
 bulbs, 162–4
 focal plane, 32
 for professional use, 164
 related to shutter speed, 28
 use with focal plane shutters, 32
 capacitors, 164
 checking for reflections, 184
 cubes, 29, 163, extender, 163, 177
 effect of light-reflecting surfaces, 170
 electronic (strobe), 28, 164–8
 in photomicrography, 220–1
 electronic tubes, 99–100
 factor, 168
 fill-in, 180
 hot shoe, 176–7
 lamps, 162
 meters, 170
 multiple, 182–3
 open, 183–4
 optimum distance, 173
 positioning, 174, 176–9
 powder, 162
 power, related to aperture, 168–9
 problems of under-separation from
 lens, 177
 ring, 184–5
 safety precautions, 185
 studio equipment, 184
 synchronization, 19, 28, 32
 synchro-sun, 180–1
 test exposures, 169
 underwater units, 185
 used in aquarium photography, 226–7
 used in photographing small creatures,
 225
Flowers, photographing, 147–9
Fluorescence, photographing, 232
Fluorescent lamps, effect on colour film,
 100
Focal length, 15
 related to aperture setting, 22–3
Focal point, 15
Focus, differential, 111

Focusing, 20
 controls, 18
 in photomicrography, 208, 211
 in TLR cameras, 37
 microscopes, 206
 using close-up lenses, 190
Focusing rings, 20
Forensic photography, 48, 185
Formats, film, 51–3
Framing, 108, 110

Gelatin, 44
Glass, non-reflecting, 236
Glassware, photographing, 233
Grain, 45
 used for effect, 92
Grey cards, 57
Guide numbers (flash), 168–9

Half-frame, 52
Hides, 141–3
 construction, 143
 positioning, 138
Highlights, 92–6
Hot shoe, 176–7
Hyperfocal distance, 71–2, 74

Illumination, see Lighting
Infra-red photography, 185
 film, 47–8
Interiors, 123
Inverse square law, 168–9, 200
Inverted telephoto, 77
Iris diaphragm, 17–18
 automatic, 111
 construction, 20–1
 fully automatic, 40
 ignored in photomicrography, 208

Kelvins, 96
Köhler illumination, 215–17

Landscapes, photographing, 107
Latitude of exposure, 54
Leaf shutters, 18
Lenses, 20–5
 aberration, 22–3
 ability to form images, 15
 achromatic, 206
 apochromatic, 206
 aspheric, 81
 bayonet and screw mounts, 40
 'blooming' process, 25
 close-up, 188–91
 choice, 196
 effect on image quality, 191
 construction, 17, 20
 convex, 204
 fish-eye, 78
 fixed-focus, 20
 fluorite, 82
 focal length, 16
 hoods, 220
 immersion, for microscopes, 212–13
 interchangeable, 24, 37, 40, 75–83
 inverted telephoto, 77
 long focus, 76–7
 macro, 80–1, 198–9

 mirror, 77
 numerical aperture, 222
 perspective control, 78, 123
 planapochromatic, 206
 planochromatic, 206
 reducing internal reflectance, 25
 retrofocus, 77
 reversal, 199–200
 standard, 75
 telephoto, 76–7
 tilt and shift, 79
 wide-angle, 77–9
 for architectural photography, 122
 used with extension tubes, 196
 zoom, 79–80
 with macro lens facility, 198
Lettering
 on transparencies, 259, 261–3
 photographing, 264–5
Light
 artificial, 10–11
 for portrait photography, 126
 polarized, 223, 238–41
 properties, 9
 reflection, 11
 refraction, 12, 14–16
Light boxes, 258
Lighting
 equipment, 134
 for coins and medals, 230, 231
 Köhler illumination, 215
 specimens for microscopes, 206
 specimens for photomicrography,
 213–18
 supplemented by flash, 179–81
'M' shutter settings, 28, 29
Macrophotography, 188
Magnesium ribbon, 162
Magnification, 193–4
 in photomicrography, 209, 211
 limits, 212–13
 range of microscope, 205
Magnification ratio, 193
Medals, photographing, 229–31
Medical photography, 185
 see also Photomicrography
Microphotography, 188
Microprisms, 211, 212
Microscope adaptors, 75
Microscopes
 basic principles, 204–7
 coupled to cameras, 188
 numerical aperture of objectives, 212
Mired shift values, 98, 99
Modelling lamps, 184, 226
Mounts, for transparencies, 259
Movement, 84
 camera, 67, 84–8
 in photomicrography, 219
 'frozen' by electronic flash, 166
 or subject, 88–91
 photography of, 65–7

Natural history photography, 136–49
 of small creatures, 224
Negatives, 95
Night photography, 156–61

Oil-painting technique, 236–7
Orthochromatic films, 45

Panchromatic films, 45
Panning, 89–91
Parallax error, 35, 37, 38
 compensating for, with close-up lens,
 190
Pentaprism, 37, 60
Perspective, 75, 83
 in architectural photography, 122
Phase contrast system of illumination,
 223
Photomacrography, 188
Photomicrography, 188, 204–23
 use of electronic flash, 220–1
 with fixed-lens cameras, 207–9
 with interchangeable-lens cameras,
 209–12
Piezo-electric devices, 164
Pinhole cameras, 9, 10
Plant photography, 147–9
Plates, glass, 19
Polarized light
 plane rotation, 238
 use in crystal photography, 238–41
Portrait photography, 76, 126–35
Preview button, 111
Primary colours, 13
Primary image, 205
Prisms, 14
Projecting transparencies, 258
Projectors, slide synchronization, 261

Quench tubes, 171

Rangefinders, 18, 20, 35
Real image, 204
Reciprocity failure, 102, 176
Reciprocity law, 102
Record photography, 104
'Red-eye' effect, 163, 177
Reflection, 11
 from coins and medals, 229
Refraction, 14–16
 effect in underwater photography, 150
 spectrum formation, 12
Refractive index, 14

Resolution, 23
 in microscopy, 212
Roll-film, 52–3

SLR, see Single-lens reflex cameras
Screening process, 50
Secondary colours, 13
Secondary image, 205
Selenium cells, 54
Sheet film, 53
Shutter release, 33
 effect on camera shake, 85–6
Shutter speed
 for night photography, 156
 combatting camera shake, 84
 control of, 19
Shutters, 17, 18, 26–33
 between-lens, 18, 26–9
 control of speeds, 27
 delayed action, 28, 32, 87
 electronic timing, 27
 focal plane, 18, 29–32, 168
 leaf, 18
 speed related to aperture, 64–5
Silicon photodiodes, 55
Silver halides, 44
Single-lens reflex (SLR) cameras, 18,
 38–40
 through-the-lens (TTL) metering,
 60–3
 wide-angle lens, 77
Slave units for multiple flash, 182–3
Soft-focus attachment, 131
Spectrum
 composition of, 9
 secondary, 81–2
Spherical aberration, 16, 81
 in microscope lenses, 206
 in mirror lenses, 77
Sports photography, 89
'Spotting' transparencies, 260, 265
Stop, see Aperture
Sun, position in relation to buildings,
 122
Surveillance photography, 185

'T' shutter settings, 27
TLR, see Twin-lens reflex cameras
Thyristors, 172

Title slides, 259
Transillumination, 206
Transparencies, 45
 selection for presentation, 258–9
 to illustrate lectures, 261–4
 use of lettering for captions, 261–3
 viewing and projecting, 258–61
Tripods, 88
 for night photography, 156
 shots close to ground, 149
 use in bird photography, 137
Tungsten colour film, 96
Twin-lens reflex (TLR) cameras, 18,
 36–7
 limitations, 37

Ultra-violet, 9, 232
Umbrella reflectors, 178
Underwater photography, 150–5
 flash, 185

'V' shutter setting, 29
Vibration
 camera, 87–8
View cameras, 41
Viewfinder cameras, 34–6
 exposure meters, 59
Viewfinders, 17, 18
 in SLR cameras, 39
 in underwater photography, 153
Viewing tables, 258
Virtual image, 204
Vision, 204

Water, optical characteristics, 150
Water-colour technique, 234–5
Waterproofing equipment, 155
Wavelength, 9, 12
Wildlife parks, 143–6
Window displays, 159

X-rays, 49
'X' shutter settings, 28, 29, 32
 for electronic flash, 168

Zoom lenses, 24
Zooming range, 79
Zoos, 143–6